Still Philadelphia
A Photographic History, 1890–1940

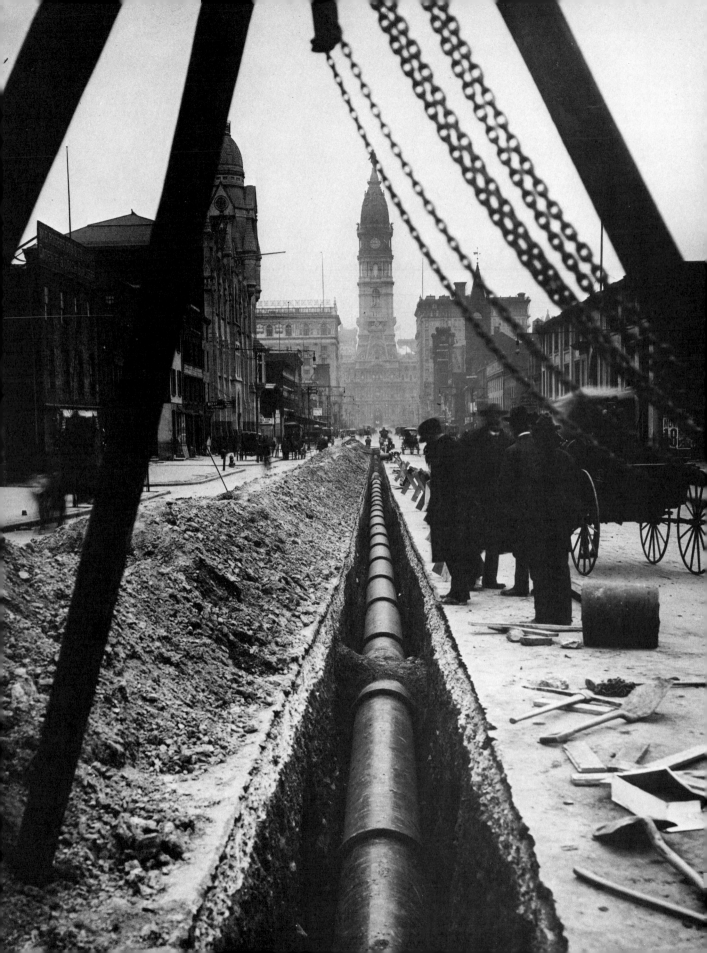

Still Philadelphia

A Photographic History, 1890–1940

Fredric M. Miller

Morris J. Vogel

Allen F. Davis

Temple University Press

Philadelphia

*Publication of this book was assisted
by a grant from the Samuel S. Fels Fund.*

Temple University Press, Philadelphia 19122
© 1983 by Temple University. All rights reserved
Published 1983
Printed in the United States of America

Design: Arlene Putterman
Maps drawn by Heidi Perov

Library of Congress Cataloging in Publication Data
Miller, Fredric.
 Still Philadelphia.

 Includes index.
 1. Philadelphia (Pa.)—Description—Views.
2. Philadelphia (Pa.)—Social life and customs
—Pictorial works. I. Vogel, Morris J. II. Davis,
Allen Freeman, 1931– . III. Title.
F158.37.M57 1983 974.8′1104 82-19227
ISBN 0-87722-306-8

To our colleagues and friends at Temple University

Contents

Preface ix

Acknowledgments xi

Introduction xiii

The City of the 1890s 3

Immigrant Havens 31

Workshop of the World 73

The Vision of Reform 119

A Gallery of Faces 149

Technologies of Change 171

The Rise of the Downtown 197

The New Philadelphia 223

The City of the 1930s 253

Sources 283

Index 285

Preface

This is a book about Philadelphia and about photography, but it is not the usual book about either. It concentrates on the history of the city during a fifty-year period from about 1890 to 1940. It focuses on the city of immigrants and industry, and not on the lives and houses of the wealthy. It says little about unusual civic occasions and nothing about political events. You will not find a photograph of a mayor or a celebrity, or even pictures of the Sesqui-Centennial Exposition, a baseball game, a strike, or the Mummers Parade. Although City Hall can be detected in many photographs, and a few public buildings, such as the Art Museum, may be seen in the distance in some views, we have avoided the ceremonial, carefully composed shots of institutions, public buildings, and private mansions that usually grace photographic books on Philadelphia and other cities. In fact, this may be the first illustrated book on Philadelphia without a picture of Independence Hall.

On one level, this is a Philadelphia family album. It is filled with pictures of ordinary people who look out at us from the past. Some of these people are captured accidentally and some are posed, but none are seated for a formal portrait. Most are wearing their everyday clothes and many are working, shopping, walking, or playing. In addition to the faces, the photographs in this book record thousands of places—neighborhoods, markets, mills, factories, houses, and even a few farms—ordinary scenes that capture some of the texture of life in another age.

On another level, this is the pictorial story of a great industrial metropolis in transition. It is the story of a railroad city, a city of trolleys and subways and horse-drawn vehicles before it succumbed to the automobile. It is the story of a city filled with major industry before the factories closed and the nature of work changed. It is the story of a city spreading out, expanding and doubling in population in fifty years. It is the story of urban exuberance and vitality where ethnic groups mixed and mingled, but it is also the story of slums and poverty.

Some photographers represented here are famous—Lewis Hine and John Vachon, for example—and some are less well known, like John Frank Keith, Philip Wallace, and G. Mark Wilson. But most of the photographs in this book were taken by anonymous photographers, some working for the city, some for the Octavia Hill Association or the Philadelphia Housing Association, some hired to take pictures of various businesses and industries. We are not as concerned with who took the photographs, or the technical quality of the print, or the equipment used, as we are with what these photographs can tell us about the nature of urban life. We do, however,

constantly ask: Why was this photograph taken? What was the purpose and the point of view of the photographer? What does the photograph tell us accidentally?

We have tried to select the best quality and the most visually interesting photographs available, but occasionally we have included a print of poor quality because the subject was important or the scene remarkable. We have searched many archives and private collections, but the surviving photographic record remains incomplete. Despite our efforts there are only a few photographs in this book taken in the winter or in the rain. Women, blacks, and some ethnic groups are underrepresented, even though we have done our best to include examples of the diverse mixture of people which made Philadelphia an exciting and vital city during the years from 1890 to 1940. Children are probably overrepresented because the photographers found them fascinating and appealing, and we did too. There are not as many interior views as we would have liked, and not as many family photographs as would have been desirable, but interior views for this period are rare and often stilted and formal, while most family photographs are simply portraits or of poor quality. Perhaps this book will stimulate a search of attics and family albums to uncover a more personal photographic record of the city. One final caveat: during the fifty-year period covered here the city was filled with conflict and violence, yet the camera recorded little of this turmoil. But the surviving photographs document the overwhelming presence of poverty and one can imagine the discontent and the anger that was just below the surface.

This book can be read or viewed in a variety of ways. One can begin at the beginning and move through systematically to the end, and discover that the book does chart change and development over time. One can read each chapter as a separate unit, or even open the book at any page. But the book has a larger meaning as well. It is a serious book, yet it has no footnotes or bibliography. It is meant to be savored and enjoyed by those who live in Philadelphia, and those everywhere who share our excitement about old photographs and urban life.

Acknowledgments

In preparing this book we have been dependent on the aid and cooperation of a great many institutions and their staffs. Without their help and permission to reproduce photographs this book would not have been possible. We would especially like to thank the following: John Alviti and Jeffrey Roberts, Atwater Kent Museum; R. Joseph Anderson, Patricia Proscino, Gail Stern, and Shawn Weldon, Balch Institute for Ethnic Studies; Robert Looney, Free Library of Philadephia; Kenneth Finkel, Library Company of Philadelphia; James Mooney, Peter Parker, and Linda Stanley, Historical Society of Pennsylvania; the staff of the Print and Photograph Division, Library of Congress; the staff of the Still Pictures Branch, National Archives; Roland Baumann and Linda Ries, Division of History, Pennsylvania Historical and Museum Commission; Ward Childs, Allen Weinberg, and Commissioner of Records Edward Plocha, Philadelphia City Archives; Thomas Whitehead, *Philadelphia Inquirer* Collection; Department of Special Collections, Temple University Libraries. For permission to use photographs on deposit at the Urban Archives Center, Department of Special Collections, Temple University Libraries, we would like to thank: Mrs. E. Douglas Hersey-Hess, City Parks Association; Anthony Lewis, Housing Association of Delaware Valley; William Reynolds, Octavia Hill Association, Inc.; Lee Webster, School District of Philadelphia.

A number of people read early drafts of this book, gave us advice and encouragement, and shared their knowledge of photography and Philadelphia with us. We would like especially to thank: Dennis Clark, Perry Duis, Kenneth Finkel, Charles Hardy III, Theodore Hershberg, Glen Holt, Cynthia Little, Meredith Savery, Thomas J. Schlereth, and Richard Tyler.

Randolph Cuirlino copied many of the photographs that appear in these pages. Kenneth Arnold supported this project from the beginning and contributed to its success in many ways.

Introduction

Philadelphia looked different in 1890 or even in 1940 than it does today. As we study the photographs that survive from the half-century between those dates we are struck by the clothes, the faces, the appearance of the buildings, the horses, and the billboards. As we look at an instant in time frozen by the camera, the very texture of the urban landscape seems strange and foreign. Yet there is a certain thrill as we become for a moment an observer of, even a participant in, another age.

It is a black-and-white world we enter into, which is one of the things that makes it seem foreign. We live today in a world of Technicolor, of bright flashes of reds and oranges and of subtle pastels. Before 1940, and especially before 1920, the world was made up more of grays and browns and the dull red of brick, which the camera turned into shades of gray. Yet we have come to accept the black-and-white world of old photographs and documentary films. In fact, there is a danger that, because it is black and white, we will assume that it is authentic, or that we will be nostalgic for a world now past.

The camera seems to authenticate and to reinforce our memories, and the stories we have heard from our parents and grandparents. But the camera is selective and the photograph, like any historical document or recollection, should be examined critically and with care. All the photographs in this book were taken with a point of view and a purpose. Sometimes the purpose is clear: a housing reformer takes a picture of a back alley in order to convince the people and the legislature of the need for better laws regulating back alleys and housing; a city photographer is sent out to document the resurfacing of a street or the construction of a new subway. In either case the result was calculated; the photographer considered where he was going to stand, what he was going to include in (and exclude from) the picture. If he had stood in a different place, or turned his camera to the left or right, or taken the picture a few minutes before or after, we might have a completely different photograph and an entirely different interpretation of the scene. We also have to consider that in the 1890–1940 period photographic equipment was awkward; professional cameras usually required tripods and took time to set up, adjust, and focus. The 35 mm. camera, with its ease in shooting many pictures rapidly, was not perfected until the 1920s, and even then only a few photographers used it. For the most part, the nature of the equipment increased the planning necessary. Also, with film speeds slower than they are

today, it was difficult to stop action, so photographs required careful composition and arrangement of the subject. Most photographs were taken in the summer, spring, or fall, with the sun shining. Interior shots were rare, and tended to be more posed and artificial than the outdoor views. Happily, even in the most carefully posed picture some things appear by accident, so the reality of the past is recorded. We can study the clothes, a billboard, the look of a cobbled street, a barber pole, a saloon sign, and the people who are not posed but caught in accidental movement, or caught acting for the camera. Studying the accidental and the ordinary can give us a sense of the past, its texture and feel.

Photographers began to take pictures of cities from the moment the daguerreotype was invented in 1839. Photographers tended to live in cities, and thus the urban environment became a natural source of subjects. The first photograph taken in Philadelphia was a daguerreotype made in October 1839 by Joseph Saxton from the Philadelphia Mint. Photographers soon discovered a market for urban views. For decades their pictures of buildings and city streets helped Americans define and understand the urban environment. Most of these photographs, however, celebrated and promoted the city. Photographers took pictures of public buildings, of grand boulevards and clubs, of churches, and of prominent citizens standing in front of their mansions. Most photographers were urban boosters who presented the city as civilized and orderly, as a place where business and culture existed in harmony and where all groups worked together to promote progress. This grand style of urban photography rarely showed ordinary people, middle-class neighborhoods, factories, slums, immigrants, or any hint of conflict, tension, or violence. This style of urban photography, with its carefully framed shots of public buildings, remained popular well into the twentieth century and continues to this day to dominate the pictorial accounts of urban America.

There was another American city, however, a city of neighborhoods and crowded alleys, of streetcars and subways, of stores and shops, factories and mills. This other city was also recorded by photographers, although not as consistently as the elite and ceremonial metropolis. It is to this other city that this book is devoted. The poor at first attracted attention because they were exotic and foreign. But then, beginning with Jacob Riis about 1890, the poor and their overcrowded neighborhoods became the focus of photographers and reformers who wanted to shock their viewers into realizing that much in America needed changing.

The camera and urban photography came of age in the late 1880s and 1890s, although techniques were still primitive by later standards. New technology, especially the perfection of the sensitive dry-plate technique, the introduction of flexible film, and the development of the inexpensive camera, expanded the possibilities of photography for the amateur and professional alike. One result was the candid snapshot. Another was the introduction of halftone reproduction, which helped to create the modern urban press, which in turn did so much to create a distinctive urban mentality and a sense of the city.

The camera and the photograph helped Americans define and visualize the city in the fifty years after 1890. The camera created conflicting images of progress and order on the one hand, and of teeming slums filled with dangerous and diseased foreigners on the other. The conflicting photographic images of these years symbolized American ambivalence toward the city, at once the center of civilization and a threat to American democracy.

More than the camera and the press, however, helped create the distinctive modern city and an urban attitude in the late nineteenth century. A new transportation system enabled a large number of urban dwellers to live miles from their work. New building techniques led to larger commercial buildings, while the department store, theater, and hotel created a special flavor in the urban downtown. Added to these innovations was the constant stream of new immigrants, especially between 1890 and 1920, that provided both cheap labor for the city's expansion, and the ethnic mix that provided the tension and conflict and sometimes the violence that were also characteristics of the modern city.

Philadelphia was a dynamic and powerful industrial metropolis in the period from 1890 to 1940, growing from one million residents to its peak population of almost two million. It spilled out of the central area and riverfront neighborhoods, almost filling out the modern political boundaries that date from the consolidation of 1854, when the city was extended to include all of Philadelphia County. Nearly continuous residential settlement engulfed once geographically isolated communities like Germantown and Bustleton, and spread into neighboring counties in both Pennsylvania and New Jersey, beginning a network of suburbs tied to the central city by railroad, subway, and trolley.

Even as the population spread outward, the city's core became more densely developed. A specialized downtown transformed the center city area as stores, office buildings, and warehouses

displaced homes. Dramatic new high-rise structures competed with City Hall as symbols of the new central business district. But while downtown financial institutions directed the city's commerce, it was the mills, factories, foundries, refineries, publishing houses, and workshops that powered Philadelphia's extraordinary growth. By the late nineteenth century, Philadelphia—with more than 20,000 manufacturers—was one of the world's preeminent industrial centers. It led the nation in the production of manufactured goods.

The vitality of the city in this period is visible in the images of its commercial core and its industrial workplaces, in the scenes of street life, in its bustling older neighborhoods and the residential construction in its newer areas. It is also visible in the faces of the people who lived in the city. Philadelphia drew much of its strength from new residents, who were attracted to the city by its unmistakable opportunities. Southern Italians, eastern European Jews, and Slavs enriched an ethnic mix that included Germans, English, Irish, Scandinavians, and many other groups. European immigrants were joined in the city by a steady stream of blacks from the American South, enlarging a community that predated the Revolution.

By the time World War II broke out there were already indications—obvious in retrospect—that the Philadelphia created in the years since 1890 would not last. The flow of European immigrants, which had given a distinctive tone to many of the city's neighborhoods, effectively ended with the immigration restriction acts of the 1920s. The urban growth of the 1920s also took forms that the city could not contain. The radio, the telephone, and other instruments of mass communication enlarged the aspirations of city dwellers and broadened their experiences. Not until after World War II would automobile-induced mass suburbanization move many of the city's residents and much of its commerce beyond the city's borders, but even in the 1930s Jenkintown to the north and the suburbs along the Main Line of the Pennsylvania Railroad to the west were suggestions of what was to come. The Depression of the 1930s caused a decline in the industrial base and hid deeper structural changes that led to the decentralization of industry and the decline of Philadelphia as an industrial center in the years after World War II.

Philadelphia's golden age as a city of immigrants and industry had ended by the 1940s. It had spanned two generations of the city's history. It had been a period of growth and change stimulated by new kinds of immigrants, new technologies, and a variety of industries. The golden age did not mean prosperity for everyone. Many were poor. Many were destroyed

by the industrial city as it created wealth for others. The contrast between the crowded slums and the mansions of the wealthy symbolized the contrasts and contradictions that were present in all areas of the city's life. Still, there was dynamism and excitement in the industrial city, and some of what made Philadelphia special in the years from 1890 to 1940 is captured in the photographs that follow.

Still Philadelphia A Photographic History, 1890–1940

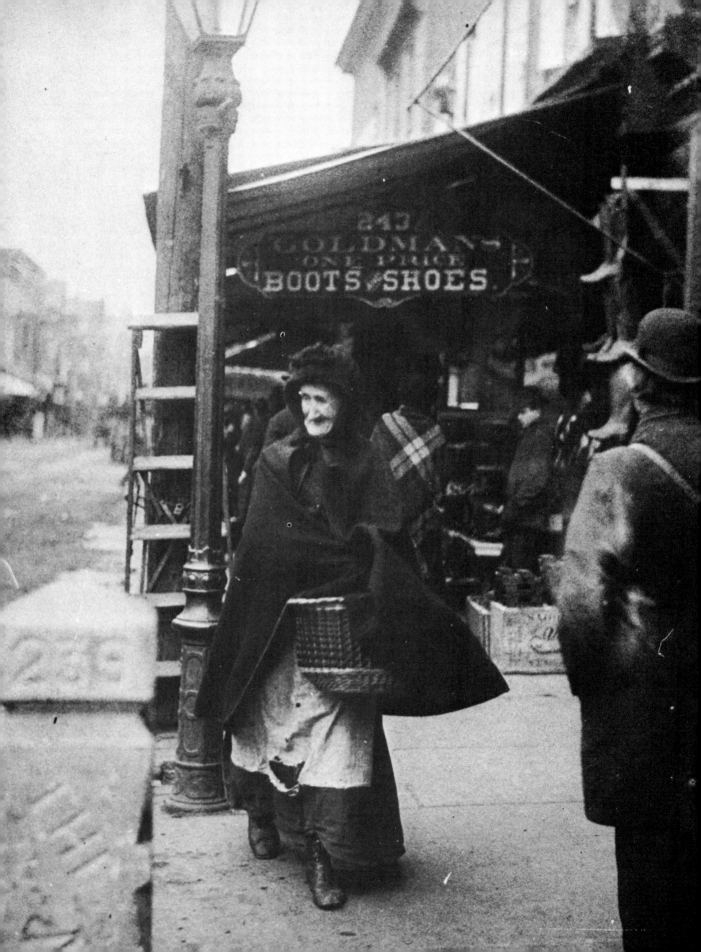

The City of the 1890s

Philadelphia in the 1890s was recognizably modern and yet very much a city that showed its past. It straddled the centuries in its social and physical arrangements. Neighborhoods surrounding the city's core and lining the Delaware River were still home to most Philadelphians. These districts were organized much as neighborhoods had been for most of the century. Their residents, still largely engaged in manufacturing, worked in small nearby firms as artisans and craftsmen. Shopkeepers who tended small stores served local customers. Often heard were boasts that this was a city of homes and a city of neighborhoods.

Those labels would be applied accurately well into the twentieth century. But their continued use should not be taken to imply stagnation. In the face of extraordinary population growth, Philadelphia was able to remain a city of homes and neighborhoods only by growing into new areas. Expansion had been the constant theme of the second half of the nineteenth century. It affected the city's physical appearance, reshaped the way business was done, and altered the way men and women earned their livelihoods. The changes would go much further in the twentieth century. The 1890s were a moment of balance. The old city was still visible, but there was the unmistakable presence of new urban forms.

When the decade began, only 25 of the city's 130 square miles were distinctly urban. To the east, the boundary of the built-up area was the Delaware River, although the prosperous city of Camden across the river was accessible by several ferry lines. To the north, development reached along Broad Street as far as Erie Avenue, to Allegheny Avenue east of Broad, and to Lehigh Avenue on the west. West Philadelphia was built up to 49th Street, although some undeveloped pockets remained. In South Philadelphia, development reached to Snyder Avenue along the Delaware and Wharton Street near the Schuylkill.

Within the city's political boundaries (which date from 1854), there were a number of old towns outside the urban area. By the early 1890s, all had been linked to the core by an extensive railroad network and by horse-drawn streetcar lines. Some of the towns were self-contained industrial communities with large immigrant populations, like Frankford and Manayunk, while others, like Bustleton and Hestonville, remained rural market centers. Germantown was a large, old, and complex community separated by open land from the rest of the city, although it already served to some extent as an upper-income residential suburb. Other

The 200 block of South Street in the mid-1890s.

railroad suburbs were in early stages of development along the Pennsylvania Railroad's Main Line. At the other extreme were the many shantytowns, such as those in South Philadelphia's "Neck," that dotted the landscape near rivers, creeks, and old highways. But all these varied districts were home to only a small proportion of the city's one million inhabitants in the early 1890s. Perhaps nine out of ten Philadelphians lived within the built-up area of the city.

The city was thus physically compact. Jobs and homes were concentrated within two miles of the new City Hall. Factories, offices, and warehouses were within or close to residential neighborhoods. Most Philadelphians—rich and poor, native and immigrant—lived within walking distance of their jobs. Wealthy families and professional people lived in larger houses on "good" streets. Yet they were often close to workingmen and the poor, whose smaller homes were tucked into narrow courts and alleys in the city's core, or crowded near workshops and factories in the expanding industrial districts.

Even as the city grew, the single-family home remained its dominant housing form. Philadelphia's reputation for long, straight vistas of brick row houses had been reinforced by the building boom of the 1870s and 1880s. As many as half of the 200,000 row houses in Philadelphia in the early 1890s were less than twenty-five years old. The majority were two-story, six-room structures. The city had hundreds of small building and loan societies, open and relatively flat land, an established grid street system, and manufacturing areas widely scattered along rivers and rail lines. This unique combination encouraged the large-scale building of row homes. By the 1880s, Philadelphia had been nicknamed the city of homes.

The city of homes was also a city of neighborhoods, many of them characterized by long unbroken rows of repetitive houses standing right at the building line. In spite of their sometimes unattractive physical texture, the neighborhoods did not completely lack appeal. Residents often proclaimed the self-sufficiency of their communities. Jobs, homes, stores, and social activities were close at hand. Community bonds were often reaffirmed by ethnicity, which added a human dimension to a sometimes otherwise bleak landscape. Shopping strips catering to specific ethnic groups often added color to neighborhoods while announcing the composition of the local population. The eastern end of South Street, pictured at the beginning of this chapter, was the commercial center of the city's major eastern European Jewish neighborhood, and there was another cluster of shops serving a largely Jewish clientele on Marshall Street near

Girard Avenue. The Italian market at 9th and Washington was another example. The ease with which row houses could be converted into combined store-dwellings enabled entrepreneurs with little capital to enter business on their own. A pushcart or a sidewalk barrel made business even more democratic and neighborhoods more obviously ethnic in tone.

Ethnicity and race isolated neighborhoods from each other. So too did public transportation. It was generally easier to go downtown from an outlying neighborhood than to travel from one neighborhood to another. Thus each area of the city had something of its own character, determined by the kind of work done there and the race and ethnicity of its residents. Kensington, for example, with its large British and Irish populations, was dominated by textile mills and machine shops. South Philadelphia, still home to a substantial Irish population, held growing black, Italian, and Jewish settlements. Major employers were dockside industries, warehouses, railroads, sugar refineries, coal wharves, and the needle trades. Just north of downtown, the deteriorating area that included the old Spring Garden and Northern Liberties districts served multiple functions. Sections housed poorer downtown workers, a tenderloin area, the "furnished-room district" of cheap lodgings, and scattered warehouses and factories.

Downtown was the one area that was already very different from the communities of jobs and homes. Since its appearance at mid-century as a specialized commercial area, the downtown had moved steadily westward. Its march culminated in the completion of City Hall tower and the installation of the William Penn statue on its pedestal in 1894. On either side of City Hall were the two major railroad terminals, the Pennsylvania's Broad Street Station and the Reading Terminal. Wanamaker's took up half a city block at Market and 13th, and other major dry goods stores—Snellenberg's, Strawbridge and Clothier's, Lit Brothers', and Gimbel's—were spaced eastward along Market Street. Museums, theaters, hotels, banks, and offices had already spread westward from the original downtown by the Delaware River to 20th Street. The whole area between Vine and South Streets and the two rivers (William Penn's Philadelphia) had been steadily losing population since the Civil War, though Rittenhouse Square had emerged as a luxury residential area. The district between Vine and South had declined to 100,000 residents when City Hall was topped, but this was twice the population it would have fifty years later, when Philadelphia was near its peak census count. Specialized though it was, the downtown of the 1890s was not exclusively devoted to offices, retailing, and entertainment. Small workshops,

Philadelphia in 1896, showing the main developed areas.

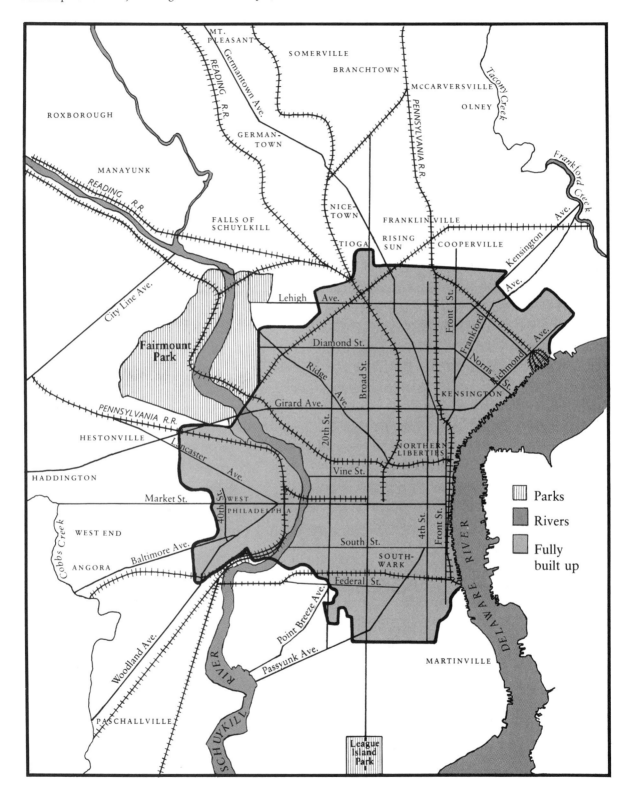

especially in printing and the garment trades, were found throughout the area. Blocks of older row houses were scattered throughout, often surrounded by stores and office buildings.

The city's most characteristic outdoor sights—immigrants and streetcars—explained much of the transformation that was underway in the 1890s. It was often asserted that Philadelphia was the most American of major cities, because its foreign-born citizens never exceeded one-third of its population. But immigrants and their children—and in the 1890s this meant half the population—had a profound local impact. The mass immigration of Jews from eastern Europe and Italians hit its peak in the twenty-five years that bracketed the turn of the century. Together with the continuing streams from Ireland, Britain, Germany, and rural America, these newcomers furnished the labor force for the city's economic transformation. The very presence of strange faces and costumes on the city's streets speeded suburbanization as the native-born middle classes sought refuge in outlying areas. The streetcars—especially after their electrification as trolleys in 1892—made middle-class mass suburbanization possible. With the prospect of journeying to work at speeds of ten to fifteen miles per hour, Philadelphians with comfortable incomes were able to contemplate moving out of the old neighborhoods, away from the increasingly crowded, busy, industrialized, alien, noisy, and—some feared—violent and crime-ridden center, to newly developed pleasant suburban surroundings. The city stood on the brink of breaking out of its historic geographic limits.

Because we tend to confuse expansion with optimism, it is easy to overlook the other side of the 1890s. The depression that began in 1893 and lasted through most of the decade was the most severe that the nation had ever experienced. Particularly hard-felt in the industrial cities, the depression brought with it mass poverty and misery, class conflict and violence. Many Americans, generally believing these troubles the peculiar curse of class-riven and less prosperous Europe, had usually considered themselves immune. But even in the non-depression year of 1890, the United States Census recorded that almost 14 percent of the city's male labor force and 12 percent of its women workers were unemployed for one month or more. In the depths of the depression, unemployment may have reached one quarter of the working population. Clearly, city lives were often stories of deprivation and struggle in harsh circumstances. Factories and sweatshops, street labor and unemployment, crowded slums and forlorn shantytowns—these could all be survived and decent lives created, but rarely was survival free of pain and heartbreak.

The contrast between the old Philadelphia and the new was repeated in the lives of its different classes of citizens. How the city felt depended on where one lived and worked. To some the workshops and mills meant prosperity, to others they meant hardship. When the lives of all the city's citizens are considered, there is a hollowness to turn-of-the-century boasts about prosperity. Yet there can be no doubt that Philadelphia was extraordinarily dynamic as its people anticipated the new century.

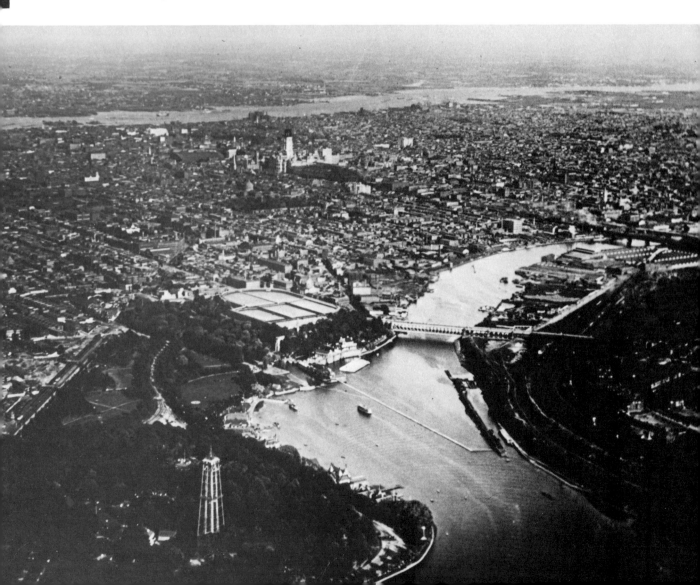

Photographer William N. Jennings captured these panoramas of Philadelphia from a balloon during an ascent that he estimated reached one mile. Taken on the Fourth of July, 1893, they are the first aerial views of the city. Fairmount Park and the Schuylkill River occupy much of the first image at left, giving the city a more open appearance than it warranted. An observation tower is in the foreground; behind it the Fairmount Reservoir occupies what is now the site of the Art Museum. City Hall tower, then under construction, rises above the city's center. In the photograph below, the balloon has floated eastward and now provides an aerial close-up of the substantially built-up sections of lower North Philadelphia. Few open spaces remain. Most prominent is the campus of Girard College, which breaks the grid in the center of the image. Several blocks to the right are the huge walls and radiating spokes of the Eastern State Penitentiary, built three-quarters of a century earlier on Fairmount Avenue in what was then a peaceful, rural location.

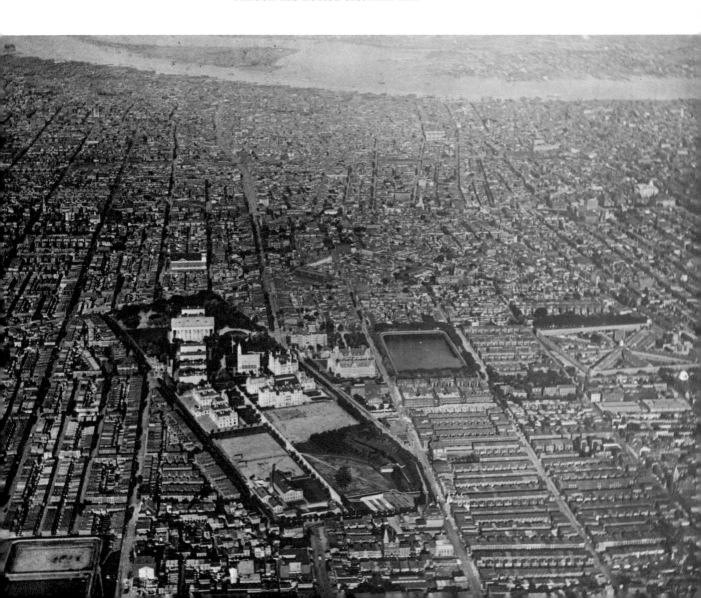

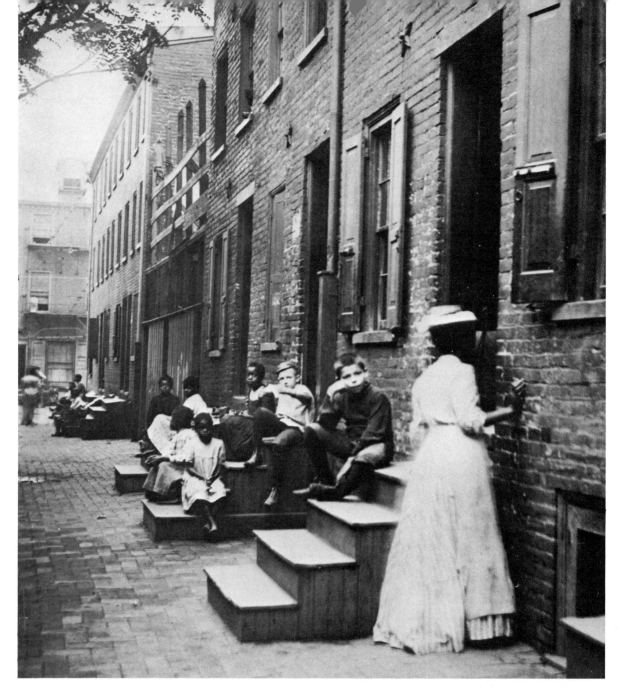

The address is not indicated on this turn-of-the century photograph, but the original caption, "Negro quarters," suggests that the scene was in the strip between Lombard and South Streets between the Delaware and Schuylkill Rivers. This black neighborhood dated back to the early nineteenth century, when it was the city's unfashionable southern boundary. As the children on the stoop illustrate, this neighborhood was not segregated in the modern sense. When this picture was taken, the area's cheap substandard housing was attracting growing numbers of new immigrants, especially Jews and Italians. The Octavia Hill Association reformers, for whom this picture was made, indicated their interest in the scene by the specific information they listed on its back. Nine houses faced out on this court. Each had three rooms and housed a single family, which paid a rental of $1.80 to $2.00 per week. All shared a common yard.

In the 1890s, South 4th Street was one of the many shopping strips for recently arrived Russian Jews, most of whom made their first Philadelphia homes in the oldest parts of the city. This photograph was taken on a market day, looking north from the public market building at 622 South 4th Street towards South Street. Clothing and household goods are displayed in the street and hang from the awnings. Most of the people are fairly well dressed in contemporary American fashion, perhaps because it is market day. Only one woman in traditional European garb is visible. The street looks half empty in comparison with the crowded scenes of New York's Lower East Side. Indeed, the low density of even the poorest slum areas of Philadelphia contrasted sharply with New York.

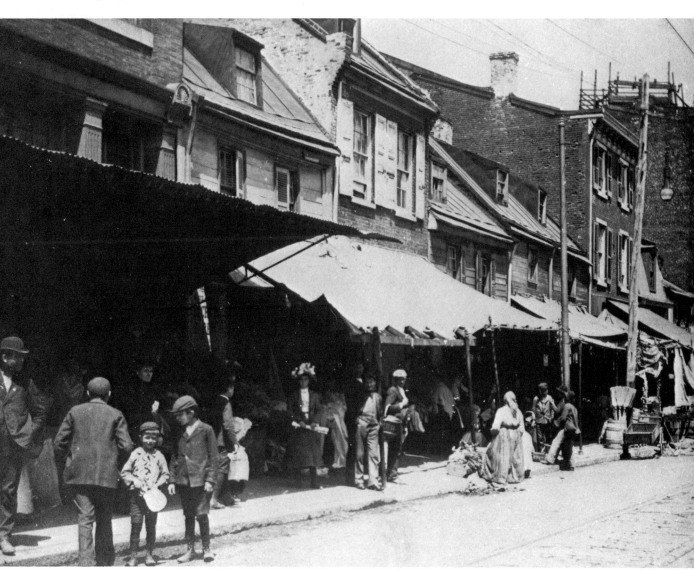

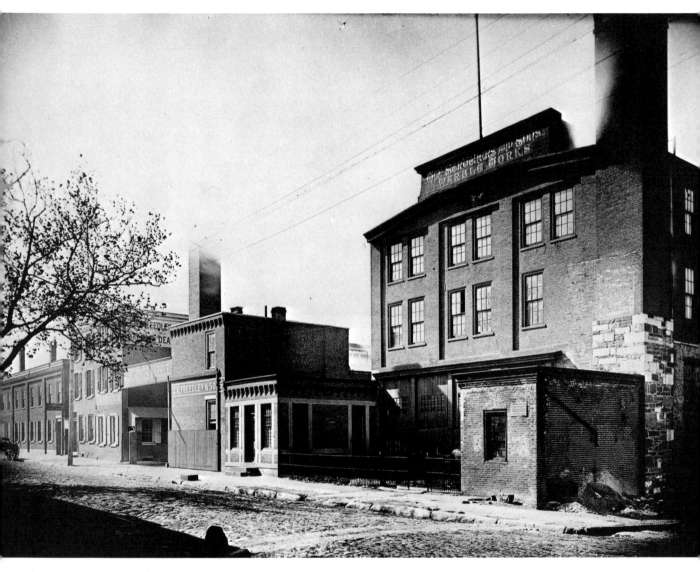

These views of opposite sides of South 24th Street were taken from the corner of Walnut in 1888. They are suggestive of the diverse uses to which adjoining parcels of land were put in the late nineteenth century, and of the close juxtaposition of home and workplace common at the time.

A few blocks west of fashionable Rittenhouse Square and abutting the Schuylkill River, this area was the western edge of the early nineteenth-century city. From that time, it had been given over to such industrial activities as stonecutting and railroading. It was also a poor neighborhood and an early center of Irish residence. Looking south (above), the west side of the street held six stone and marble yards in the two blocks from Walnut to Spruce. The east side of the street was primarily residential—as the northward view from Walnut (right) shows—but there was another stoneyard across the alley to the rear of these houses. Several stonecutters and marble polishers lived on this block (and yet others resided in the surrounding neighborhood), as did laborers, expressmen, and drivers. Some of these laborers and teamsters probably held jobs relating to the Baltimore and Ohio Railroad terminal directly across the street.

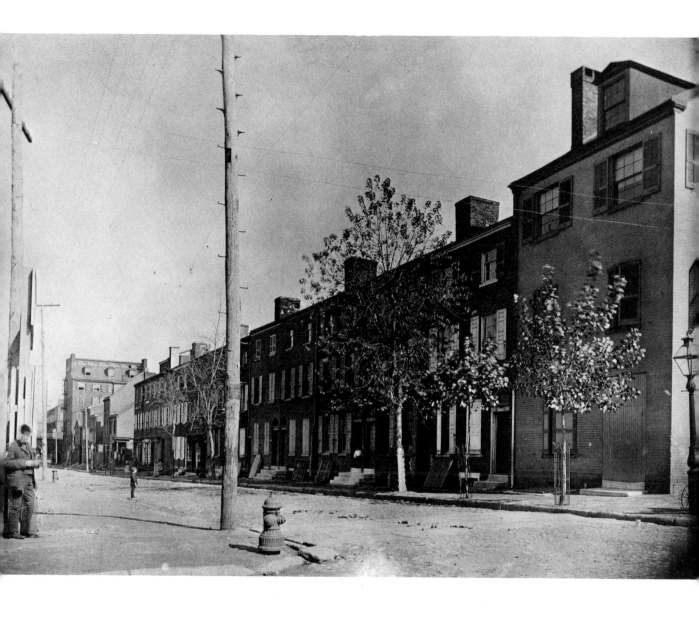

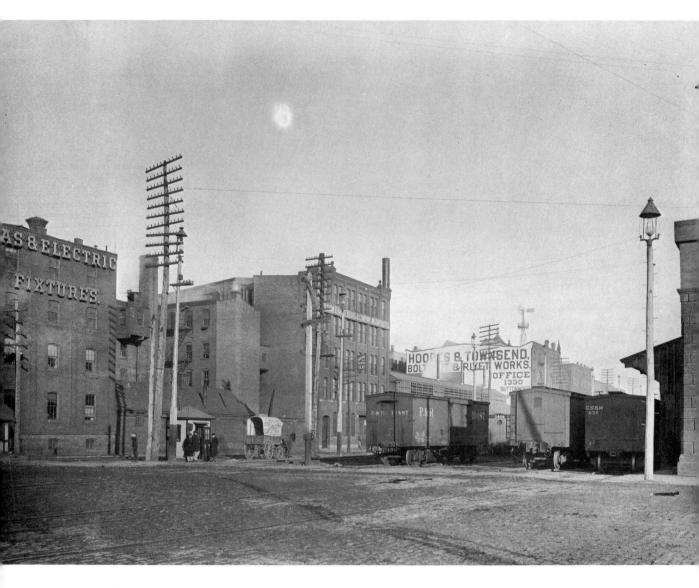

The official city photographs on the facing page are deceptively bucolic, suggesting a time when the strip along Callowhill Street near Broad may have been a quiet and pleasant place to spend a hot summer afternoon. The city's purpose in taking these pictures is unclear; both date from August 1894. But the scene above was recorded in the same year at Broad and Noble Streets, a block away from one of these pictures, and corrects this first impression. This was a mixed industrial and residential neighborhood, with coal yards, foundries, and metal works, crisscrossed by the tracks of the Reading Railroad and dominated by the giant Baldwin Locomotive Co. The boy smiling for the camera (right) is on 18th Street, across from Baldwin's western edge. The group lounging on bales of hay (above right) is on 13th Street, facing the plant's eastern edge across a block-square freight yard. The juxtaposition of coal and hay merchants is a reminder of nineteenth-century energy sources.

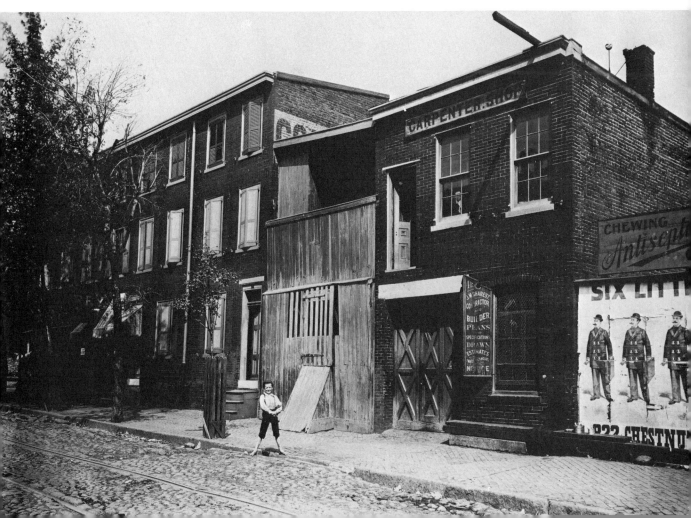

The 1200 block of Callowhill Street, photographed in 1894, was around the corner from hay dealer Charles Schaal (previous page). The businesses pictured are representative of the services required in a mixed residential-industrial neighborhood that was both home and workplace to large numbers of single men. Notice the prices advertised for meals and lodging; room and board would come to more than half an unskilled laborer's daily one-dollar wage. The water pitcher in the window over the cigar store suggests the absence of indoor plumbing. Street life was of no interest to the city photographer. The adults were witnesses to the picture taking, rather than its objects, while the dogs and children were more interested in their own activities.

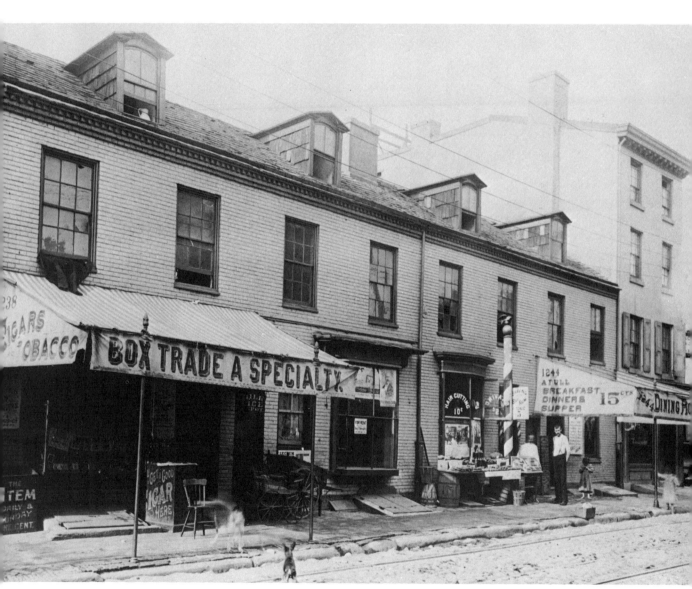

This is an official city photograph, taken in 1895 for unknown reasons, of a cluster of neighborhood shops on Girard Avenue at Front Street. The view again captures commercial activity in an industrial neighborhood. Both the grocery and pawn shop spill out of their walls onto the sidewalk, while the Chinese laundry is more restrained, leaving an informal play area on its sidewalk. Commercial laundries were established in the closing decades of the century, lightening the drudgery of housework for some women. But in a neighborhood such as this they were more likely to find their customers among single men.

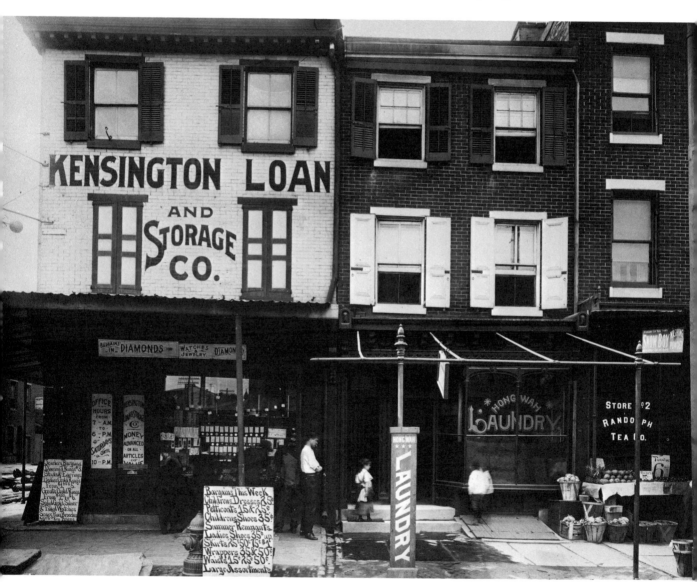

Loxley Court is a short alley that runs north off of Arch between 3rd and 4th Streets. When these photographs were made in the 1890s, the neighborhood—like the court—was a hodgepodge of factories, warehouses, and homes. The court's physical appearance had not changed much since the mid-nineteenth century. Its residents also suggested an earlier phase in the city's history. Mostly native-born or of Irish, German, or English ancestry, they held jobs similar to the occupations that would have been represented here half-a-century earlier. Several clerks and shoemakers, a tailor, a boxmaker, a machinist, a policeman, and a fireman lived here. Only the presence of an electrician betrayed the coming of the new century. The children stopping for the camera apparently found the quiet court a good place to cycle in this densely crowded neighborhood, which was largely devoid of open spaces.

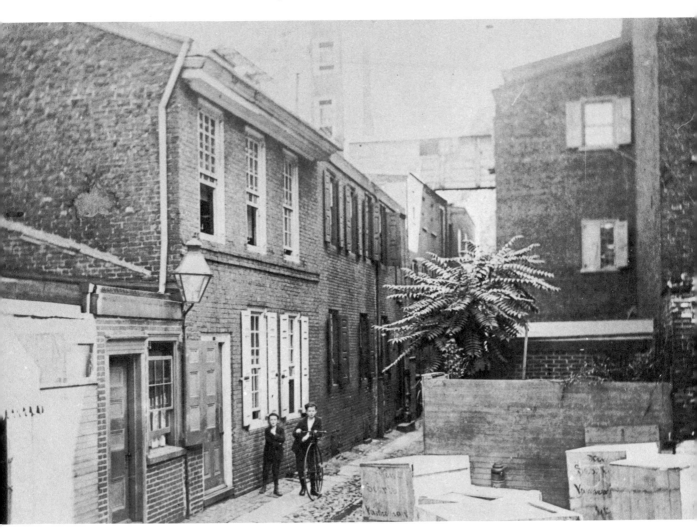

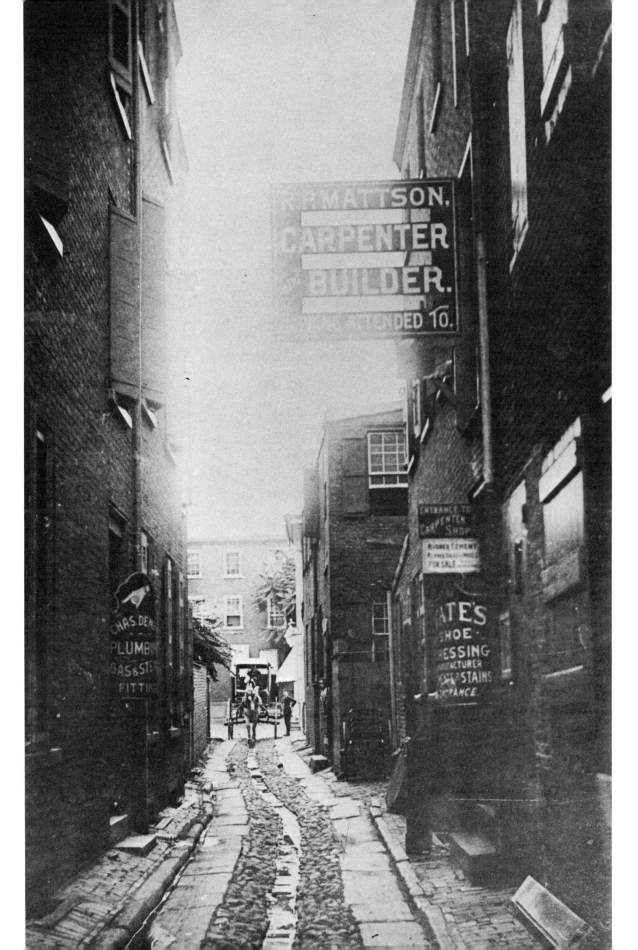

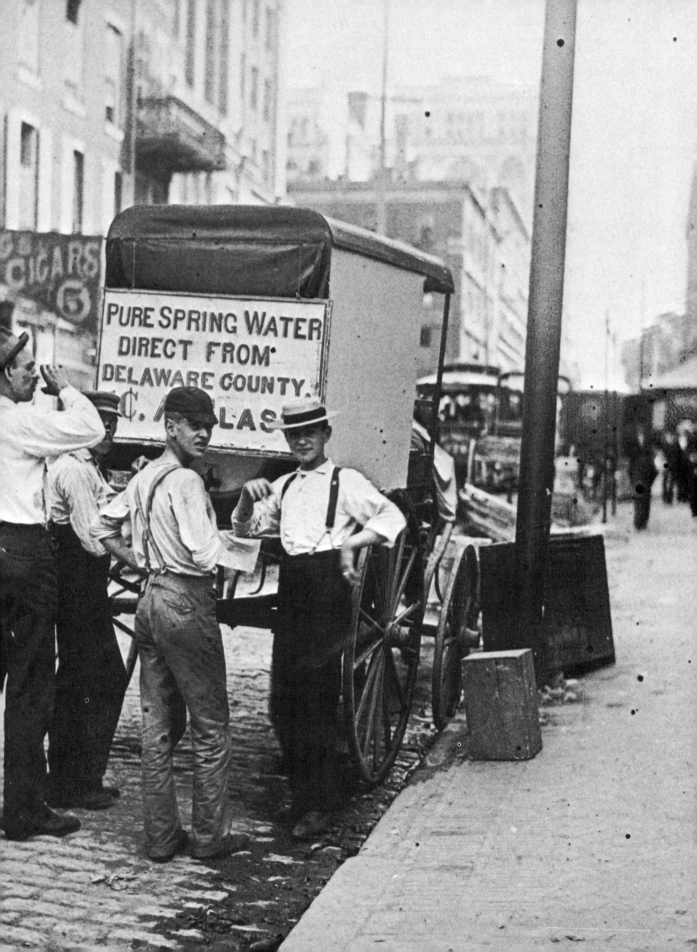

Street vending has a long local history, as these undated scenes from the 1890s show. Customers (left) at 5th and Market Streets, in the city's commercial district, pause for drinks. For one penny, each got a glass of water presumably more refreshing and more healthful than the untreated Delaware and Schuylkill River water that flowed through the city's pipes. But they used a common drinking glass, a sight that would become rare as early twentieth-century health campaigns heightened public awareness of infec-

tious diseases. This image bears the stamp of Gilliams and Stratton, a professional photography studio located at 806 Walnut. Several other pictures in this chapter also appear to be that studio's work, although they are not so stamped.

The woman (below) selling produce on barrel tops is on South Street. She displays her goods on a sidewalk crowded with sacks and barrels in front of one of Philadelphia's more than 3,000 cigar shops. Wooden barrels, the most common container of the nineteenth century, can be detected in a great many old photographs.

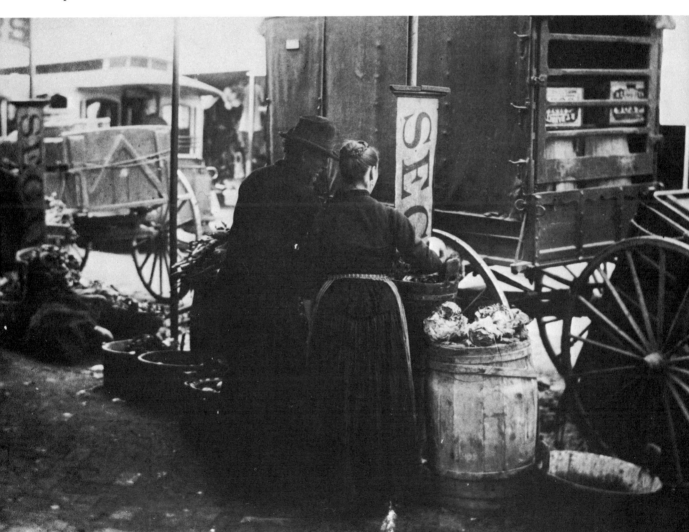

Delaware Avenue in the mid-
1890s was a congested jumble of
railroad cars and horse-drawn
wagons. Its fifty-foot width
seemed generous when the street
was laid out along the river's
edge in the 1840s, but trains and
ferries soon created serious traf-
fic problems. Looking south
from Walnut Street towards the
warehouses on Pine Street, wag-
ons face in several directions and
railroad cars wait in the middle
of the thoroughfare. On the left
are the docks of the Pennsylvania
Railroad's freight station, and on
the right is the station itself. The
avenue was widened to 150 feet
in 1897–1899, but for another
thirty years all passenger and
freight traffic crossing the Dela-
ware River from downtown had
to make the inconvenient and
time-consuming ferry crossing.

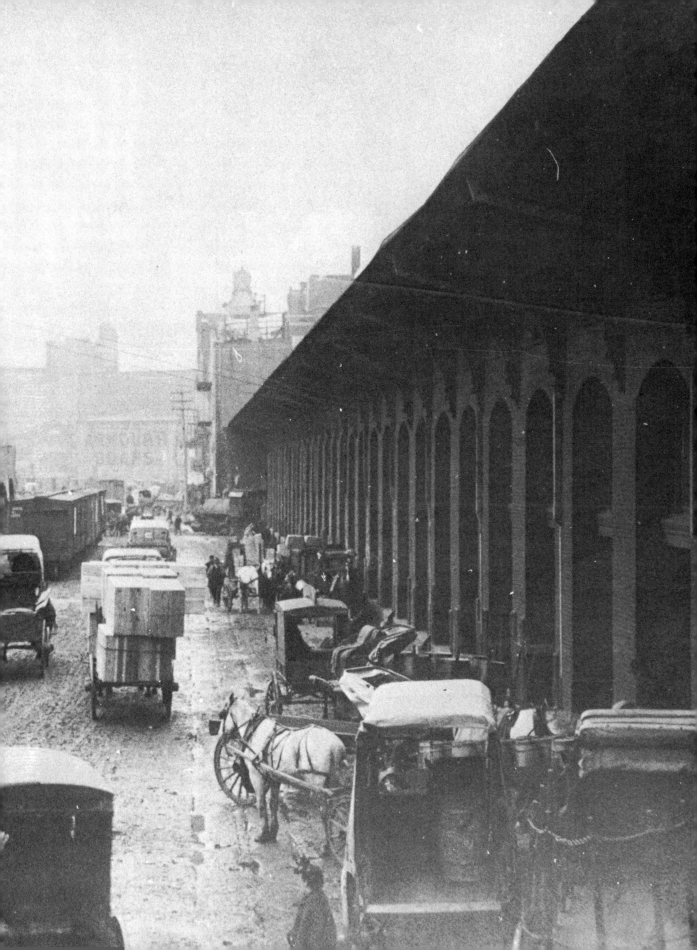

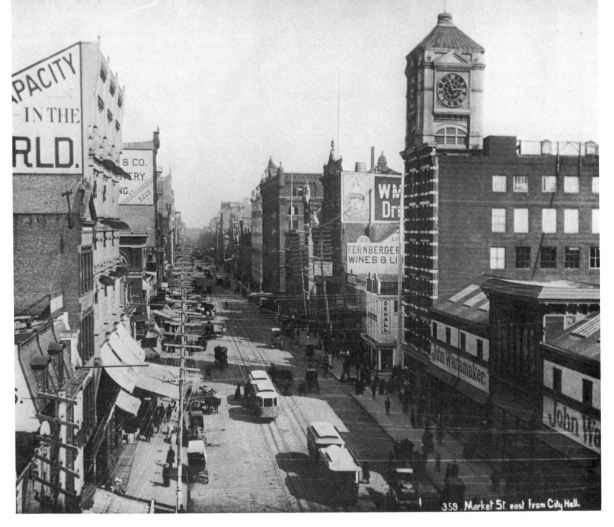

359. Market St. east from City Hall.

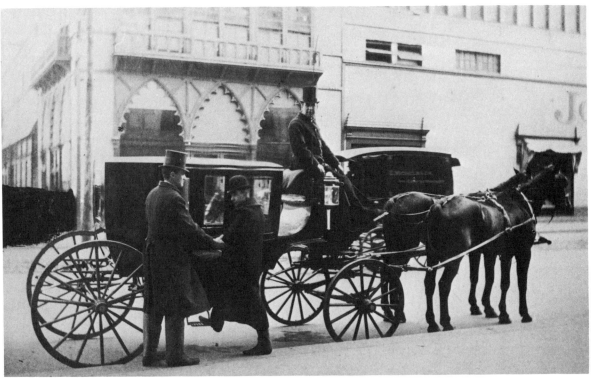

The commercial downtown developed rapidly in the late nineteenth century. Land in the city's central core had previously been given over to mixed uses, containing residences and industries as well as businesses. But in the closing decades of the century, the area between Arch and Walnut Streets took form as primarily a business district. The new Wanamaker's department store, built at the beginning of the twentieth century, was an important symbol of the emerging downtown; it made clear that the downtown had shifted away from its original site along the Delaware River to the vicinity of City Hall and the train stations that freed commercial activity of its dependence on river transport. To the left, two photographs from the mid-1890s reveal a glimpse of the first Wanamaker's building at Juniper and Market, which had been the freight shed of the Pennsylvania Railroad until 1876. The view eastward along Market Street was taken from the newly completed City Hall. Trolleys were just then being introduced into the city. The scene at 5th and Walnut (below), captured two years earlier in 1893, shows some of the horsecars that had composed the city's mass transit system since 1858. The jumble of telephone and electric wires in both street views reveals other new technologies.

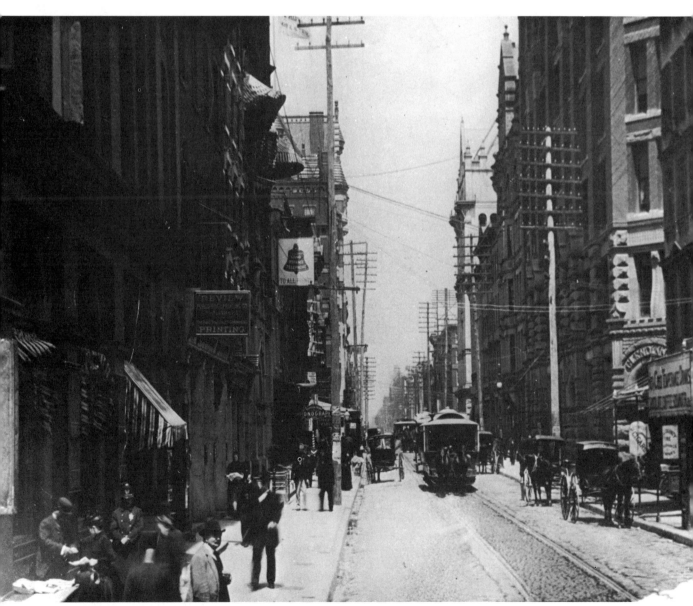

Dating from the mid-1890s, the photograph below presents a scene in the heart of the city's downtown. Shown is the north side of Chestnut Street, looking eastward from 11th Street. Well-dressed men walk under the awning of Anthony J. Chauveau's confectionary shop and by a pair of street lamps announcing the Chestnut Street Opera House. Both are out of focus because the photographer's attention was on the woman in the foreground, intruding on this commercial scene. A scavenger attracted by the rubble of a street excavation, she was preparing a bundle of splintered boards, probably for use as firewood. Others on the street seem oblivious to her, indicating that she was not an unusual sight during the depression of the mid-1890s.

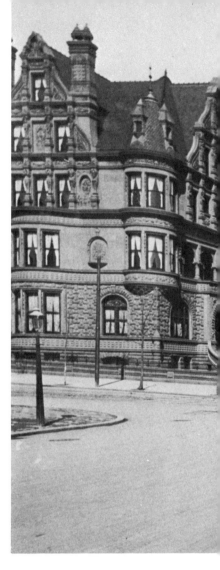

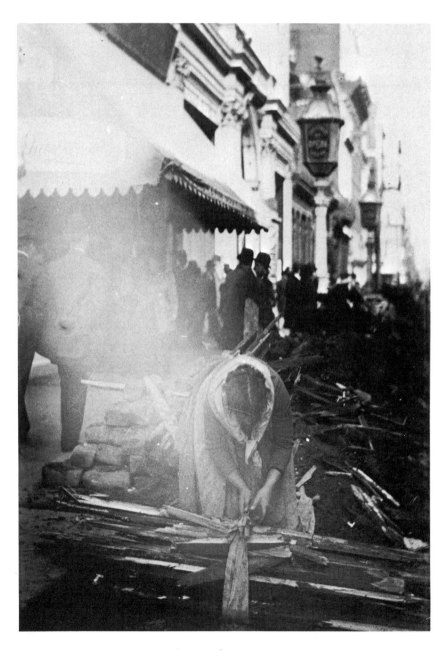

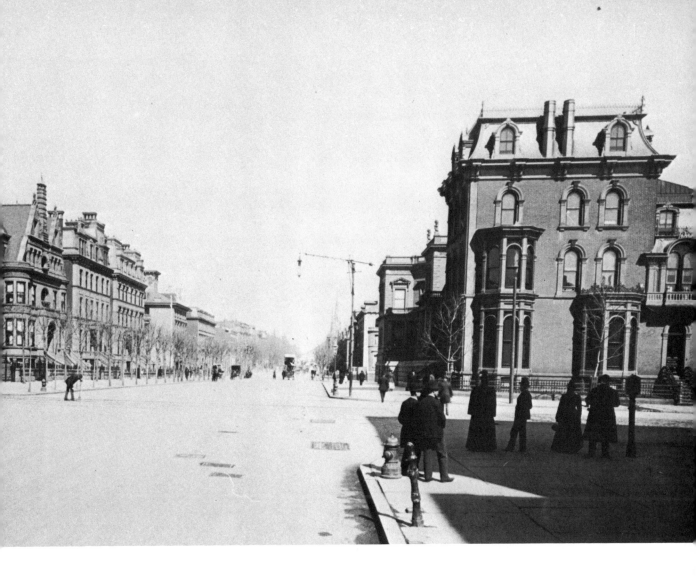

The city's outward growth in the closing decades of the nineteenth century brought with it the emergence of new well-to-do residential sections in North and West Philadelphia. The photograph above depicts the northward vista along Broad Street across its intersection with Girard Avenue. The picture is undated, but the young trees lining the street suggest that it was taken in the early 1890s, not long after these prosperous and imposing homes were completed. These new neighborhoods were made possible by changes in transportation technology—the introduction first of streetcars and then of trolleys—which enabled well-off Philadelphians to live outside the central district and commute to work. The homes of the two men who controlled the city's mass transit monopoly—and thus played a major role in shaping new neighborhoods like this—are visible in this image. The house of P. A. B. Widener is the first on the left; that of W. L. Elkins is second on the right.

While prosperous, this neighborhood was not entirely fashionable. Excluded from traditional upper-class Philadelphia, Widener and Elkins built their homes here because they could not gain acceptance in more socially correct areas like Rittenhouse Square or the Main Line. In the late 1890s these families moved again, taking up residence north of the city in Cheltenham Township. The three structures beyond the Widener mansion are twin homes; beyond them is LaSalle College.

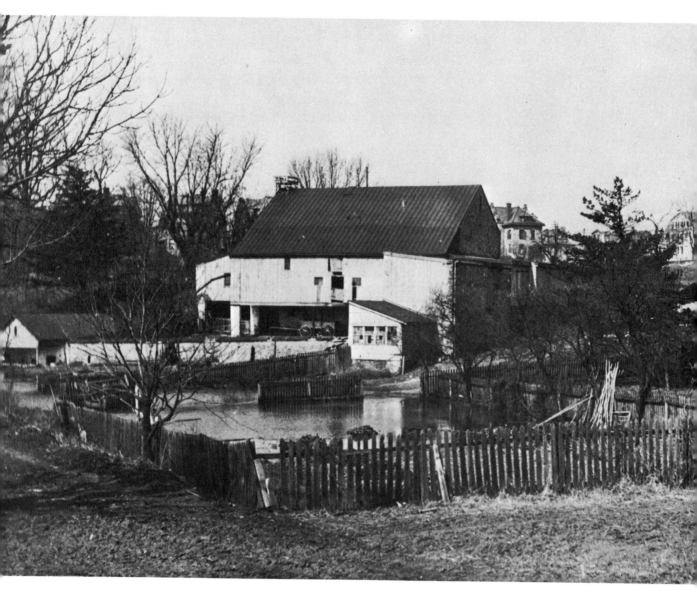

Even as the twentieth century began, large sections within the city limits showed little evidence of the great industrial metropolis nearby. Jacob Jones's farm at 62nd and Lansdowne in far West Philadelphia (above) was one of several hundred still operating in the city. Yet several tracts surrounding Jones's barn had already been subdivided for residential development, and some blocks held long rows of twin houses by the time this photograph was taken in 1901. A 1901 city photograph of bridge repairs (right) revealed Oak Lane Avenue where it crossed the Reading Railroad tracks in far North Philadelphia as an unpaved market path. Note the plank bridge and the police watch booth. The railroad had recently made Oak Lane Village a somewhat fashionable middle-class suburb.

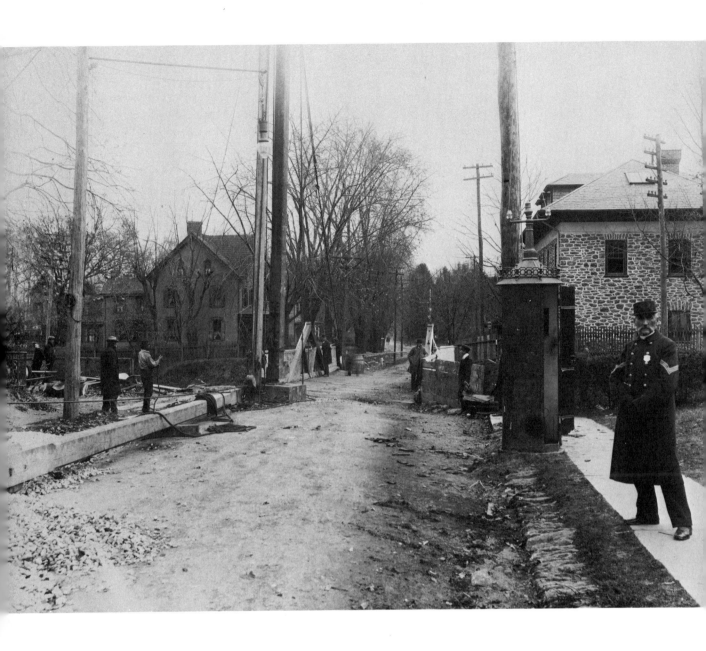

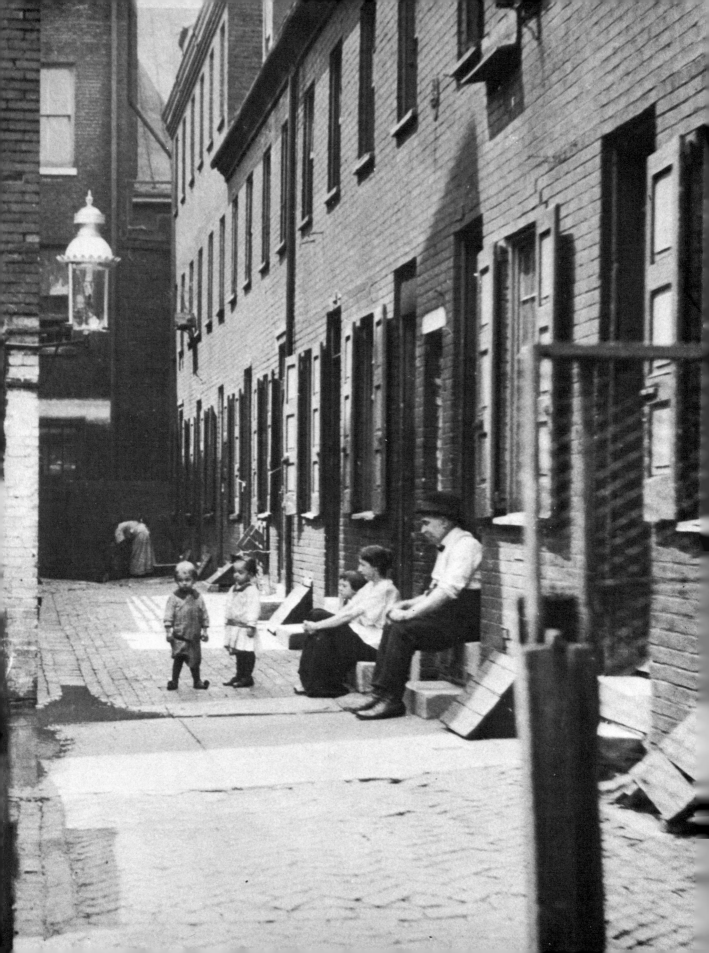

Immigrant Havens

Between the 1890s and the 1920s waves of immigration from southern and eastern Europe and from the American South transformed Philadelphia. Most of the new immigrants settled in the older part of the city, from Allegheny Avenue to Snyder Avenue between the rivers, while others found jobs and homes in outlying industrial communities like Manayunk and Frankford. As many former inhabitants moved to newer parts of the city, the immigrants and their families took over and extended the old row house neighborhoods, at the same time adapting them to their own needs. They tended to live near their jobs and near members of their own ethnic group. They shopped on local streets and had few opportunities to travel. It was in the individual neighborhoods—in Kensington, Moyamensing, Haddington, and the rest—that people really lived their lives.

The immigrants who poured into Philadelphia added to an already diverse population. Although the city did not have as great a concentration of immigrants as Chicago or New York, at any time throughout the whole period from 1890 to 1940 a clear majority of the city's people were either European immigrants and their children or southern black migrants and their children. By the end of the nineteenth century, Philadelphia had large, established British, Irish, and German immigrant populations. But the most significant immigration in these years came from southern and eastern Europe. There were fewer than 10,000 eastern European Jews, and a similar number of Italians, in the city in 1890. By 1910 the Russian Jewish population was well over 100,000. The greatest Italian immigration came after 1910 and extended into the twenties. At the end of that decade, the Russian Jewish and Italian communities in Philadelphia each numbered nearly 200,000. There was also a large population of both gentiles and Jews from other parts of eastern and central Europe, including about 20,000 Catholic Poles. In all, by 1930 there were a million Philadelphians who had either been born in Europe or whose parents had been born there.

The second great stream of migration came from the American South. Philadelphia had a black population of about 50,000 in the nineties, one of the largest concentrations in the North. World War I stimulated a migration of southern blacks that continued in the next decade, increasing the number of blacks to over 100,000 by 1920 and over 200,000 ten years later.

While each immigrant group had its own pattern of jobs, neighborhoods, and culture, their physical surroundings were similar because of the Philadelphia row house. The oldest parts of the city near the Delaware River were a jumble of courts and alleys dating from

Providence Court, behind 10th Street
below Vine, in 1921.

the eighteenth century, before the days of public transportation and large industrial enterprises. But the city was really shaped by the building boom that followed the Civil War. About 90 percent of the nearly 400,000 homes put up between 1860 and 1920 were two- or three-story brick row homes. Developers in North, South, and West Philadelphia broke up the standard city blocks, which measured about 400′ × 500′, into three or four rectangles by putting through small streets. With uniform building lots ranging from 14′ × 50′ to 18′ × 100′, it was possible to fit two hundred homes onto a single standard block. Before World War I, when the average annual income of manufacturing workers ranged between $500 and $1,000, row homes cost between $1,000 and $3,000, while a two-story, six-room dwelling could be rented for under $20 per month.

The two largest ethnic groups of the nineties, the Irish and the Germans, never concentrated in distinctive ethnic neighborhoods the way some of the later arrivals did. Some neighborhoods, like Gray's Ferry and Spring Garden, had substantial Irish populations, but they held only a small proportion of the city's Irish residents. Like the Irish, the Germans were also spread fairly evenly throughout the city, but they did constitute noticeably large minorities in some sections of North Philadelphia, particularly Strawberry Mansion and Tioga. Both the Irish and the Germans gradually moved out of the older city as districts such as Southwest Philadelphia, Olney, Oak Lane, and Logan were developed in the early decades of the twentieth century.

The Italians, the Russian Jews, and the Poles had a very different history. In 1900 the major Jewish neighborhoods were crowded along the Delaware River to the immediate north and south of the central district, in what used to be called Southwark and the Northern Liberties. The Italians were even more concentrated in South Philadelphia, immediately west of the Jewish settlements. By 1930 the two groups had diverged. The Italians in large measure stayed in South Philadelphia, expanding to the south and west, though there was a significant community in West Philadelphia as well. The Jews, in contrast, had moved out into North and West Philadelphia, Logan, and Oak Lane, leaving only a modest number in South Philadelphia. The Poles, a much smaller group, followed yet another pattern. They settled primarily in such outlying industrial districts, both new and old, as Nicetown, Bridesburg, Port Richmond, and Manayunk. Like the Italians, they tended to stay where they settled. All three groups—Jews, Italians, and Poles—were highly concentrated in distinct neighborhoods throughout the period. And they all had their

own ways of preserving their strength and unity in the New World, including fraternal groups like the Jewish *Landsmanshaftn*, hiring arrangements like the Italian *padrone* system, and neighborhood centers like the Polish national parish churches.

More than for other groups, the experience of Philadelphia's blacks was dictated by discrimination and segregation. Initially concentrated in South Philadelphia around and just below South Street, blacks gradually moved into lower North Philadelphia and northern West Philadelphia in the early decades of this century. By 1930 blacks remained more concentrated and had a lower rate of home ownership than the other ethnic groups. The cheap row house system had opened up ownership to about half of all Philadelphians by the late twenties, but, as in so many other areas, blacks were excluded even as the new immigrant groups began to take advantage of the unique situation in Philadelphia.

The row house city, so uniform on the outside, was really a diverse mixture of different ethnic groups. Italians, Jews, Poles, Irish, Germans, blacks, and members of other ethnic groups moved around, founding new communities and abandoning old ones. Even neighborhoods that a church, market, or social club defined as Irish, Italian, or Polish rarely contained a majority of that ethnic group. While one group might dominate a block, it rarely dominated a neighborhood. Before World War I, even blacks lived in neighborhoods with white majorities. Philadelphia was a kaleidoscope of shifting neighborhoods. Streets of row homes were extended north and south along the axis of Broad Street and around new industrial concentrations. Even with the growth of such newer areas as Olney and West Philadelphia in the early twentieth century, the old part of the city below Allegheny Avenue and between the rivers was still home to the vast majority of the immigrants and their families in 1930. In fact, it numbered a million inhabitants, a clear majority of all Philadelphians, as late as 1940. Encircled and divided by industrial belts hugging the rivers and rail lines, cut through by retail and commercial strips, and itself surrounding a changing downtown, the old row house city remained the heart of Philadelphia.

Central Philadelphia in 1914.

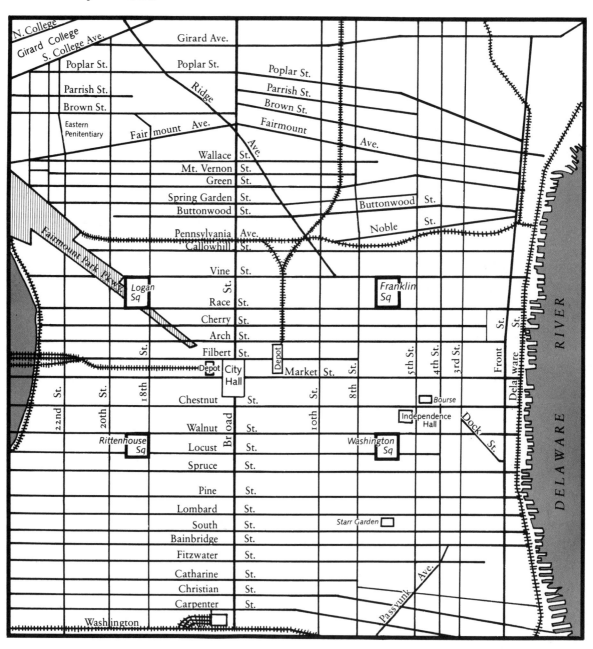

Most of the old industrial Philadelphia of the turn of the century is displayed in this dramatic 1930 aerial photograph. The view is from the north, looking south straight up Broad Street to the new skyscrapers downtown, then through South Philadelphia and on to the undeveloped areas near the Navy Yard. It thus encompasses everything south of Allegheny Avenue and east of 52nd Street, and shows clearly how the industrial city was shaped by rivers, rail lines, and row homes. The dominance of the row house—grid street pattern is obvious, as is the repeated division of larger blocks into smaller units. The industrial districts along the rivers and railroads, together with the downtown, are the major breaks in the all-pervasive grid. Especially evident in this photograph are the swaths cut by the Reading and Pennsylvania Railroads, which intersect in North Philadelphia between the two major-league baseball parks, Baker Bowl to the left and Shibe Park—later Connie Mack Stadium—on the right.

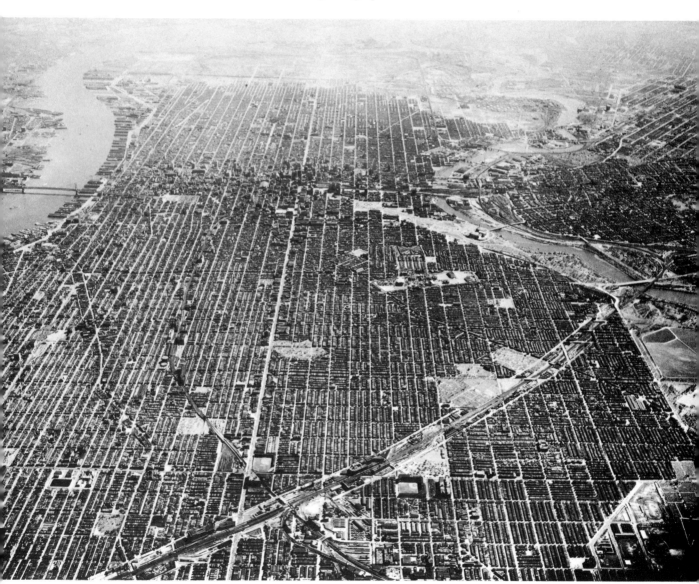

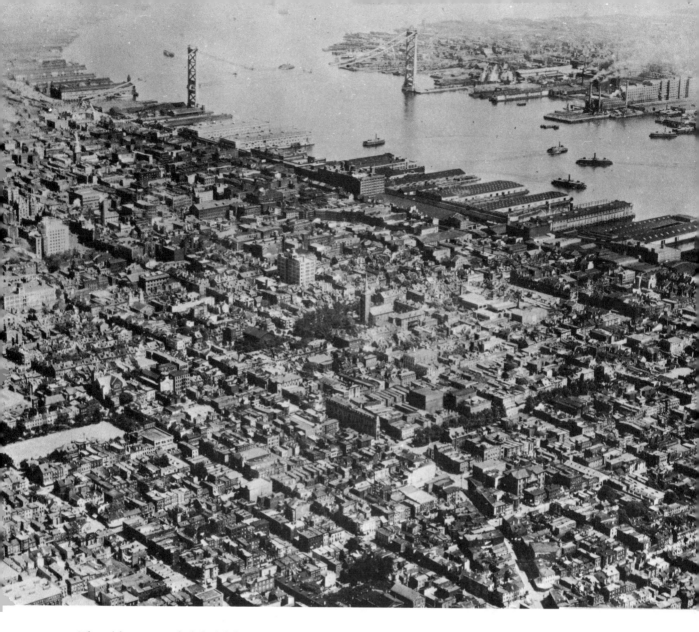

The oldest part of Philadelphia was the subject of an earlier aerial photograph, taken in the summer of 1924, showing the area from Catherine and 7th Streets northeast to the Delaware River (now Benjamin Franklin) Bridge, then under construction. It thus takes in not only the waterfront and the historic district around the prominent steeple of St. Peter's at 3rd and Pine, but also some of the city's worst neighborhoods, including Southwark, below South Street. In the jumble of small streets, courts, and alleys scattered among the warehouses, factories, lofts, and markets were the homes of thousands of immigrant Italians, Poles, and, especially, Russian Jews, the center of whose settlement was in the vicinity of Snellenberg's, the triangular building in the lower center of the scene. About nine of every ten people in the area shown here were recently arrived immigrants or their children. The worst part of the district, and therefore the most photographed by reform groups, was near Starr Garden, the open space to the far left. But conditions there prevailed only to a slightly lesser degree throughout the entire area shown in this view.

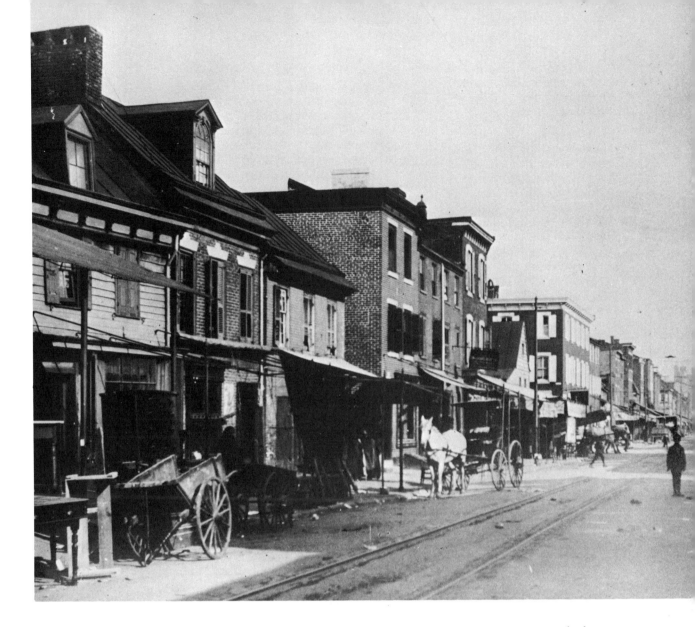

The photograph above offers a turn-of-the-century, street-level view of the 700 block of Bainbridge Street, one of the main shopping streets for the Russian Jewish community in Southwark. The lack of activity depicted is artificial, the result of the Octavia Hill Association photographer's being more interested in buildings than in commerce and choosing his moment accordingly. The mixture of wooden and brick buildings is characteristic of the city's oldest neighborhoods, which were among the few parts of the city where most of the homes were not identical two- and three-story brick row houses. We can see as well the storefront awnings and horse-drawn wagons that were common features on such shopping streets. However, the trolley tracks and electric poles remind us that this was no backwater. Only about a decade before this photograph was taken, Philadelphia's first trolley had run here, inaugurating a new era in the city's development.

The heart of the major area of settlement for Philadelphia's eastern European Jews is depicted in these three photographs.

The photograph below was taken about 1905 on the newly cleared site of the market shed that formerly stretched from 3rd to 5th Streets along Bainbridge. It was a place to loiter and to talk, to see people and be seen. The view here is toward 5th Street. The large building in the center is the Young Women's Union; founded in 1885 by established Jewish families to provide services for poor children and their parents, it was later known as the Neighborhood Center. Some of the children the center was meant to help are seen in the photograph at right. It was taken in 1910 on the 300 block of Kater Street, which runs between Bainbridge and South, just behind the area shown below. The block's population was overwhelmingly Russian Jewish. In this year the tiny Fourth Ward, running only from South to Fitzwater east of Broad, had about 8,000 Russian Jews, most of them concentrated east of 8th Street. The contrasts of Southwark are evident here—an unpaved street with utility poles, substantial brick houses facing unsteady wooden ones, and children playing in filth and garbage. Another side of the same community is revealed in the third photograph (below right), which was taken in June 1917. These storefronts were located at 770–774 South 5th Street. The signs indicate a print shop, a carpenter, a kosher lunchroom, and a Hebrew school. The presence of the American flag—a reminder of wartime patriotism—and the use of both Yiddish and English in most signs are visible evidence of the gradual assimilation of Phildelphia's eastern European Jewish community.

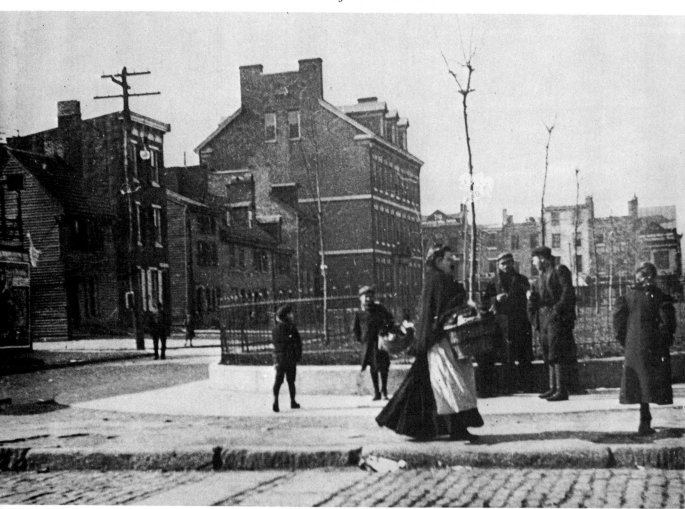

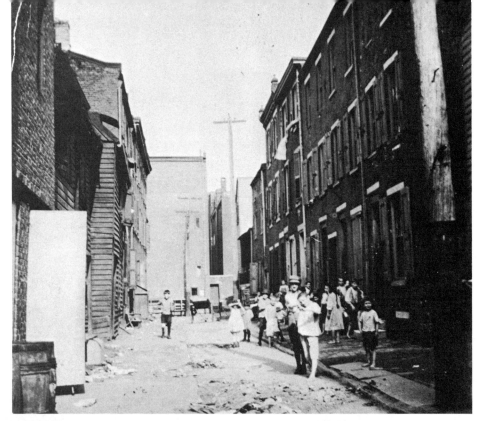

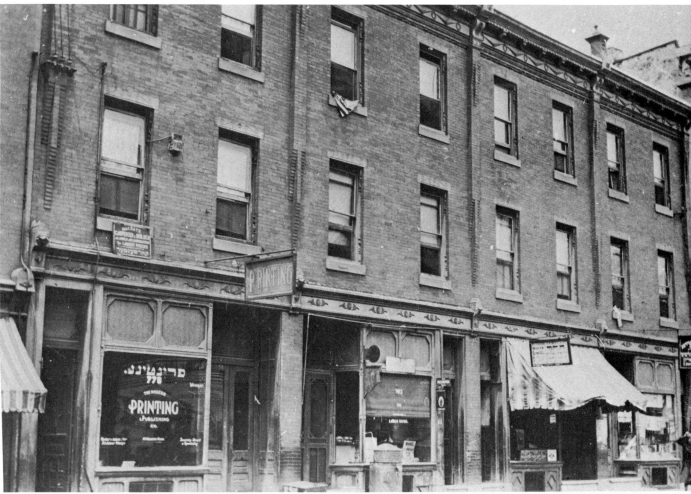

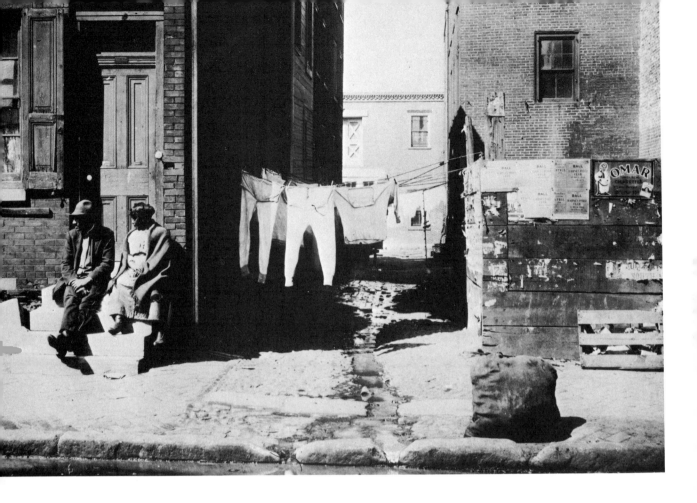

The narrow strip between Pine and Christian Streets west of 7th held the largest concentration of the nearly 100,000 blacks who lived in Philadelphia before World War I. They included recent migrants from the South, families established in business since before the Civil War, and a few who could trace their ancestry in Philadelphia to the colonial period. The photograph above, from 1914, shows an old couple in front of a three-story row house at 1235 Fitzwater Street, just around the corner from the Union Baptist Church. Some idea of the area's role as the traditional center of black life is given here by the notice of the forthcoming ball at Barney Ford's Club. But the other side of that life is also visible behind the house, where the rear additions and courtyards can be seen. In 1910 the Third Ward (Fitzwater to Christian, east of Broad) had a density of 130,000 people per square mile, about ten times the figure for predominantly middle-class Germantown. As the reformers of the Housing Association noted in their caption to this photograph, the laundry was suspended over surface drainage from a large outhouse and three hydrants located in the courtyard. Philadelphia's blacks were facing even worse crowding when the photograph at right was taken in 1921, at the height of the Great Migration. Burned out of a shaky wooden tenement at 724 Bainbridge Street, this family was forced to camp outside. With no easy alternative to settling in the city's traditional black neighborhoods—already crowded with European immigrants—new arrivals from the South often found accommodations in alleys and back courts, sometimes with the unhappy result pictured here.

40

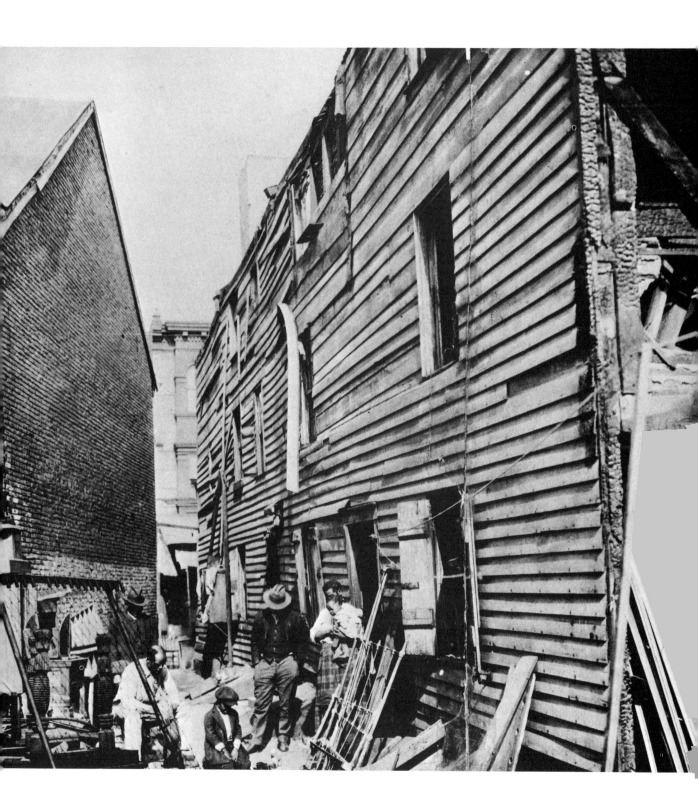

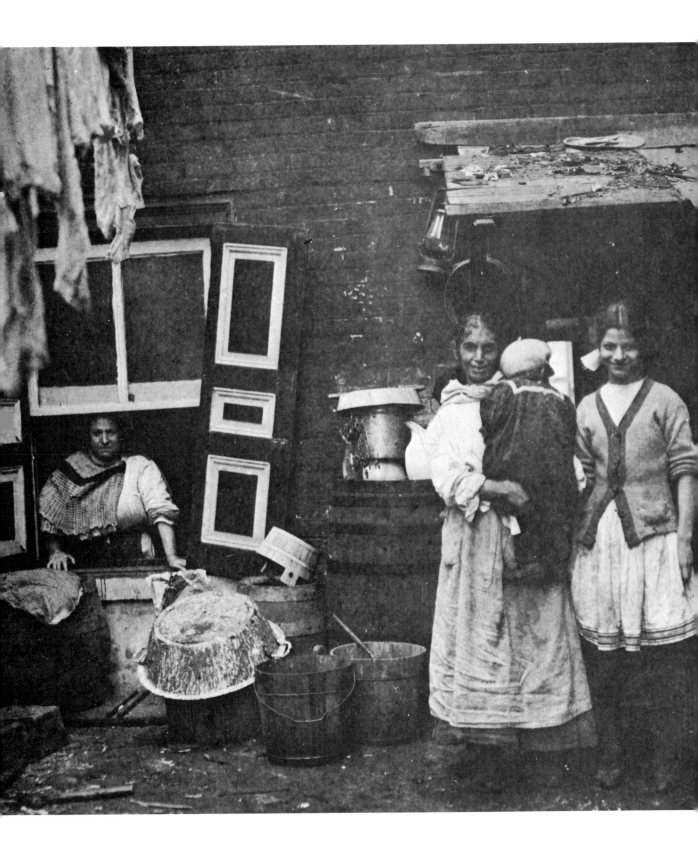

Italians who came to Philadelphia settled for the most part to the west and south of the Russian Jews, but their physical surroundings were similar. The first of these Housing Association photographs (left) shows the Tutendari family at their home at 1009 Montrose Street (between Christian and Carpenter Streets) about 1920. This block contained a dozen small row houses and was only about a block and a half from the textile plants, mills, and coal yards along the Washington Avenue railroad corridor. Living in the heart of Philadelphia's Little Italy, the Tutendaris were surrounded by Italian institutions, from Catholic churches like St. Paul's (one block east) to C. C. A. Baldi's factory (two blocks southeast). Such institutions probably helped them retain such old-country customs as the way of dress depicted in this photograph. Another Italian street scene was recorded by a Housing Association photographer on Mildred Street, which ran between 7th and 8th near Christian (below). This picture of a vegetable seller with his goats and his cart was taken in the teens, when the block was almost entirely Italian. The photograph was made into a lantern slide to illustrate Association-sponsored lectures. The scene identified the neighborhood and its rather alien residents to the middle-class groups that usually made up the audiences for Housing Association programs.

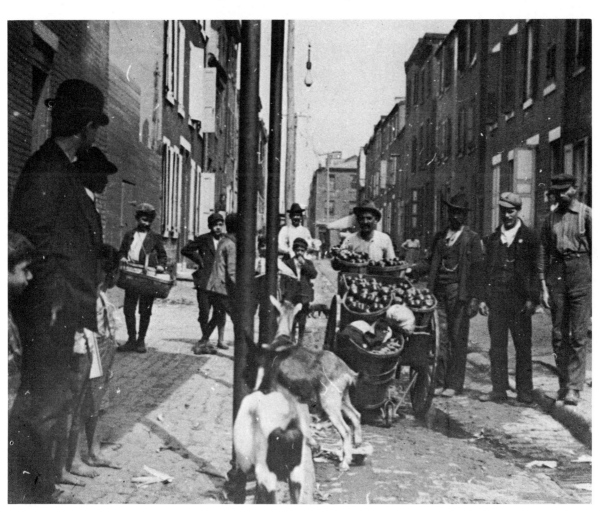

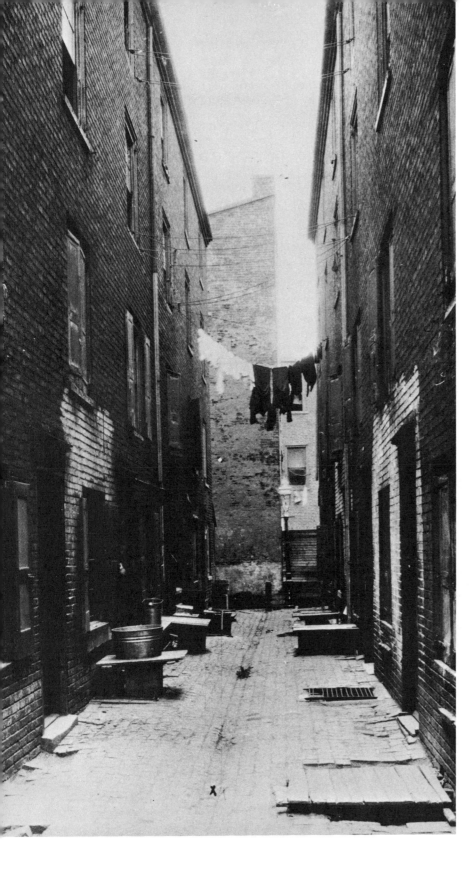

The area near South Street was as infamous for its old courts and alleys as it was famous for its ethnic variety. The two small wards between Chestnut and Fitzwater Streets east of Broad still had about 250 courts and alleys in 1900. The photograph at left shows the 500 block of South Howard Street in 1917. South Howard extended behind 112 Naudain, itself a small street between Lombard and South. Lined on each side with six four-story houses, the alley backed up against a large soft drink factory. In the other directions, it was surrounded by establishments serving the busy docks and markets of the adjacent waterfront. The houses shown here were defined by local law as tenements: multi-family structures more than three stories high. A few blocks to the north was St. James Street, which ran off 226 South 2nd Street. When the photograph at right was taken there in August 1919, the family pictured here shared the alley and adjoining courtyard with Joseph Jaspan & Sons, local roofers, which accounts for the wood in the back. Twelve tiny row homes lined the south side of St. James Street. According to the city directory, most of the families here were Irish. The alley itself led to the rear of the Protestant Episcopal Mission. Given the ethnic background of the neighborhood, however, residents were probably sustained more directly by the nearby cigar and furniture factories and by the Dock Street Market just a block away. These two alleys, hemmed in but kept alive by surrounding commerce and industry, were typical of those parts of working-class Philadelphia that were created before the Civil War and remained busy and vital for a century thereafter.

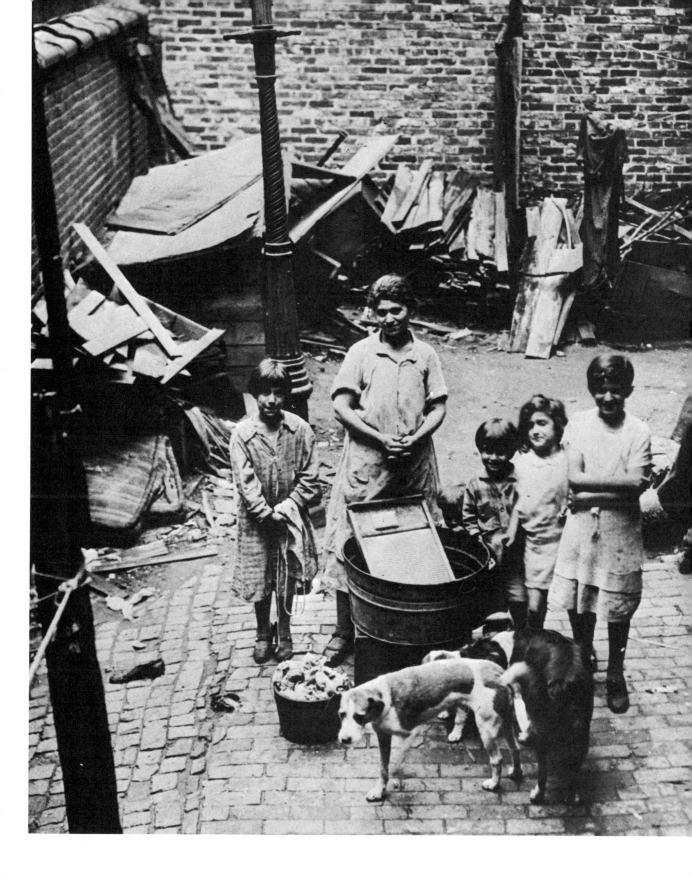

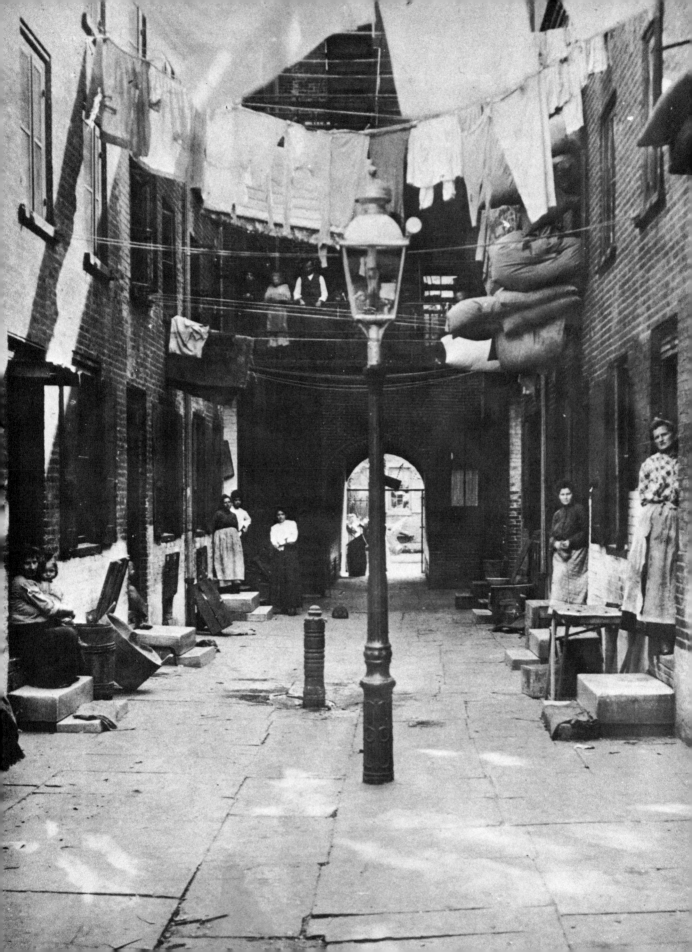

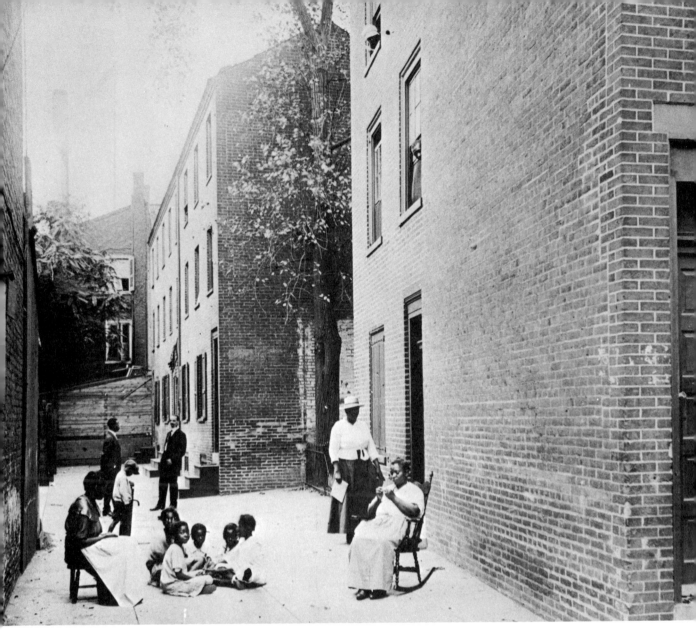

Like small alleys, enclosed court-yards could be found throughout the older parts of South Philadelphia. In the photograph above a carefully arranged group poses at the entrance to a courtyard behind 1326 Kenilworth, just half a block from Broad Street. At its other end, the court exited on a small alley called Brewery Place, named after the large brewery on Fitzwater Street. The properties were owned by the Octavia Hill Association, which probably used this 1910 photograph to demonstrate the morally uplifting effects of good housing. The Association was also responsible for the photograph at left, taken in the vicinity of 9th and Christian to illustrate Emily Dinwiddie's pioneering 1904 study, *Housing Conditions in Philadelphia*. According to the caption, the court's nine houses—located behind a tenement—were serviced by a single hydrant and a single lamp. The washtub, laundry, and bedding visible in the court are tangible reminders that along with such unhealthy conditions went an intimate lifestyle and a lack of privacy.

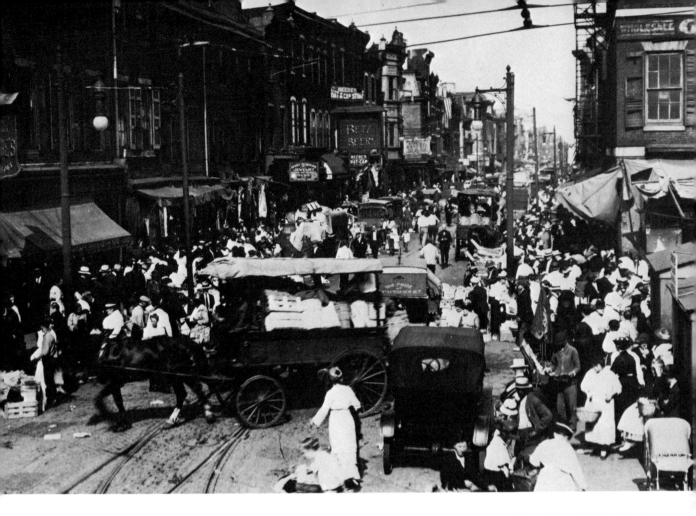

The combination of ethnic culture and overcrowding in the old neighborhoods contributed to a lively street life. The view above looks west from the corner of Front and South Streets (only half a block from Howard Street, pictured on page 44). It was probably taken on a Friday or Saturday, when the farm market was held here. The bustling vitality owed much to the crowded blocks on either side of South occupied mainly by Russian Jews, and to the industries, especially sugar refining, located on the waterfront right behind the photographer. But the scene also reveals some of the changes affecting Philadelphia by the midteens. Alongside the women with their wicker baskets, the shoppers strolling in the streets, and the horse-drawn wagons, automobiles and trucks are very much in evidence. Like the lower part of South Street, South 4th Street, pictured at right, was also a major Jewish shopping area. This is a view of the 700 block in 1926, complete with pushcarts and storefront row houses. Among the latter are a kosher butcher and delicatessen across from each other, Levin's bakery, a dry goods store, and the New York Silk and Woolen Store. The pushcarts generally did not compete with such established businesses, concentrating instead on produce. Though this official city photograph was purposely taken when the shoppers were absent, the stores, pushcarts, and even the elaborate building facades all show what made 4th Street so important to the Jewish immigrant community.

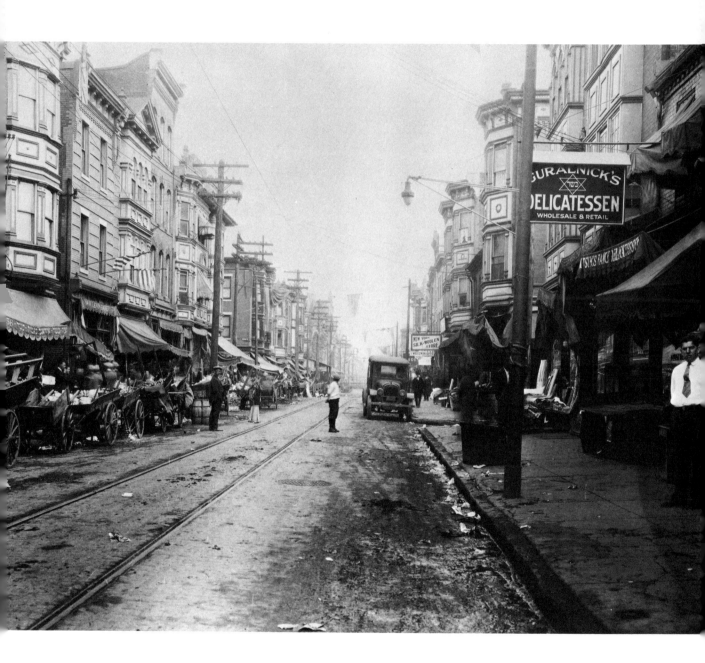

South 2nd Street had been the site of a market building of some kind since the mid-eighteenth century, and in the early twentieth century area truck farmers still brought their produce to regular Wednesday and Saturday markets. The photograph below, taken in October 1916, shows the west side of the market looking towards Head House Square. Most of the produce retailers and wholesalers were Jewish, but the obviously mixed nature of the clientele reflects the presence of large numbers of Poles, blacks, Italians, and others in the neighborhood. The photograph at right shows a butcher's stall in the South 2nd Street Market in 1914. While this is clearly a staged photograph, the abundance of food and the furnishings and equipment are genuine.

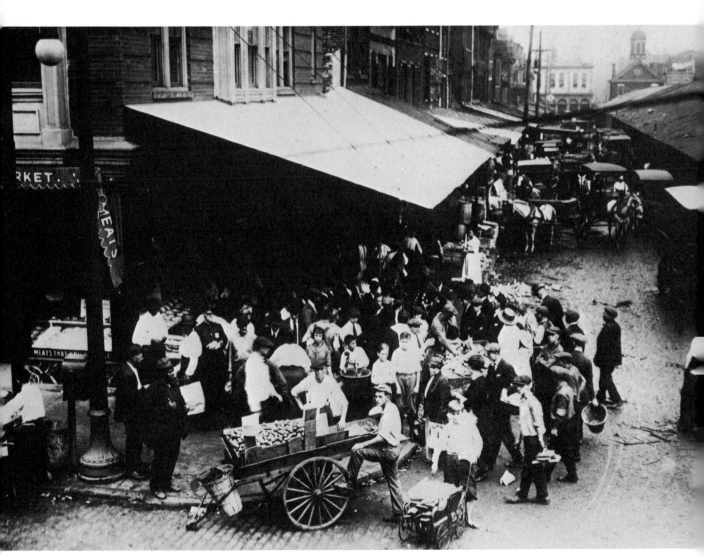

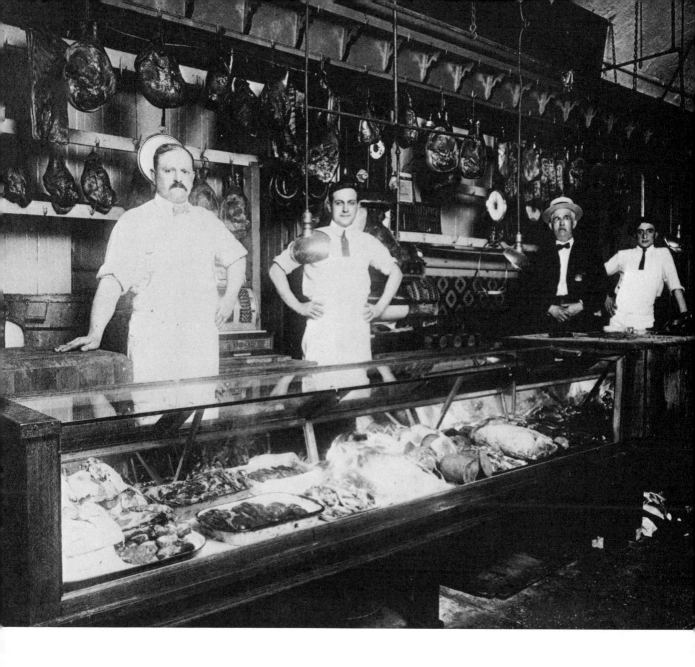

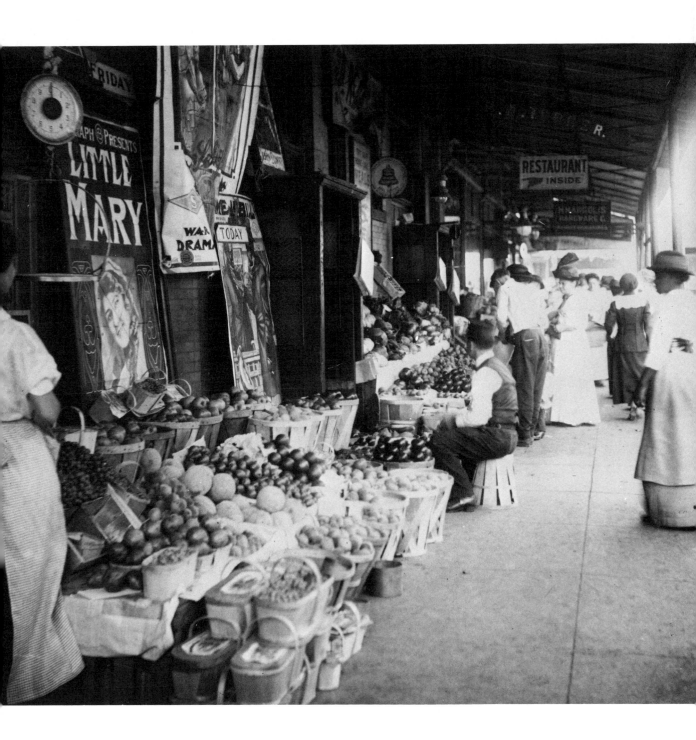

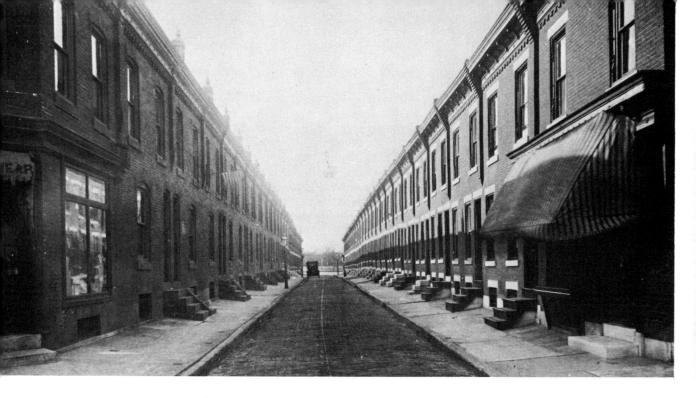

As South Philadelphia was built up to the west and south in the late nineteenth century, the ethnic divisions of the old neighborhoods were continued and the row house form became nearly universal. The 1600 block of Federal Street, shown at left, was in an area developed in the 1870s. The block was the site of the New Federal Market, one of the twenty-five market buildings put up by the city at the insistence of businessmen in the late nineteenth century to take the selling of food off the streets. When this photograph was taken in September 1914, this predominantly black and Italian area was sustained in large measure by the industries along Washington Avenue two blocks to the north.

The abundance of produce reflects the relative prosperity of such industrial areas in the mid-teens, while the posters advertising a "War Drama" and a movie by Little Mary—Mary Pickford—are reminders of the changes taking place when this photograph was taken. A newer part of South Philadelphia is captured in the photograph above, taken in January 1919 on the 400 block of Durfor Street. This is a classic portrayal of the row house street, although the absence of people is artificial. This block, located between Ritner and Wolf, was lined on each side with twenty-six two-story houses, built as a unit in the late 1890s. The only variation was in the slightly larger buildings at the corners, used for stores or shops. It was in areas like this that the row house achieved its greatest dominance. Below Mifflin Street and east of

Broad, all but two thousand of the nearly sixteen thousand dwellings existing by 1930 were two-story brick row houses. The residents of Durfor Street, living in a relatively new part of the city, enjoyed a well-paved, lighted, and drained street. They also enjoyed some open space in the form of Mifflin Square in the background. Without it, the unrelieved uniformity of the block might have seriously compromised its great advantage—the provision of a separate home for each family.

Much of the city's industry was concentrated in North Philadelphia and Kensington. The area, bounded and organized by the railroad corridors stretching from Glenwood Avenue east to Port Richmond and from Callowhill Street north to Nicetown, contained the largest concentrations of the textile, iron, steel, and machine-building industries. The photograph below, a 1930 aerial view of Brewerytown, at 33rd and Thompson, shows the intimate relationship between railroad, industry, and row house so characteristic of Philadelphia. In the foreground, hugging the railroad tracks, are the major breweries, Bergdoll's, Bergner and Engel's, Poth, and Balta, all abandoned during Prohibition. Behind them are other factories, the largest housing the Walters Milling Co. Finally, the standard blocks of row homes fill the background, with larger houses on major streets and smaller ones on back streets. This neighborhood was still overwhelmingly white in 1930, with a large German population, symbolized by the steeple of St. Ludwig's Roman Catholic Church in the upper right corner of the picture. Serving as centerpiece of the photograph opposite, taken in 1929, the new North Broad Street Station of the Reading Railroad highlights that company's key role in the development of North Philadelphia. Baker Bowl, home of the Phillies from 1887 to 1938, was across the street from the station at

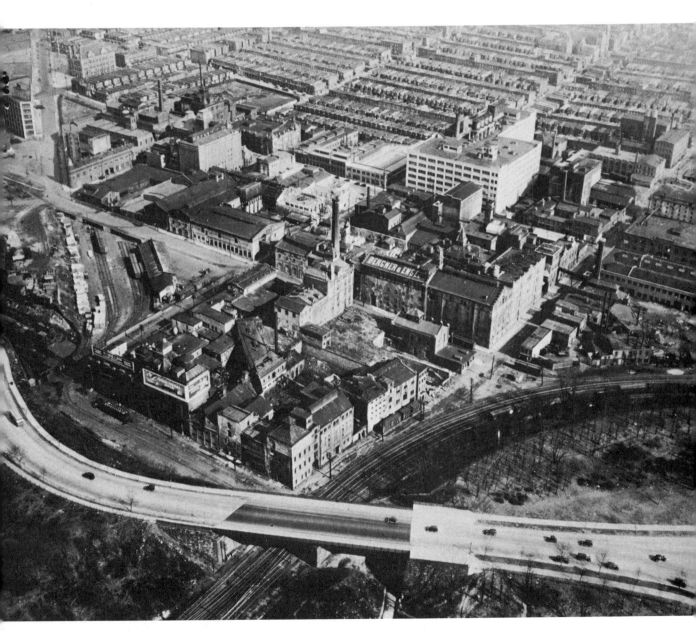

Broad and Huntingdon. As in Brewerytown, the row houses behind the railroad were erected during the great building boom following the Civil War. The area shown most clearly here, between Cumberland and Lehigh and Germantown and 13th, was fully developed by the early nineties. Most of the homes were small, only two stories on a lot measuring 14′ × 48′. They were surrounded by churches, stores, meeting halls, and, above all, factories, from the old Ritter Furniture Factory at Germantown and 10th (top right) to the E. A. Wright printing and engraving plant next to the Reading Station. By the late twenties the area was ethnically mixed, with significant black, German, Russian Jewish, and Irish populations inhabiting the blocks pictured here in the heart of North Philadelphia.

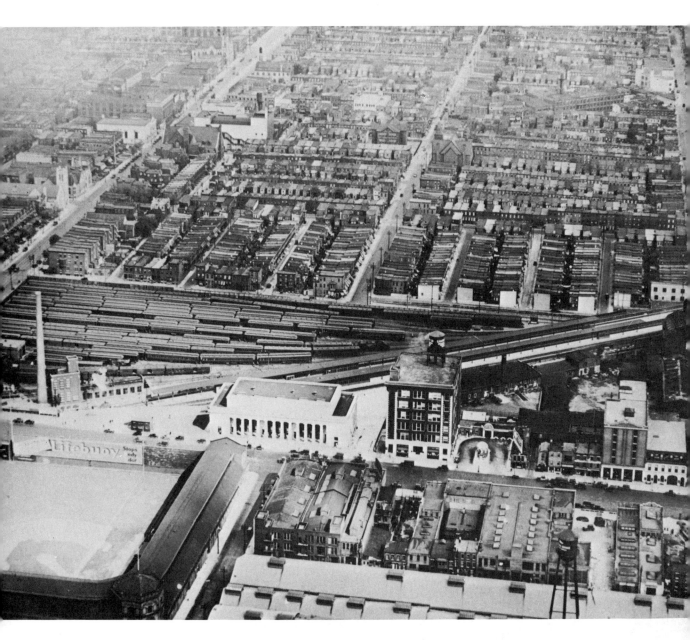

The photograph below depicts the J. Bromley & Sons mill on Lehigh Avenue between A and B Streets in Kensington. The rooftop perspective, common before the advent of aerial photography, emphasizes the dominance of the rug and lace factory complex over the small row houses in the background. The Bromley establishment included eighteen buildings on one city block and had been completed in 1899, about a decade before this photograph was taken. The workers at Bromley's and at the other rug and wool mills visible in the distance were predominantly of Irish, British, or German ancestry. They tended to live very close to their place of work. In its physical layout, its ethnic makeup, and its industrial structure, this was a classic mill town. Yet another pattern of industry prevailed in the older areas of North Philadelphia further south and closer to the river. In contrast to the large textile mills above Girard Avenue, lower Kensington, filled with factories,

warehouses, and workshops, was more industrially diverse. The J. C. H. Galvanizing Co. at 1110–1114 North Front Street, pictured at right in September 1915, comprised several small brick and wooden buildings. Within a two-block radius were such larger enterprises as Schmidt's Brewery, the Barnett File Works, and the Davis Glazed Kid Factory. Lumber and coal yards and gasworks were also present, with row houses scattered in between. With large eastern European Jewish and gentile populations and a significant German presence, the area's ethnic makeup reflected its industrial diversity. The businesses depicted here were typical of the older tradition of metal and craft work developed before the age of large factories, which persisted well into the twentieth century. The photograph was probably taken to document the street repair, but the camera so intrigued the workers and the neighbors that they posed for the picture.

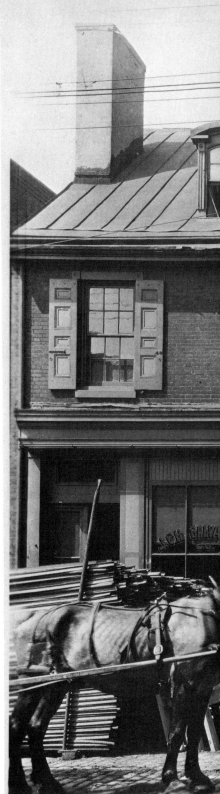

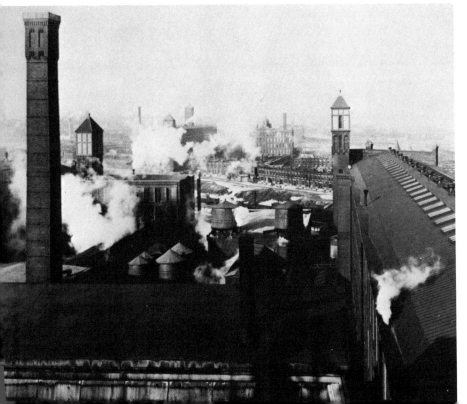

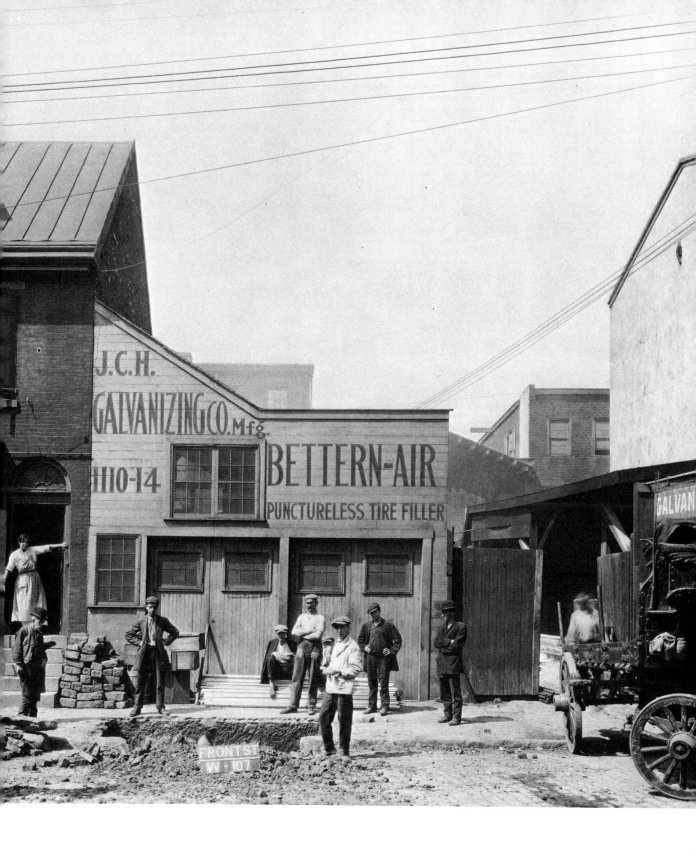

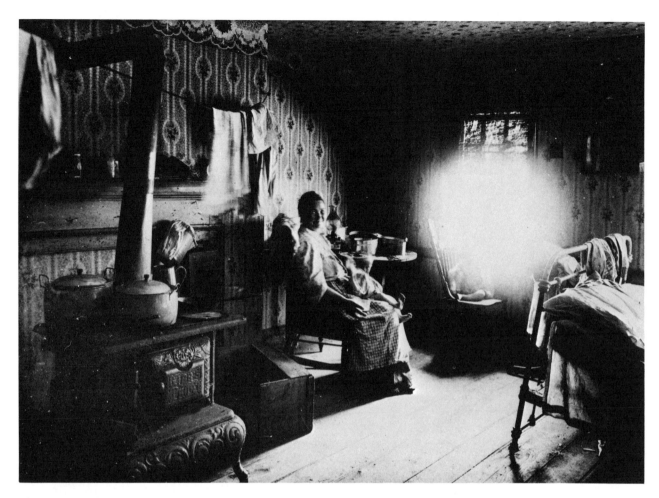

In the oldest part of North Philadelphia, the Northern Liberties just above Vine Street, social life and housing conditions were similar to those in Southwark. The view above, taken by the Housing Association, shows the single cellar room at 534 North Front Street, which in 1912 was home to a family of five, including the two barely visible infants, one on the woman's lap, the other at the room's lone window. The four-story building in which this photograph was taken faced the tracks of the Pennsylvania Railroad and, across them, the eight-story Philadelphia Warehousing and Cold Storage building. This family had a total income of $18 per month, of which $4 went for rent. Only three blocks away to the northwest, the 2nd Street Market was another indication of the similarities between the Northern Liberties and the South Street area. The market house between Fairmount and Poplar, pictured (right) in 1914, provided fresh produce to the neighborhoods. The area had recently been dominated by Germans, both Christian and Jewish. By the teens, Russian Jews were the largest single ethnic group, though St. Paul's German Lutheran Church remained at Brown and American, only half a block from the market. Despite the obvious similarities, living conditions in this area were even worse in some ways than they were in its southern counterpart. The Northern Liberties was more industrial, the houses older, and rooming houses or tenements, like the one in the photograph above, much more numerous.

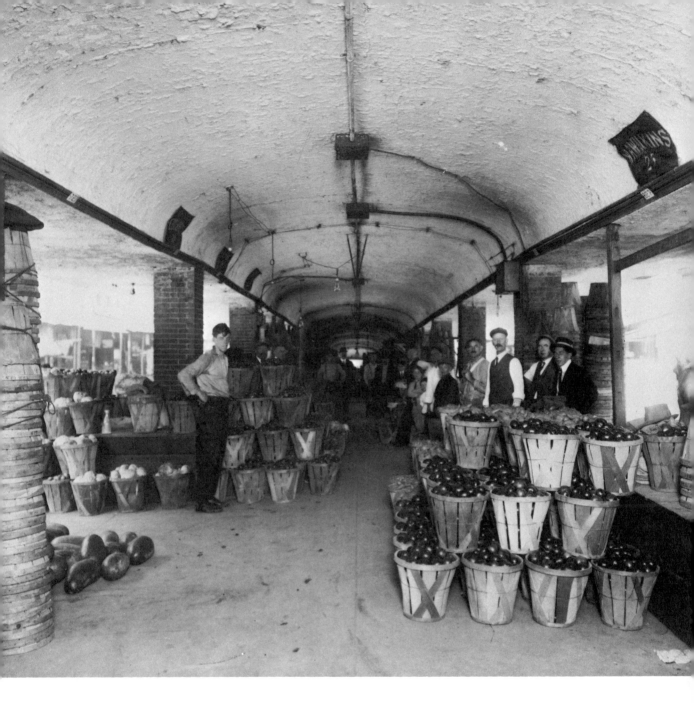

Though the row house form was extended into newer areas of North Philadelphia, these neighborhoods were more prosperous and uniformly residential than the districts along the river. Pictured below are residents of the neighborhood at 7th and Oxford in 1904. Though there were some factories to the east and a major industrial corridor along the Reading tracks at 9th Street, this immediate area was dominated by the Trinity Reformed Church and Congregation Adath Jeshurun. The residents in 1904 were primarily Irish, German, or older stock American, whose respectable prosperity is underlined here by the clothing of the children and the bicycle owned by one of them. But the older groups were rapidly being displaced by the increasing population of eastern European Jews. About seven blocks directly south, Marshall Street already contained the best-known of North Philadelphia's Jewish pushcart strips. The photograph at right shows Marshall between Poplar and Girard in 1925. Clothing and food were the staples of the pushcarts, though they offered a wide variety of other goods and services. There were no large industries along this stretch of Marshall Street, though a good deal of needlework was done in the homes above these shops. In fact, the only structure on this block that was not a row house was a synagogue, housed in a building that had been the old Grand Army of the Republic Hall.

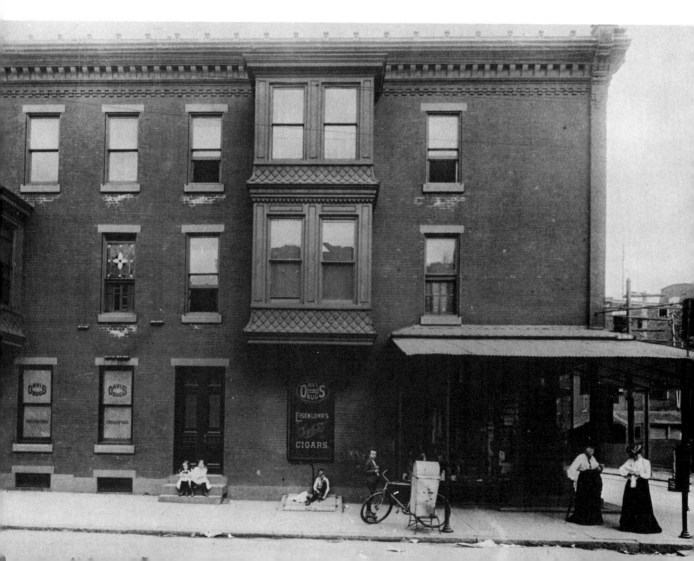

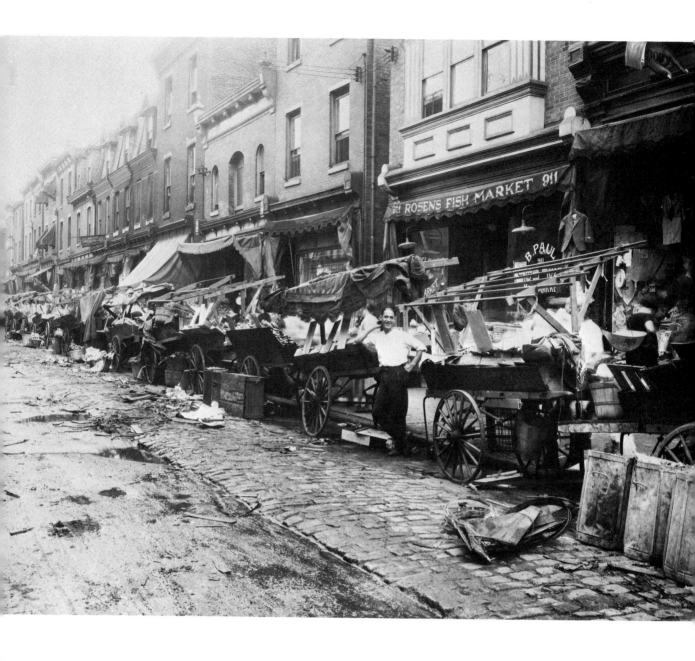

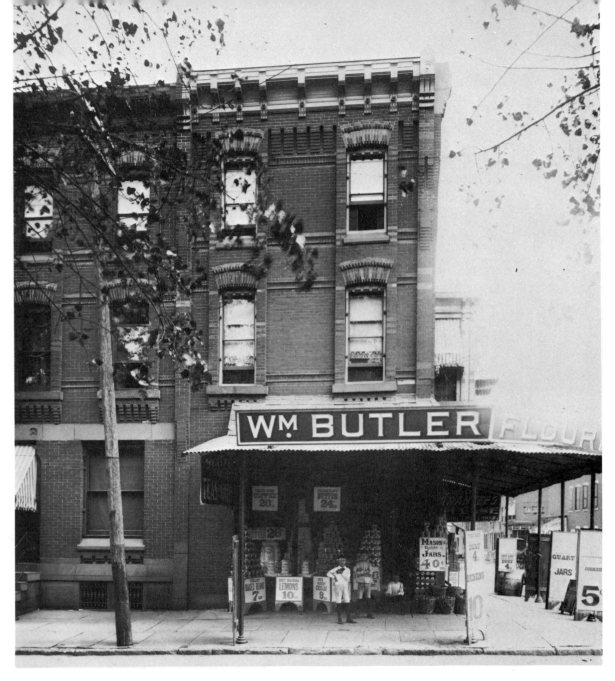

This grocery at 12th and Diamond Streets in central North Philadelphia was photographed in 1901 (above). The prominent displays of flour and Mason jars remind us that even in this middle-class area much baking and canning was done by women at home. The awnings on the adjacent houses emphasized the self-conscious respectability of this neighborhood, which was only about two decades old. While most of the people who lived here were of Irish, German, or British ancestry, their families had typically been in this country for several generations. The well-paved street with its trolley tracks, the local grocery with its neat signs, the large houses, and even the saloon next to the store were all common in the respectable middle-class neighborhoods that lined Broad Street in North Philadelphia at the turn of the century.

The tightly packed living conditions typical of the less fashionable reaches of North Philadelphia are evoked in this 1928 rooftop photograph of the 2400 block of Jefferson Street (right). The view looks west towards the Kane Public School, with the Athletic Recreation Park building in the background to the left. With homes built right up to the street lines, these tiny backyards, separated by high wooden fences, provided the only private outdoor space. Since the street was the only large open area, active street life was as much a necessity as a preference. By the late twenties, the population here was dominated by large German and Irish communities. About half a mile to the north, on the 2400 block of Diamond Street, the impressive row houses pictured on the next page were close to North Philadelphia's changing racial boundary when they were photographed in 1924. While this neighborhood, next to Moylan Park, was still primarily eastern European Jewish, the area to the south and east was fast becoming predominantly black as a result of the Great Migration. The problem that the new arrivals faced is illustrated in this scene. Though there were major industries just to the northwest along the railroad corridor at Glenwood Avenue, most blacks could only get jobs like the ones pictured here—as teamsters for a nearby stable owned by the city sanitation department.

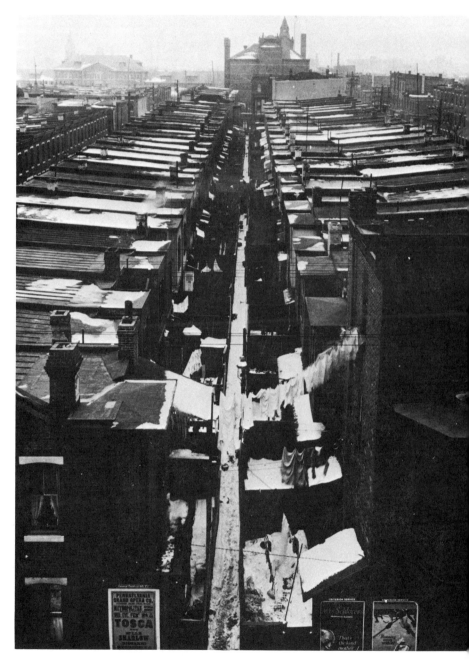

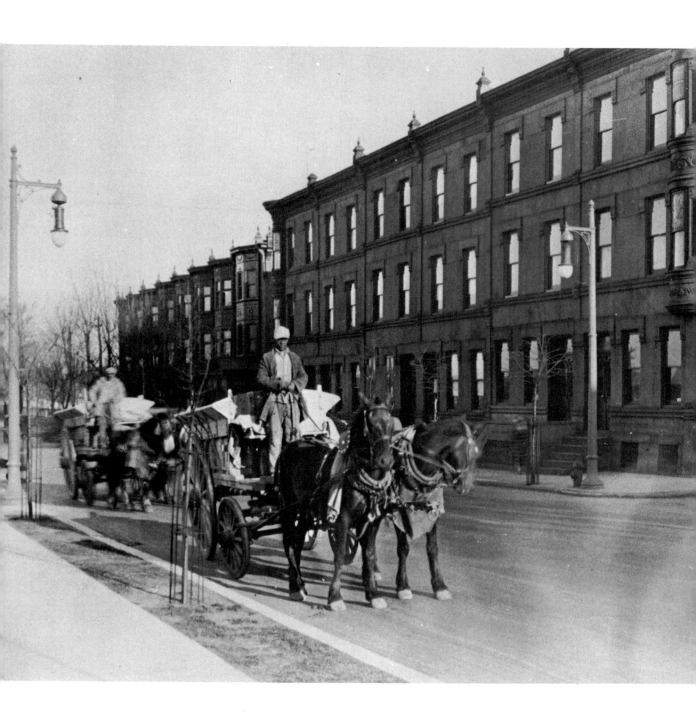

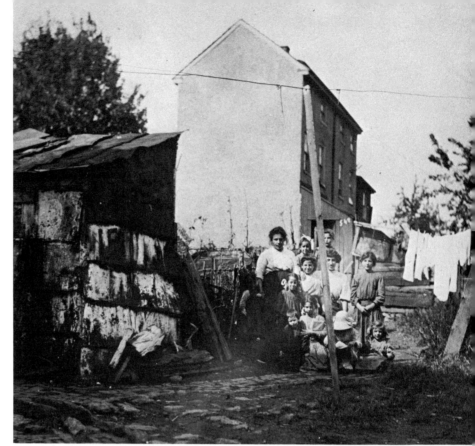

Immigrants and industry were not confined to North Philadelphia, Kensington, and South Philadelphia. The two photographs at right were taken in 1913 on the 500 block of East Rittenhouse Street in Germantown—which is usually thought of as an old colonial town and middle-class suburb. The photographs were taken for the Octavia Hill Association, which owned these properties and was planning renovations. The Association noted that the old frame houses in the bottom photograph housed three families each and had no indoor plumbing or water supply. The block was adjacent to the Reading Railroad and such neighboring industries as the Germantown Spinning Mill at High Street. Not surprisingly, this area had a large ethnic population, including most of Germantown's Italians. The third photograph (next page), taken in 1920, is of Clearview Avenue, a small street just past Chew and below the Washington Lane train station. It contained about a half a dozen wooden and brick row homes, all two stories and measuring only 14′ × 30′. The wooden houses had been there since at least the 1870s. The street came to a dead end at the Reading tracks near the wooden fence visible here. In the extraordinary housing mixture characteristic of Germantown, this row of houses bordered on the estate of the Cope family, while Clearview, on the other side of the tracks, was a typical street of brick row homes. A few years after this picture was taken, the buildings were gone and the area had become the property of Awbury Arboretum.

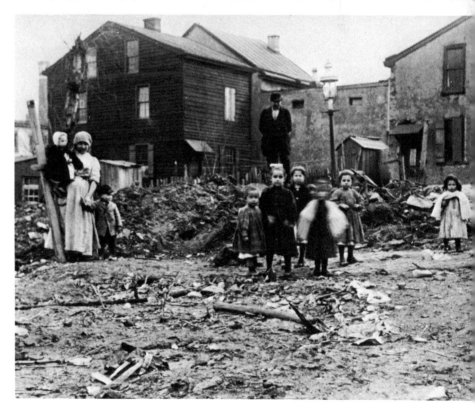

65

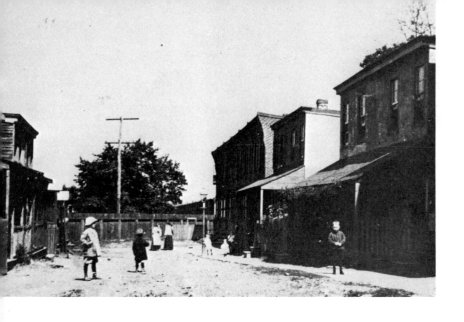

Of the several small communities with histories of their own within Philadelphia's political boundaries, Manayunk was perhaps the most distinctive, a self-contained mill town separated from the rest of the city by the Wissahickon Creek and undeveloped land. Since the 1820s it had contained one of the nation's greatest concentrations of textile and milling industries. The 1926 aerial photograph at right shows how the pattern of river-centered industry and hillside housing created in the early nineteenth century was still in place a hundred years later. Built on a steep slope parallel to the Schuylkill River, Manayunk was also graced with an early nineteenth-century canal. Originally built as part of a transportation system, the canal was soon exploited as a source of water power for the mills that lined its banks. Shown here on the island between the river and the canal are the buildings then occupied by the Imperial Woolen Co. and the Zane Soap and Chemical Factory. St. John's Church appears prominently in the right rear on the mainland, next to Manayunk Park. The railroad, which was built along the river, enhanced the town's growth and the business district spread along Main Street parallel to the tracks. Manayunk's topography made it especially appealing to serious photographers such as G. Mark Wilson, who took the photographs on the following pages in 1923. The first depicts the rear of mills, businesses, and homes backing onto the canal. The second illustrates how workers' houses lined the streets leading down to the river. In contrast to the rest of Philadelphia, many of these homes were built of stone rather than brick. The aerial view illustrates how houses were interspersed with such community institutions as Catholic churches, schools, breweries, and small mills. Most distant from the canal—and its pollution—were larger and more expensive residences. In Manayunk, as in most mill towns, physical patterns mirrored social arrangements.

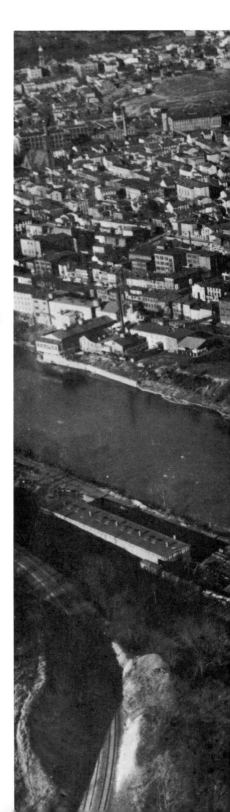

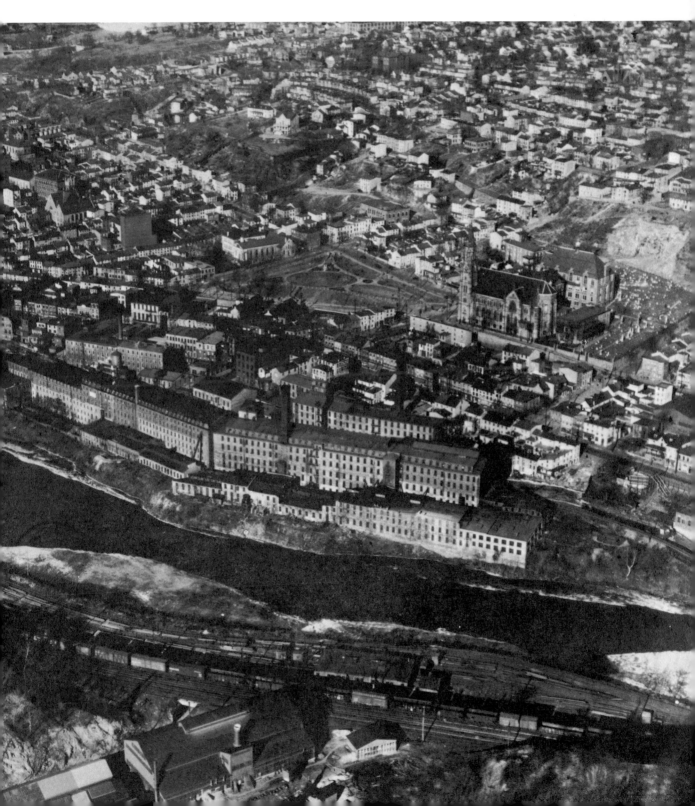

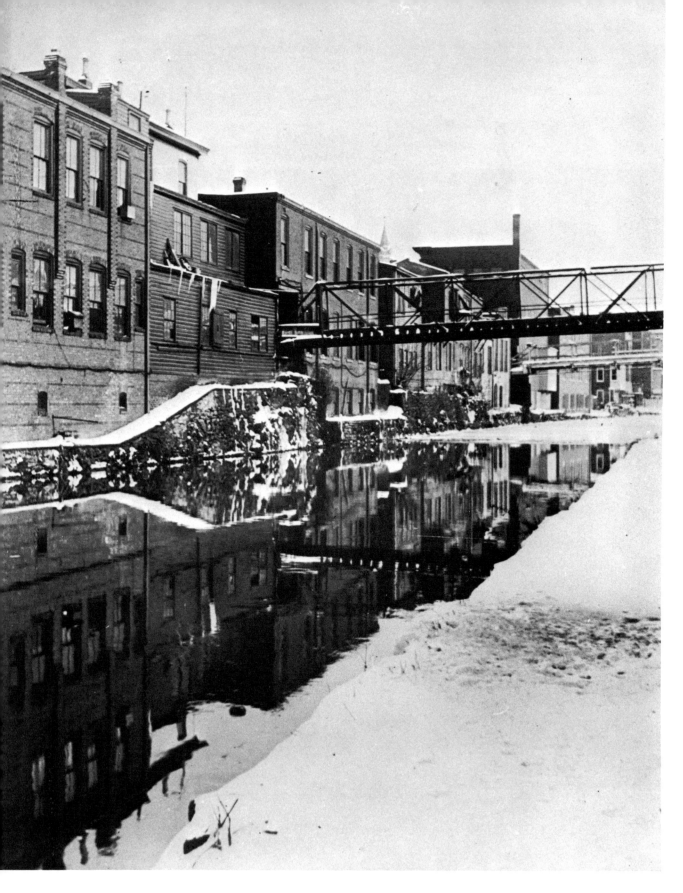

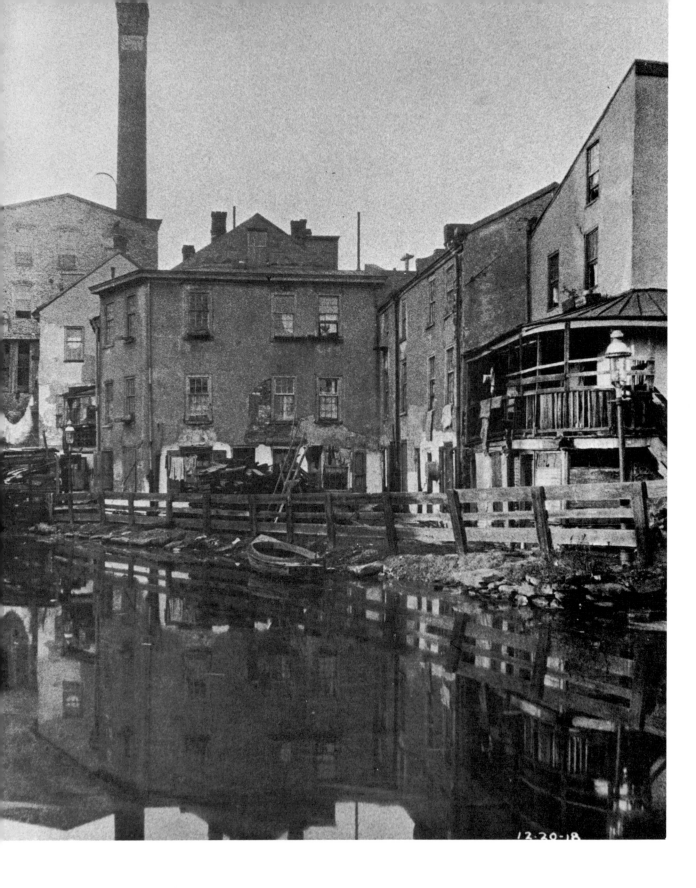

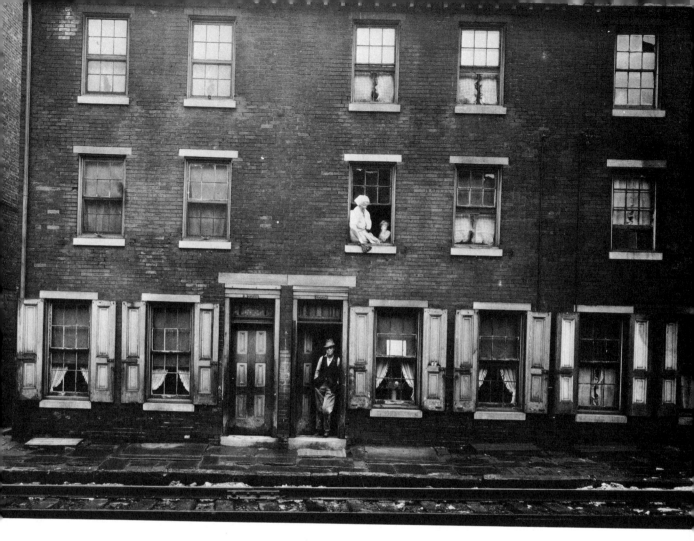

These two photographs illustrate something of Manayunk's uniqueness. At left is a Housing Association photograph taken in 1918 of mill workers' homes. These homes along the canal near Levering Street were among the oldest buildings in the community. The tiny houses, some as small as 14′ × 14′, abutted the canal but faced Main Street. Visible in the background is one of the old buildings of the Davis Yarn Mills. As in the rest of industrial Manayunk, most of the residents were either Polish, Irish, or British. The work force had been predominantly Irish or British until the Poles started to arrive in the 1880s. They were the predominant ethnic group by the time these views were taken, though the older groups were still present in large numbers. A few blocks further up the river, a group of homes on Cresson Avenue near Green Lane was depicted by an official city photographer in February 1928 (above). The people who lived here had to contend not only with the railroad but also with the crowds attending the adjacent Empress Theater, one wall of which is visible. Nevertheless, the houses look well maintained, with the curtains, doors, and window frames adding a note of prosperity in the year before the Depression began. Of course, such trimmings may be the reason the photograph was taken here; they may be the exception rather than the rule. But most residents of this neighborhood owned their homes and would have had an incentive to care for them. This particular block was in an area with a fairly large Italian population, some Irish families, Jewish tailors and small businessmen, and a Chinese laundry—a not uncommon ethnic mixture in industrial Philadelphia.

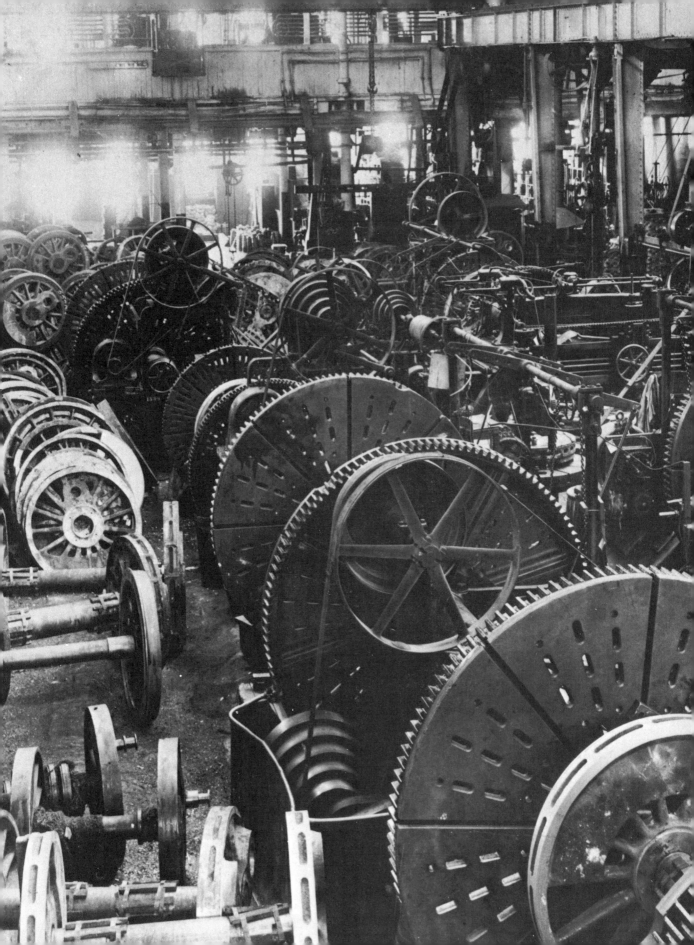

Workshop of the World

Philadelphians justly called their city the "workshop of the world." Over the course of the nineteenth century, first craftsmen and then factory workers made the city an industrial giant. The production of textiles and metal goods put Philadelphia at the center of America's industrial revolution. In the half-century before World War II, the city's factories and mills continued to dominate vast sectors of American manufacturing. The city led the nation in the production of such diverse products as locomotives, streetcars, saws, steel ships, textiles, rugs, hosiery, hats, leather, and cigars. It held second place in the production of sugar, fertilizer, foundry castings, petroleum products, chemicals, and drugs. Just as striking was the diversity of Philadelphia industry: the United States Census listed 264 manufactured articles in 1910, and the city produced 211 of them.

Industry influenced the kinds of lives Philadelphians led. On an obvious level, the work people did determined their standard of living—their access to the good things in life and their share of its tragedies. Even as the city in general prospered, many of its workers were chronically insecure financially. Low wages and long hours in often seasonal jobs were especially prevalent in textiles and the garment trades, which together accounted for a substantial share of the labor force. But much early twentieth-century industrial work was characterized by regular layoffs and chronic job insecurity. Conditions improved by the 1920s, but the Great Depression of the 1930s stood as a reminder of the inherent economic instability of modern industrialism.

Work also affected health and longevity. Much of the physical labor of the city was unsafe; dock, construction, and rail workers and users of power machinery were often job casualties. Certain diseases respected occupational status when it came to picking their victims. Brown lung, for example, claimed its toll in the city's textile and carpet mills. And child labor, even when physically safe, often devastated and stunted young lives.

Ethnicity, race, and gender influenced employment patterns. Blacks, for example, were often excluded from skilled construction work and better manufacturing jobs—except during wartime labor shortages. They suffered especially from low wages, underemployment, and the consequences of both. Women regularly accounted for more than a quarter of the labor force throughout the half-century before World War II, but they were concentrated in textile mills, needle trades, and domestic service until the end of the nineteenth century, when they

Gear-cutting shop in the Baldwin Locomotive Works, early twentieth century.

also found work in the growing office sector and such expanding services as the telephone company. They held relatively few jobs in the city's important metal and machine industries.

The nature of industry also shaped the ethnic composition of the city's population. With the exception of cloth and clothing, Philadelphia's major industries relied on skilled and semiskilled workers. Few area manufacturers required great concentrations of unskilled workers— certainly none needed the same kind of massive labor force that steel and automobile production attracted to Buffalo, Pittsburgh, Chicago, and Detroit. Not coincidentally, the eastern European immigrants—Slavs, Croats, Poles, and Serbs—who filled these positions in raw, new industries elsewhere found fewer opportunities in Philadelphia. There were, to be sure, jobs for the unskilled. Outdoor jobs as laborers in the construction and maintenance of the city's public works infrastructure, its railroads and housing, tended to attract Italian immigrants.

The location of industry, almost as important as its nature, affected the residential choices of employees. Before World War II, the luxury of commuting to work was denied most industrial workers. They lived instead near their jobs in factory neighborhoods. As industrial districts expanded along the river and rail corridors, in the early twentieth century, row house neighborhoods grew around them in Kensington, Bridesburg, Port Richmond, Tioga, Nicetown, East Falls, and South Philadelphia. Twentieth-century factories were larger than the workshops they displaced. They visually dominated their neighborhoods, symbolizing their role as the center of their workers' lives. Older and smaller workshops did not disappear. Like the new garment sweatshops of the early twentieth century, they were a pervasive presence in the older neighborhoods surrounding the city's ancient core and in South Philadelphia.

Workplaces were the symbols of the industrial city, and work—perhaps as much as religion, family, and ethnicity—defined an individual's social role. In the modernizing world, as old values were constantly challenged, industrial jobs taught new values and new habits appropriate to an urban environment. And because the workplace dominated the worker's day and neighborhood, those lessons could be imposed by a foreman or a boss. Especially in the newer and larger factories, work demanded attention to the clock and to often arbitrary rules.

Philadelphia's workplaces attracted and affected their labor forces, but the industries themselves were subject to change. The manufacture of radios and electronic equipment burgeoned in the 1920s, while textiles and metals went into decline even before the process was accelerated

by the Great Depression. Still, textiles and metals—along with the garment trades, paper, food processing, oil, and chemicals—were the city's dominant industries as late as 1940. But there were differences in the industrial scene. By 1940, big plants employed more of the city's workers than smaller factories, reversing the situation that had obtained at the close of the nineteenth century. Sweatshops had become the exception. Child labor laws, workman's compensation, unemployment insurance, paid vacations, and minimum-wage and maximum-hours laws had humanized the industrial workplace to some extent. Also, industrial workers were often the second and third generation in their families on the job. They did not need training in the work habits or lifestyles of the industrial world. Entire sectors of Philadelphia's population had come to expect that their lives would be spent in industrial work.

Industry was the city's economic life blood throughout the period, but it did not account for all job opportunities. Agriculture was a reminder of Philadelphia's past—there were still 240 farms within the city limits in 1940, and the 1930 census counted almost 5,000 Philadelphians engaged in farm work. Small businesses and pushcarts offered immigrants a glimpse of the American dream. Stores and offices, warehouses and government agencies employed a growing proportion of Philadelphians, taking up some of the slack left as the proportion of city residents in manufacturing jobs fell from about half in 1890 to less than a third in 1930.

An office opening and a plant closing framed the 1920s with powerful symbolism. The decade began with Sears, Roebuck and Co. opening its new distribution center in the city's Northeast. It ended with Baldwin Locomotive, once the city's largest employer but already declining because of competition from automobiles and trucks, abandoning its Broad and Spring Garden Streets site for Eddystone, below the city on the Delaware River. The service economy spelled the end of the industrial city, and the automobile meant the end of the great industrial center as it had existed for a century.

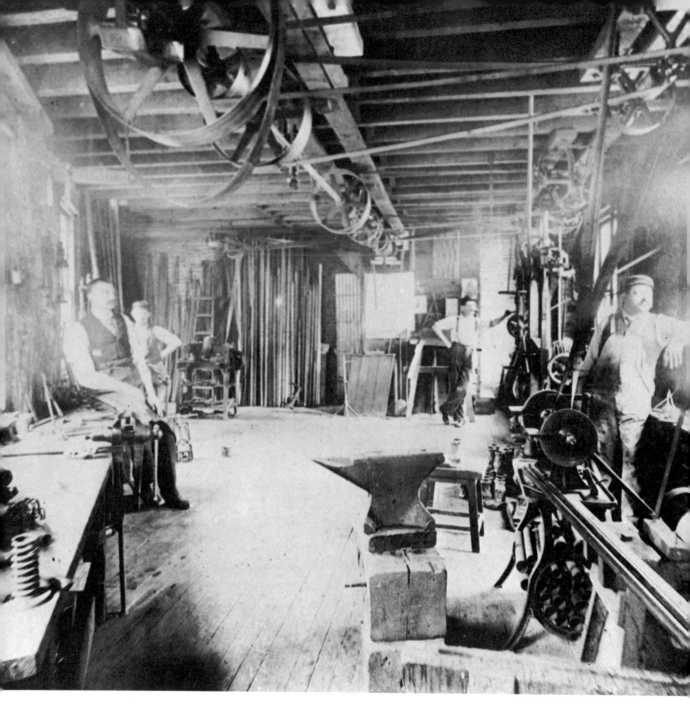

Eagle Builders' Iron Works, photographed around 1890 (above), was located on St. John (now American) Street in Kensington. Typical of the machine shops that dominated Philadelphia's iron industry in the nineteenth century, the firm depended on the skills of its small work force to turn out specialized goods. Using both hand tools and power machinery (with power supplied by shafts and belts from a steam boiler in the basement), the company manufactured gratings, gates, railings, awnings, and other iron goods to builders' specifications. Gradually overshadowed by such industrial giants as Baldwin and Brill, workplaces like this became less common in Philadelphia over the twentieth century.

The Baldwin Locomotive Works was the nation's largest. In its prime in the two decades before World War I, the plant was Philadephia's largest employer and might average 3,000 locomotives a year. But there were few average years. When business was normal, between 17,500 and 19,500 men worked at the Broad and Spring Garden Streets site; when orders dropped off, the work force could shrink to well under 10,000. Baldwin's employed predominantly skilled workers, paying in 1913 an average of $15 per week—slightly more than other Philadelphia industries—for 55 hours on the day shift, or 65 hours for night work. Baldwin was unusual for a large factory in that it had no time clocks, relying on supervisors to note absences or tardiness.

It is not clear whether these photographs of the shop floor were taken by Baldwin's official photographer, but the two office scenes—dating from 1898—are by William H. Rau, an important independent Philadelphia photographer. Like a number of the other images in this section, they were taken to document and advertise a local business. They were also meant to display the power of industrial Philadelphia.

The gear-cutting shop (below) is indicative of the scale of the Baldwin operation. Yet the workers welding boiler plate (next page, bottom) and operating lathes (next page, top) suggest how work might be broken up into small group tasks before the advent of the assemby line. The plant used a joint piecework system, in which groups of men shared responsibility for tasks. In the erecting shop (page 79), we may note the problem that everbigger completed engines would present to a plant in a con-stricted urban area. The final assembly of locomotives was moved in 1907 to a site outside the city in Eddystone, Pennsylvania. The rest of the operation followed over the next two decades. The city location occupied 17 acres; the Eddystone plant ultimately spread over 225 acres.

While the manual laborers in these shots are rigidly posed, the office scenes are more lifelike. The ornate executive suite (page 80) contrasts with the more functional office (page 81). The clerks in the latter shot are almost all male. Sixteen women worked for Baldwin in 1916, presumably as part of the 245-person office force. Female employees, like the one in the foreground, found their entry into such scenes facilitated by the adoption of the typewriter, one of which is also clearly visible in the photo.

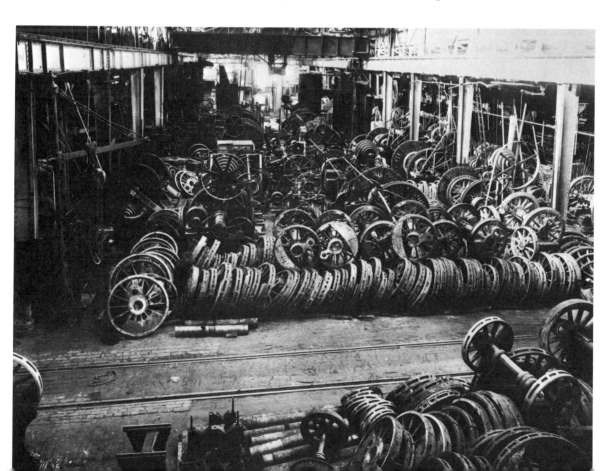

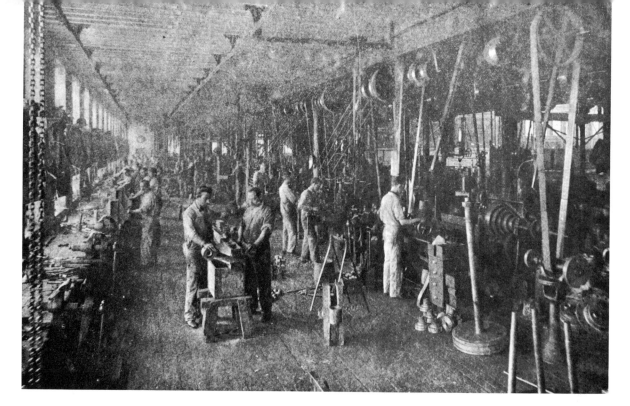

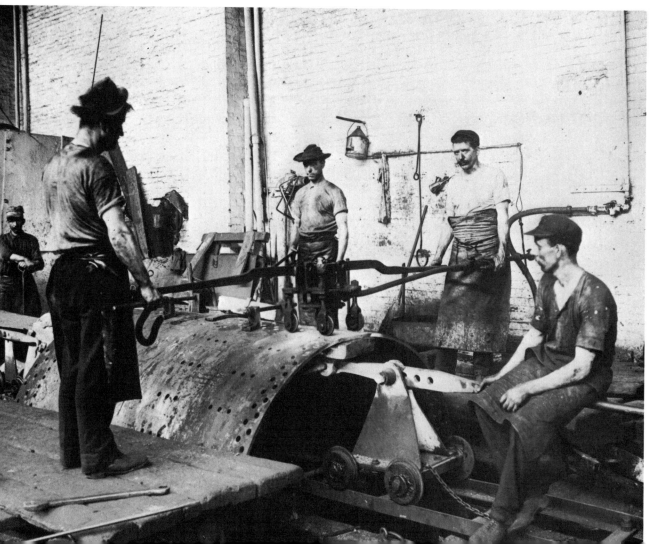

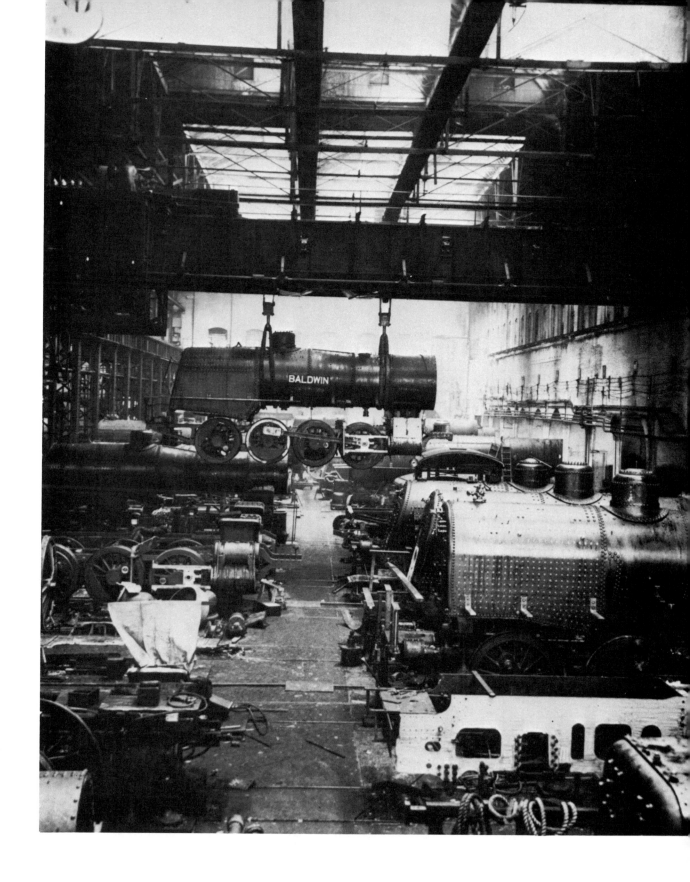

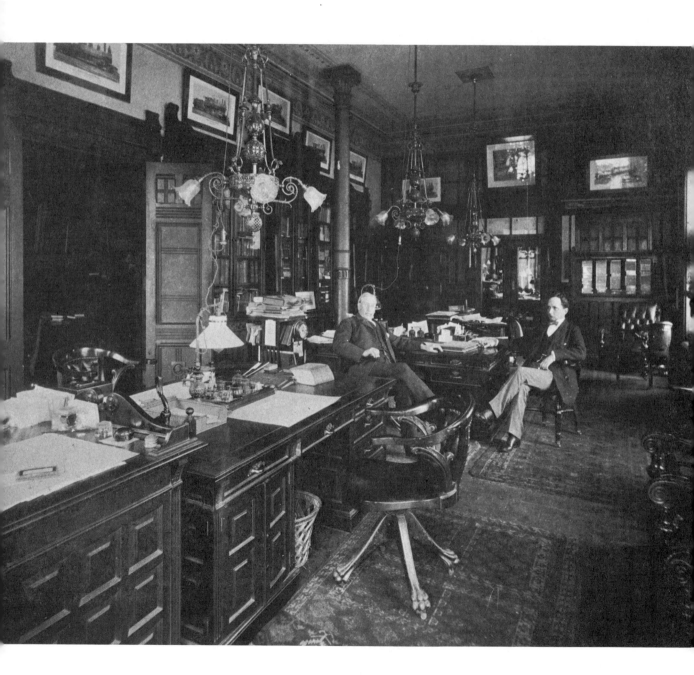

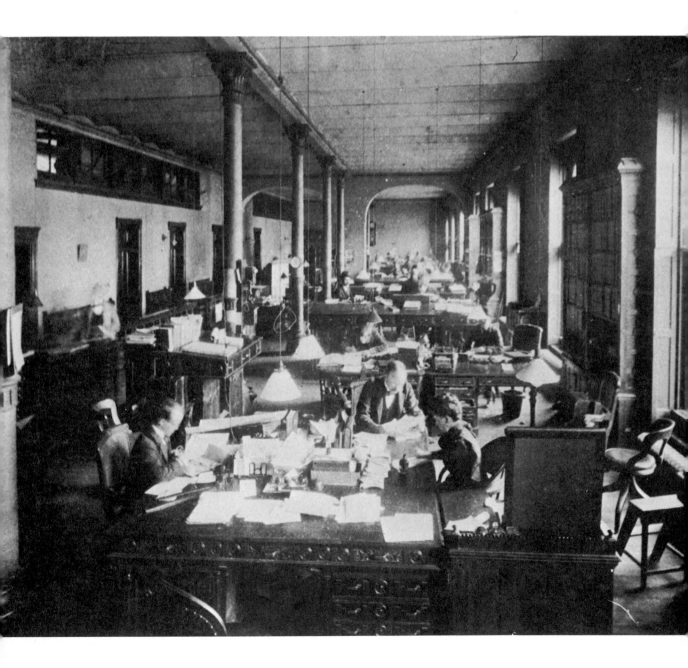

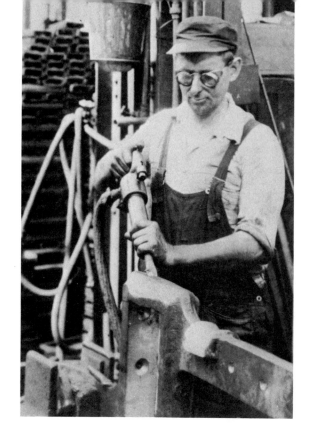

These photographs of the J. G. Brill Co. date from the early 1920s. They were taken for the firm, which issued a series of illustrated company histories, catalogs, and promotional pamphlets explaining its work to potential investors and customers and to the general public. Brill advertised itself as the largest manufacturer of electric street railway cars in the world. John George Brill, a German immigrant, had organized the company in 1869, after working as a cabinetmaker for the firm that had manufactured Philadelphia's first streetcars. As technological innovations harnessed mechanical power for street transit, Brill produced cable cars, steam dummies, storage battery cars, trolleys, electric interurbans, trackless trolleys, and ultimately buses. After two decades at 31st and Chestnut, the firm moved to 62nd and Woodland in far West Philadelphia in 1890. When these photographs were taken, almost 2,500 men worked "under normal conditions" at this plant.

While the close-up of a worker chipping surplus metal (left) is stiffly posed, workers seem to be actively attending the casehardening equipment (below). No workers are readily visible in the erecting shop (next page). After assembly, cars destined for American buyers would be rolled onto flatcars for rail shipment, while cars to be used abroad would be dismantled, crated, shipped, and reassembled at their destinations.

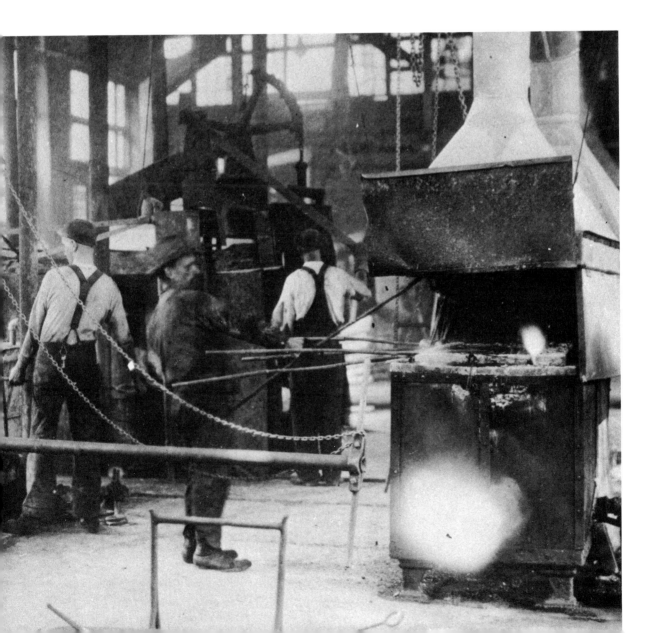

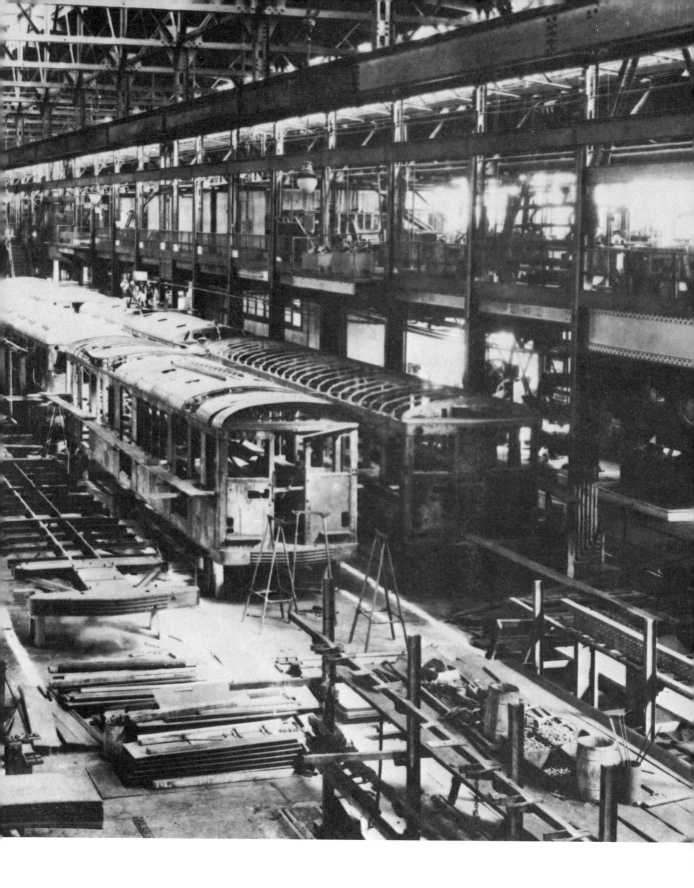

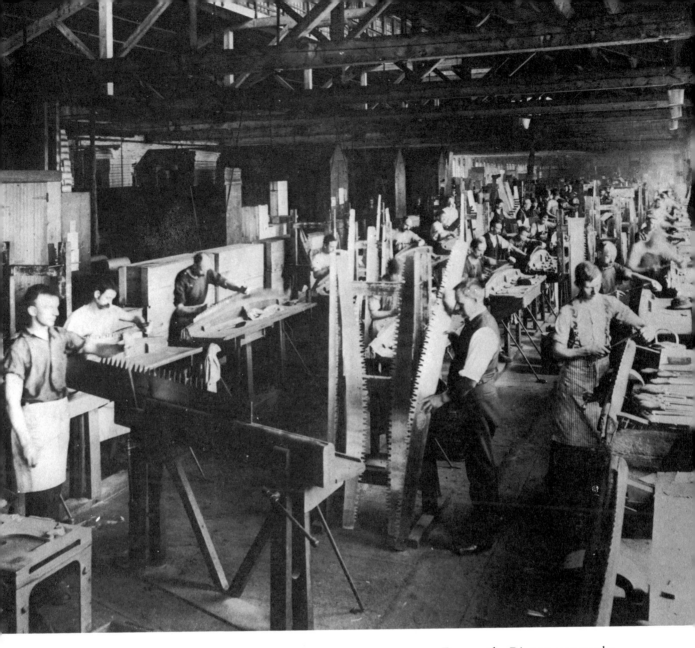

Even as the Disston saw works grew to be a major employer, the emphasis in the workplace remained on skilled precision work. The workers in the photograph above, part of a force of about 2,000, are using hand files to finish individual saw blades. The saw factory shared a site in the Tacony section with two other Disston companies—a file works and a foundry—which employed an additional 1,000 workers in 1916.

Stetson. The name conjures up the golden age of the American frontier. But the hat that covered cowboys and rustlers, good guys and bad guys alike, was as much an institution on the streets of Kensington as it was on cattle drives and in Dodge City saloons. John B. Stetson began making hats in Philadelphia in 1865. Eventually his plant at 4th and Montgomery grew to twenty-five buildings on nine acres with over 5,000 workers. The firm was one of the biggest employers in the city, and the largest hat maker in the world.

These photographs date from about 1910, when the plant was in its prime. Note the size of the sewing room (right), with its hundreds of seamstresses sewing by hand. In the fur-cutting room (facing page, above), more of Stetson's 1,000 female employees work by hand while men tend the machines, as they do in the photograph on the facing page, below. The shrinking room (page 88, top) was one of the plant's most unpleasant work environments because of intense heat and the chemical solutions in use. In this period, such unattractive jobs were generally left to Italian immigrants. Note the platforms on which the men stand to keep off the always wet floor. Blocking hats (page 88, bottom) was also a wet job, but a less disgreeable one.

Stetson was more than a place to work. It was practically a company town. John Stetson, who died in 1906, was intensely paternalistic, involving himself in many aspects of his employees' lives. He maintained a hospital and organized a building and loan society that encouraged home ownership by employees in the neighborhood. Celebrations

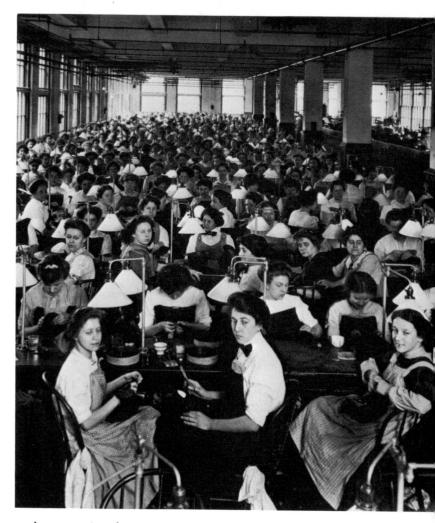

and community observances took place in the company auditorium. The 1910 Christmas assembly is pictured on page 89. Note the separation of men and women. Stetson made it a point to welcome workers into his office. Workers apparently reciprocated, treating the company as a way of life, but they could not keep their company going. The Great Depression of the 1930s and changes in men's fashions ultimately crippled Stetson. Vacant North Philadelphia lots are all that remain of the city's connection with the hat that won the West.

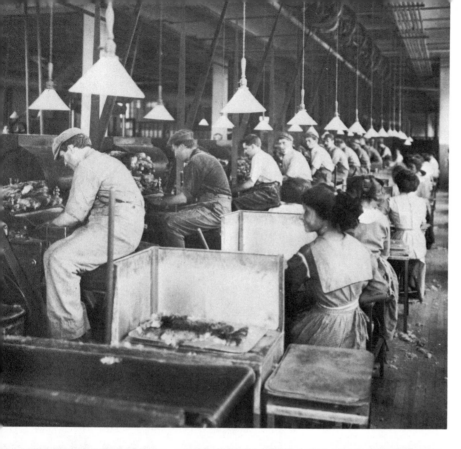

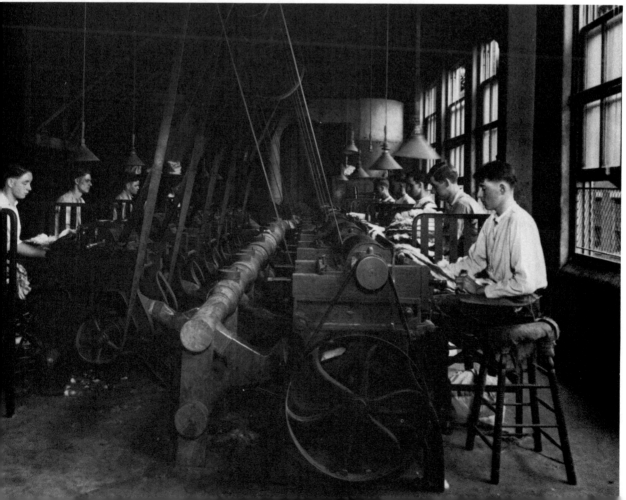

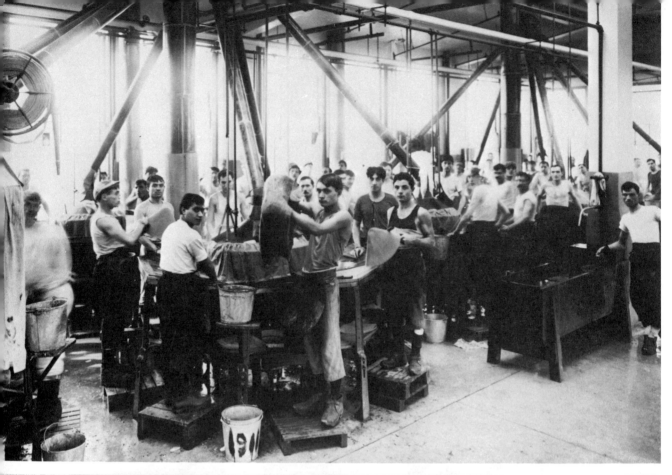

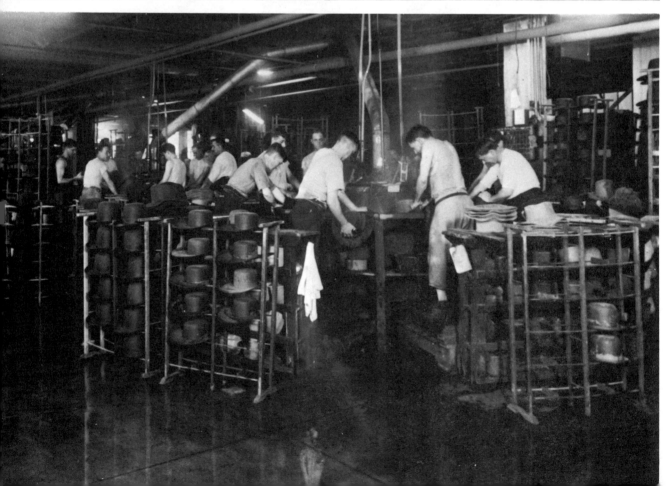

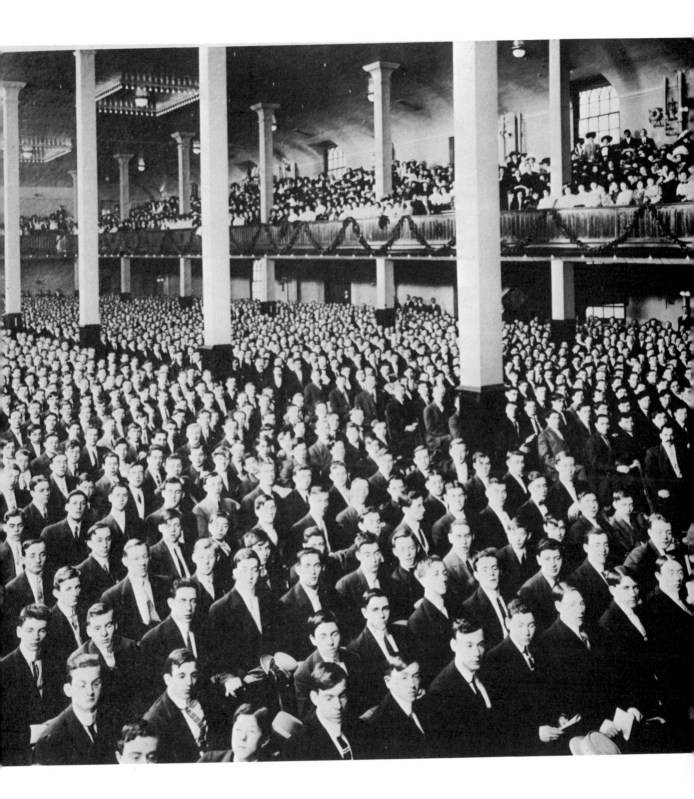

89

These photographs of Sauquoit Silk Manufacturing Co. (right and below) were taken in 1918. The relative youth of the workers, a commonplace in nineteenth-century textiles, may be the result of shifts in labor force participation resulting from America's entry into World War I. Sauquoit, located at 4015 Clarissa Street just below Wayne Junction, manufactured silk yarns for weaving and knitting, and also produced finished silk fabrics. The girls are winding silk, the boys are throwing or twisting it.

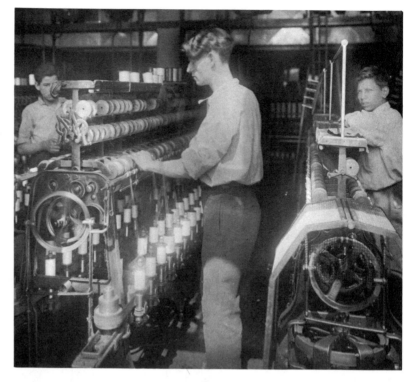

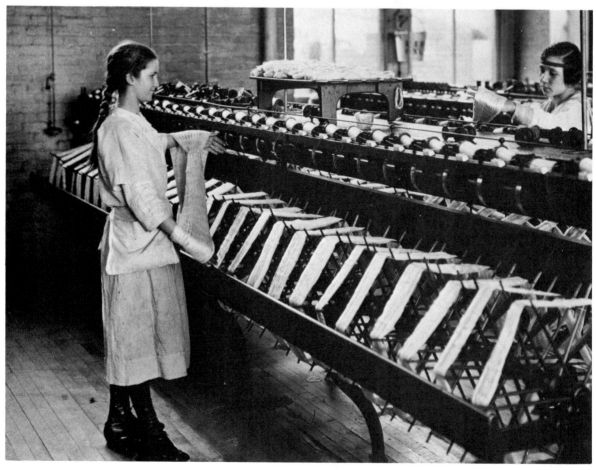

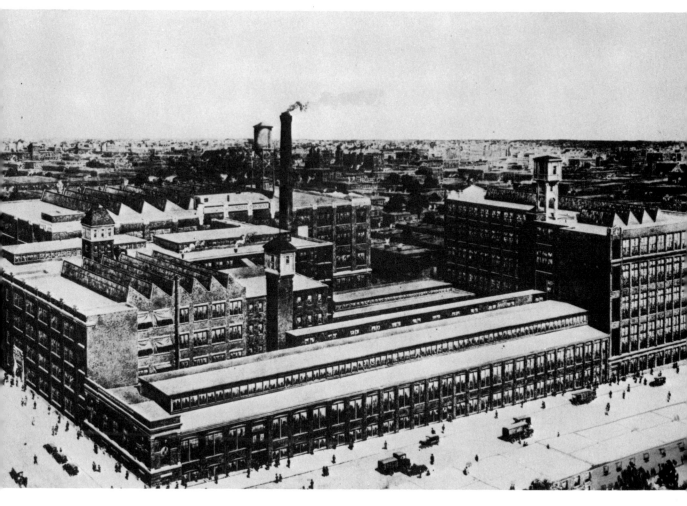

When these photographs of the Hardwick and Magee Co. were taken in 1925, only the nearby Bromley Mills and the Dobson Mills in East Falls employed more Philadelphians in the manufacture of rugs and carpets. Hardwick and Magee, at 650 West Lehigh Avenue, had about 600 workers.

The plant building (above) dominated a neighborhood of two-

and three-story row houses on the edge of Kensington. Other factories shared the landscape and the labor force. Inside one of the weaving sheds (following spread), two long rows of carpet looms dwarf the weavers. A close-up of one loom (page 94, bottom) displays a Jacquard appartus, which used hundreds of punched cards to control the weaving operation and determine the design and color blending of the product. Coming off the loom is a Bindhar Wilton rug. The women (page 94, top) are burling, or removing loose threads or lumps of yarn from finished carpets.

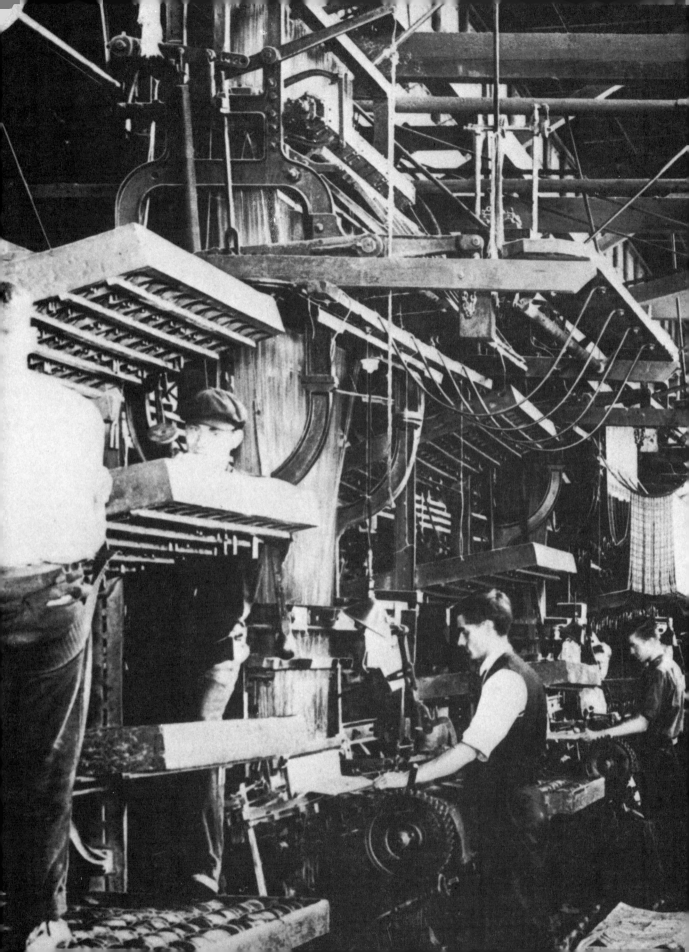

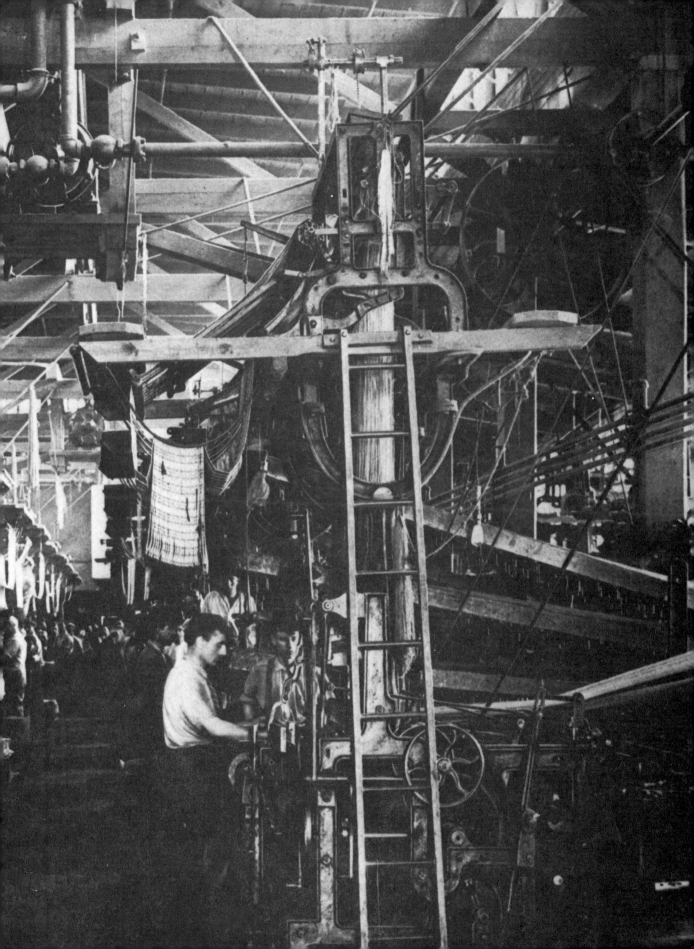

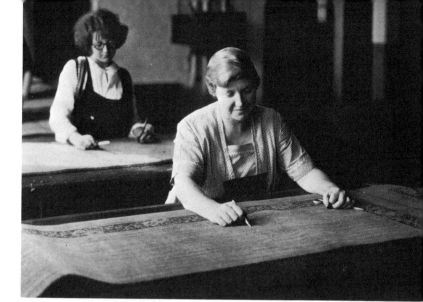

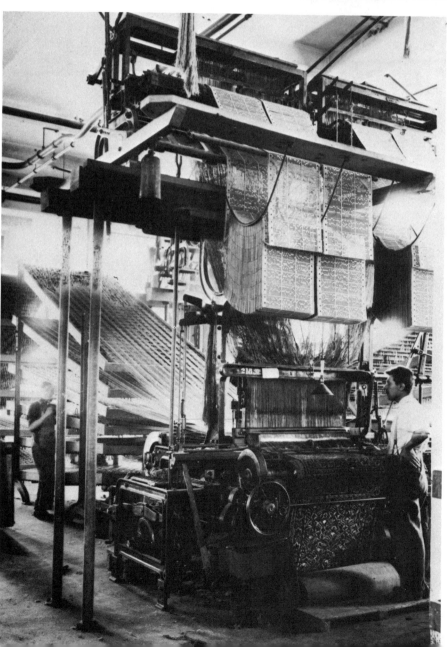

The carpet industry was the last branch of textile production to convert to mechanical power. Hand looms like the one pictured below had made Philadelphia the nation's leading carpet manufacturer. They predominated through the nineteenth century, and even the city's largest and most mecha-nized carpet mills maintained hand looms into the twentieth century.

This photograph is by Frank H. Taylor, a prominent local photographer who illustrated several turn-of-the-century booster guidebooks for the Chamber of Commerce. The purpose of this image is unclear. The woman is working rag carpet, a coarse product created by drawing a rag fiber through a cotton warp. The location is not specified; the openness of the foreground suggests that the work is not going on in a home (though the home had been a common site for mid-nineteenth-century hand loom weaving). The scene may be one of the city's numerous small carpet weaving mills in the early twentieth century.

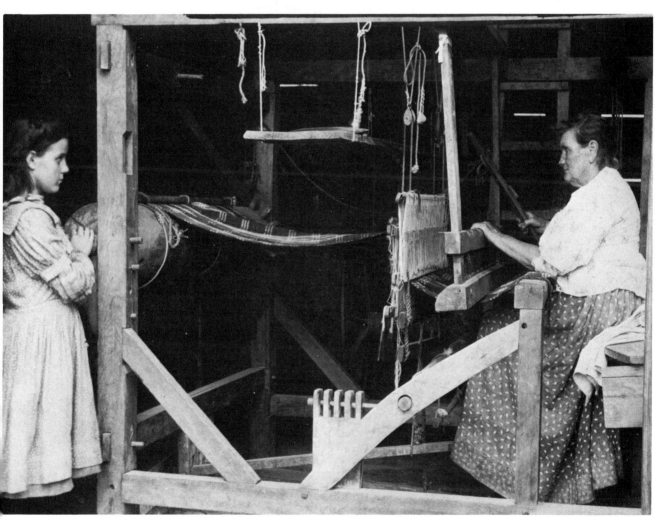

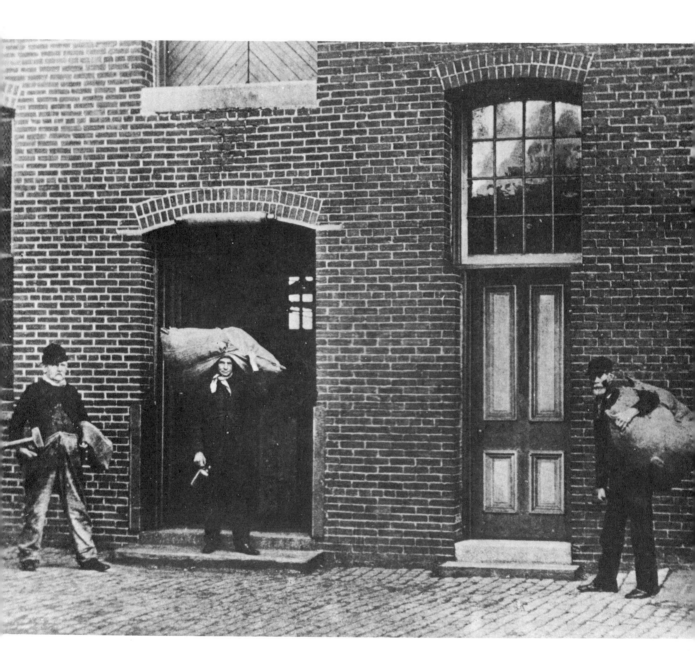

This 1906 photograph at left of the entrance to the Yewdall and Jones woolen mills reveals the continuation of cottage or home production of textiles alongside centralized factory manufacturing. The mill, at 54th and Poplar Streets, produced worsted yarns for weaving and knitting. With almost 200 workers—mostly women—in the building, Yewdall and Jones also sent work out to be done at home. The workman in the doorway is leaving the mill, carrying home a bundle of wool and a jug of oil, the latter used to keep the wool supple while he draws it over the combs. Meanwhile a man is returning finished work—combed wool ready for spinning in the mill. The tops (longer fibres) and noils (shorter ones) are in separate bags. The figure on the left is turning in his combs and wool sacks, apparently because he is out of work.

The photograph at right, dating from 1905, shows a more common form of early twentieth-century home production—garment manufacture. Taken by reformers, its original caption read: "From Chestnut Street to Ellsworth Street. First to the sweatshop to be made. Then to the Italian home to be finished. Lastly back to Chestnut Street to be sold." The photograph was intended to show middle-class shoppers frequenting fashionable Chestnut Street that they might be perpetuating exploitation, child labor, and misery in Italian South Philadelphia.

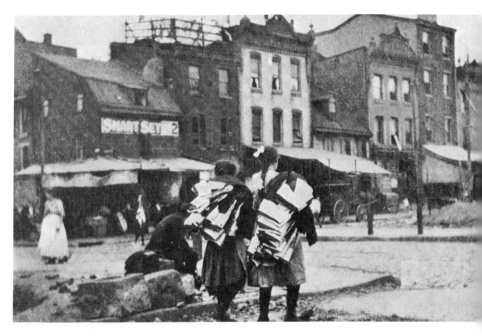

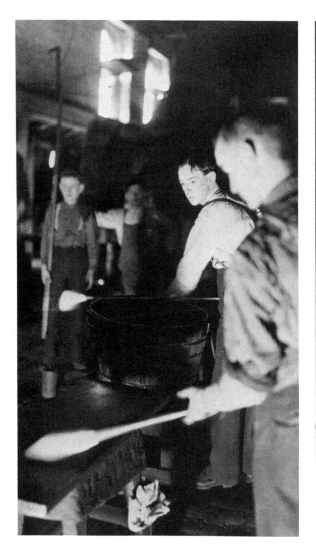

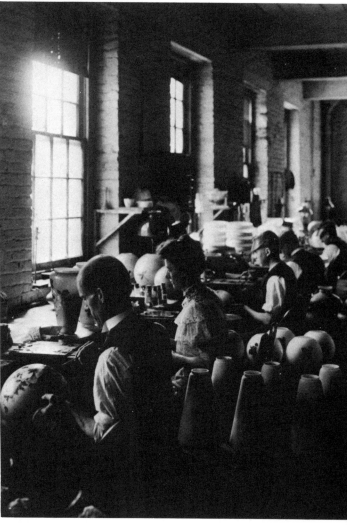

There were more than twenty manufacturers of decorative glass in Philadelphia in the first decades of the century. These photographs, dating from 1906, are of Gillinder and Sons, 135 Oxford Street. Gillinder, with almost 500 employees, was the city's largest producer of decorative glass. Most other firms had fewer than ten workers. Workers in the industry were predominantly male.

Two of the images indicate something of the skill and intensity required in the craft. They also suggest why small firms, capitalizing on the skills and aesthetic sensibilities of master craftsmen, could survive. Above left, a workman prepares to roll hot glass on a marver, a stone or plate on which the glass is shaped. Above right, workers paint glassware. Lamp chimneys behind them await decoration. At right, workers grind glass.

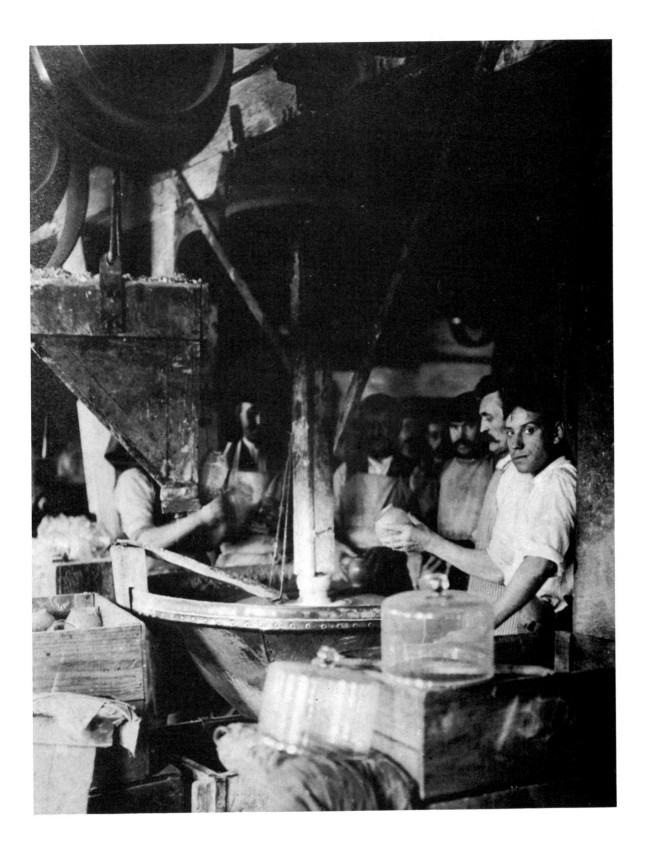

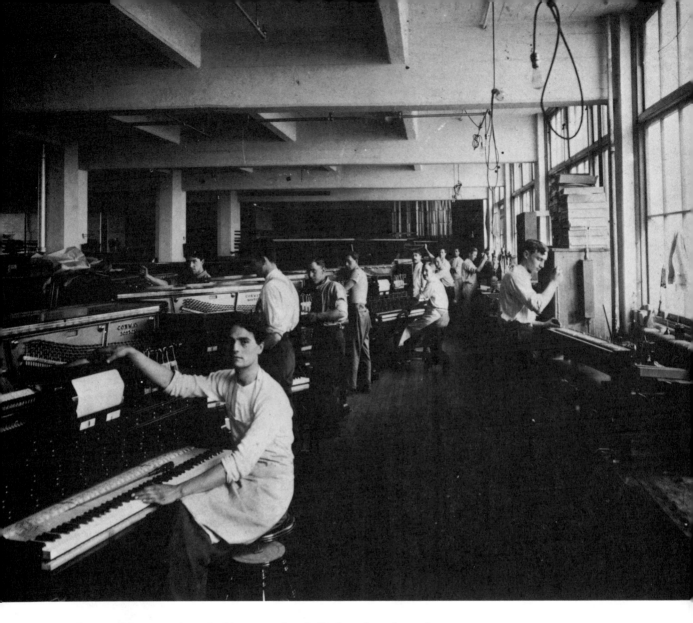

The manufacture of musical instruments is an example of the skilled precision craftsmanship in fairly intimate work settings for which the city had been known in the nineteenth century, and which continued into the twentieth. This photograph of the Cunningham Piano Co. dates from about 1910. The firm was located at 50th and Parkside, in a nonresidential strip of West Philadelphia between the Pennsylvania Railroad tracks and Fairmount Park. Ten other firms in the city with from two to sixty employees built pianos and organs at the time.

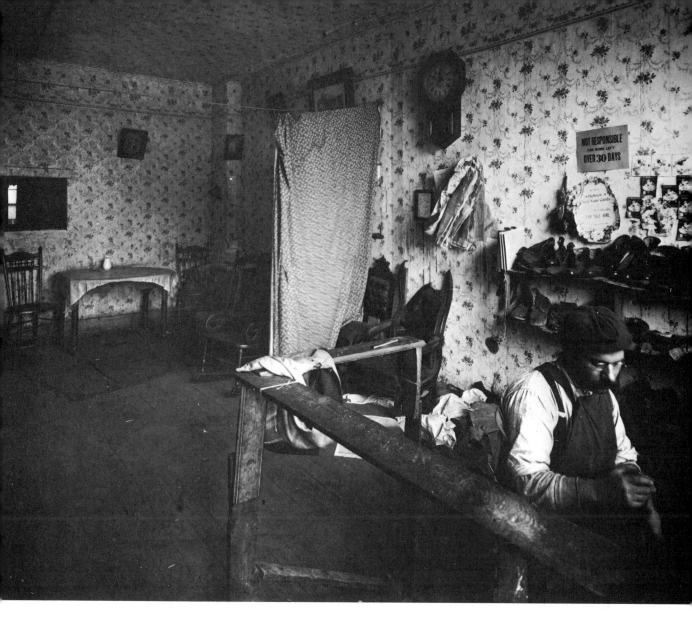

Dr. George Woodward took this photograph in 1903. Better known for continuing the work of his father-in-law, Henry Howard Houston, in developing Chestnut Hill as an upper-class suburb, Woodward was also an important housing reformer and philanthropist. Here he was calling attention to cramped living quarters at 508 South 7th Street in this heavily immigrant neighborhood, where Simon Mochrik had turned part of his small home into a shop by stringing a curtain across the room. Woodward here inadvertently revealed an important segment of the Philadelphia economy. Well over 1,000 shoemakers, mostly Jews and Italians, worked in small repair shops, many like this one. Small-scale businessmen, they traded on skills they brought from the Old World, maintaining their independence and some hope of achieving success in the New World. Long hours were generally the norm in this kind of business, but the combination of home and shop meant that personal life did not disappear during the work day. As the sign on the wall indicates, Mochrik also sold Hebrew new year's cards. But apparently he did not prosper. Thirty years of listings in city directories reveal Mochrik's combined home and shoe repair shop at four addresses in this poor neighborhood.

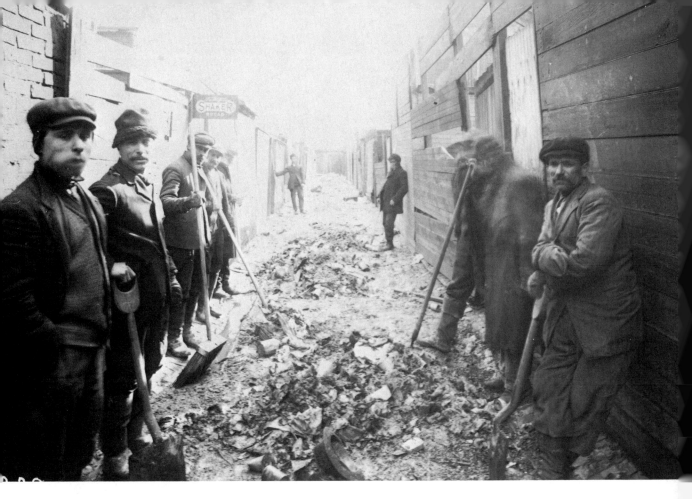

This official city photograph of street cleaners in Hogg Alley in 1912 was meant to document the activities of a municipal department—streets and sanitation. The crew was part of Philadelphia's large force of street laborers. The men, mostly Italians, clearly did not fear exposure as idlers, for they leaned back against the sheds and fences lining the alley and returned the camera's gaze. The accumulated trash and debris was, according to reformers, typical of conditions in the courts, alleys, and back streets of the neighborhoods around the city's central area. Hogg Alley—to the north of Vine Street, between Broad and 13th Streets—was in the rear of residential, commercial, and industrial properties.

This photograph of street workers at 10th and Market was part of a series of colorful street scenes taken around the turn of the century. These men, like many of those in Hogg Alley, are apparently Italian. The wooden barrels are part of the texture of city life of a day gone by.

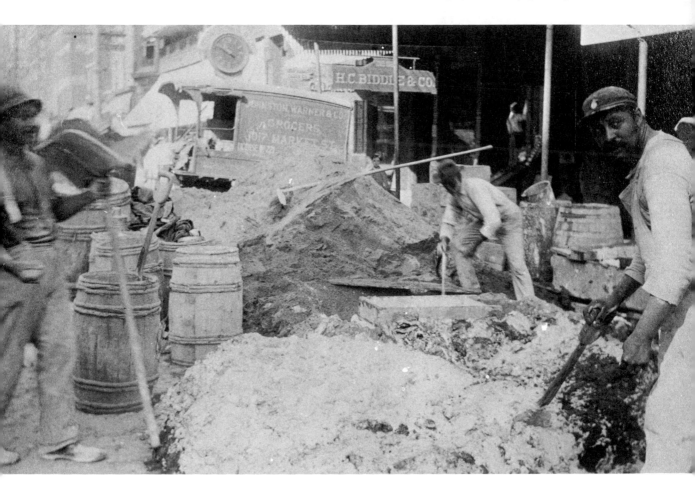

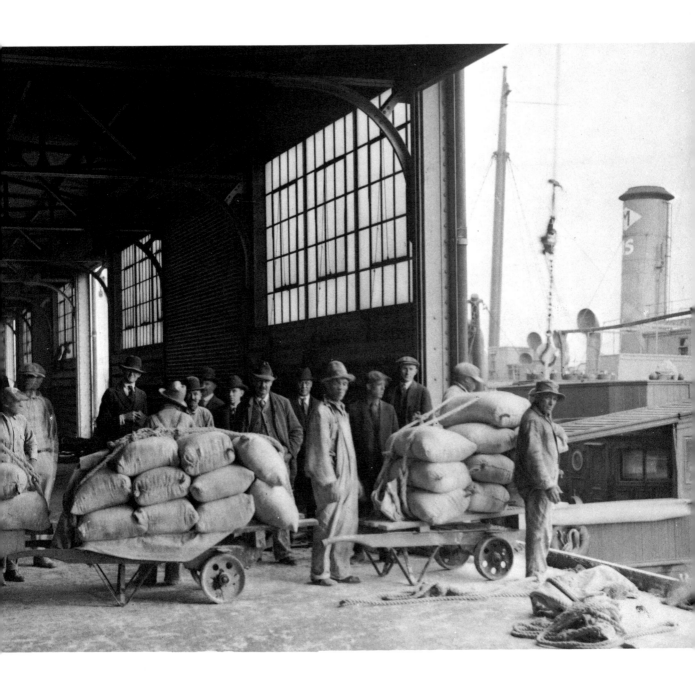

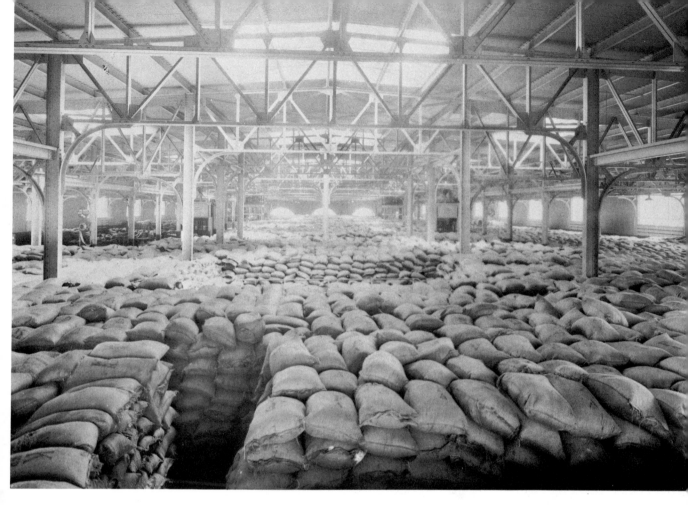

Since the colonial period and the early West Indies trade, Philadelphia had been a center of sugar refining. Three firms (Pennsylvania Sugar Co., W. J. McCahan, and Spreckles), each employing more than 2,000 workers, were operating in the city when these photographs were taken in the early 1920s. The refineries depended heavily on the port, and in turn were a source of its vitality. Above, a cargo of 8,700 tons of raw sugar is stored on the upper deck of Pier 40 South, at Christian Street. At left, dock workers prepared to hoist jute sacks of raw sugar on the last stage of their journey to a Philadelphia refinery. Both are official city photographs.

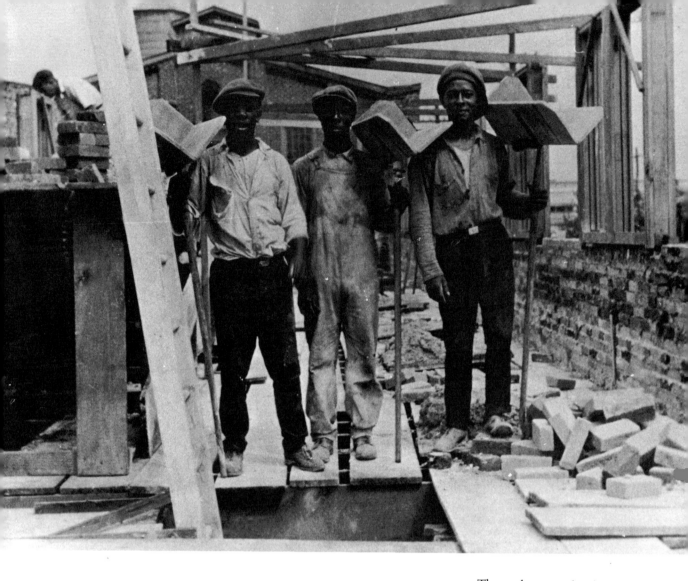

These photographs, from an annual report of the reformist Octavia Hill Association, were taken to document the construction of model homes for families of limited means. But they are quite stark in what they reveal about race and employment opportunities in Philadelphia. The bricklayers were white and hod carriers were black. The opportunities for advancement from the less-skilled, lower-paying job were practically nonexistent. The photograph dates from 1924, but its message—that racism limited mobility—applies to much of the twentieth century.

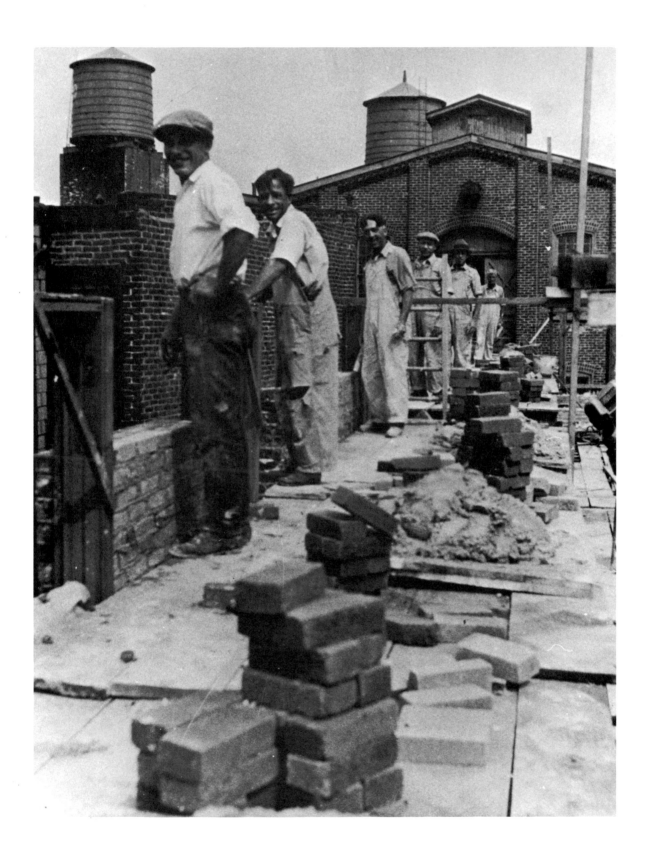

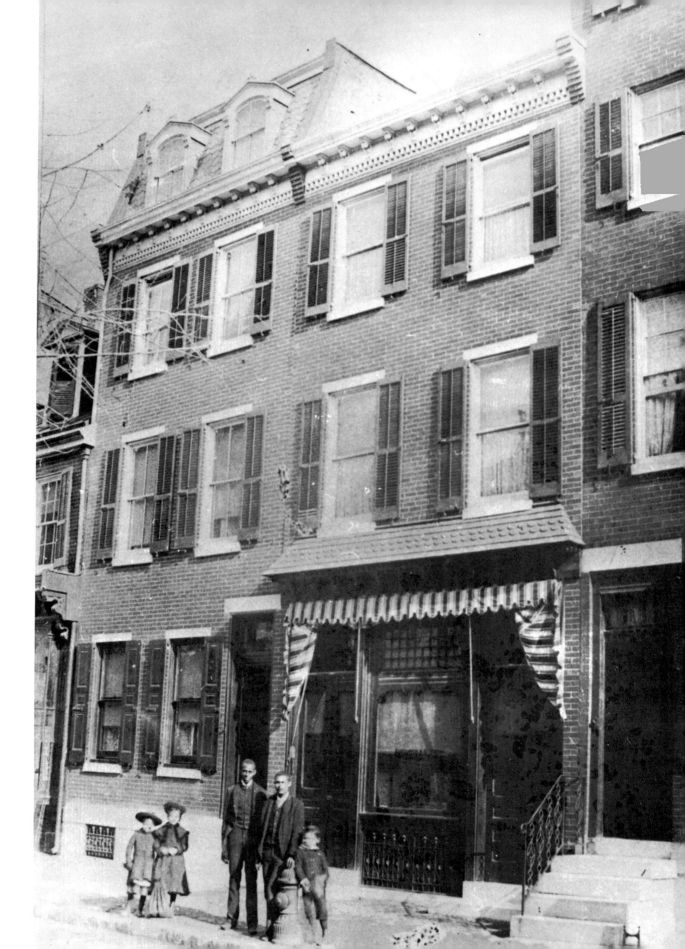

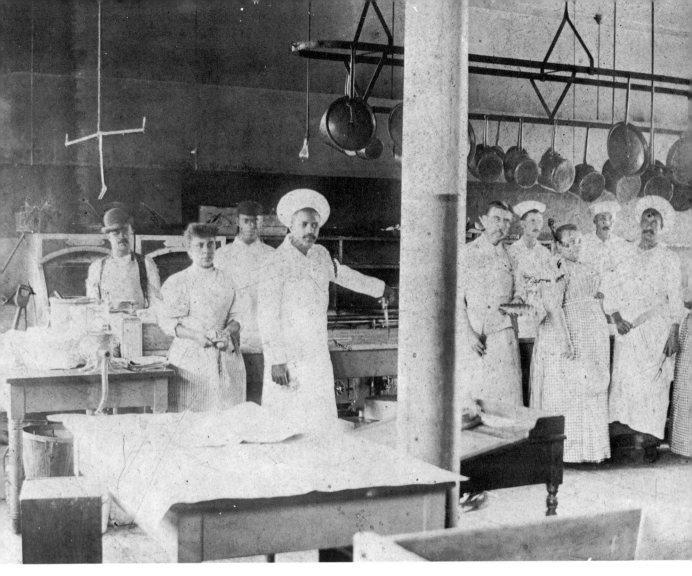

Blacks, excluded from a wide range of craft and industrial jobs, occasionally made the transition from service work to service business. Philadelphia's black caterers, who made their first appearance in the early nineteenth century, were a prime example of this. Independent businessmen and women who served a citywide clientele, the caterers were especially influential in the black community. Shown at left is Baptiste Catering at 255 South 15th Street, near the fringe of the early twentieth century's major black neighborhood. The Baptiste concern traced its origins to 1818 in the old French settlement near Spruce and 4th, which had been composed largely of refugees of both races from the revolution in Santo Domingo. The identity of the family group in front is unknown, but the look of pride and prosperity may suggest ownership. Documentation for the interior scene (above) is similarly scanty, though indications are that it is the Baptiste-Dutrieville Catering Service, product of a merger of black-owned firms.

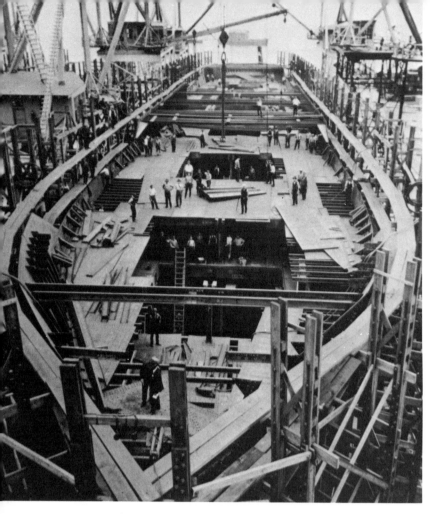

Several months after the United States entered World War I, the government awarded a contract to the American International Shipbuilding Corp. to establish the country's largest shipyard at Hog Island, on the city's southern edge. When work began in September 1917, Hog Island was a desolate waste, covered with underbrush and practically inaccessible. The 1,000-acre yard, with its fifty ways, was constructed simultaneously with the first order of fifty 7,500-ton ships. Within months of the original order, contracts for another 130 cargo and troop ships were signed.

Philadelphia had been a shipbuilding center since the colonial period. For the war effort, Kensington's Cramp Shipyard, which dated from 1830, doubled its labor force from 5,000 to over 10,000 workers. But Hog Island was of a different order of magnitude. Its labor force averaged 26,000 men. Some weeks there were 35,000 workers in the yard. Because so many were new to shipbuilding, the yard opened a training school with 150 instructors. There were barracks for 6,000 day laborers.

All three photographs are from the summer of 1918. They depict a hull nearing completion in early July (above), while nearby another hull is in an earlier stage of construction (right). A cele-bration marks the launch of the yard's first ship on August 5, 1918 (next page). Plans called for this launch to be followed by a completed ship slipping down the ways every other day for the following year.

Hog Island did not long survive the war's end. By the early 1920s the government was trying to enlist private industry in schemes to make use of the closed yard. Much of the site ultimately became part of the Philadelphia International Airport. Cramp also found war contracts a fickle source of prosperity. The yard closed in 1927, dealing a paralyzing blow to Kensington's economy. It reopened, briefly, during World War II.

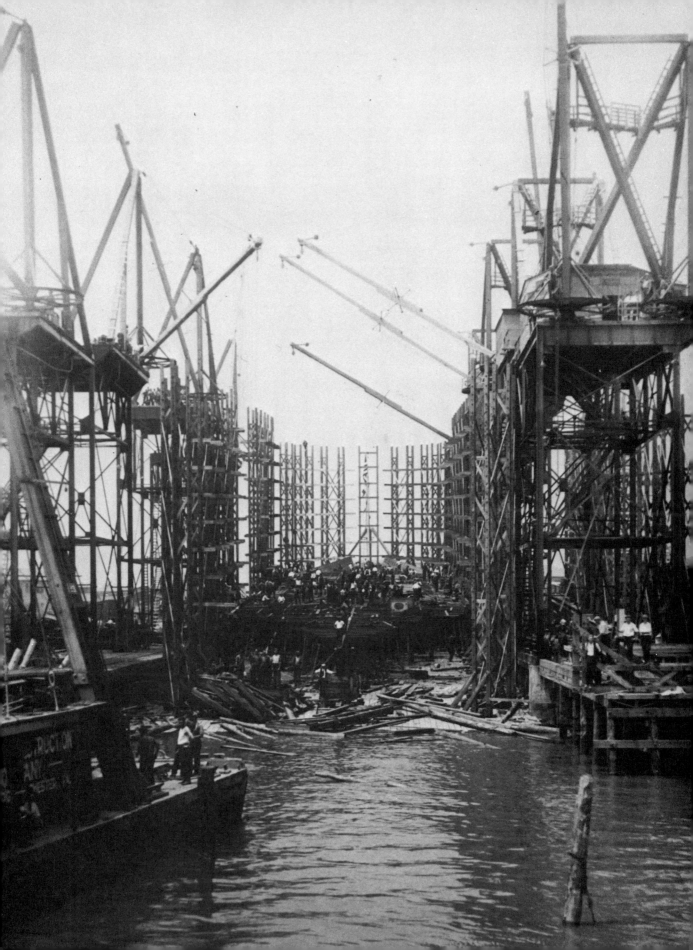

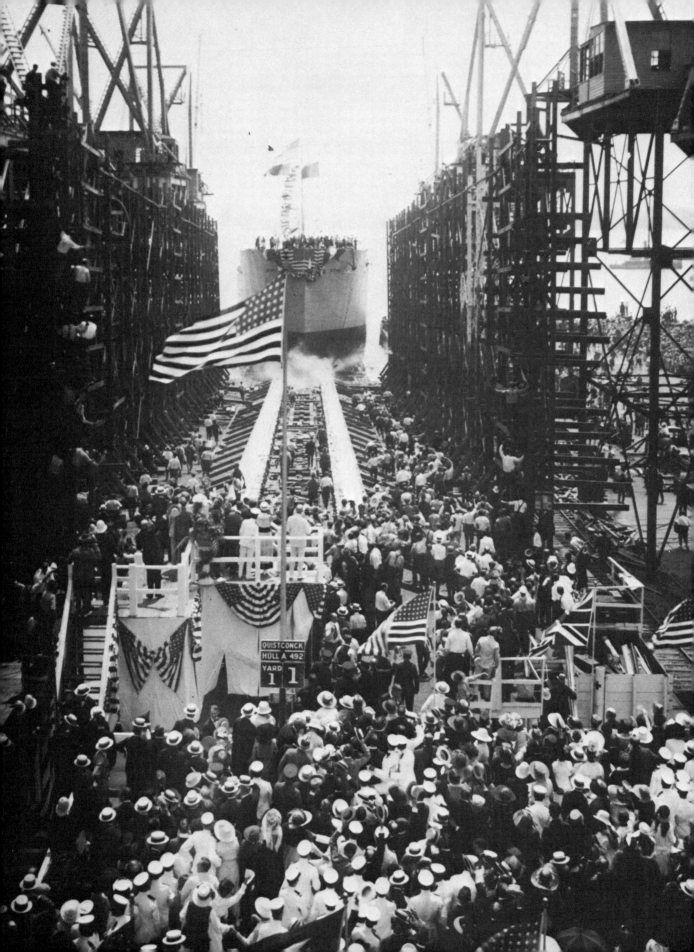

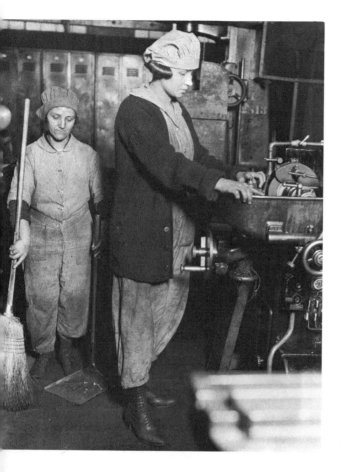

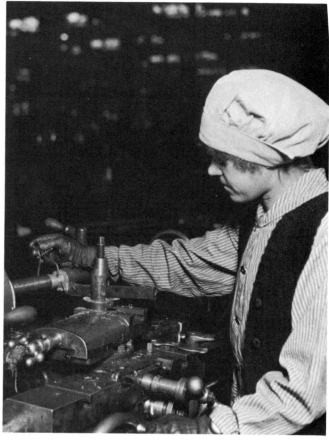

While women accounted for more than one-fourth of Philadelphia's industrial labor force by 1890, they were always more evident in some sectors—textiles and the garment trades especially—than in others. They were unlikely to work, for example, in the metal trades—especially in the larger shops. But World War I temporarily disrupted labor supply and demand, and machine shops, facing large orders for war materiel and losing male employees to military service, began to recruit women workers. With the war's end, though, women by and large failed to hold these newfound industrial jobs.

United States government photographers recorded the entry of women workers into the war plants, taking highly posed and stiff photographs to document the domestic war effort and inspire the home front. The scenes on this page were taken at the Midvale Steel Co. At left, one woman grinds a small gear while another sweeps. At right, a woman lathe worker measures tolerances with a caliper. The following spread documents work at the Frankford Arsenal. In the large image, women load incendiary bullets. In the small image, they join a male laborer in pasting Liberty Loan messages on shrapnel, an activity probably created entirely for the camera.

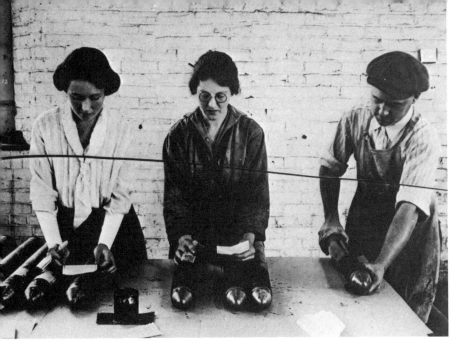

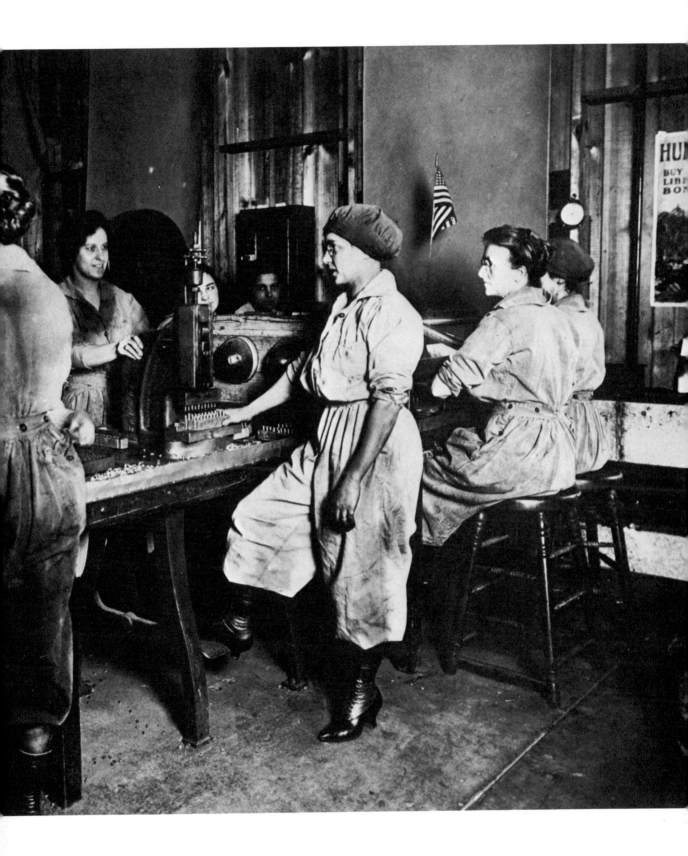

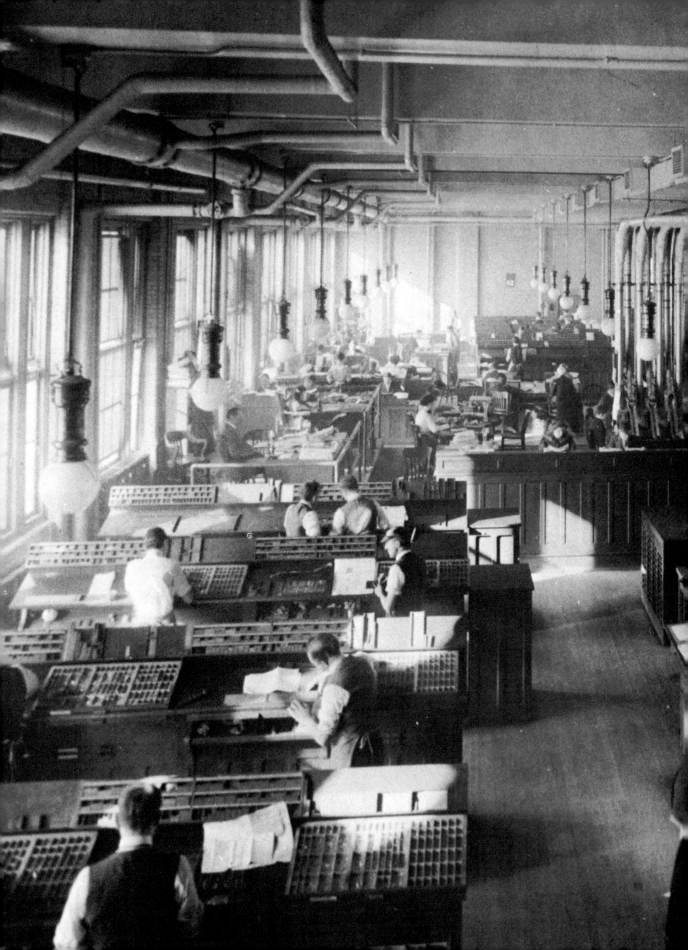

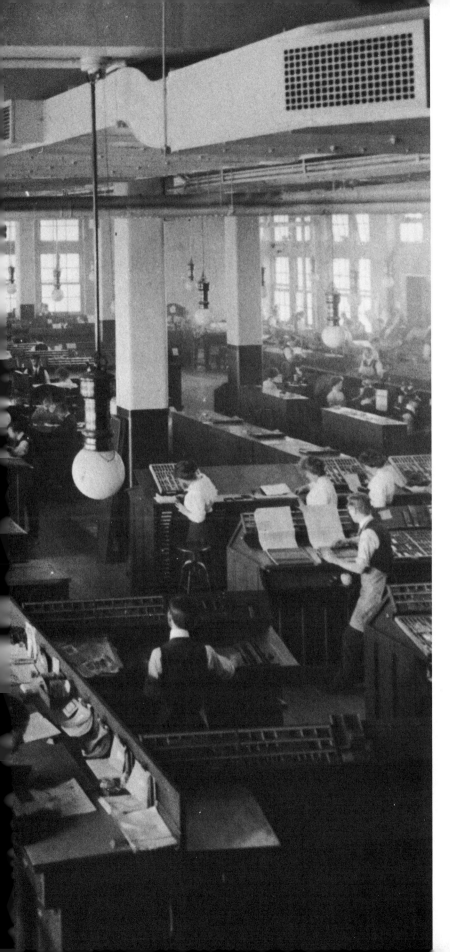

While the number of Philadelphians in the service sector has grown dramatically in our own time, a substantial proportion of the labor force has long been in the service trades. Banking, insurance, publishing, government, education, and medicine—to list the most notable examples—were well represented in the city even in the colonial period. This early twentieth-century scene of the composing room of Curtis Publishing Co. depicts the production side of one of the city's major white-collar employers. Curtis, which produced the *Saturday Evening Post*, among other publications, had 3,000 employees in 1916. With 1,800 office personnel, it had the largest nongovernmental office force in the city at that time.

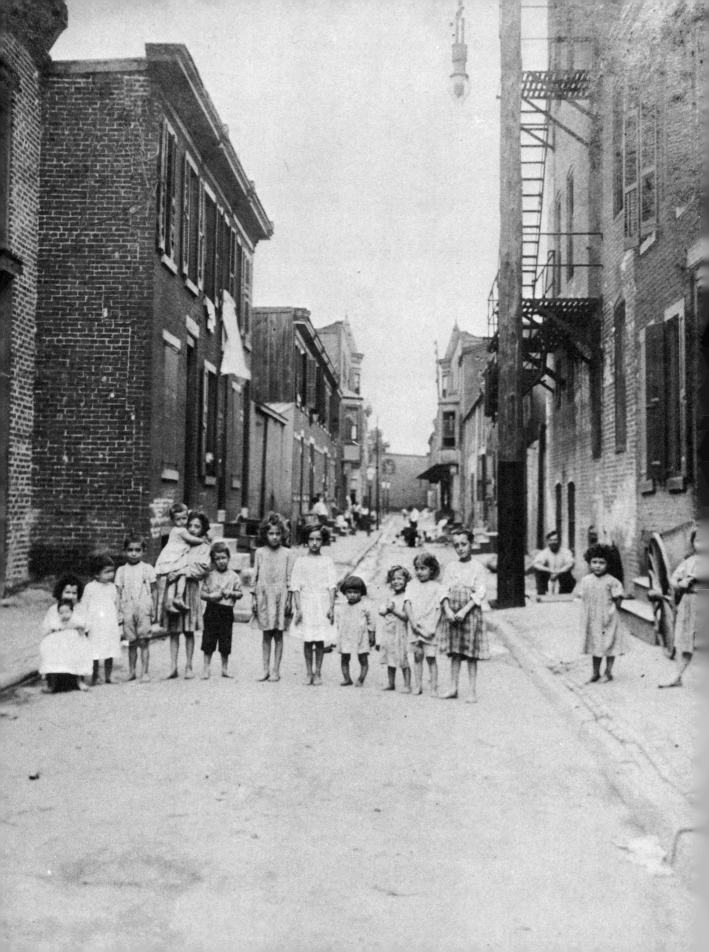

The Vision of Reform

In the nineteenth century, Philadelphia grew to become one of the largest industrial centers in the world; and, just as in other industrial cities, progress created many problems. There was inadequate, overcrowded housing, pollution, disease, and ethnic and racial tension that sometimes flared into violence. During much of the century, however, the citizens of Philadelphia prided themselves that their city was better off than other major cities, certainly better than London or Manchester, but even superior to Chicago, Boston, or New York. Compared to many other cities, its row houses did provide good housing even for the poorer classes. But Philadelphia was not without its slums, its open sewers and privies, its overcrowded shacks in back alleys. Indeed, when it came to tuberculosis and typhoid fever, Philadelphia outdistanced most other American cities and made a few citizens realize that there was trouble in the alleys behind the "paradise of small houses."

There had always been poverty in Philadelphia, even in the times of William Penn and Benjamin Franklin, and leading citizens supported a variety of almshouses, missions, charities, and philanthropic organizations to help the worthy poor, those hard-working but temporarily unfortunate people who became victims of depression or accident. Of course, there were also the unworthy poor, who deserved no support from the community. They had become poor, it was assumed, through their own laziness, or because they drank too much or because they were simply unfit.

Gradually during the last decades of the nineteenth century, attitudes toward the causes of poverty began to change. A few public-spirited citizens in both England and America argued that it was not individual weakness so much as the environment, especially the deteriorated urban environment, that caused people to become poor. The shift in attitude happened over a period of time and even many of the most advanced reformers continued to believe that some groups—blacks, Chinese, and Italians, for example—were more difficult to rehabilitate and teach to live properly in the city than people of northern European stock. But if one accepted the premise that society and the environment caused poverty, then one could change the environment, improve housing, build parks and playgrounds and better schools, and eventually eliminate poverty.

In Philadelphia, the gradual movement toward an acceptance of an environmental explanation for poverty began with philanthropy and reform in the area near 6th and Lombard,

Beulah Street, between 7th and 8th,
south of Tasker, photographed by the
Housing Association in the early teens.

then one of the worst black sections of the city. The efforts of Theodore Starr, a Quaker philanthropist, in the 1880s made this area the center of much of the reform effort in the city. Starr organized a savings association, kindergarten, day nursery, and playground. In 1884, Susan Wharton, a young woman from a distinguished and wealthy Philadelphia family who had worked with Starr, organized the St. Mary's Street Library, where she was assisted by her cousins, Helen Parrish and Hannah Fox. These young women reformers, concerned by poverty and poor housing, were strongly influenced by the British movement that sought to improve living conditions in the industrial city. They were especially influenced by John Ruskin and by Octavia Hill, one of Ruskin's disciples. Beginning in 1864, Octavia Hill had promoted a scheme of "philanthropy plus 5 percent" to rehabilitate some of the worst sections of London's East End. She restored and cleaned up dilapidated housing and then rented it out to deserving tenants at reduced fees. Return on investment was limited to 5 percent, but the heart of the scheme was to use "friendly" rent collectors who would also counsel and advise tenants and teach them the middle-class values of thrift, sobriety, hard work, cleanliness, and order. Hill's scheme was a combination of sympathy and paternalism, but it was based on the faith that better homes, especially clean and orderly homes, could make better citizens.

Helen Parrish and Hannah Fox borrowed Octavia Hill's ideas, becoming benevolent landlords near 6th and Lombard. In some ways they used techniques more harsh than Octavia Hill's, for they often invaded apartments to throw out liquor bottles and sometimes evicted tenants for having illicit affairs. But they did not always insist on regular payment of rent, and they sought to promote pride in the neighborhood as well as thrift and sobriety. In 1892 the St. Mary's Street Library became the nucleus for the Philadelphia College Settlement, and in 1896 Parrish and Fox helped to organize the Octavia Hill Association to promote housing reform in the city. The settlement movement, which was also imported from England, was based on the idea that well-educated citizens had a responsibility to share their knowledge with the less fortunate, and that by actually living in a poor section of an industrial city they could learn as well as teach. Like other schemes to change the city, the settlement movement was filled with paternalism and prejudice, but settlement workers did become leaders in the effort to reform the city and to alleviate poverty. The Philadelphia settlements were never as famous or as important as their counterparts in Boston, Chicago, and New York, but the Philadelphia settlement workers

cooperated with the Octavia Hill Association to promote housing reform in the city. They endorsed philanthropy plus 5 percent and model tenements, but they also worked for the passage of better tenement house laws. They believed that if the American people could only be told the truth about the way people were living in the cities they would rise up and change things. In order to tell that truth they compiled statistics, charts, and graphs, and they wrote articles and books. But they also discovered that photographs could be very effective in getting their reform message across. They were strongly influenced by what was going on in New York, especially the work of Jacob Riis.

Other photographers in England and America had taken pictures of slum alleys and street urchins, but Jacob Riis was the first in America to document slum conditions with the express purpose of changing them. In 1890, the Danish-born Riis published the book that was to make him famous, *How the Other Half Lives*. Through a simple and dramatic prose style he was able to communicate some of the human dimension of life in the slums. But even more important than his prose were the dramatic photographs that he took of the tenement district of New York. Riis was not trained as a photographer, but he quickly realized that words alone could not communicate the horror and the moral indignation that he felt as he roamed the worst sections of the city. At first he hired photographers to accompany him on his forays, but the results were not very satisfactory, so he bought a camera and taught himself how to use it. He even tried the new German invention of flash powder to illuminate dark alleyways and corridors. Occasionally he set a tenement house on fire, but he took some striking photographs that depicted the reality of slum life.

In January 1888, Riis gave his first lantern slide lecture on "The Other Half— How It Lives and Dies in New York." It was the first of thousands of illustrated lectures that he gave all over the country. Lantern slides had been used for several years, most frequently to project European scenes or famous paintings and sculptures. Riis was the first to use the lantern slide to arouse the moral indignation of his audience. But Riis was also a creative and innovative photographer. His haunting portraits of slum children, his views taken down tenement alleys, are now so familiar that they have become almost clichés. In the 1890s, however, they were not only shocking; they also set a new style for urban photography. Most of his shots were carefully posed. Even his night shots, taken with flash powder, were far from candid, but rather were

designed with a particular purpose in mind, and that purpose was to make the viewer angry that people were living under such conditions in America. Riis probably gave his slide lecture in Philadelphia. His style and his moral indignation certainly had an impact on the Philadelphia reformers in the Octavia Hill Association and in the later Philadelphia Housing Association. When they came to take pictures of the Philadelphia slums and to use lantern slides, their photographs, even of the group of street urchins gathered in an alley, bore a striking resemblance to the work of Jacob Riis.

The Philadelphia reformers used photographs not only to depict the situation that needed to be changed but also to show what changes were possible. They tried to communicate their own middle-class values, to promote cleanliness, neatness, and order. There remained great cultural differences, however, between the reformers and the immigrants they sought to help. The reformers were never able to give up their prejudice against certain ethnic groups or to outgrow their benevolent paternalism. But by the early twentieth century they had abandoned their philanthropy plus 5 percent schemes, though the Octavia Hill Association continued to restore and rent houses (by 1916 the Association owned or managed over 400 houses). More and more, they put their faith in legislation. These reformers were part of the progressive movement, part of the factual generation that believed that reform would follow naturally if all the facts were only known. The reformers saved their greatest sympathy for the children trapped in the slums. At the same time, their greatest hope was to rescue those children and give them an equal chance. Yet whether it was a campaign against child labor or for neighborhood parks or better housing, their tactics were consistent. First there was a careful investigation to ascertain the facts, then publication and publicity followed by lobbying in City Hall or the state legislature to assure passage of the corrective legislation. The campaigns were not always successful, and even if passed, legislation did not always solve the problem; but the reformers continued to document the ills they saw around them. Inevitably photographs became an important part of that documentation.

Lewis Hine was the most important photographer in this effort to document the drama and danger of an urban environment in the early twentieth century. Trained as a sociologist, Hine, like Riis, taught himself photography. At first he used his photos to illustrate his lectures at the Ethical Culture School in New York. Then increasingly he used his camera to illustrate reform articles, and he became a staff photographer for *Charities and the Commons*, a social

work journal that became *The Survey* in 1909. In 1908 Hine resigned his teaching job to become a full-time investigator and photographer for the National Child Labor Committee. He traveled all over the country on this assignment, stopping in Philadelphia for a few days in June 1910. Twenty-five years later, this time under the auspices of the Works Progress Administration, he returned to the city. Hine took haunting photographs of children in the factories and on the streets. He showed them eating, running, playing, and selling. He made the children he photographed into individual and appealing human beings. His photographs avoided the obvious horror that Riis was so fond of recording, but just as surely they documented the need for reform.

A good example of how investigation and documentation led to reform is the attempt in Philadelphia to pass more effective housing legislation in the first decade of the twentieth century. In 1903 the Octavia Hill Association hired Emily Dinwiddie, a New York social worker, to investigate three blocks in the city, one predominantly Italian, one black, and one mixed Russian, German, Polish, and Irish. Her report, published as *Housing Conditions in Philadelphia* and profusely illustrated with photographs, documented overcrowding, poor drainage, offensive and dangerous privies, inadequate water supply, and other unhealthy conditions. The housing reformers then put pressure on the legislature to pass a better tenement inspection bill. Letter-writing campaigns, newspaper publicity, and the cooperation of many groups and politicians helped win passage of the bill, but a major exhibit organized and mounted by the Octavia Hill Association, complete with maps, models, and photographs, played an important role. The bill, however, turned out to be inadequate and did not solve the problem of poor housing in the city.

Undaunted, the reformers continued to document the need for reform in the city. They helped to organize the Philadelphia Housing Commission in 1909. This organization, which changed its name a few years later to the Philadelphia Housing Association, cooperated closely with the National Housing Association and other groups, including many businessmen and health experts, to pass legislation and to eliminate the worst slum conditions in the city. It was often a slow and discouraging battle, however. The reformers first started to promote zoning in 1915, but it was not until 1933 that the first zoning ordinance was passed. Despite defeats and setbacks, the reformers persisted in their efforts to promote a clean, safe, and efficient urban environment. An important part of their legacy is the photographic record of the things that needed to be changed in Philadelphia.

Philadelphia at the turn of the century had hundreds of private agencies, organizations, missions, and shelters that sought to aid the homeless and destitute. Some of these, such as the Midnight Mission for Rescuing Fallen Women and the Franklin Home for the Reformation of Inebriates, specialized in serving a specific group; others, such as the Central Soup Society of Philadelphia and the Home for the Homeless, were less selective.

Many were sponsored by a particular religious group and almost all sought to give temporary help to those in trouble. They also tried to separate the worthy from the unworthy poor as they dispensed moral instruction to the downtrodden.

The photo below left is of the Bethesda Rescue Mission at 119 South Street near the docks and waterfront. Here transients and the homeless could get lodging

for as little as five cents and a meal for a dime. There usually were restrictions on the length of stay and the accommodations, as the photograph makes clear, did not invite long-term residence. The photograph below right is of the Wayfarers Lodge and Workshop, run by the Philadelphia Society for Organizing Charity at 1720 Lombard Street. The Society also ran another lodge at 80 Laurel Street. The object, according to the 1903 *Philadelphia*

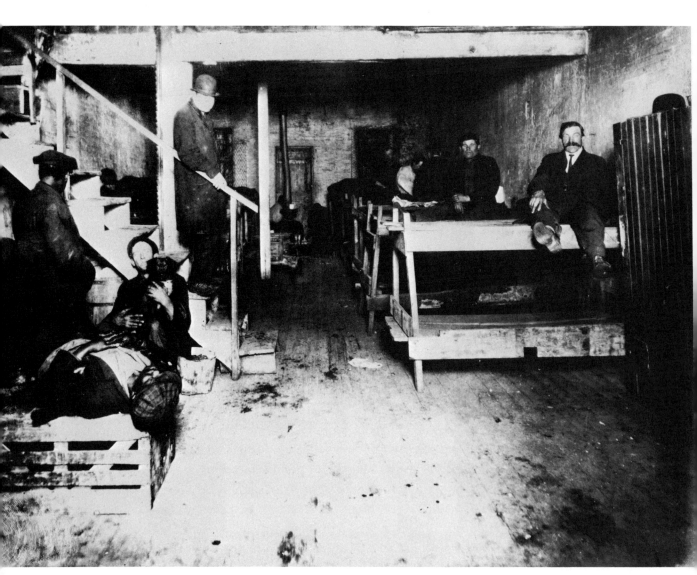

Social Services Directory, was to furnish lodgings, meals, and a bath in exchange for work, "to do away with the lodging of the homeless in police stations, and to render begging by this class or their free shelter without any return in work unnecessary." To work was to prove one's worthiness, of course. "Men work sawing, splitting, box-filling and bundle making." The women, "who have entirely separate quarters," were given cleaning and laundry work. "Between three and four hours' work will secure supper, bath, lodging and breakfast. The bath is compulsory."

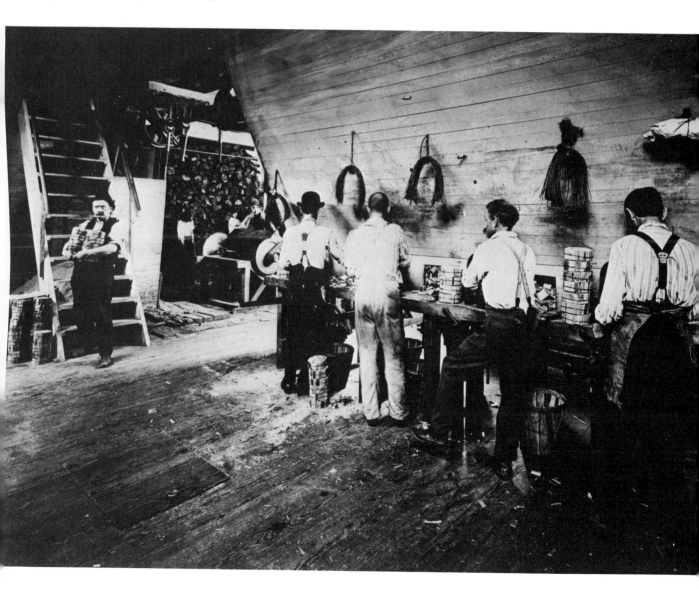

Philadelphia, like all industrial cities, was a place of opportunity for burglars, pickpockets, petty thieves, gamblers, prostitutes, and other criminals. Especially after the 1880s, the camera became a useful tool in various police and reform attempts to control the spread of crime, for having photographs of known criminals made it easier to spot them and give them longer sentences if they were arrested again. Note that criminals were photographed with hat on and with hat off for this Philadelphia Police mug book. In the last part of the nineteenth century almost everyone wore a hat outdoors, which of course changed one's appearance. Emma Goldman was not an ordinary criminal, but an anarchist and radical who was arrested in Philadelphia in 1893. Before coming to Philadelphia she had delivered an impassioned speech in New York in which she shouted: "Ask for work. If they do not give you work, ask for bread. If they do not give you work or bread, then take bread." The New York chief of police got a court order for her arrest on the charge of inciting to riot. He alerted the Philadelphia authorities, who arrested her before she could speak in the city. After her photograph was taken for the mug book she spent several days in Moyamensing Prison alongside pickpockets and thieves. Eventually she was returned to New York, tried, and sentenced to a year in prison.

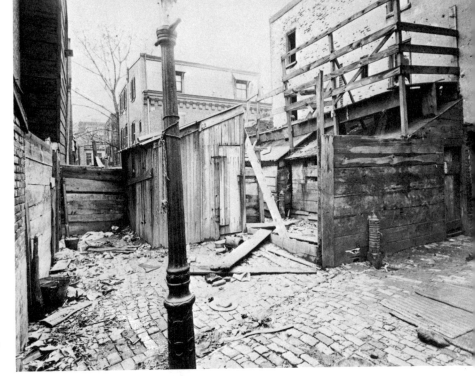

These before-and-after photographs capture the spirit of the Octavia Hill Association's work. The housing in Franklin Court, off the 700 block of Lombard Street, was not merely dilapidated; it offended the reformers' moral sense, to the extent that they even adopted the new name of Franklin Court in place of the former Brown's Court when they renovated the property in 1904–1905. The Association's scrapbook noted of the bottom photograph that "the result speaks for itself." The neatness of the buildings is matched by the stiff propriety of the new residents, who are carefully dressed and lined up for the photographer. The man with the broom approaches the reformers' ideal image of a respectable black workingman. To his left stands the Association's friendly visitor, and behind her the more professional project manager.

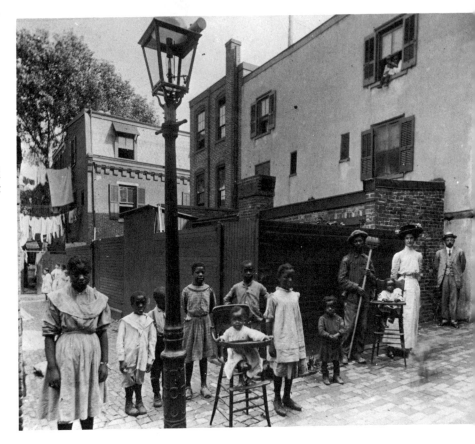

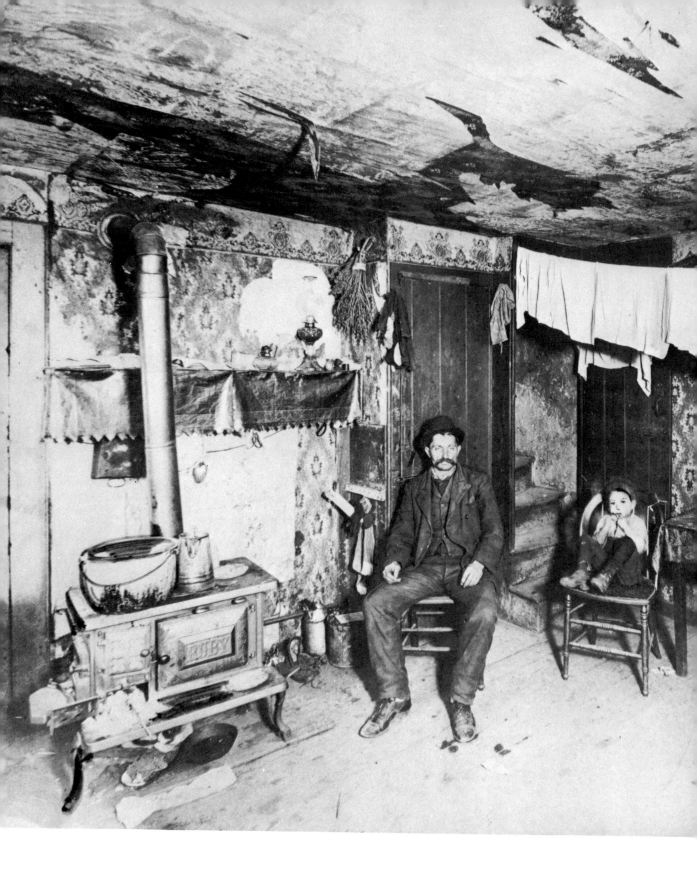

The Octavia Hill Association reformers promoted cleanliness, neatness, and order inside the house as well as outside. Mabel Kittredge, a New York reformer, suggested what they were trying to do in a book entitled *Housekeeping Notes: How to Furnish and Keep House in a Tenement Flat*. She recommended wood-stained, uncluttered furniture, iron beds with mattresses, unupholstered chairs, and shelves rather than bulky sideboards. Influenced by the Arts and Crafts Movement of the late nineteenth century, the reformers tried to promote simple rooms free of "dust collecting and germ-ridden" carpets, drapes, and wallpaper. These three photographs of one-room apartments at 513 Rodman Street were taken by the Octavia Hill Association

to illustrate their efforts. The first (left) depicts a man and boy who lived in the three-story building when the Association took it over in 1908. The Association's caption notes that they paid their rent to an absentee landlord in England. The other two photographs (following spread) form one of the before-and-after sets so common to reform photography. The "before" photograph shows a lived-in kitchen cluttered with washtubs, laundry, tools, clothes, cooking utensils, even an old Christmas decoration. In the "after" picture much of the clutter has been removed. A window has been installed to let in light and fresh air. The offensive wallpaper has been torn off, the cooking utensils and laundry put away, the woodwork stained, and the few ceremonial objects gathered on a shelf. It is interesting to note that the remaining chairs are of recent machine manufacture, and the older, more primitive (and to our eyes more interesting) chairs and stools have been removed. It is doubtful, however, that an immigrant family living in one or two rooms could have kept a kitchen this neat and orderly. In fact, most immigrants would have been unhappy living among such sparse furnishings and in such order. The stiff pose of the individual in the "after" photograph certainly reinforces that impression.

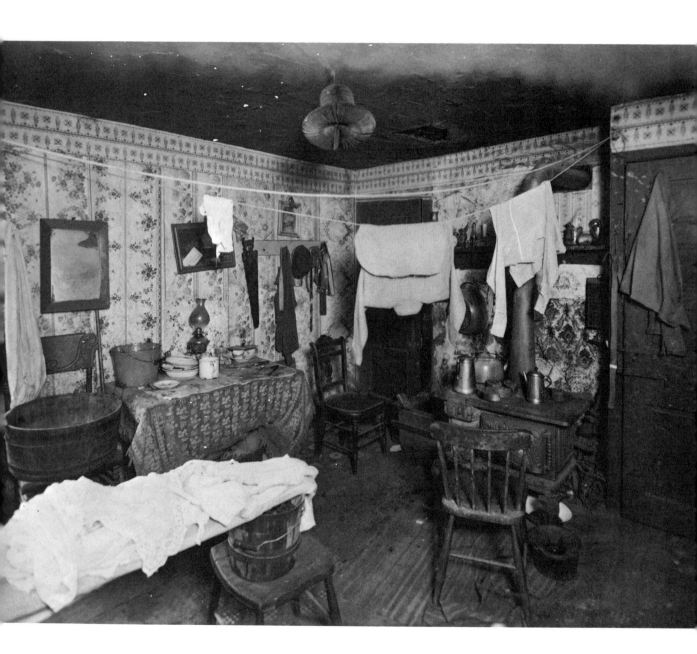

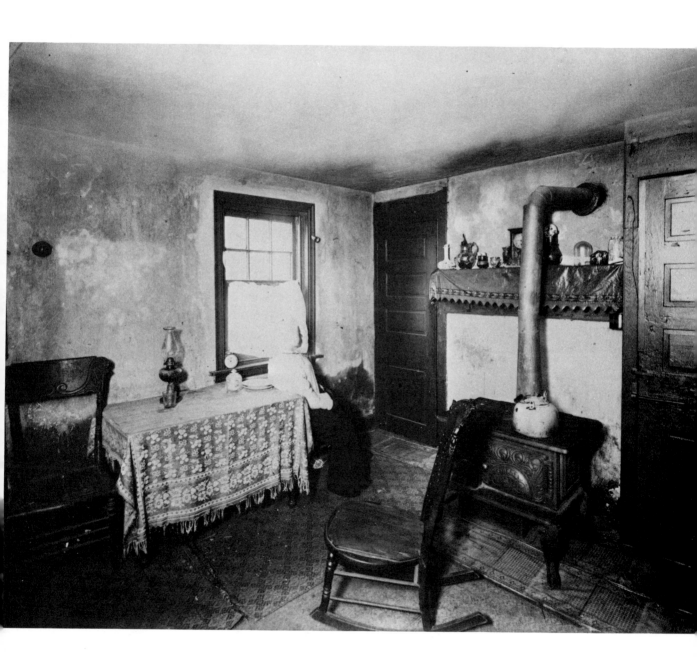

131

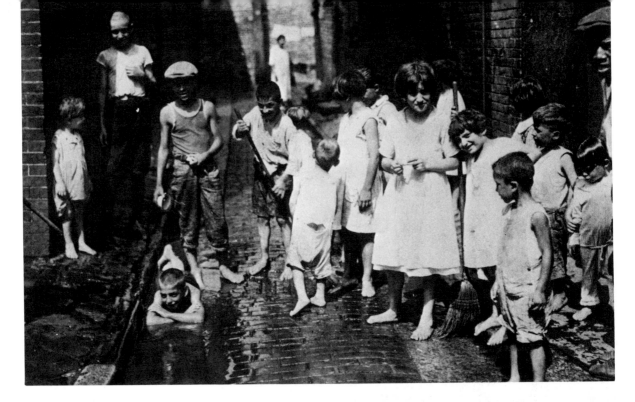
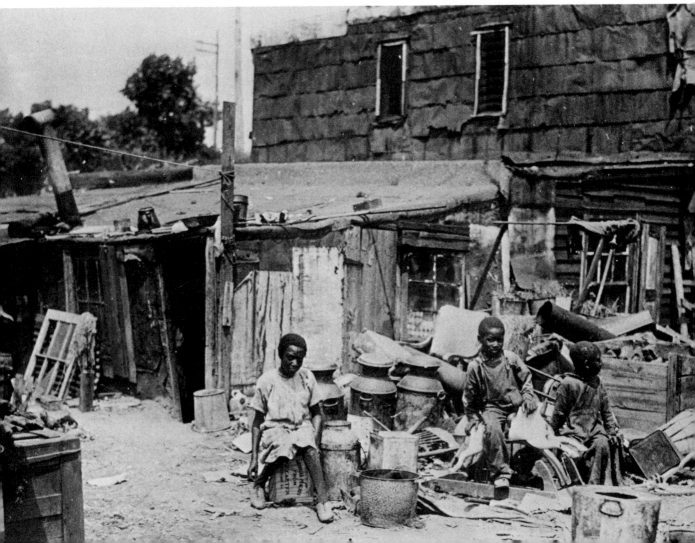

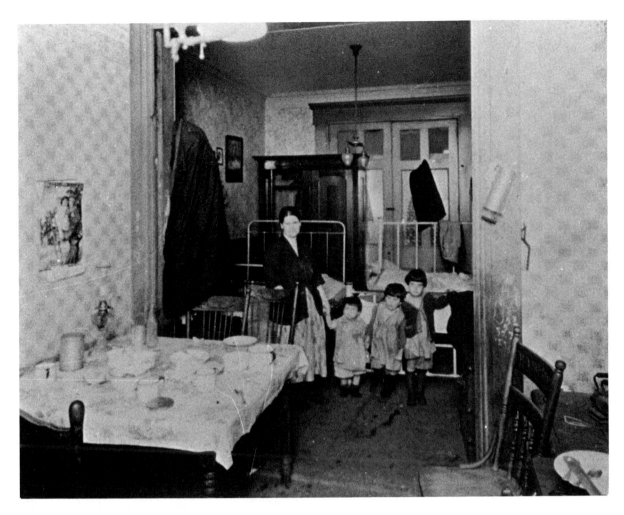

In contrast to the Octavia Hill Association, the Philadelphia Housing Commission was more concerned with improving sanitation than renovating buildings. For the reformers of the Commission, the city's main housing problems were outdoor toilets, surface drainage, open sewers, windowless rooms, and overcrowding, which not only encouraged crime and vice, but fed diseases like scarlet and typhoid fever, tuberculosis, and diphtheria. Under the vigorous leadership of Bernard Newman from 1911 on, the Commission used lantern slide shows, photo exhibits, lectures, and publications to advance its vision of a hygienic and efficient Philadelphia. These four photographs typify the Commission's appeal. The two at left are taken from hand-colored lantern slides. "Surface Drainage in South Philadelphia" was the matter-of-fact caption on the top photograph. The bottom one, taken at 3rd and Oregon on the city's outskirts, was identified as "Dilapidated House on Dump. Home of Junk Dealer." The photograph above was also taken from a lantern slide, one of many illustrating overcrowded cellars, attics, and apartments. Sanitation and disease were the themes of the last photograph (following page), showing the rear of 423 East Rittenhouse Street in Germantown in 1912. Its caption read, "Stable manure piled in yard. Removed monthly. The stable fly that breeds in such material breeds infantile paralysis." Bernard Newman believed that once such conditions were exposed they "would not stand a minute before an enlightened public opinion." Unfortunately, changes came much more slowly than he had hoped, and not without many setbacks for the housing reformers.

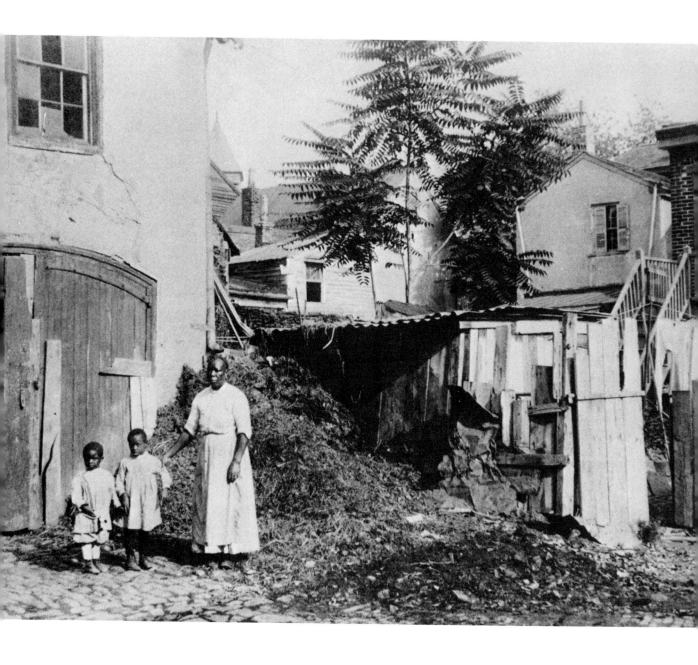

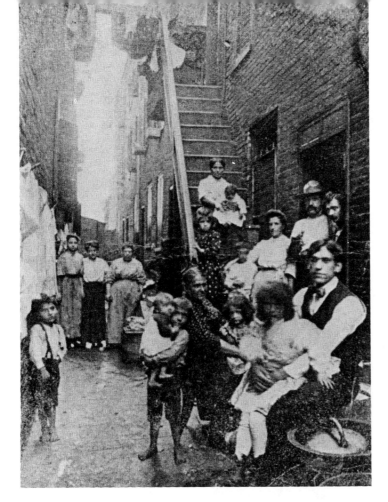

The housing reformers bestowed their greatest sympathy on the babies and children who had to live in overcrowded tenements and play in filthy alleys. They believed that if those children could only be provided with a better environment to live and play in, they would grow up to be useful and productive citizens. Borrowing something of Jacob Riis's photographic style, the reformers took pictures of children lined up in alleys or carefully posed in front of slum houses, and captioned their photos to attract the sympathy of those who lived in more fortunate surroundings. The two photographs on this page were taken by Helen Jenks, an early member of the Octavia Hill Association. The photograph at left was taken in an alley containing some of Philadelphia's relatively rare tenements. At right, children of the neighborhood around 7th and Lombard—near Starr Garden—pose for her camera in August 1905. Photographs of children in alleys and back streets were a staple of the Housing Commission, which took the three photographs on the following spread in the teens. At left is Horstman's Court, off 322 Fitzwater, where eleven houses huddled behind the Mt. Vernon Public School. The similar photograph in the center is unidentified, but its caption reads "Baby's [sic] try to exist here." A more extensive caption identifies the scene at right as "An Italian Blind Alley. Some of Philadelphia's 80,000 Italians are squeezed into these homes." Often smiling and playing children unintentionally weakened the photographer's message of disease and deprivation.

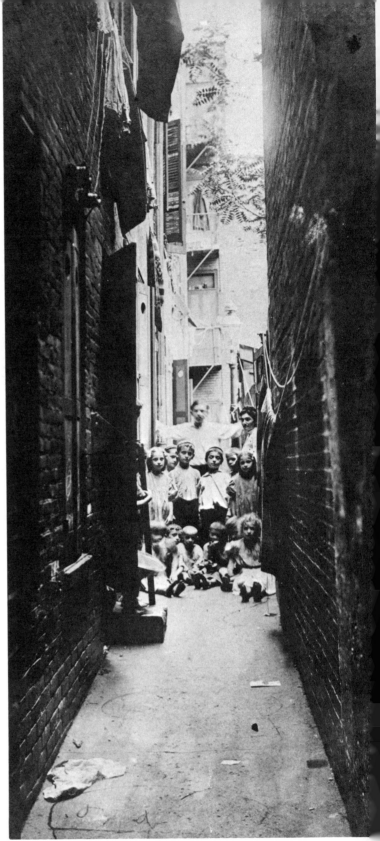

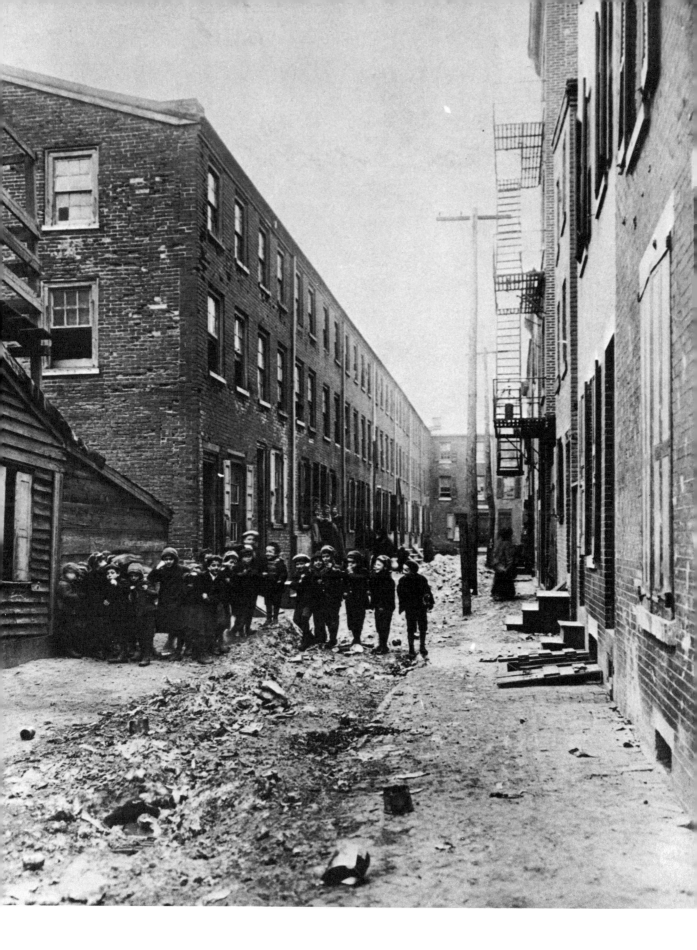

The slums could be dangerous for children. The before-and-after photographs below, taken from a lantern slide used by the Philadelphia Housing Association just before World War I, probably illustrate a victim of *cholera infantum* (diarrhea and enteritis). In 1913, almost 1,800 young Philadelphians died from these stomach disorders, which flourished in unsanitary housing.

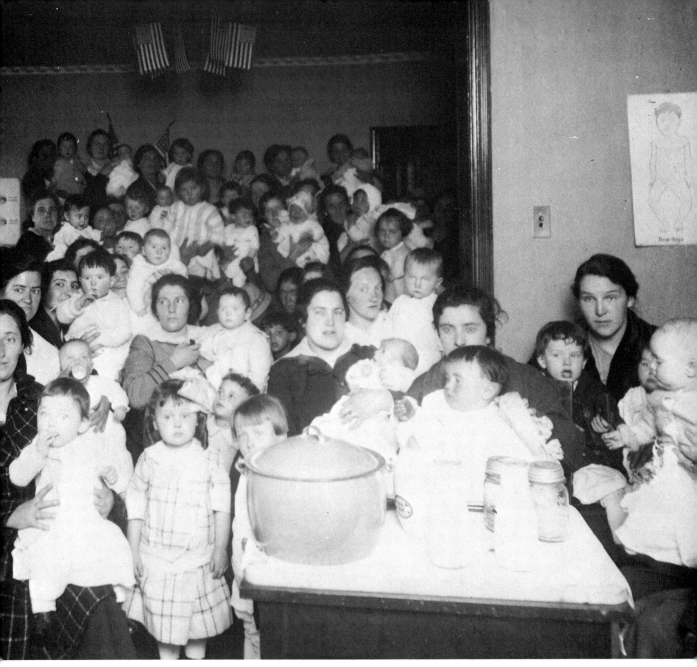

Through demonstrations and clinics, both the public school system and the private Housing Association tried to help immigrant women care for their children. Good nutrition and cleanliness were often associated with Americanization. The flags in the May 1917 Board of Education photograph above were perhaps a direct result of the nation's entry into World War I only four weeks before. But the picture of Lincoln in the Housing Association photograph (following page) of "Baby's Bath," from the early thirties, makes a more general connection between sanitation and traditional American values. While educators and social workers did not always give prudent advice, they did promote hygiene and make young mothers aware of the dangers of disease so common in the urban environment. If they could not directly improve the environment itself, they at least could give the children pictured here a much better chance of surviving it.

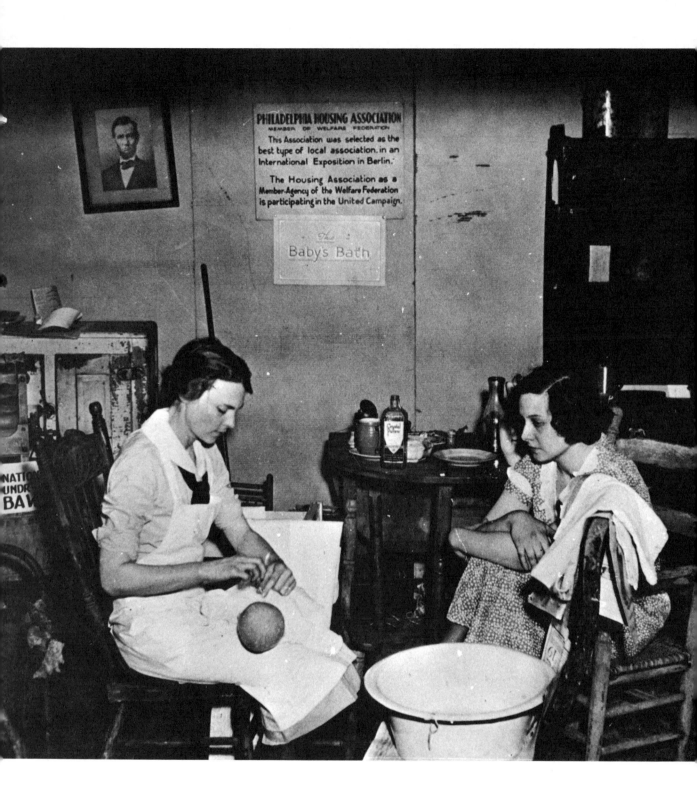

In June 1910, Lewis Hine, then employed as an investigator and photographer for the National Child Labor Committee, spent a few days in Philadelphia. These two photographs survive and are typical in many ways of the Hine photographs from this period. He always recorded the name, age, and occupation of the children he photographed, and he usually talked to them and made them feel at ease before he snapped the shutter. These photographs and the captions he wrote illustrate his concern and his genius.

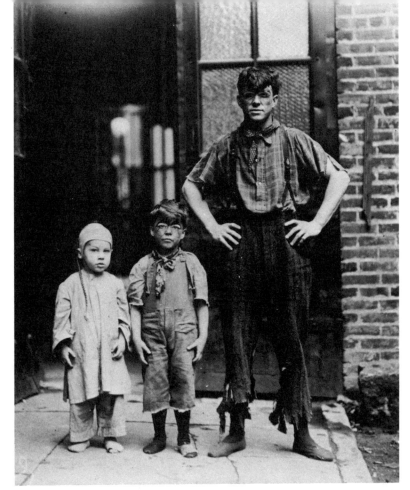

"This picture shows the 'Four Novelty Grahams,' acrobatic performers at the Victoria Theatre, Philadelphia. The father is 23 years old. Willie is 5 years old, Herbert is 3 years old. At 9 P.M. June 10, these children were seen performing on the stage. Four times daily they do a turn which lasts from 12 to 14 minutes. Herbert, the youngest, was said by the father to have commenced performing on the stage as an acrobat when he was 10½ months old. Willie, now 5, is said to be the youngest acrobat in the world. The mother of these boys was formerly a school teacher, and is now performing with this trio on the stage. The children are bright and strong, but have a lack of playfulness about them which shows them to have forgotten the best years of their childhood."

"Michael McNelis, 8 years old, a newsboy. This boy has just recovered from his second attack of pneumonia [and] was found selling papers in a big rain storm today [June 12]."

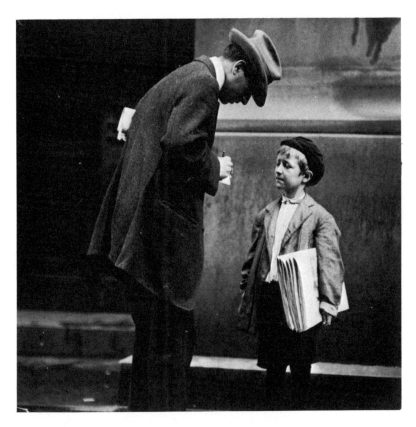

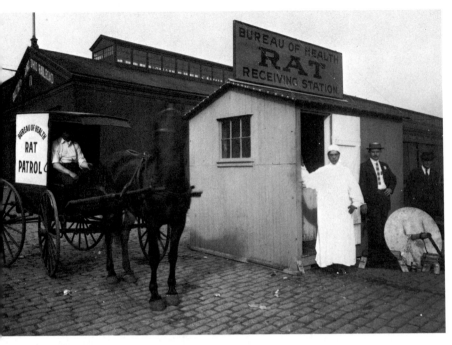

Reformers constantly sought to control the spread of disease and epidemics in the city by eliminating open sewers and other breeding grounds for germs. In 1914 the Department of Health and Charities instituted a campaign to rid the city of rats. Posters placed around the city announced "Kill the Rats: And Prevent the Plague." The poster went on to explain that the rat is the "known carrier of the Bubonic Plague, Rat Leprosy and other diseases." Aside from being a health menace, "the Rat destroys property and merchandise to the extent of $10,000 EACH DAY IN PHILADELPHIA." The City Health Department offered suggestions for killing or trapping the rats and as an inducement paid a bounty of five cents each for live rats and two cents each for dead ones. The live rats were more valuable presumably because the disease-carrying fleas were supposed to leave the carcass soon after death. Of course it was also more difficult to capture live rats. A city photographer documented the rat receiving station at the Race Street Pier on Delaware Avenue, as well as the Rat Patrol and a display of dead rats and rat traps.

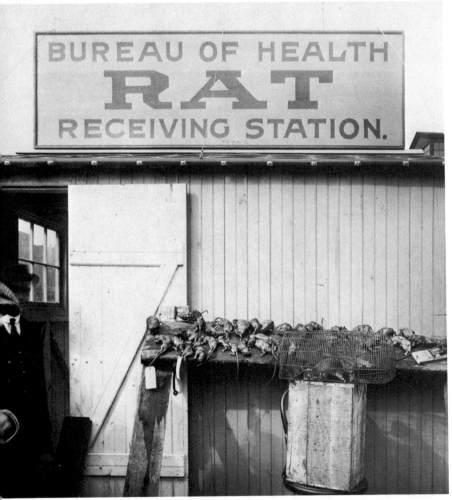

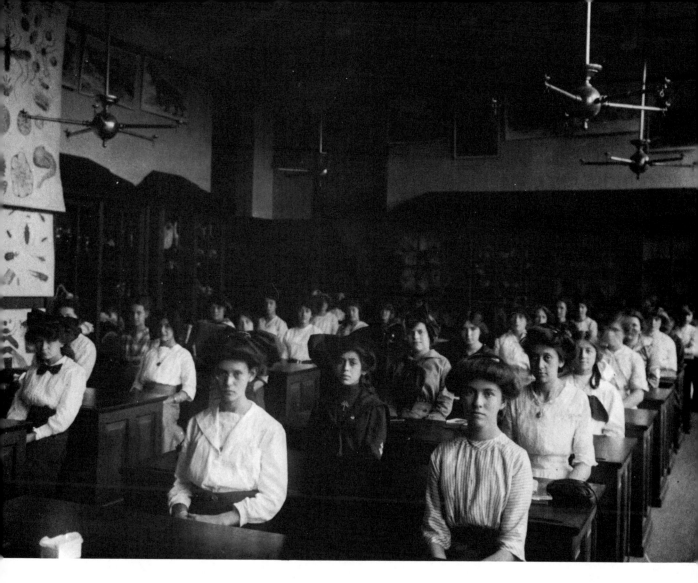

Next to improving the home, the most important instrument for reforming society was the school. Led by John Dewey and others, the reformers tried to make school relate more closely to life. They may not have transformed society, but they did change the schools.

The photograph above is of a natural history class at William Penn High School about 1915. This was an official city photograph, probably for use in illustrating a brochure; perhaps the serious occasion explains the serious demeanor of the women.

Note that the room is equipped with both gas outlets and electric lights. There is no way of knowing how many of these young women went on to college and medical school, but we do know that a larger percentage of women went to medical school in the teens than in any decade after that until the 1970s. The photograph on the following page, top, represents another educational program the social workers promoted vigorously—a group of immigrant women laboriously writing their first letter in English.

The next two photographs illustrate a different type of education for life—vocational training. This kind of education was often sex-biased; women learned domestic service and men learned auto repair. Although certain class and ethnic groups were encouraged to take vocational courses while others were prepared for college, vocational education did often provide a path out of the slums.

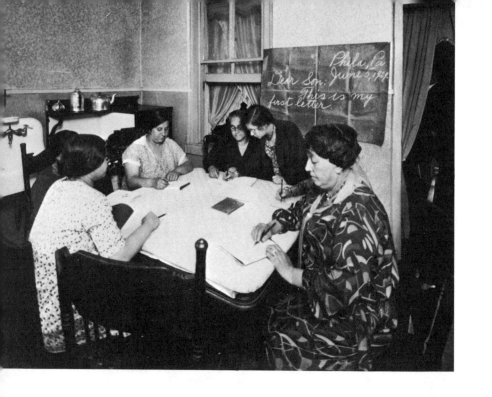

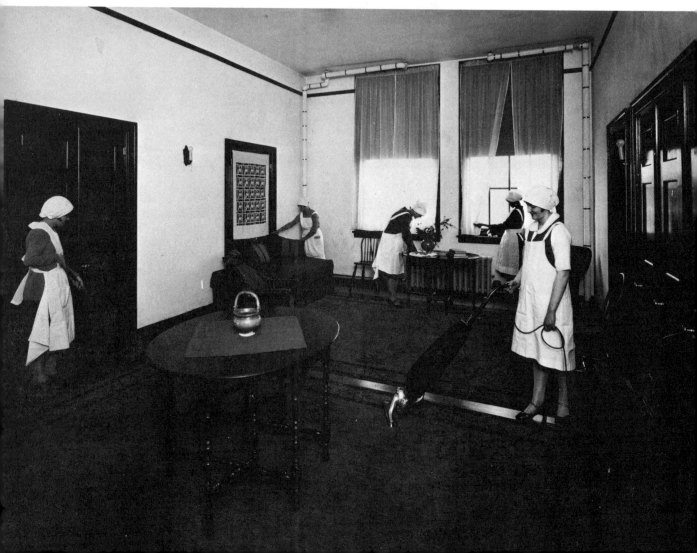

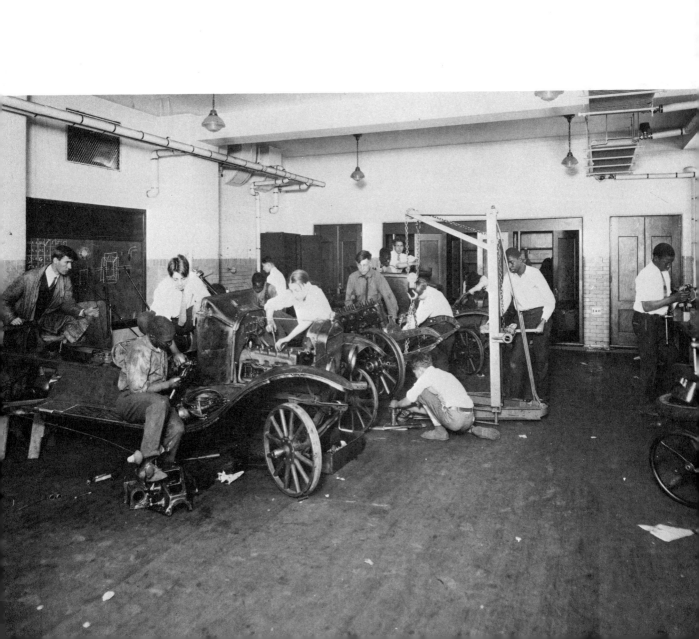

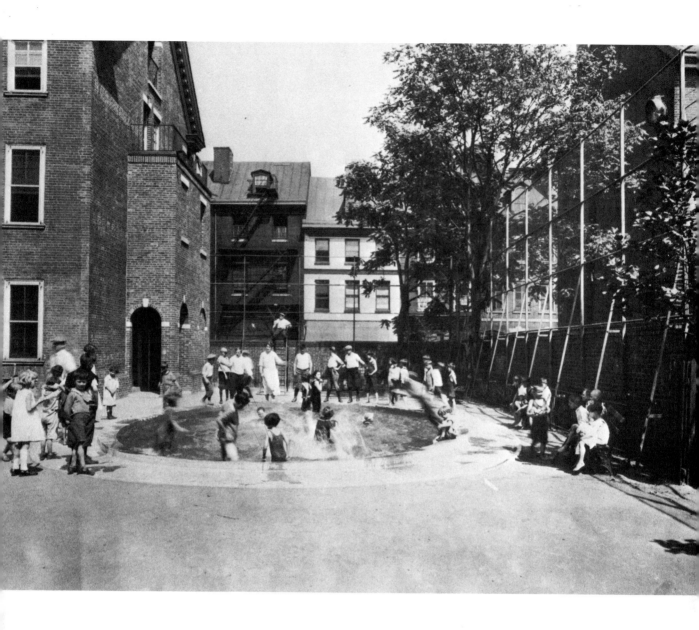

The campaign for parks and playgrounds was in many ways similar to the housing reform movement. Both relied on middle- and upper-class individuals for support and membership. Both saw overbuilding and overcrowding as important causes of disease, crime, and immorality. And both used photography to make their points about life in immmigrant and working-class neighborhoods. In fact, photographs from the Housing Association were often used in programs and reports of the City Parks Association, and vice versa. The photograph at left was taken by Philip Wallace for the 1924 Annual Report of the City Parks Association, which had been founded in 1888; it shows the wading pool of Smith Playground at Front and Lombard. The Association sponsored the creation of dozens of such small open areas in residential neighborhoods, as well as the establishment of the parks along the Cobbs, Tacony, and Pennypack Creeks. Closely related to the playground movement was the establishment of day nurseries. A local Association of Day Nurseries was created in 1898. Its motto was "Civilization marchs forward on the feet of little children," but civilization in Philadelphia had not marched past segregation when the photograph below was taken. It depicts the all-black Lincoln Day Nursery, which was started at 17th and Bainbridge in 1906 and later moved to 19th and Ellsworth, where this photograph was taken. The nursery's play area backed on to a lumber yard and rail spur, visible here. These photographs illustrate the reformers' notion of wholesome activity for the city's young people.

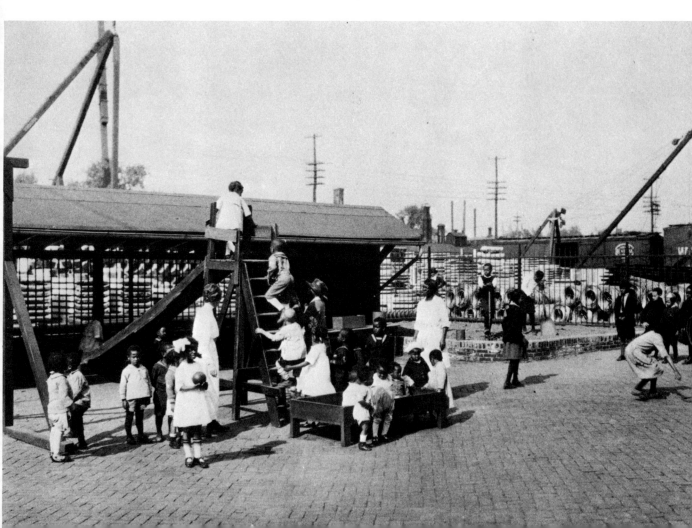

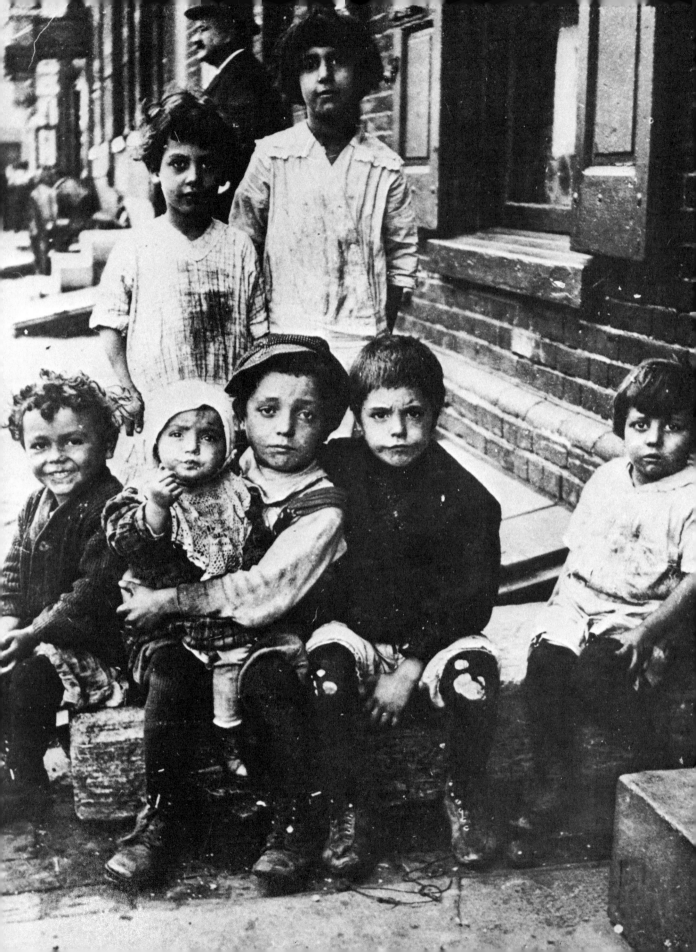

A Gallery of Faces

The reformers studied and observed the city's immigrant and working-class communities in order to change them. Occasionally, almost by accident, they captured some of the vitality, some of the excitement and charm of the people, especially the children, who posed happily in front of their cameras. There were others who observed lower-class life because it seemed exotic or merely strange. Still others, forced to travel through poor neighborhoods on their way to work, looked with a mixture of fear and fascination. Then there were those who were merely curious about strange people and uncommon customs. Photographs, often illustrating newspaper and magazine accounts of the activities of these neighborhoods and their residents, helped fill these diverse needs for information. They sometimes substituted for personal contact between the two Philadelphias.

The perception of these immigrant and working-class communities depended to a great degree on the observer. The reformers were appalled by the conspicuous poverty, and troubled by the wreckage of lives and families that seemed, at times, a consequence of an environment gone out of control. They were also pleased by tales of individual success, by people "rising above" their backgrounds and educating themselves or their children for roles in the society at large. But even the most sensitive outsiders, who understood how low-wage jobs and unresponsive government exacerbated already difficult situations, rarely appreciated the personal strengths on which most of the city's people drew. Their very presence in Philadelphia, in the case of new migrants from Europe or the rural South, involved heavy and obvious human costs. It was often difficult for those in comfortable surroundings to understand how the less fortunate were not consumed by their environment. However they responded to their poverty, to their uprootedness, it was tempting to interpret their actions in the context of social failure.

Some Philadelphians were fearful of the threat to stability and American values represented by these often poor and non-English-speaking residents of the immigrant and working-class districts. Because of their skewed perceptions, these alarmists often confused the victims of urban pathology with its perpetrators. Similarly, they confused the persistence of old ways with a stubborn refusal to adapt to new conditions. Not all outsiders were discomfited by the persistence of European or rural habits. Some Philadelphians were charmed by the very quaintness of these quarters and their denizens—words these visitors used in describing the city's older neighborhoods and newer residents. The quest for authentic experience sometimes

South Philadelphia children, photographed by the Housing Association in the 1920s.

149

focused the attention of outsiders on the city's poorer neighborhoods, where it seemed that the material comforts of modern life had not yet intruded and destroyed old customs. But whatever the reason the other Philadelphia examined the people around the city's core, only rarely did its gaze penetrate to the small facts of everyday life—the triumphs and defeats alike—that accounted for the survival and adjustment of these people.

Most of the photographs in this chapter were taken by outsiders. They were meant to reinforce either the reform or the ethnic romantic vision of the old neighborhoods in the first quarter of the twentieth century. And yet they can reveal another dimension in the present. It may have been the photographer's goal to portray the poor and downtrodden and to suggest what might be done for them, but he also captured something of the determination and resilience of his subjects. The people in many of these images are simply not as unhappy as their situations seem to warrant. In other cases, photographers sought picturesque highlights in out-of-the-way corners. But the pictures they took also suggest the strength derived from old habits carried into a new environment. What from the outside appears quaint may instead be understood as legitimate adaptation or even exuberance.

The last set of photographs in this chapter was taken by an insider of sorts. John Frank Keith, although a descendant of one of Pennsylvania's colonial governors, lived among the working-class people who were his subjects. Rather than demand change or chronicle the picturesque, his pictures were meant to portray everyday life. Although the images in this chapter differ in their intent, they all contribute to the same theme. Through them there has been passed on to the present a sense of the struggle of ordinary people as recorded in their faces. And the message of these faces is that to survive was to triumph.

In December 1905, Helen Jenks, one of the leaders of the Octavia Hill Association, recorded children in front of the Association's playground at Front and League Streets (next to 937 South Front). Established in 1902 to give children a wholesome place to play in a crowded neighborhood, the playground was supplied with swings, a sand pile, and games. The parents of the children photographed were most likely of Irish, Scottish, or English ancestry, and their fathers were probably employed as longshoremen or laborers on the Delaware. Jenks found that a gas lamp repairman competed successfully with the playground for the children's attention. Indeed, the Association eventually concluded that the streets held more attractions than the organized activities in the playground, as the poses and expressions captured here indicate.

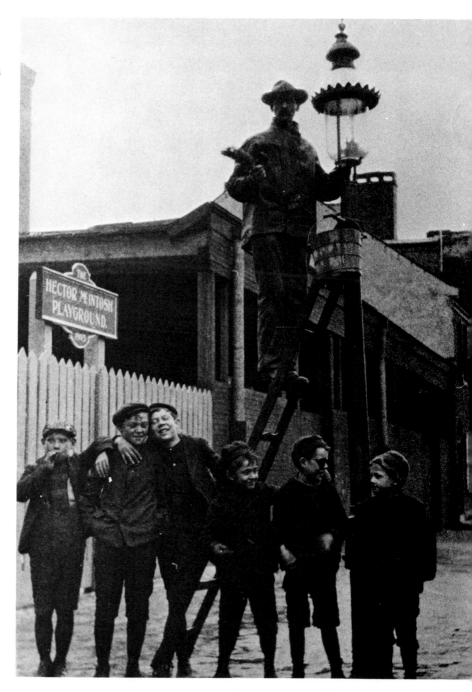

On May 6, 1915, the city government dispatched one of its photographers to record the trash-littered street and sidewalk in front of 910 South 5th Street. The camera itself became the focus of attention, as neighborhood residents—largely oblivious to the debris—posed for the photographer. The poster in Yiddish and English for the National Theatre indicates some of the other entertainment available in this Jewish immigrant neighborhood.

152

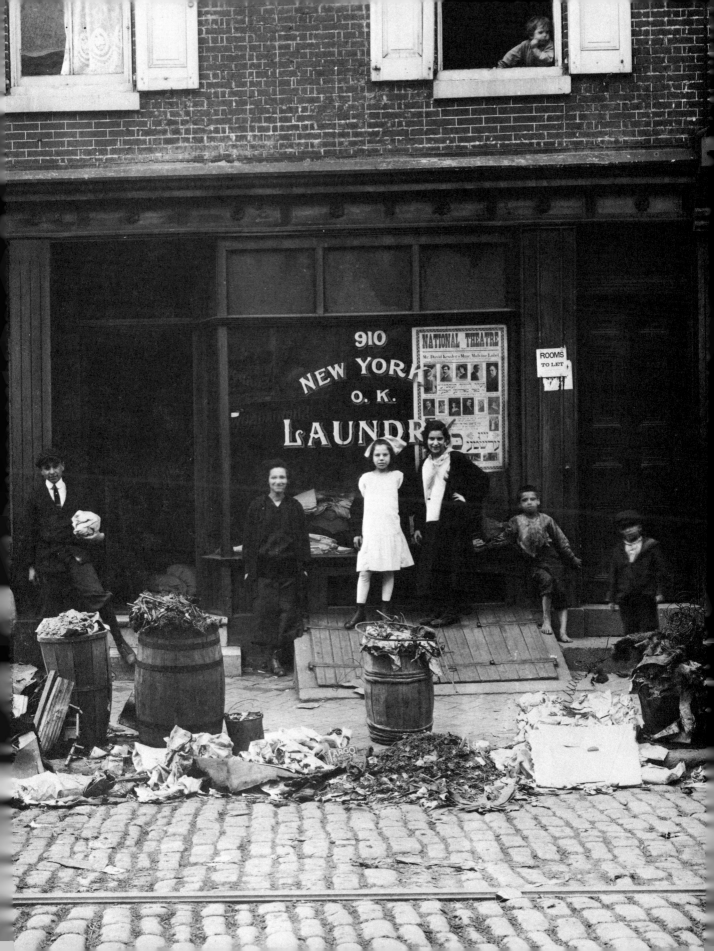

An unknown photographer for
the Octavia Hill Association,
sent out to document poor living
conditions, brought back the
shots on this page as well. Taken
about 1905, they show outdoor
scenes in one of the city's older
neighborhoods, probably South-
wark. The photographer re-
corded the unwholesomeness of
the physical environment and the
poverty of the inhabitants. He
also captured the resilience and
vitality of these people. The faces
of children and adults alike show
the mixture of resignation and
determination probably nec-
essary for survival in this
environment.

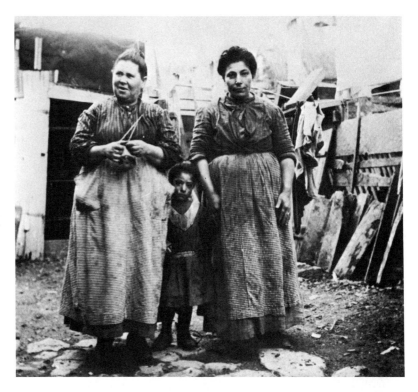

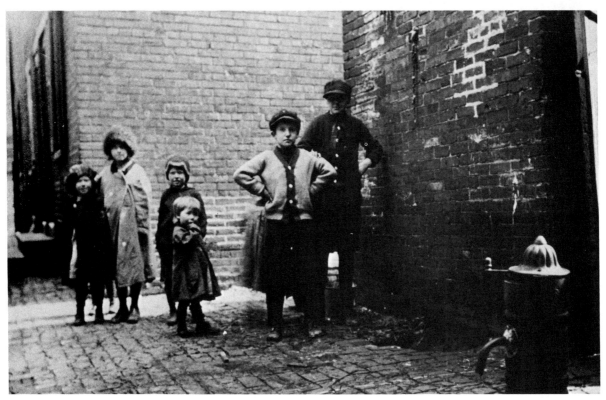

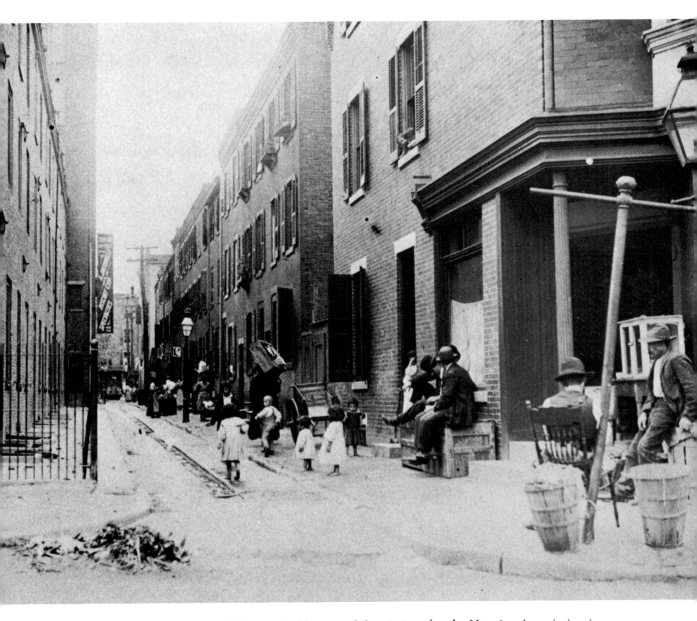

The crowded homes of the city's older neighborhoods forced life outdoors. In a side street near 5th and Passayunk in 1911 (above), we see the conviviality of stoop sitting and children at play. Young and old make the best of their limited circumstances. On the following spread, two photographs record outdoor social scenes at the other end of the old city. Taken for the Housing Association in the early 1920s, they depict Percy Street, a narrow alley of small, crowded homes running between 9th and 10th Streets in the heavily Jewish neighborhood around Girard Avenue.

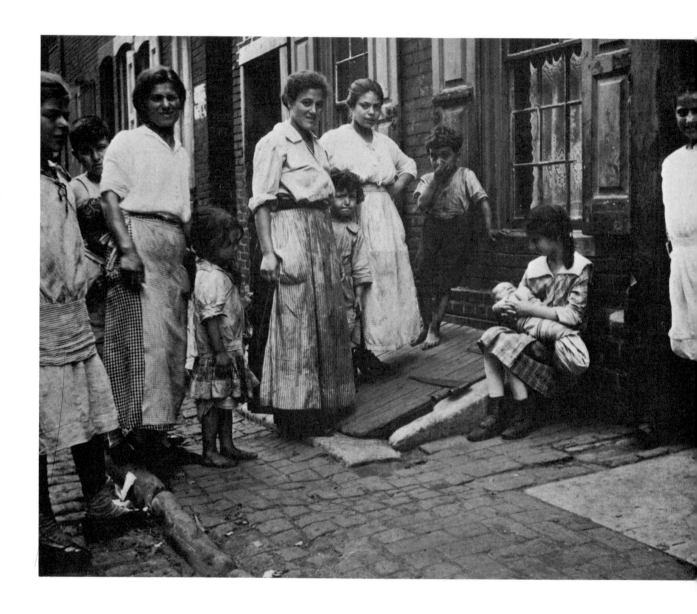

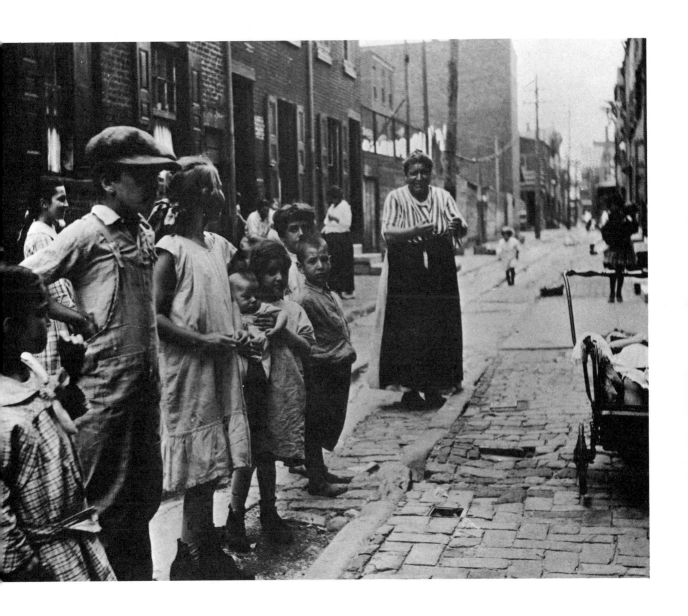

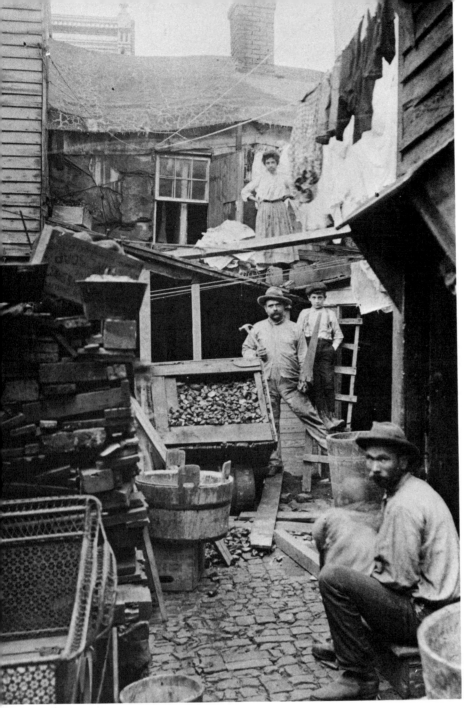

This scene is from a Housing Association lantern slide of the teens. It was taken at 616 Pemberton Street, between Bainbridge and Fitzwater Streets, to illustrate the overcrowding and dilapidation of the four small houses clustered together behind an old frame building. But it is the people captured in the photograph who draw the viewer's attention, while the deplorable conditions become an almost picturesque backdrop.

Charles and Maryann Rosner ran a restaurant and boarding house at 1704 Callowhill Street when this photograph was taken in about 1906. We can imagine something of the pride of proprietorship the couple felt—a pride especially obvious in the aproned male figure in the doorway.

Restaurants in working-class neighborhoods were often run in conjunction with boarding houses. They often catered to unattached men, who made up a disproportionate number of in-migrants to the city. Rosner's was across the street from the Baldwin Locomotive Works. It was probably one of the places Baldwin president Alba Johnson referred to when he noted that many of his workers ate their lunches in boarding houses near the plant.

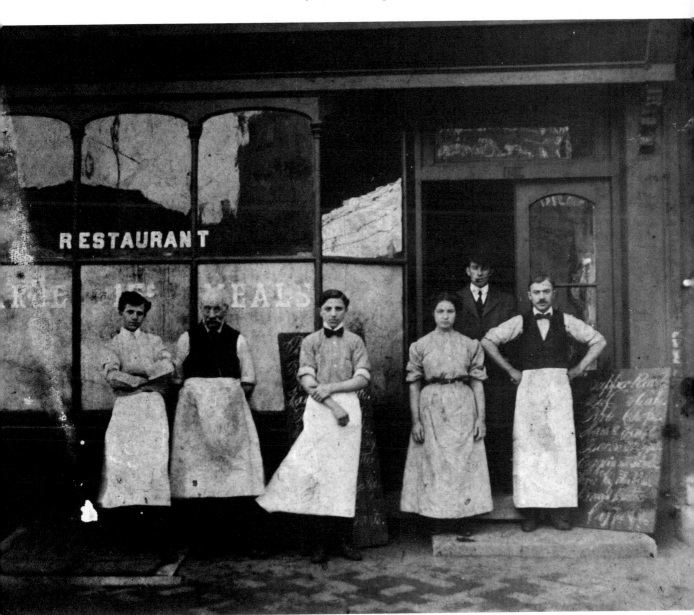

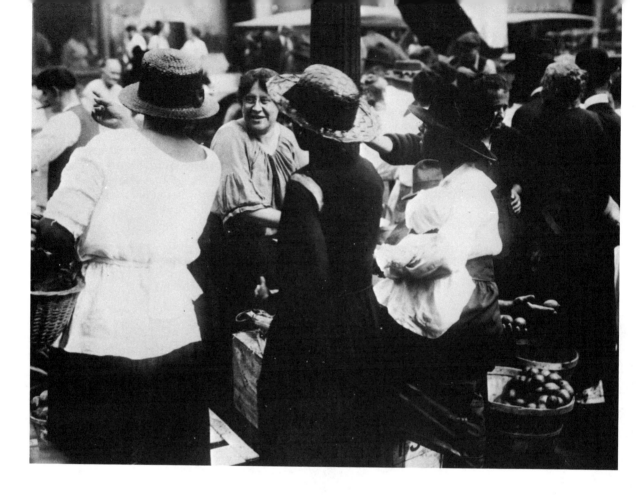

Local street-markets go as far back as the city itself. The municipal government had maintained first market sheds and then, beginning in the middle of the nineteenth century, enclosed market buildings. But immigrants pouring into the city at the turn of the twentieth century created their own markets, less formal than the city's official institutions. Often they were no more than lines of pushcarts drawn along the sidewalks of busy commercial strips in immigrant areas. Here merchants lacking the money to open their own shops might pursue the rags-to-riches dream. Customers, also often with limited resources, might search for bargains and find they could do business in their native language. The face-to-face contact of the marketplace epitomized the human scale of the city's older neighborhoods.

These photographs (above and right) were taken in September 1920 on South Street near Front. They were taken for the Philadelphia Commercial Museum to illustrate the colorful "shoppers and types" encountered in the street trades. The surrounding neighborhood was black, Jewish, and Italian.

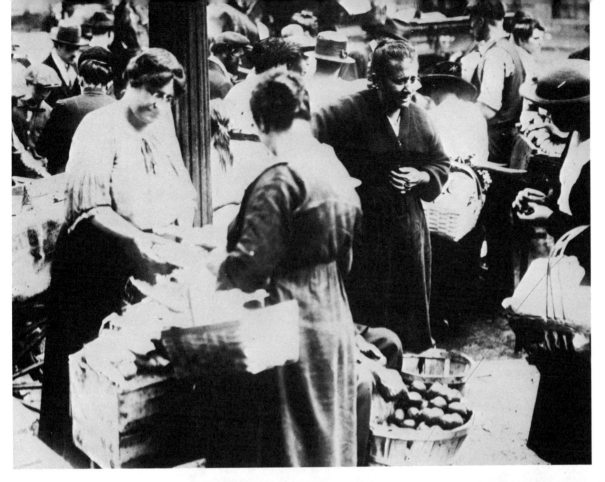

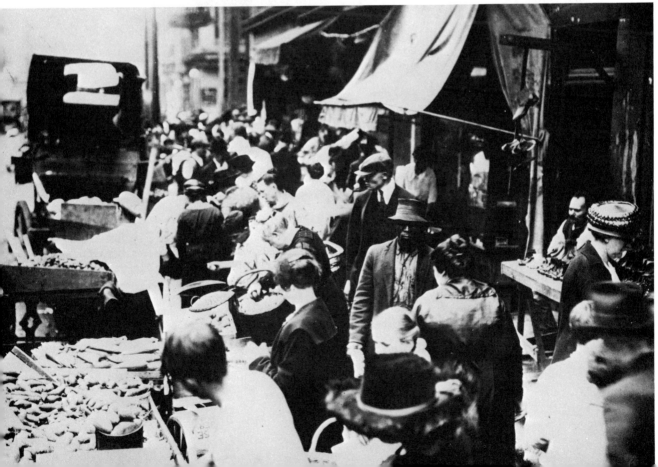

Photographer G. Mark Wilson's quest for picturesque Philadelphia led him to quaint scenes, some superficially evocative of Europe. He captioned this early 1920s photograph "not in Florence, Genoa or Naples," but the facts he supplied with the image make it clear that the scene was uniquely American. The couple seemed to be courting. The man, Wilson noted, was Jewish, the woman Irish, a circumstance almost unimaginable where Old-World customs and proscriptions still held sway. The stairway was in the old city, just north of Market Street, between Water and Front Streets.

This Syrian family lived at 10th and Ellsworth Streets, in the heart of South Philadelphia's large immigrant quarter. The woman in the doorway, holding a chicken and an egg, offers mute testimony to the continuation of rural habits in the midst of the industrial metropolis. Raising chickens on rooftops was not uncommon in this neighborhood when this picture was taken in the early 1920s. Hanging on to old ways provided reassurance to new Americans adjusting to vast changes. At the same time, of course, and more concretely, this custom raised their standard of living. Photographer Wilson also called attention to the "strange small boy" off to the side.

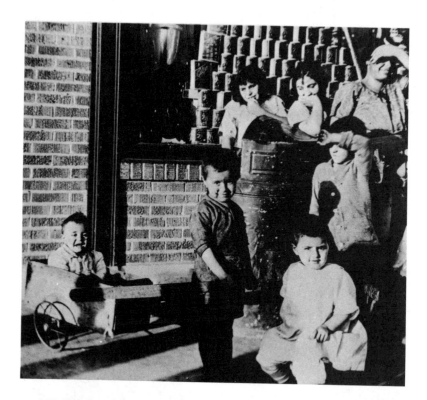

Like many photographers of the urban scene, Wilson could not resist children's faces. But he did not take the trouble to identify this group, his reason for recording it, or the location. The image dates from the early 1920s.

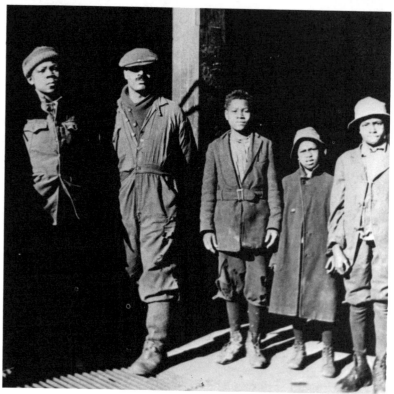

New Philadelphians in general seem to have interested Wilson. But while his photographs were fairly direct, the captions he attached to them, which suggested how the pictures were to be read, presented stereotypes common among native white Americans at the time. In this early 1920s image of a black stevedore and his family, Wilson used the absence of the man's wife to indicate his point of view. She was in the house "fussin-up"; she didn't want her picture taken in "deese clos." Wilson shot the scene at 2nd and Brown.

164

The immigrants and children of immigrants who lived in this alley off the 500 block of North 2nd Street in the early 1920s had not adopted our modern, urban notions of privacy. Wilson's photograph of McKinley Court shows that its residents still treated the outsides of their homes as extensions of the insides. Note the cheesebags hanging from second-floor windows. The washtub next to the door suggests that laundry was done in the alley. It is clear that life spilled outdoors into the public way, making the absence of people in the photograph especially conspicuous.

The restrained aesthetic sensibility of the present may find this sign-speckled building of the early 1920s either picturesque or garish. The showplace of ventriloquist "Professor" Samuel Lingerman may have caught the attention of photographer G. Mark Wilson for the same reasons. Such exuberant outdoor advertising, not at all rare in the nineteenth century, was becoming less common in the twentieth. The church sharing the 700 block of North 5th Street is Greek Orthodox.

John Frank Keith captured the face of everyday Philadelphia in his photographs of the 1920s. An amateur photographer, Keith earned his living as a bookkeeper in a Dock Street fish market, snapping pictures for pleasure on the weekends and in his other free time. His Kensington neighbors posed for him, as did other Philadelphians he met on his expeditions through working-class sections of the city. He photographed his subjects in front of their homes, allowing them to express themselves rather than imposing stylized expressions on them. Some of his subjects mugged for the camera, some were visibly ill at ease, even grotesquely unnatural. A few, responding to familiar environments, stood naturally for the camera. Most wore everyday clothing, others were decked out in communion or Sunday finery. Keith gave away some of the postcard-size silver prints he made to his subjects at no cost, and took some pictures for as little as a nickel. These Keith photographs offer a rare and suggestive glimpse of ordinary Philadelphians at home.

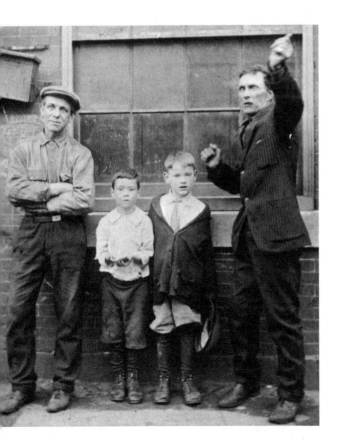

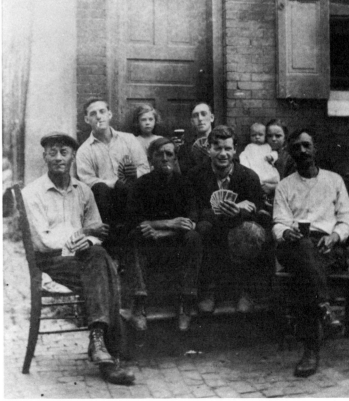

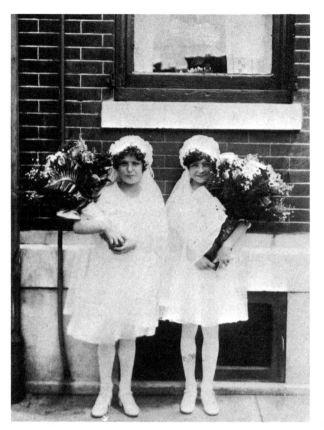
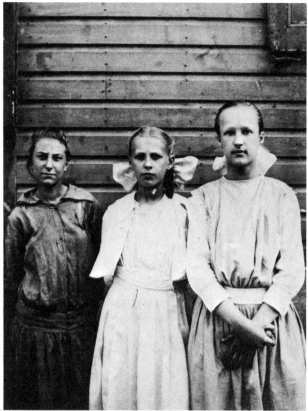
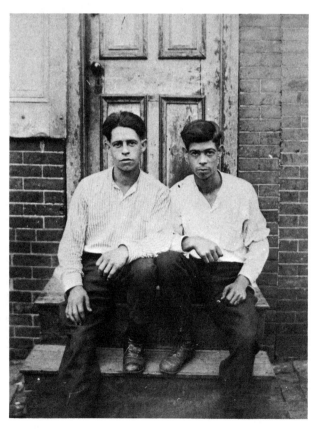
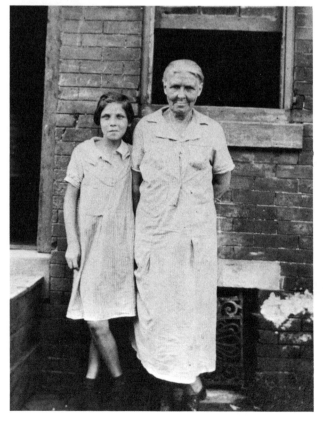

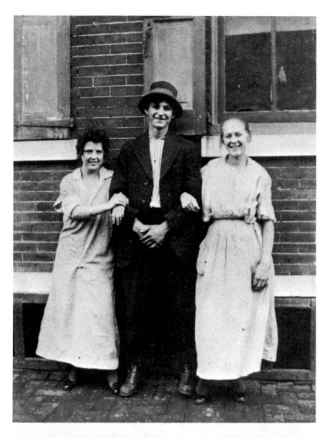

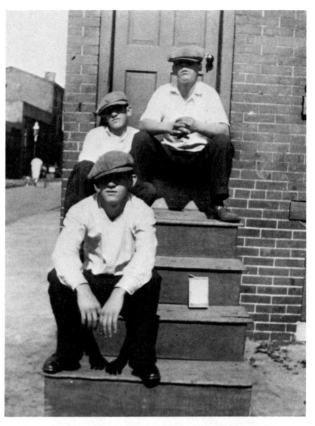

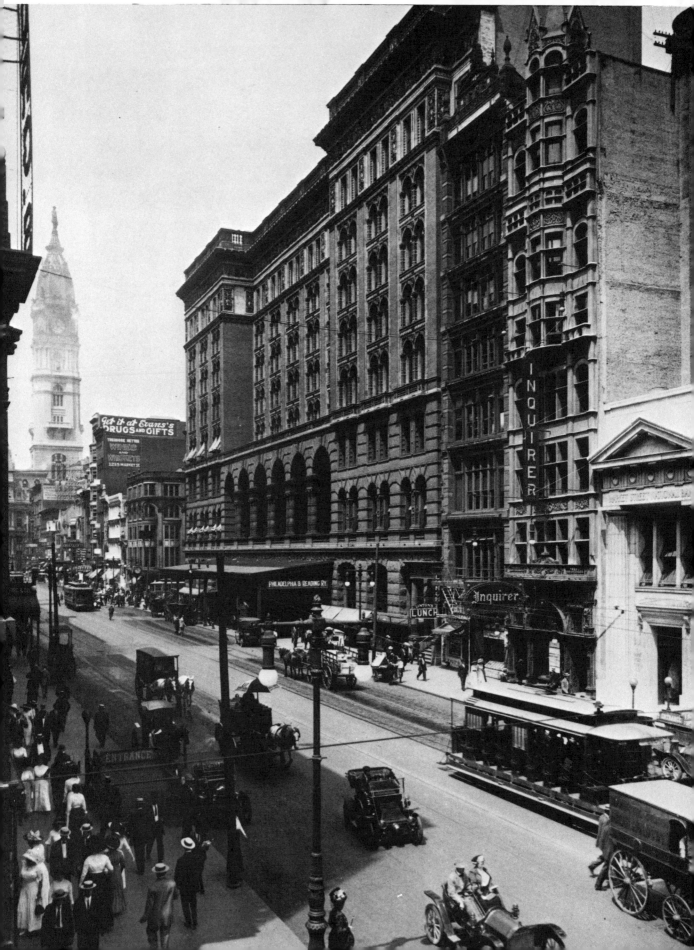

Technologies of Change

The complex web of neighborhoods, industrial districts, and commercial centers that made up Philadelphia was held together by elaborate systems of transportation and communication, and sustained by private and public utilities. While Philadelphia's population was doubling between the 1890s and the 1930s, spectacular innovations—especially in mass transit and electrification—radically altered the shape of the city and the quality of urban life. Electric lights illuminated newly paved streets; trolleys and subways carried commuters to homes with indoor plumbing and filtered water. At the same time, the changes in transportation had multiple and sometimes contradictory effects, dispersing the city's residents into specialized and segregated neighborhoods while temporarily enhancing the scope and influence of the downtown.

The technological breakthrough with the greatest initial impact on the city was the trolley, which finally shattered the bonds imposed on urban growth by horse-drawn transportation. The vast horse-drawn street railway system had been consolidated in the 1870s and 1880s by William Kemble, Peter Widener, and William Elkins. They had experimented with a cable system before being convinced of the superiority of electricity by the success of Boston's system. Philadelphia's first electric trolley line began operating along Catherine and Bainbridge Streets on December 14, 1892. By January 1897 the entire trolley system, with over 400 miles of track, had been converted from horse or cable to overhead electric power. Not only did the trolley tracks then extend to every corner of the city, but they also connected to a complex interurban network. Both within and outside the city, lines were commonly extended into undeveloped areas. Intricate dealings among landowners, building societies, and politicians usually assured that development soon followed. In 1902 the transit magnates formed the Philadelphia Rapid Transit (PRT) Co. The company was chronically short of money and complaints about service were unending. It took a wave of rider protests in 1905–1906 to persuade the PRT even to heat its cars in winter.

The electric trolley system was soon overextended, creating a demand from users that it could not fulfill. Ridership peaked about 1915 with 86 routes running on 600 miles of track, but the trolleys were frequently delayed by horse-drawn wagons and autos in massive traffic jams. The high costs of building and maintaining the system were already causing serious doubts about the long-term future of the trolley. No major technological innovations were made after the late nineties. Some lines were abandoned in the twenties, and the PRT had raised its fare

Market Street, August 1911.

from 5 cents to 8 cents, or 7½ cents for a token, by 1926. Philadelphia's last new trolley line was built in 1932, along Olney Avenue, and the system continued to carry most of Philadelphia's commuters for years thereafter. But the beginning of the end came in 1923, when the city inaugurated its first bus line, from Broad and Erie up Roosevelt Boulevard to the growing Northeast.

Even as the new trolley system was being built in the nineties, the search began for a faster way to bring people downtown without causing the massive congestion the trolleys created. Elevated railroads and subways already existed or were planned in other large cities. The Pennsylvania and Reading Railroads were offering competitive local commuter service by the turn of the century, having lowered fares and increased service to the Main Line and Chestnut Hill. Largely to preserve its monopoly and forestall a city rapid transit system, the PRT began to build an elevated along Market Street in 1903. On March 4, 1907, it began operations from 15th Street all the way to the comparatively open spaces near 69th Street. By October 1908 the line had reached Delaware Avenue as a subway, with an elevated spur running down to South Street to serve the New Jersey ferries. The PRT also announced plans for the Broad Street Subway in 1906, but it soon became clear that a private company simply could not build and maintain subway and elevated lines. In 1907 an agreement was reached whereby the city would build the lines and lease them to the PRT.

After various delays and a pause for World War I, the twenties and thirties witnessed another burst of rapid-transit construction. The Market Street Subway was continued to form the Market-Frankford Subway-Elevated, completed in November 1922. The Broad Street Subway from City Hall north to Olney was opened in 1928. It was pushed south to Snyder Avenue by 1938. The Ridge Avenue spur, completed in 1932, was planned as part of a larger line along Locust Street to southwest Philadelphia. Like several other planned subways, it was never finished. Not to be outdone by the PRT, the Pennsylvania and Reading Railroads electrified their commuter service between 1915 and 1933, and the Pennsylvania's Suburban Station next to City Hall opened in 1930. Another milestone was passed in 1936, when a high-speed line over the Benjamin Franklin Bridge was opened.

These developments in transportation were paralleled by equally important changes in city services, utilities, and communications. The most important change was the

adoption of electricity in everyday use throughout the city. The Philadelphia Electric Co., organized in 1899 to end the chaos of competing electric utilities, began in 1902 to create a unified system based on the use of alternating current and incandescent lighting. High-voltage cables were also developed about 1900, allowing the construction of a grid system based on generating stations throughout the city that could provide cheap electricity. The first major generating station, with a capacity of 4,000 kilowatts, was erected in 1898. Over the next three decades Philadelphia Electric built six large steam generation plants, including huge establishments on the Schuylkill at Catherine Street in 1915 and on the Delaware at Richmond in 1926. The Richmond plant alone was planned for a capacity of 600,000 kilowatts. In 1928 even this was surpassed by the new hydroelectric plant at Conowingo, outside the city on the Susquehanna River.

The supply of electricity to homes proceeded steadily in the years before World War I, and most new housing was wired during construction. In the early 1920s, Philadelphia Electric conducted a drive to wire older homes, especially the two-story brick houses in the immigrant neighborhoods. About 120,000 homes were wired, so that by the end of the decade all but the poorest Philadelphians had some electricity in their homes. Ironically, the development of street lighting, the first urban use of electricity, lagged in Philadelphia. The gas monopoly, the United Gas Improvement Co., operated the firm that supplied fixtures, and exerted a great deal of influence on the city to retain gas streetlights. So in the older areas the streets were lit by gas even as the homes were converted to electricity.

Next to Edison's light bulb, Bell's telephone was the most famous invention of the 1870s. Bell Telephone of Philadelphia was formally incorporated in 1878. Its system was based entirely on the transfer of calls by operator until 1921, when automatic phones were first installed locally. By the end of the 1920s the automatic system was in place for most city calls. Nevertheless, in the late 1930s, after more than fifty years of everyday use, a telephone was still more likely to be found in a business than in a home. The city had over 150,000 business phones and not quite 200,000 residential ones. In contrast, the growth of radio—the other great innovation in communications—was both extremely rapid and overwhelmingly domestic. Philadelphia's first wireless broadcast was from the roof of the Bellevue Stratford Hotel in 1905. But the real change began in 1922, when Gimbel's inaugurated the city's first radio station, WIP. Soon every

major department store had a station, and several became affiliated with the emerging national networks. Nine local radio stations were on the air by the mid-1930s. Even more rapid was the growth in ownership of sets. In 1930, only eight years after WIP began broadcasting, over half of the city's households—a full quarter of a million families—reported having a radio. The radio had become virtually universal in middle-class areas like Olney, but even in Kensington, an industrial district, half the families owned a radio. Together, the telephone and the radio gave average Philadelphians much broader access to people and events than they had ever had before. But the inventions also encouraged them to spend more time at home, weakening the street life that had been so important in the turn-of-the-century city.

Much less spectacular, but more important for the health and appearance of the city, was the provision of clean water and underground sewer lines. The decades after 1890 witnessed a major effort to improve sanitation on the part of the city government, which was spurred by a very real fear of cholera and typhoid. By 1910 all but 42 miles of city streets had sewer lines, and ten years later that figure had been halved. Similar fears led to the creation of a modern water system. A city commission in 1899 called for the erection of large water filtration plants, a plan that coincided nicely with the political machine's affinity for expensive construction projects. The whole city enjoyed filtered water by March 1909, though the taste and smell still left a good deal to be desired. Five large plants had been built, one on the Delaware at Torresdale and the other four along the Schuylkill.

Work on the new services and utilities was accompanied by the paving or repaving of the city's streets. In 1892 the traction companies had agreed to pave and maintain the streets they used in return for the right to run trolleys on them. Over the next fifteen years they spent over $10 million putting down asphalt, brick, and granite blocks. The municipal government resumed care of all the streets in 1907, but the most difficult work in the older neighborhoods had been accomplished. By 1930 the city boasted nearly 2,000 miles of paved streets against only 100 unpaved. Philadelphia was prepared—unintentionally—for the advent of the automobile.

The period after 1910 saw the transformation of the auto from upper-class toy to middle-class necessity: between the mid-teens and the 1930s, mass transit use barely increased, while automobile ownership skyrocketed. Philadelphia had seen its first automobile in 1899. By 1908, with about 25,000 cars in all of Pennsylvania, a local automobile map existed—although

it was in reality a bicycle map with the city's widest streets colored in red as auto routes. It was the introduction of the Model T in 1907 that began the age of mass auto production, as the average price of a car plunged from $2,108 in 1908 to $604 in 1915. When World War I ended, the private auto was still something of a frill, but it was by no means rare. Nearly 100,000 cars and 7,000 trucks were already on Philadelphia's streets. The great boom of the twenties raised the figures to 250,000 cars and 40,000 trucks by 1930; the automobile had come within the reach of all middle-class families, and many working-class ones as well. Inevitably, traffic jams, auto accidents, and gas stations also arrived in force. There were 368 auto fatalities as early as 1922, and at the end of the decade accidents were occurring in the city at the rate of 17,000 per year.

Philadelphia was not immediately transformed by the automobile. After all, half the city's families still had no car in 1930, and for many who did it was a very recent acquisition. The Depression decade that followed saw no increase in local automobile ownership. Daily auto commuting within the city was relatively rare. A June 1929 survey revealed that only about one Philadelphian in eight used a car to get to work in the city, although over 100,000 cars entered Philadelphia daily from outside the city limits. State and federal highway money was earmarked for rural areas only, so there were few thoroughfares in the city designed primarily for automobiles.

The private automobile's main effect on Philadelphia through the thirties was to strengthen the trends first set in motion by the revolution in public transportation. The transit system's rapid development after 1892 had had an enormous impact on the way jobs and homes were spread throughout the city. The already existing trends of physical growth, neighborhood specialization, and declining density were accelerated. What was considered a reasonable distance to commute increased from two miles to six miles with the introduction of the trolley, and the subway-elevated increased that distance a bit more. The reduction in travel time stimulated a rapid increase in commuting. By the mid-teens, ridership on mass transit was over 400 million passengers per year, a threefold increase in twenty-five years. At the same time, by linking neighborhoods to the growing downtown, mass transit helped increase the isolation of neighborhoods from one another. It also encouraged the division of the city into areas of work and areas of residence, at least for those who could afford to commute daily. While that group

did not include most of the industrial work force, living at a comfortable distance from work now became the standard for middle-class families. The car made commuting even easier, thus solidifying the development of such suburbs-in-the-city as Mount Airy and Overbrook. It also freed urban development from its concentration along public transit corridors, helping to complete the dispersion of population within the city's borders. Thus the auto functioned as the most recent in a long succession of innovations that had enabled Philadelphia to sustain its expansion over many decades.

The railroad and the horse dominated transportation in Philadelphia in the early years of the century. Horse-drawn transportation had reached a high level of sophistication around 1900, and the construction and servicing of carriages, coaches, and wagons had created a local industry of builders, repair shops, suppliers, and craftsmen. A segment of this industry is illustrated in the top photograph opposite, taken at Broad and Carlton in 1895. The picture at right, taken in March 1903 on the south side of the 1700 block of Market Street, suggests the dependence of Mahood's Range and Stove Co. on its wagon for deliveries and installations. When the age of the car and the truck arrived, it had a greater immediate impact on horses than on railroads. The city had three major railroad systems—the Pennsylvania, the Reading, and the Baltimore and Ohio—and it was criss-crossed by multiple lines of track. Railroads attracted industry, and the two together produced substantial noise and air pollution. The last photograph, on page 178, taken for the private City Parks Association in 1913 to protest such conditions, depicts the High Line of the Pennsylvania Railroad carrying trains over both the Market Street Elevated and the vast rail yard near 31st Street in West Philadelphia. The High Line crossed over thirty tracks and passed the numerous workshops of the yard before merging with the main tracks next to Fairmount Park. Beyond the tracks to the right lay industrial plants and large stockyards along the Schuylkill River. Though they produced their own form of pollution, the horse-drawn carriages on Market Street were benign compared to the trains above them.

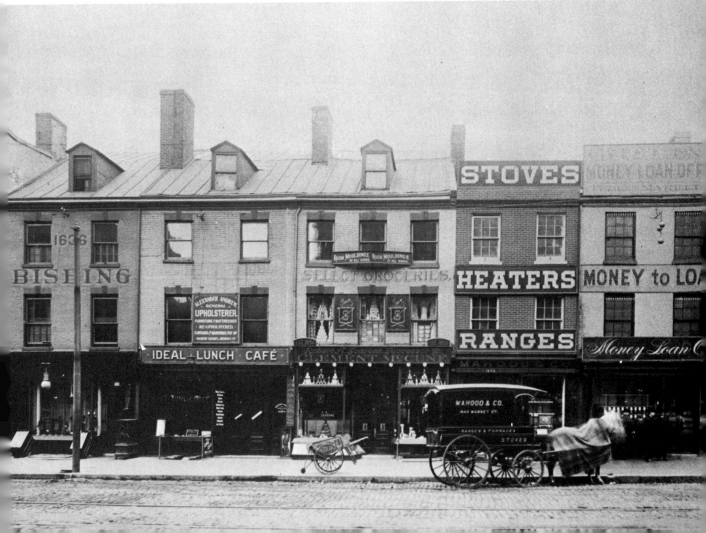

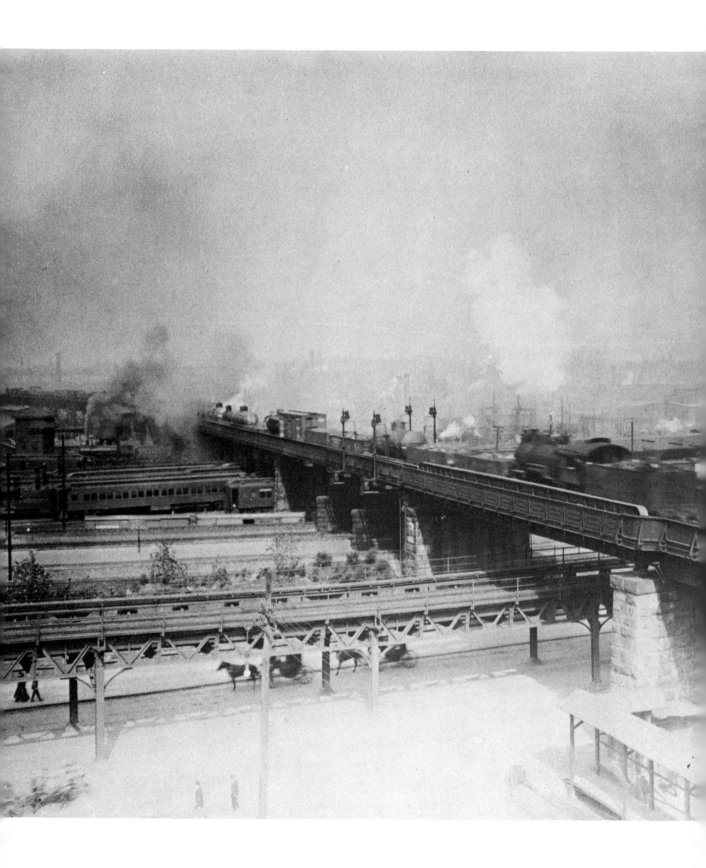

The construction and maintenance of Philadelphia's new trolley system was expensive and disruptive. The city's narrow streets and grid layout meant that virtually every main road, except for Broad Street, had a trolley running on it. The heavy use stimulated by the system placed a considerable burden of track and street maintenance on the PRT. The photograph below, typical of the work of official city photographers, shows track work and street repair on Vine Street near 13th about 1905. Such work naturally disrupted traffic and worsened the already

heavy downtown congestion. It also helped drive the PRT near bankruptcy, opening the way for the city government to play an active role in the planning and creation of a new rapid transit system. But despite such physical and financial problems, the trolley system was extended throughout the metropolitan area. In the photograph on the following page, top, dating from 1911, a car of the Philadelphia and West Chester Traction Co. has just left off commuters at the Millbourne Mills, on the city's border at 63rd and Market Streets. The blue-collar work force lived in row houses right next to the mills; the commuters pictured here were more typically white-collar, middle-class people. The extension of the trolley line to West Chester was not at all un-

usual. By the time this photo was taken, the system covered all of southern New Jersey and southeastern Pennsylvania. And in its heyday the system was not only extended; it was improved. After the Stotesbury-Mitten takeover saved the PRT from bankruptcy in 1911, about 1,500 new Nearside cars were purchased, and other models followed later in the decade. They were still running when the photograph on the following page, bottom, was taken about 1930 on Girard Avenue at the Philadelphia Zoo. On this route, number 15, the trolleys traveled from the Bridesburg Arsenal terminal to 63rd and Girard in the admirable time of just over an hour.

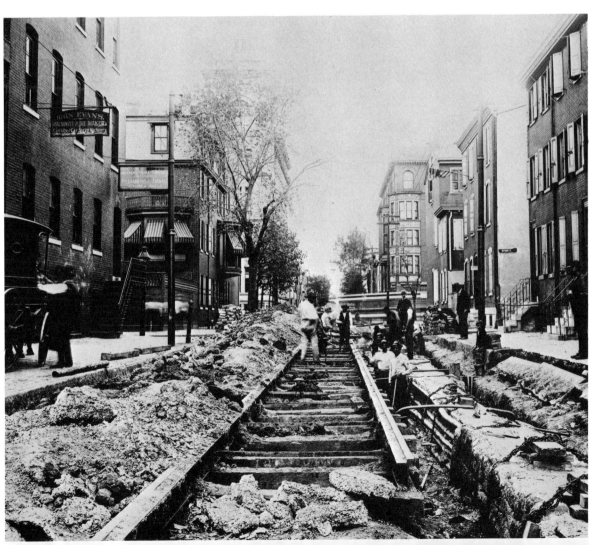

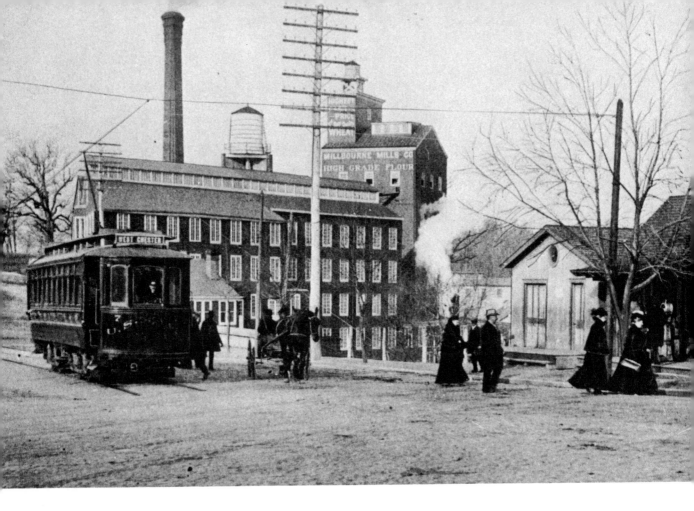

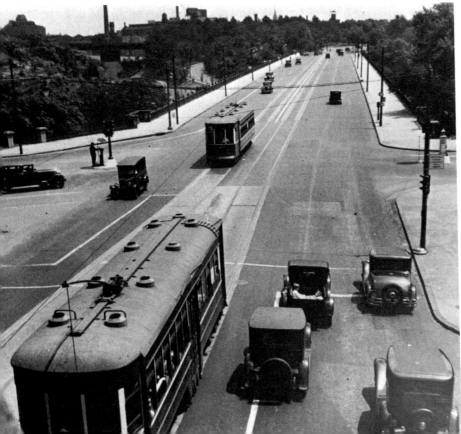

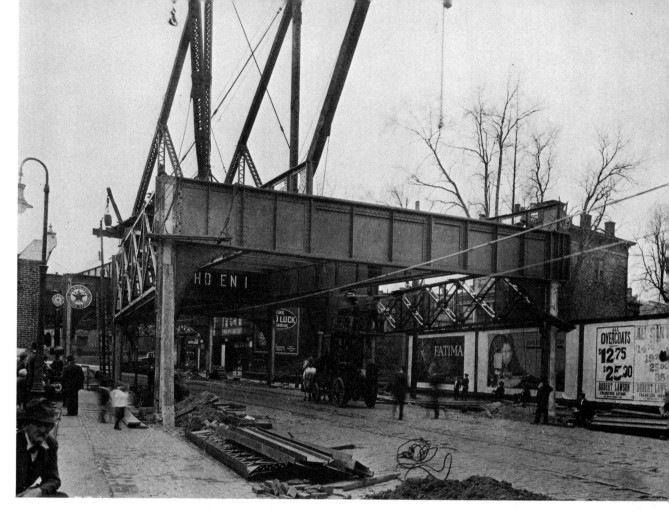

Though both the Frankford Elevated and the Broad Street Subway had been in the planning stages since the early years of the century, it was not until the twenties that these lines were finally built by the city. The photograph above shows the El nearing completion at Bridge Street in March 1921. The Frankford Elevated and the existing Market Street Subway-Elevated combined to form a transit line thirteen miles long that made the journey from Frankford to 69th Street in just 43 minutes. But because any street that has an elevated becomes dirty, noisy, and dark, Broad Street was given a subway instead. The photograph on the following page shows the North Broad Street section un-

der construction in July 1925. Less than three years later, the line was open between Olney Avenue and City Hall, bringing such growing neighborhoods as Logan, Fern Rock, and Olney within half an hour of the downtown. Tunneling under the city was a monumental task. A great deal of it was done between 1903 and 1938. The photograph on page 183 shows work on the subway-surface tunnel near 24th and Market Streets in 1931. This tunnel had originally extended from 15th to 23d Streets; constructed between 1903 and 1905, it actually predated the Market Street Elevated. By 1933, the

subway-surface line had been extended under the Schuylkill River to 32nd Street. This construction was underway at the same time as that of the Ridge Avenue Subway and the Broad Street Subway into South Philadelphia. Though they were designed at least in part for the financial benefit of politically connected contractors, all of Philadelphia's transit systems, from the trolleys to the subways, were finished in surprisingly short order. And though they may not have been intended as such, massive subway construction projects served as a pump-priming public-works program just as the Depression was tightening its grip on the city.

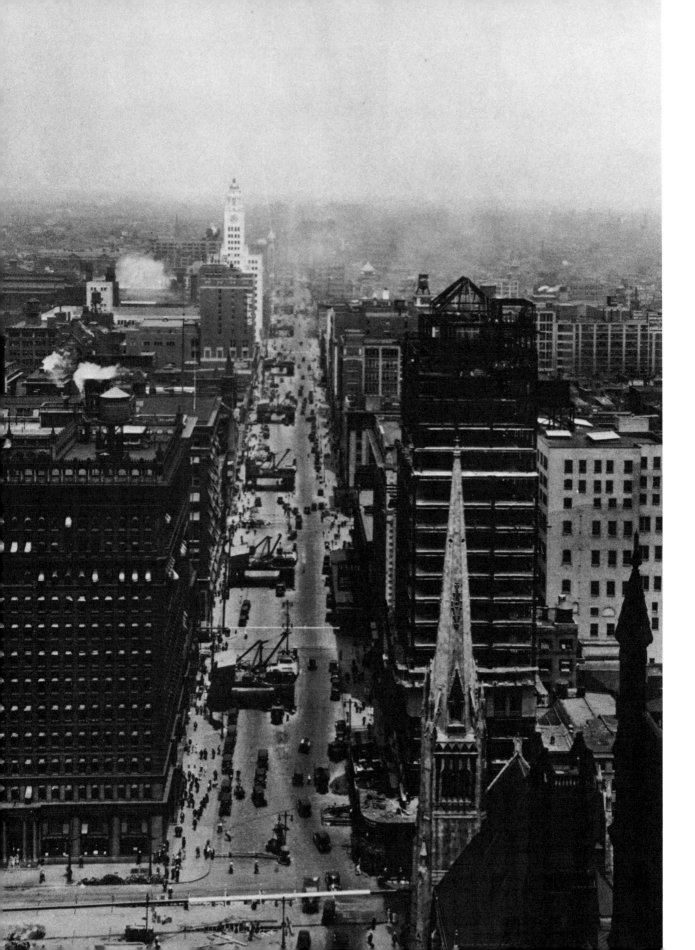

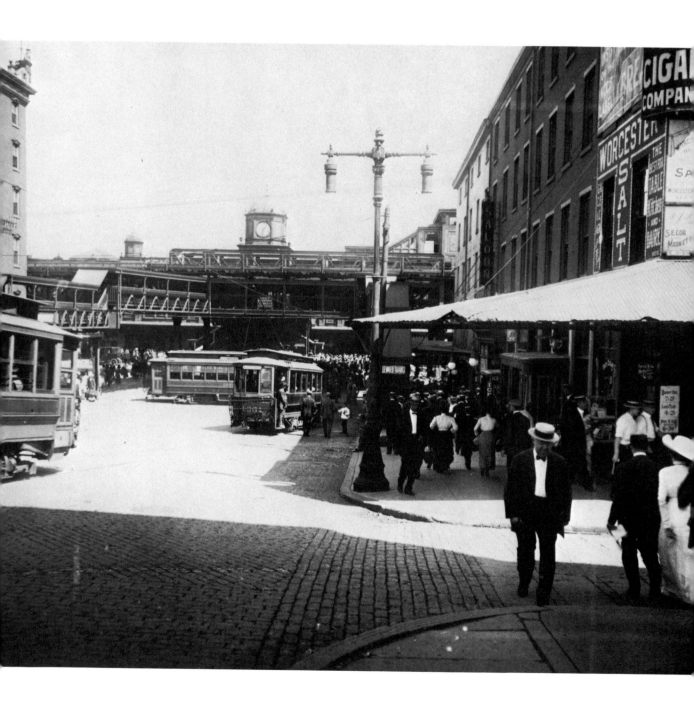

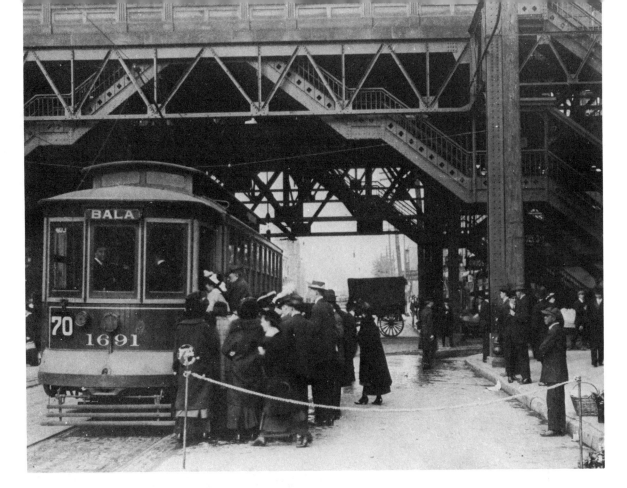

By the teens, Philadelphia's various transit systems had meshed together, allowing easy travel throughout the Delaware Valley region. The photograph at left shows the foot of Market Street in August 1910. In front of the Pennsylvania Railroad's terminal, the building with the cupola, trolleys made their loop to turn back up Market Street. A new addition was the Delaware Avenue Elevated, which ran down to South Street as an extension of the Market Street Subway-Elevated. It was torn down in 1939, after the new high-speed line over the bridge to New Jersey was opened. This photograph shows a Saturday afternoon crowd, brought by the subway and the trolleys, ready to embark for the shore via ferry and railroad. At the other end of the city, a similar connection is illustrated in the photograph above. Shoppers and commuters are boarding the number 70 trolley at 52nd and Market for the ride to 54th and City Line Avenue. If they had used the Market Street Elevated (very visible in the photograph) to come from downtown, their whole traveling time to Bala would have been as little as a half-hour. Thus, thanks to the new transit lines, middle-class people like those pictured here could live in such areas as Overbrook and Wynnefield yet still work and shop downtown.

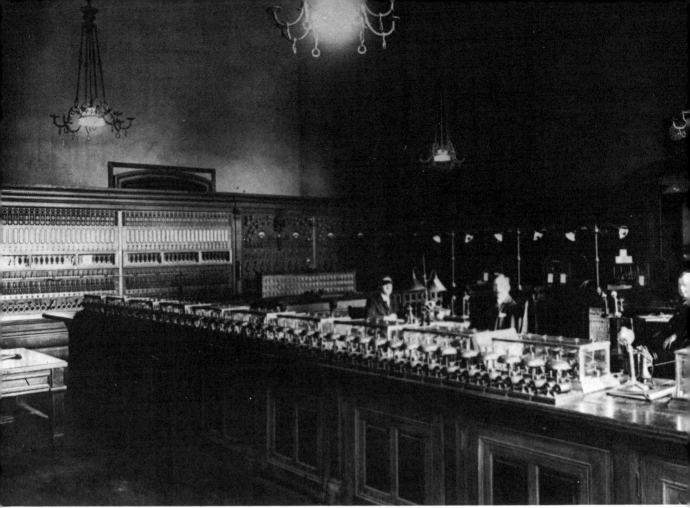

With the coming of electricity, and particularly of the Philadelphia Electric Co. monopoly, the city had a new kind of utility. By 1914, as the company photograph above illustrates, a technologically advanced system was in place. The company in that year had about 2,500 employees, served 100,000 customers, and operated three large generating plants. It was also building a fourth that still stands along the Schuylkill below Christian Street. Demand for lighting in streets, factories, and homes rose rapidly. The company advertised aggressively, stressing that to be modern meant to use electricity. That image of modernity, of science and technology at work, is the most striking theme of this photograph. In a control room at the company's headquarters at 10th and Chestnut, technical administrators are surrounded and overshadowed by large consoles containing meters, dials, and registers. The old has been adapted to the new: the consoles block up unused doorways, and electric lights burn uncomfortably in the middle of converted gas chandeliers.

Communications, like electricity, was not as frequently photographed as street paving or subway building. In its early years, radio consisted of very small transmitting stations sending signals out to home enthusiasts around the city. The photograph at right shows operator E. S. Goebel at the control panel of WDAR in the early 1920s. This was the Lits department store station. The early department store operations were soon supplanted by larger stations with more elaborate facilities. The city's telephone system also entered a new phase in the twenties. The photograph below, from 1931, shows Bell Telephone's manual switchboard at the time when local calls were being changed over to automatic dialing. The scene highlights two important features of the telephone industry in the 1920s: it provided respectable and socially acceptable office work for large numbers of women, and it was so large and complex that it had outgrown its original technology. With over 300,000 phones in the city, the number of possible connections was so great that the telephone company had to innovate or be swamped by its own success.

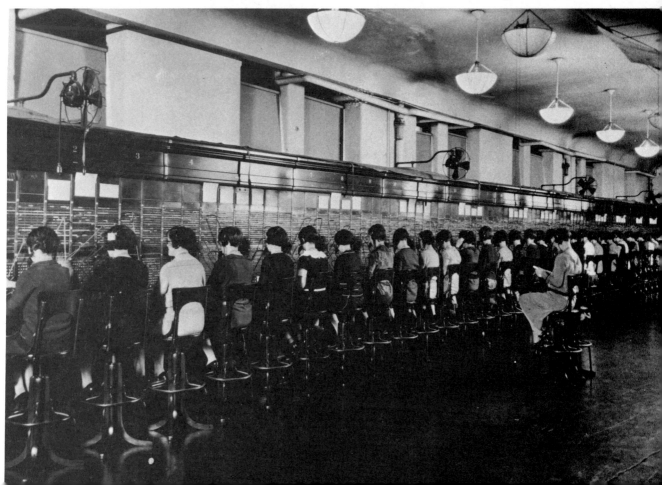

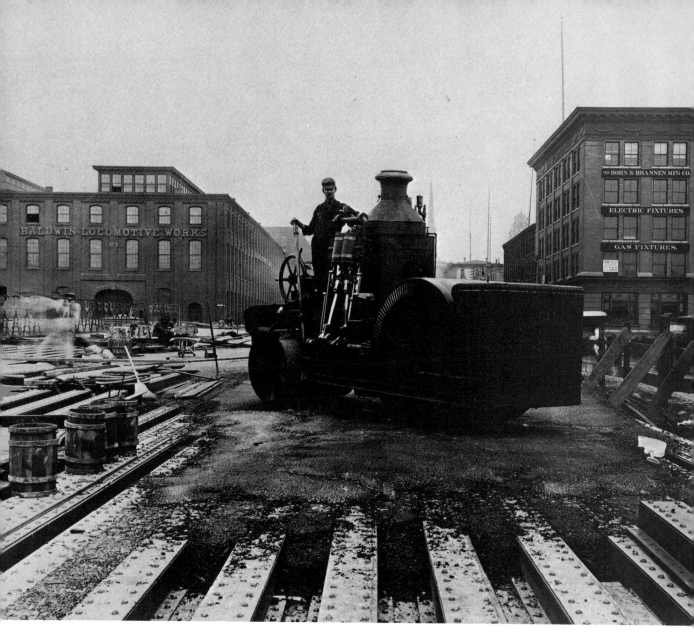

What the city did well, its official photographers photographed well. These two photographs are straightforward, posed recordings of the paving of streets and the laying of water lines. In the photograph above, taken in 1898, the Vulcanite Paving Co. is putting down asphalt on the new Broad Street Bridge over the Reading Railroad tracks above Callowhill Street. While other heavily used streets had their cobblestones replaced with Belgian block, Broad Street was done in asphalt as early as 1894. The new surface was easier and cheaper to maintain, and traffic made much less noise on asphalt than on cobblestones. At right, a water main is being laid on Broad near Callowhill in 1901. Here the city's photographer outdid himself, consciously composing an interesting picture as well as recording the event. The photograph was taken when filtered water was first being introduced into Philadelphia, and the work of tearing up newly paved streets—like the construction of the filtration plants—was the kind of lubricant that kept the city's political machine working and many immigrant laborers employed.

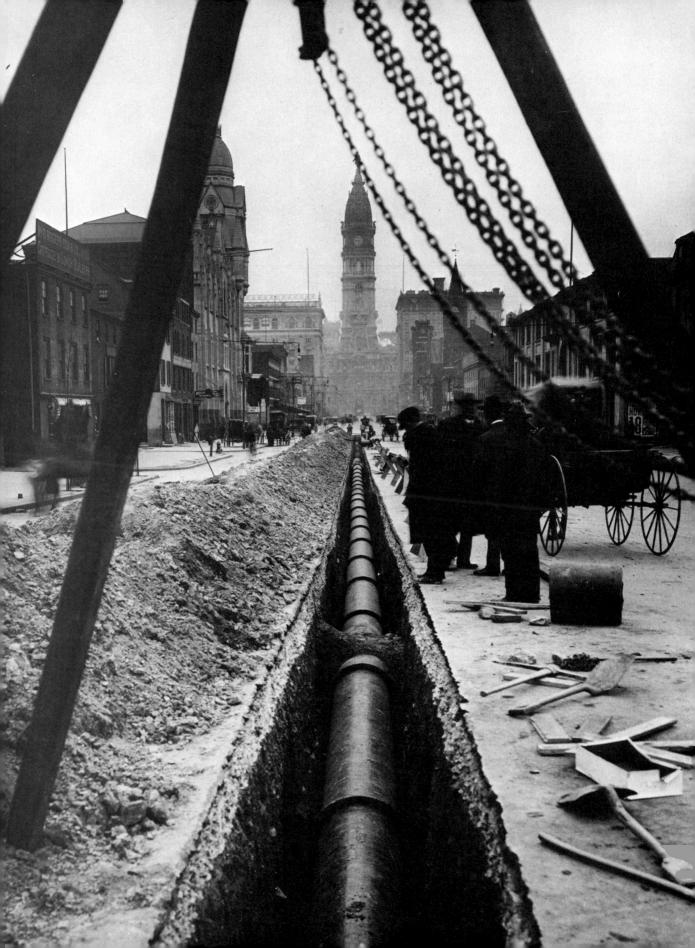

The evolution of the automobile from luxury to necessity is illustrated in these photographs. When the picture below was taken on North Broad Street about 1903, car prices averaged over a thousand dollars and annual maintenance costs were at least equal to the initial outlay. Both the traditional aristocratic composition of this photograph and its circumstances—the auto's owner had just been dropped off at his bank by his son and his chauffeur—emphasize that private car ownership was still very much the province of the rich. By the 1920s, the situation had changed dramatically. "Not a staged photo" was the City Parks Association's description of the scene at right, on the Benjamin Franklin Parkway. Apparently this shot, taken in the afternoon rush hour, depicted something of a traffic jam. Traffic flow seems unregulated, with lanes undefined and autos wandering towards oncoming traffic. Nevertheless, the auto was now a regular means of commuting for the middle-class minority, which could afford the kind of cars pictured here. By 1929, over 3,000 vehicles per hour traveled the Parkway during an average workday. In the succeeding decade, the automobile almost completed the transition from luxury to common nuisance. As the scene near 9th and Ridge demonstrates (below, opposite), Philadelphia's narrow streets and elaborate trolley system did not adjust well to the age of the automobile. Ridge Avenue was a main link between the Delaware River and Broad Street, but it was only 34 feet wide and carried double sets of trolley tracks. Even in the 1930s auto traffic here moved only at a fast walk during rush hour.

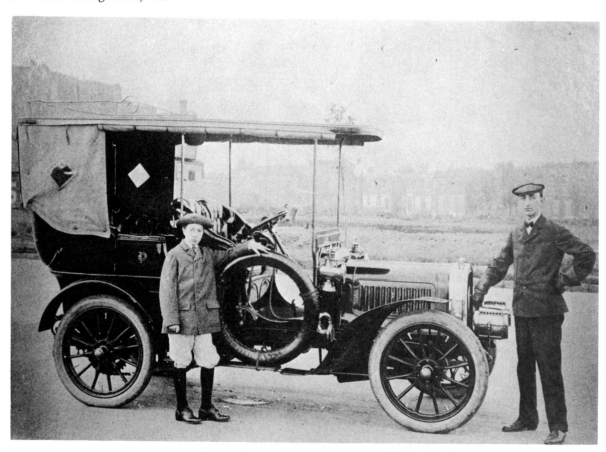

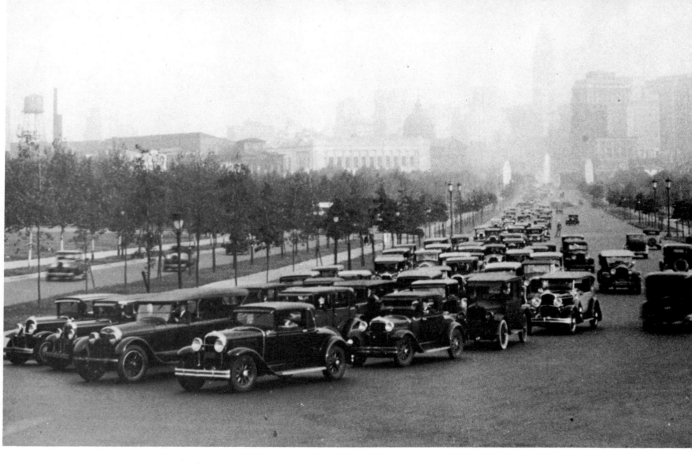

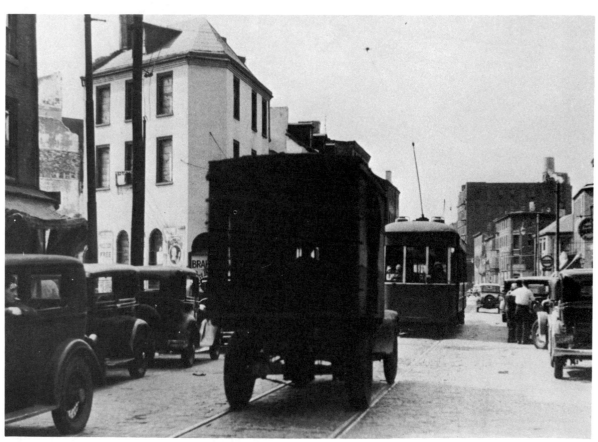

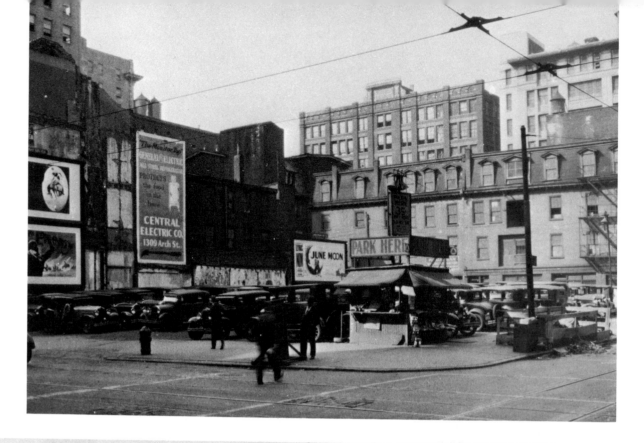

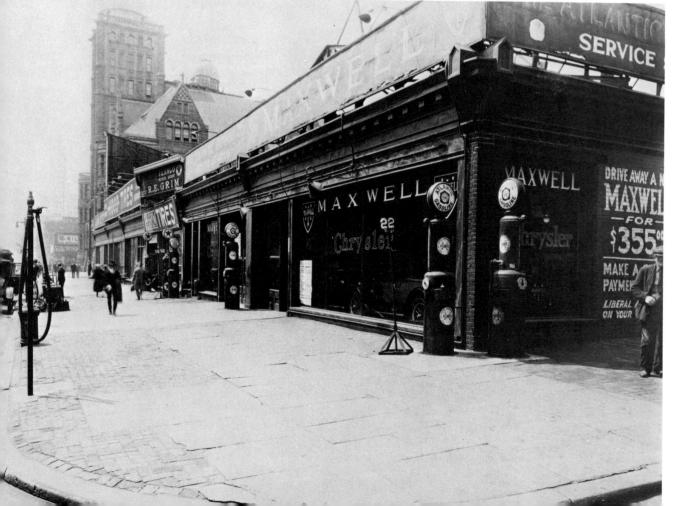

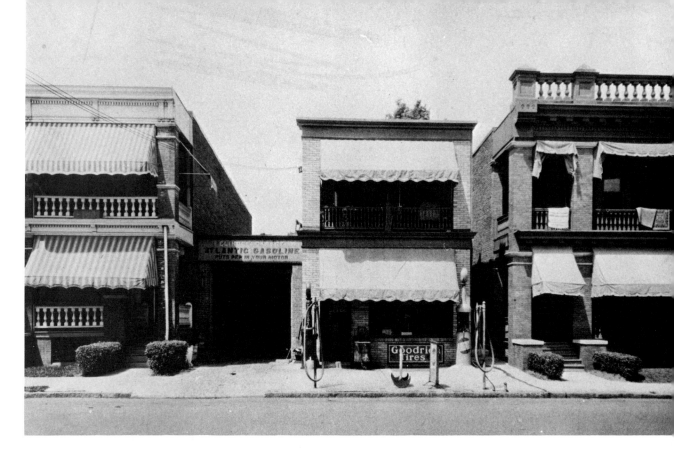

The automobile made its presence felt in many ways throughout Philadelphia. Gas stations, dealerships, repair shops, and parking lots appeared as early as the first years of the century. By the 1920s they were everywhere. With the loose and poorly enforced zoning and land-use laws of the period, such establishments generated controversy. The City Parks Association commissoned Philip Wallace to photograph a parking lot at the northwest corner of 13th and Arch (above, opposite). The Association noted that the lot was "a typical Eyesore of its kind" and campaigned, unsuccessfully, for strict regulation of parking lot esthetics, which seem to have changed little in the intervening decades. The photograph at left was taken at Broad and Mount Vernon in 1926. Broad Street, being a major auto commuting route, was lined with showrooms and auto accessory stores. The Maxwell was a moderately priced automobile at between $900 and $1,500. Nevertheless, within a short time after this photograph was taken this dealership was out of business. The showroom remained, and was soon converted to the sale of used cars. Even more troublesome than the changes downtown and on Broad Street was the appearance of gas stations and repair shops in residential neighborhoods. In August 1922 the Zoning Commission photographed a station on the south side of Walnut Street west of 54th, a solidly middle-class area (above). Only the growing size of stations and the practical economics of desirable locations gradually made sights like this less common.

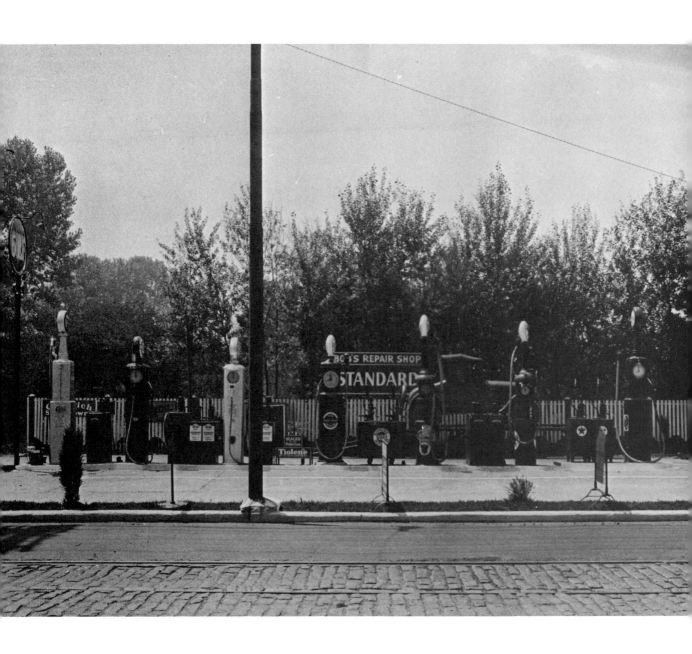

For photographers, the city of lights and automobiles proved an irresistible attraction. One of the city's official cameramen found a line of seven gas pumps in the Gulf Station at 7344 Oxford Avenue in June 1936. This was not just the new style in gas stations; it was symbolic of what was happening in automobile-dependent neighborhoods like Fox Chase and throughout Northeast Philadelphia. The same was true of the photograph below, taken by Philip Wallace on South Broad Street in the thirties. The nighttime scene is dominated by electrified corporate insignias, which overshadow the already old and familiar street lamps. Broad Street here seems to have been created by and for the automobile.

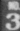

The Rise of the Downtown

In the decades after 1880, Philadelphia, like most American cities, came to be defined by its skyline. But the steel-frame skyscraper developed rather late in Philadelphia, leaving the skyline dominated by City Hall, which rose 548 feet to the top of William Penn's hat. Constructed in flamboyant Second Empire style, City Hall was begun in 1871 and finished in 1901—though it was essentially complete in the 1890s. While Chicago and New York pioneered the modern skyscraper, the first steel-frame building in Philadelphia was the nine-story YWCA building at 1800 Arch Street, built in 1892; the first commercial skyscraper, the Betz Building, had been constructed at South Penn Square east of Broad a year earlier. A great burst of construction starting in the 1890s and continuing into the early 1930s gave the city a genuine cluster of skyscrapers, but none of these buildings was taller than City Hall.

The new skyline was only one aspect of the transformation of Philadelphia's downtown. Apartment houses, theaters, vaudeville houses, department stores, an active vice district, and an improved transportation system brought a wide mixture of people into the central business district for work or play or entertainment. Meanwhile, as the twentieth century approached, the center of downtown activity moved west from near Independence Hall to near City Hall. The activities carried on within the district changed at the same time. Warehouses and factories concentrated in its northern and eastern fringe, as the central business district came to specialize almost exclusively in finance, government, commerce, and entertainment. The new mass transit systems moved hundreds of thousands of commuters in and out of the business district every day. Some traditional parts of the downtown, like the waterfront and the red-light district, remained basically unchanged throughout the period, but the number of people who actually lived downtown declined rapidly.

The downtown building boom resulted from a variety of economic and technological changes. Philadelphia already had a well-defined central business district in the late nineteenth century, with the commercial office building established as the standard downtown structure. When the new Bourse building was constructed at 5th and Chestnut in the early 1890s, it was deliberately placed at the presumed center of commercial activity. But an irresistible westward pull was already evident. By 1894, City Hall was flanked by two powerful symbols of the urban industrial era—the thirteen-year-old Broad Street Station of the Pennsylvania Railroad on one side and the new Reading Terminal on the other. Other transit developments—the electrification

13th Street just before World War I;
Wanamaker's is on the right.

of the streetcar system and the plans for subway and elevated systems to meet at City Hall—also pointed business activity to the intersection of Broad and Market Streets. When the century ended, the demand for office space was focused on this relatively small area in the city's new center.

By 1900 the seventeen-story Real Estate Trust Building and the twenty-two-story Land Title Building faced each other at Broad and Chestnut. Building followed building over the next two decades, from the YMCA at Broad and Arch to the North American Building at Broad and Sansom. Many more skyscrapers were built to the west of Broad and elsewhere downtown during the real estate boom of the prosperous 1920s. Technology and the battle for prestige produced ever taller buildings. After the opening of the 324-foot, twenty-six-story Packard Building at 15th and Chestnut in 1924, office towers commonly exceeded 300 feet. But Philadelphia's skyscrapers remained of modest stature compared to those of Chicago and New York. In a spectacular display of unintended irony, the Central Penn National Bank, Provident Mutual Life Insurance, and Fidelity Bank buildings were all completed in 1928, a year before the stock market crash. When the PSFS Building, downtown's most architecturally important skyscraper, was opened at 12 South 12th Street in 1932, local citizens joked that its sign meant "Philadelphia Slowly Faces Starvation."

But the new downtown was more than just tall buildings. In fact, the area was the center of most entertainment, business, and retail merchandising which depended on masses of people being brought together in a small space. Thus, the department store, the theater, and the hotel, along with the railroad station and the high-rise office building, symbolized the new downtown. Department stores were well-established in Philadelphia by the 1890s, and that decade saw the completion of the Lit Brothers' complex and the construction of a new Gimbel's store, both at 8th and Market. But they were soon overshadowed by the erection of John Wanamaker's emporium half a mile to the west on the site of his first dry goods store next to City Hall. The new building, designed by the Chicago firm of D. H. Burnham & Co., was built between February 1902 and December 1911. Opened just as the Market Street Subway was completed, it symbolized the westward movement of the business district.

The people who shopped in the relatively expensive department stores also patronized the downtown theaters and movies. The Schubert, Erlanger, Locust, and Forrest

Theaters were all built between 1918 and 1928. By the mid-1930s, eleven luxurious movie theaters brought Hollywood's golden age to downtown Philadelphia. Remaking the downtown also involved the creation of palatial hotels for out-of-town visitors. The nineteen-story Bellevue Stratford, the most opulent of all, was completed in 1902, and others soon followed. In 1911–1912 alone, the Wilton, Ritz-Carlton, Vendig, and Adelphia Hotels opened for business. At the same time, residential hotels were replacing the city's old inns. The first residential hotel, the Gladstone, had appeared at 11th and Pine in 1895. The core of the city was simply too expensive for the kind of picturesque but inefficient land use represented by the low-rise inns.

Economic imperatives were the driving force behind the transformation of the old city. Land values rose so high in the wake of the skyscrapers and subways that only enterprises and services that had to be in the main financial district stayed there. The land for the PSFS Building cost $1.6 million in the late 1920s. Most row houses and the stores they supported became uneconomical downtown. Population figures tell the story: while the city's overall census count doubled between the 1890s and the 1930s, the downtown population fell by half, to under 50,000. Most of the loss occurred between 1910 and 1930, and much of the decrease for the whole period was in the area between Chestnut and Vine Streets. The population there fell to 13,000 by 1920, after the construction of the Parkway and the Delaware River Bridge leveled two working-class residential neighborhoods. South of Chestnut, the downtown population fell much less rapidly, and was still over 40,000 in the early thirties. The inhabitants of center city were a diverse group. They included residents of the new luxury apartment buildings near Rittenhouse Square and surviving town houses and row homes. Philadelphia retained more houses in its central district than did most large cities. Many were occupied by blacks whose families had lived near South and Lombard Streets for generations, Jewish immigrants on Pine and Spruce Streets, and longshoremen drawing their sustenance from the waterfront industries along both rivers.

The Delaware River waterfront had been the industrial and commercial foundation of Philadelphia from the city's beginning, and it remained important in the early twentieth century despite the changes near City Hall, fifteen blocks to the west. With fifty miles of usable waterfront, Philadelphia was America's second-largest port in terms of tonnage, and its largest fresh-water port. The most heavily used six miles of docks and wharves, stretching from Port

Richmond to Greenwich Point and centering on the downtown, handled everything from coal and ore to sugar and fruit. Warehouses, factories, and markets associated with the Delaware waterfront formed a natural eastern boundary to the central business district. It was complemented on the west by the Schuylkill, which also had a significant industrial concentration, though that river was lined with railroad tracks, freight depots, and oil refineries rather than docks and wharves.

Another traditional downtown industry bordered the central business area on the north, east of Broad Street. This was the red-light district, or tenderloin, which flourished in Philadelphia despite the city's notorious blue laws and its strait-laced reputation. The tenderloin was centered on the blocks near Vine Street from 8th to 11th, but its influence extended all the way from Race to Callowhill and from 6th to 13th Streets. Here were combined the three main components of Philadelphia's "vice" area—Chinatown, known to outsiders for its opium and cocaine traffic; the furnished-room district, home of vagrancy and prostitution; and the tenderloin itself, with its burlesque halls and minstrel shows. Compared to such areas in other cities, Philadelphia's tenderloin district was small and unusual in not being exclusively devoted to illegal enterprise. Factories and warehouses shared the neighborhood with hotels and theaters, and many working people lived nearby. The area had long been tolerated and protected by politicians and the police, and the Vice Commission study of 1913 found about 3,800 prostitutes in Philadelphia, together with some 350 hotels and rooming houses catering to their needs. During World War I the Training Camps Commission, which attempted to clean up the nation's vice districts to protect the morals of the troops, decided that Philadelphia was among the most dangerous cities for soldiers to visit.

While the city's leaders ignored the vice district, they dreamed of creating a boulevard patterned after Paris's Champs Elysées. Prominent Philadelphians began in the 1880s to campaign for a boulevard lined with cultural institutions, fine residences, and exclusive shops to connect Fairmount Park with City Hall. Plans for the Parkway were on the city's agenda in the early 1890s, then stricken, then permanently restored in 1903, as politically connected building contractors like Sunny Jim McNichol were persuaded of the idea's material, as well as its cultural, virtues. In the first decade of the century the Parkway plan developed into the centerpiece of Philadelphia's version of the nationwide City Beautiful movement, inspired by Chicago's great Columbian

Exposition of 1893. After decades of planning and debate, the Benjamin Franklin Parkway was finally built between 1907 and 1918. It constituted the only major break in the wall of factories and warehouses that hemmed in the downtown on the north. Despite the accompanying cultural institutions that gradually appeared during the 1920s, the Parkway's practical value to the city proved different than planned. In essence, it helped to convey white-collar workers and executives by automobile from northwest Philadelphia and the suburbs to their jobs downtown with a minimum of distraction and delay. Along with the subways and the trolleys, it became another way—albeit a much more attractive one—of getting people from the new neighborhoods past the old industrial area into the vigorous and exciting central business district of the 1920s and 1930s.

Philadelphia's original downtown was the Delaware River waterfront, and the river was still an essential part of the central city when the photograph on page 202 was taken about 1928. A parade of ships, mostly freighters, marches past the busy docks, terminals, factories, and refineries on both sides of the river. The city had about 250 wharves during this period, including nearly 200 on the Delaware. The view also reveals how the downtown developed westward with progressively taller and newer buildings from the waterfront to City Hall. South Philadelphia's immigrant neighborhoods lie between the riverfront and the wall of office buildings. Recognition of the vital role of the port in the city's

economy, and strong competition from other East Coast cities, had recently led to a major improvement project. Between 1898 and 1912, the Delaware had been deepened and widened to provide a channel at least 30 feet deep and 600 feet wide, and some of the smaller islands in the river channel had been removed, easing the way up the river for large ships like those seen here. A related improvement was the widening of Delaware Avenue.

Built with funds from the estate of Steven Girard, the avenue was originally 50 feet wide between South and Vine. With accrued estate income and a city loan, it was widened to 150 feet at the end of the nineteenth century. The photograph at right, taken from Chestnut looking north, shows the two-year project nearing completion in April 1899. The largest building on the right, next to the river, is the Pennsylvania Railroad's terminal. On the west, or left, side the avenue

was lined with warehouses and storage facilities. Freight depots and terminals faced them along the river. Delaware Avenue thus provided Philadelphia's downtown with its traditional economic base and a well-defined eastern border.

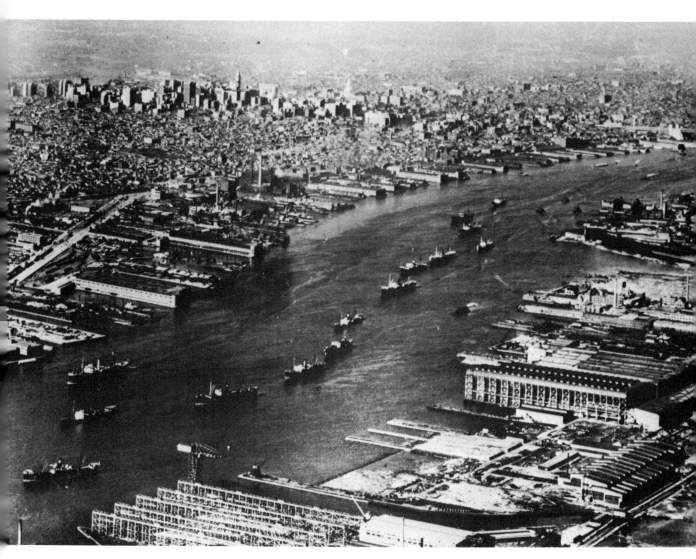

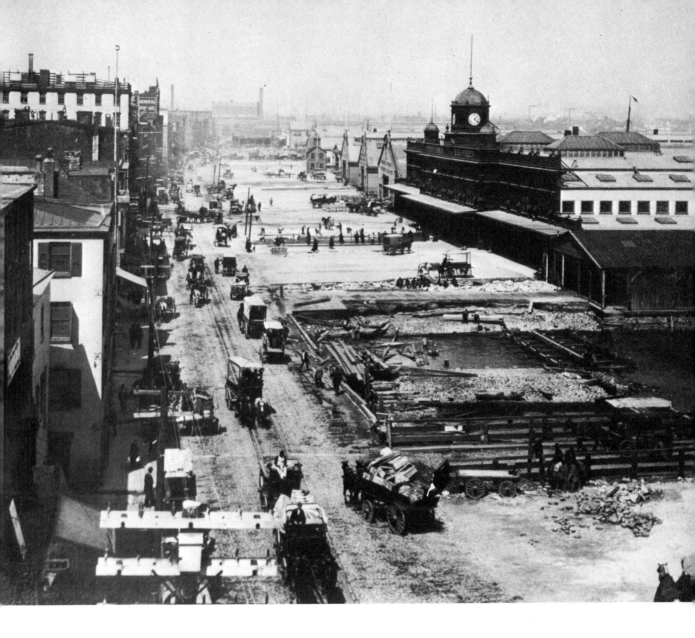

Fresh produce could be delivered directly from the ships into downtown Philadelphia. Delaware Avenue and Dock Street, pictured in these three photographs, were the centers of both wholesale and retail trade. The photograph above shows the Dock Street Market in October 1920. Dock Street stretched only three blocks, from Sansom to Spruce between Water and 3rd Streets, but it effectively monopolized a vital part of the region's produce supply until after World War II. The market was generally busiest between midnight and eight in the morning, when fruit and vegetables were loaded from warehouses to trucks in the kind of crowded confusion depicted here. By noon the street was usually quiet. More normal hours were kept by the two retail stands on Delaware Avenue, photographed by the City Parks Association in 1918. The stands were across from the Pennsylvania Railroad terminal, at the foot of Market Street. Their lush offerings of such exotic items as bananas, pineapples, and Lucca olives undoubtedly depended on the nearby docks. But photographs like these also reveal other facts about both their subjects and their creators. Wartime patriotism is illustrated by the poster and the flag fluttering over one of the stands (opposite, top). That stand also advertises a "Long Distance Telephone" in the building as an added attraction, and both stands offer such extras as briar pipes, rolls, cigars, and wicker baskets. The Association that photographed these stands labeled them "Sidewalk Nuisances," probably the last label anyone would apply today. For us they seem just the kind of enterprise that kept the old downtown vital and alive.

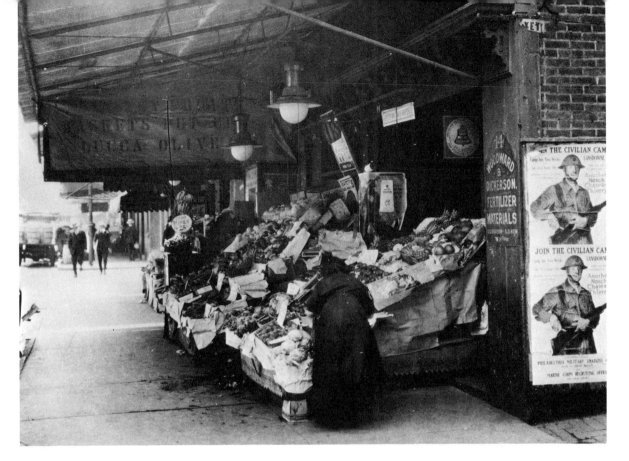

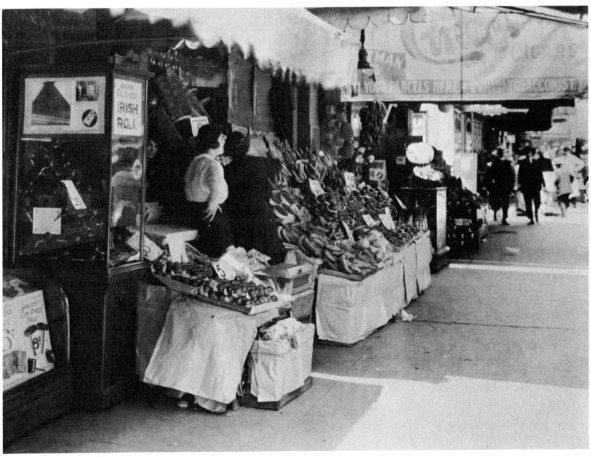

When the Benevolent Protective Order of the Elks held their convention in Philadelphia in 1907, the intersection of 8th and Market Streets was decorated appropriately, complete with a stuffed elk. He guarded the entrance of Lit Brothers' Department Store, but the building in the center of this celebratory photograph was Strawbridge and Clothier's. With Gimbel's, whose facade is visible to the left, these three relatively new stores anchored Philadelphia's downtown at the turn of the century. Retail shops lined Chestnut and Walnut, but the new department stores were the real palaces of commerce. The sense of exuberance displayed in the architecture and decorations seen here was a genuine reflection of east Market Street during its greatest period of growth and change. A more distant perspective on the same street is provided in the photograph on the

following page, a view from City Hall tower taken in 1911. This typical example of one kind of urban photography shows us the downtown before the skyscraper. None of the office buildings, warehouses, factories, or department stores exceed ten stories. The largest structure is Reading Terminal, with its huge train shed. As striking as the height of the buildings is their concentration. The entire area to the river was filled with commercial and industrial structures, including the neighborhood north of Race Street on the left. Clearly any expansion had to be either elsewhere or higher. The photograph on page 209 shows that it was both. The new downtown is seen taking shape behind the old in a 1912 view from 19th Street east to City Hall. The small businesses typical of west Market Street in the late nineteenth century are dwarfed by both the Pennsylvania Railroad's train shed and the new office towers. Already visible here is a continual line of tall buildings along 15th and Broad from Market down to Walnut. The three downtowns visible in these photographs—east Market, south Broad, and west Market— thus summarize the changes in the city's commercial core in the first decades of the twentieth century.

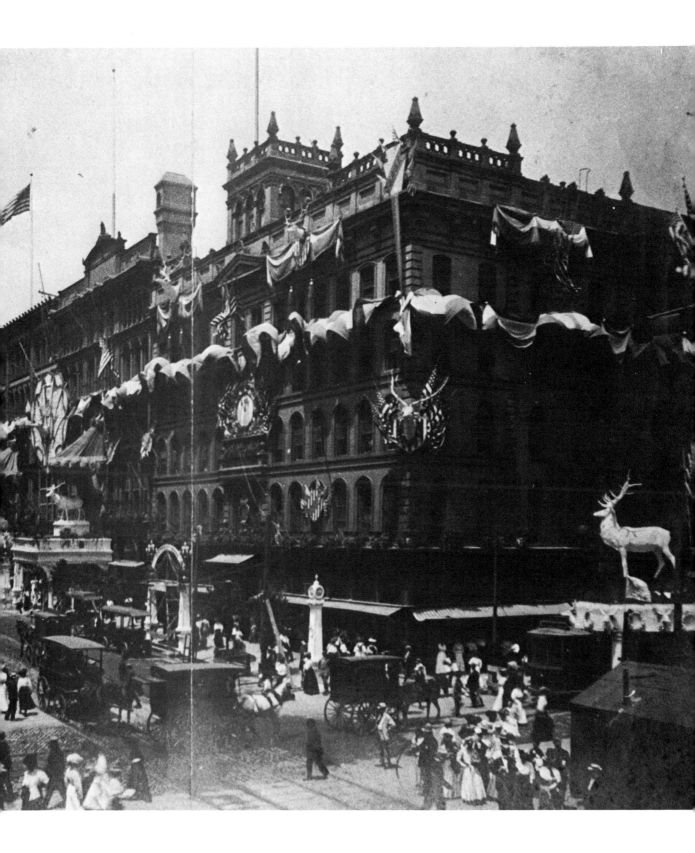

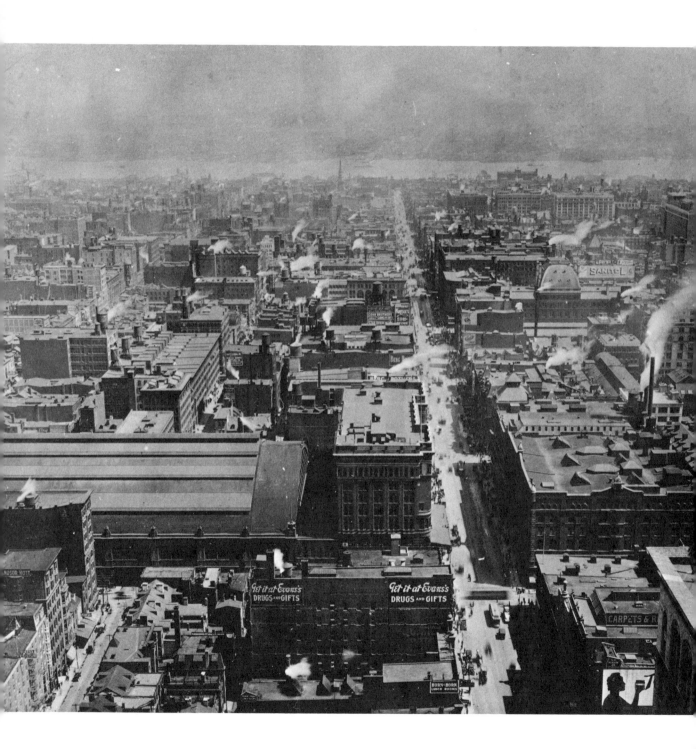

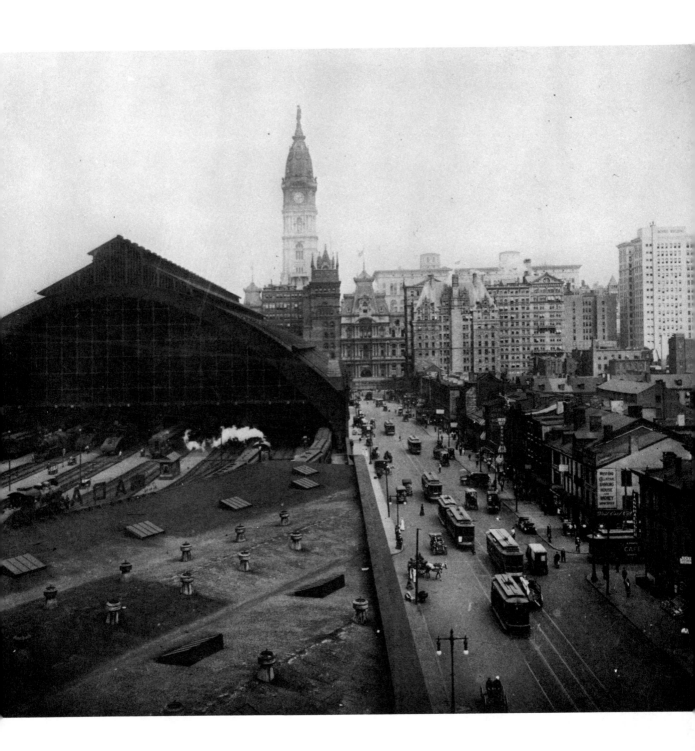

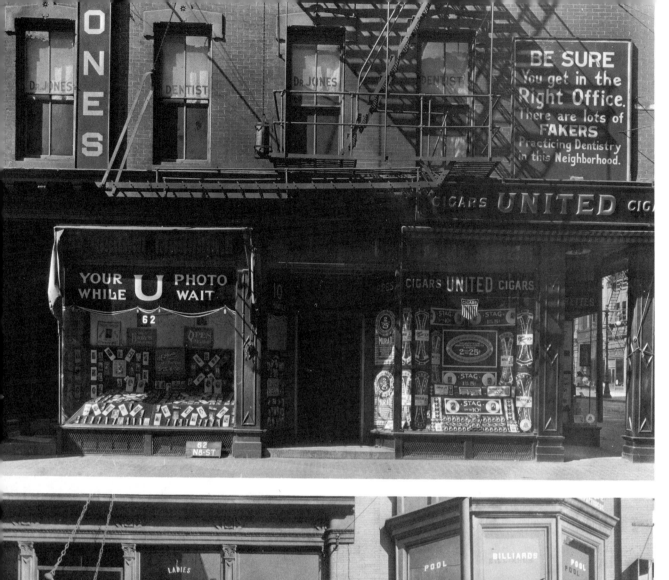

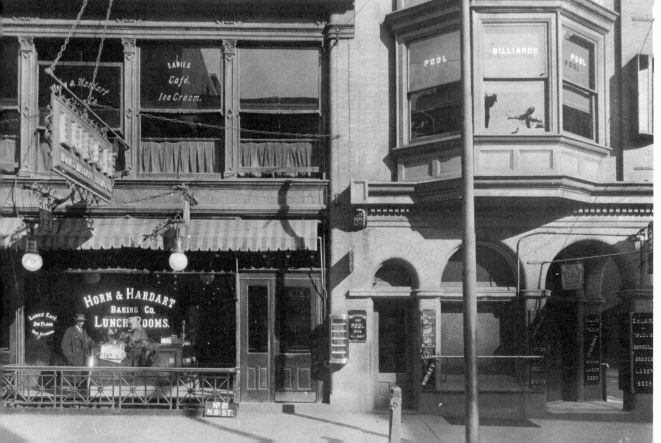

Downtown life depended as much on thousands of small shops and businesses as it did on enterprises like department stores and hotels. The two photographs at left were both taken by a city photographer on the same day in March 1915. Three typical downtown businesses located on 8th Street above Market are depicted in the top one—a dentist, a cigar store, and a photo shop. Cigar stores were especially common downtown, and chains like United had shops all over the city. Unregulated dentistry was also common. But modern city life is best symbolized by the photo shop, with its premium on speed, a forerunner of many other quick-service shops to come. The bottom picture was taken a block away, at 9th and Filbert. Horn and Hardart's also catered to the hectic downtown lifestyle, but the ladies' lunchroom upstairs reminds us that while respectable women could work downtown, their social life was still limited. They certainly would not have been found in the adjacent poolroom. This photograph was taken less than a block from the heart of the tenderloin, and the poolroom might have marked a general demarcation line between legitimacy and illegality. The photograph at right, also taken in the mid-teens, shows the 100 block of South 13th Street, just below Wanamaker's. The store in the background, the heavy traffic, the well-dressed people (including even the newsboys), the signs advertising both tailoring and medicine, and the evidence of light manufacturing and immigrant enterprise all testify to the variety of activities that comprised the downtown.

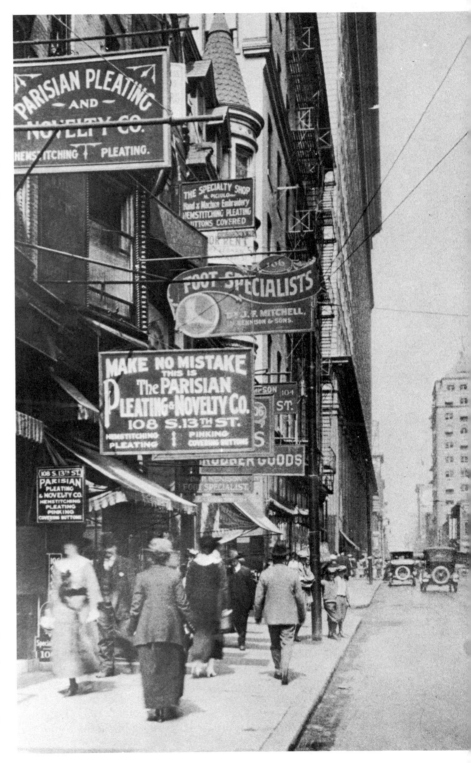

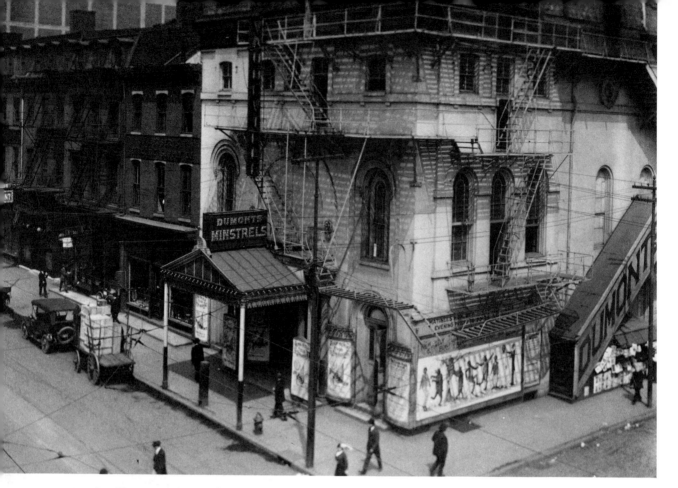

Vaudeville, minstrelsy, and burlesque flourished in Philadelphia, and the tenderloin was an integral part of the downtown. The photograph above shows Dumont's Minstrels' Theater at the corner of 9th and Arch in 1914. Black minstrelsy dated back to the 1840s in Philadelphia, and by 1914 there were three major minstrel shows on Arch between 9th and 11th. This one had been established as the American Museum, Menagerie and Theater in 1870. Minstrelsy was eventually displaced by vaudeville and the movies, but burlesque was more enduring. The photograph opposite, top, was taken near 10th and Arch during World War I. The Trocadero had recently switched from minstrelsy to burlesque; it proved to be the city's longest-lasting burlesque house. In both of these photographs,

the integration of the "vice" area with everyday life around it is evident. But the tenderloin did have a less acceptable side, illustrated by the Fremont Hotel at the corner of 8th and Race, photographed in 1915 (right). Small hotels in this neighborhood were commonly used for drugs and prostitution, perhaps accounting for this official city photograph. Next to the Fremont Hotel was the Bijou Theater, barely visible on the left of the picture. Opened in 1899 as a vaudeville theater, the Bijou switched to burlesque about 1910. While most Philadelphians considered the theaters on Arch Street marginal but legitimate entertainment, there was no such acceptance of the services provided in the hotels and rooming houses nearby.

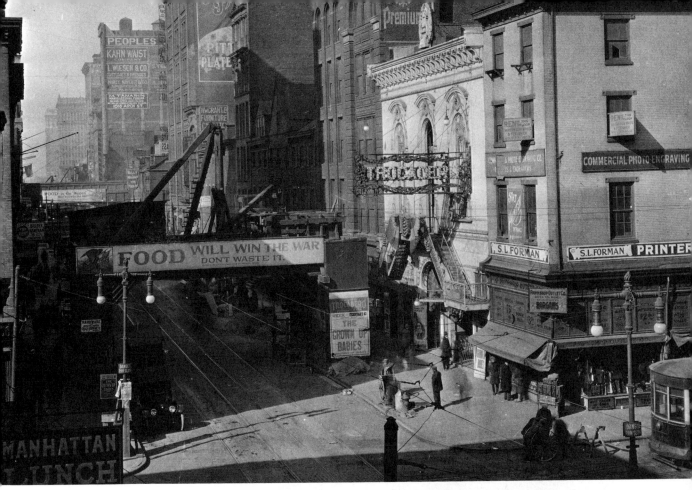

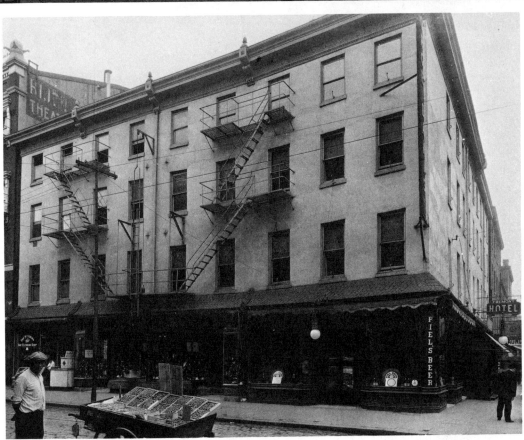

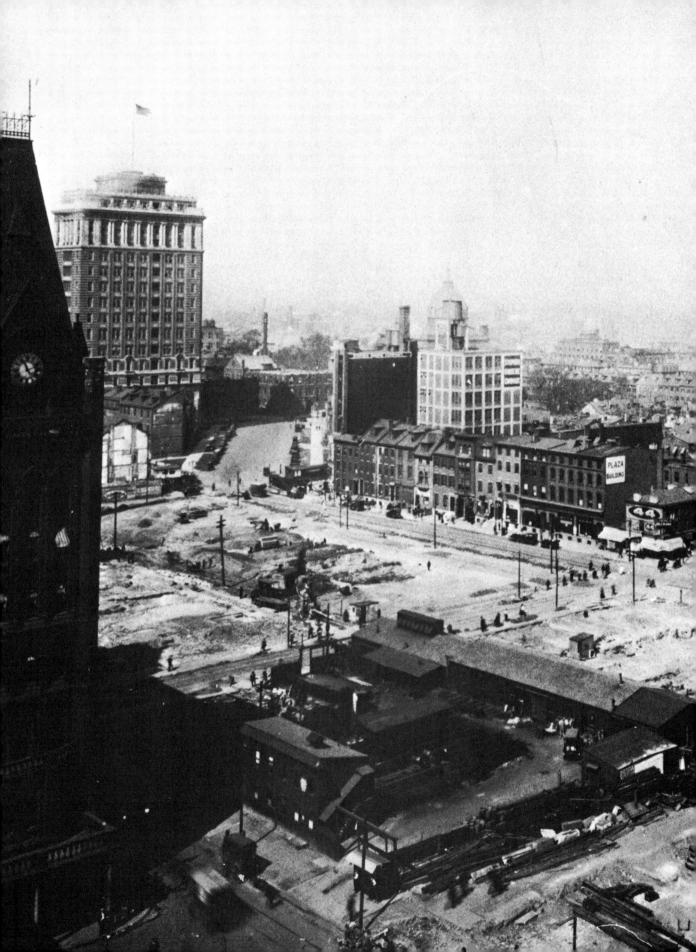

To the west of the tenderloin, a swath was cut out of downtown Philadelphia for the building of the Benjamin Franklin Parkway between 1907 and 1918. The area from Fairmount Park to Logan Square was the first to be cleared, followed by the section near City Hall. In this photograph, dating from about 1915, the blocks from Arch to Filbert between Broad and 16th have just been razed, but the block immediately to the northwest is still intact, with the Medico-Chirurgical Hospital and Dispensary just visible. The mixture of buildings that remains on the north side of Arch was typical of that removed below Logan Square, which now became Logan Circle. The Insurance Company of North America's headquarters, one of the first office buildings specifically designed for the Parkway, rises 18 stories behind a neo-Gothic turret of the Broad Street Station. As depicted on the next page, the completed Parkway of the mid-1920s was just over a mile long and 140 feet wide. It was ornamented in the proper Second Empire manner with fountains, statues, and benches. Cultural institutions were meant to line the Parkway, but construction of these lagged. The Art Museum was built wings first to ensure completion of the whole structure, which finally occurred in 1928. The Free Library (seen here on the right of the Parkway behind the cathedral), the Rodin Museum, and the Board of Education Building soon followed. But although this photograph was designed to show the Parkway as a monumental boulevard, it shows better that the Parkway became a broad highway connecting downtown Philadelphia with the northwestern and western suburbs. The photograph on page 217, with the completed Art Museum in the background, depicts what was considered expendable in the Parkway's creation. Since the extension of the Pennsylvania Railroad through to the Broad Street Station, the old industrial and residential area north of the tracks had deteriorated rapidly. This scene shows the area around 22nd and Vine Streets, with the Keebler factory in the foreground and St. Hedwig's Church behind it at 23rd and Wood. The completion of the Parkway left the neighborhood to languish for decades as an isolated, blighted enclave whose residents were unaffected by the grand cultural institutions so close at hand.

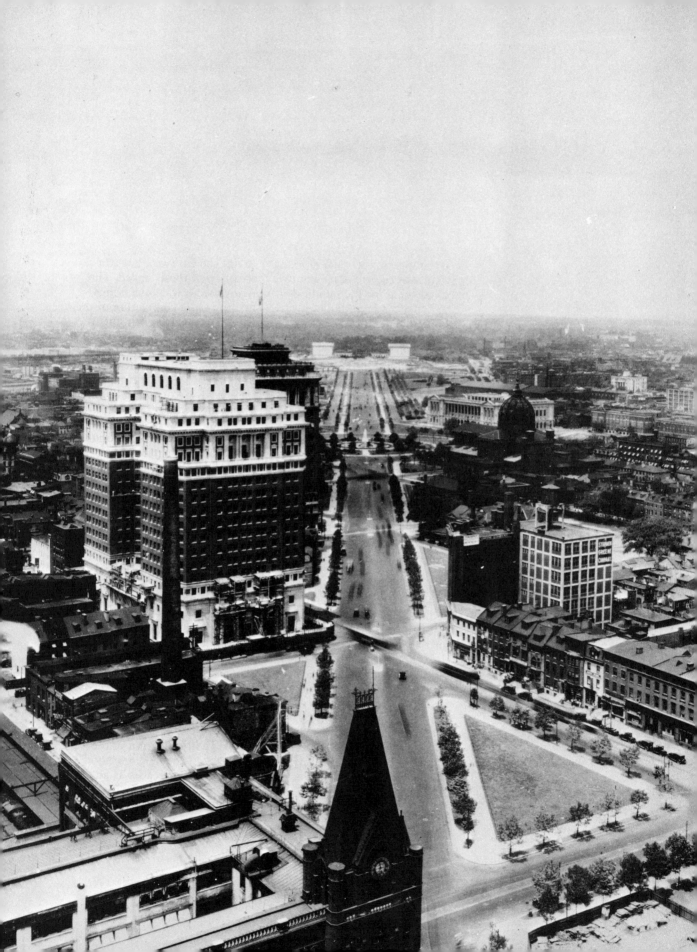

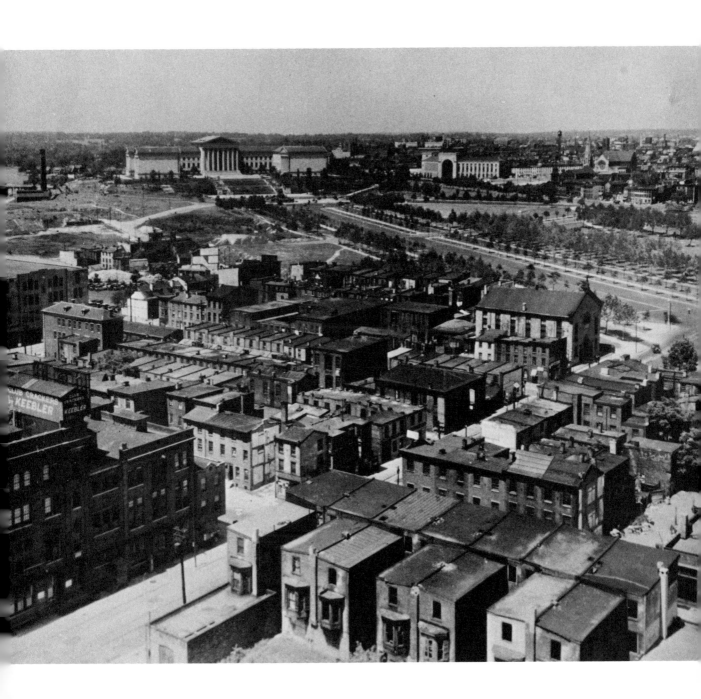

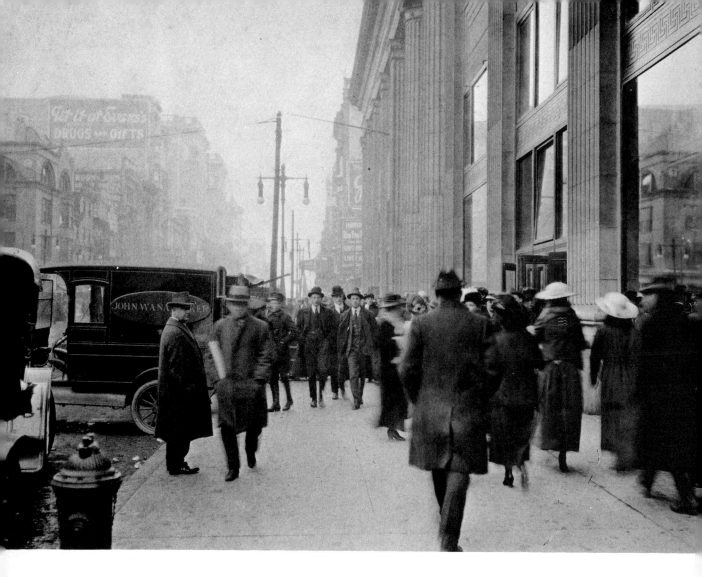

Crowds gave the city's center its special atmosphere. Shoppers, office workers, and visitors filled the streets, providing the downtown with a sense of excitement and vitality combined with individual anonymity. The photograph above was taken in front of Wanamaker's about 1914. The people entering the store and walking on Market Street exhibit the most typical downtown characteristics—they are well dressed and in a hurry. The photograph also indicates an interesting contrast between men's and women's fashions. Certainly the two men marching purposefully down the street at the center of the photograph would have been at home in front of Wanamaker's any time during the next six or seven decades. The photograph at right, taken two decades later in the early 1930s, is a view of Market Street looking west from 10th Street with the Earle Theater in the foreground. In the time since 1914 the downtown had been adorned with skyscrapers and tunneled under by subways; and congestion had increased accordingly. Crowds of shoppers and commuters became a familiar signature of America's big cities, and this kind of photograph— the downtown as a river of people—was quite common. This scene also reminds us that, despite the Depression, which hit hardest at the old heavy industries, Philadelphia's downtown remained a comparatively healthy center of office work, shopping, and entertainment throughout the 1930s.

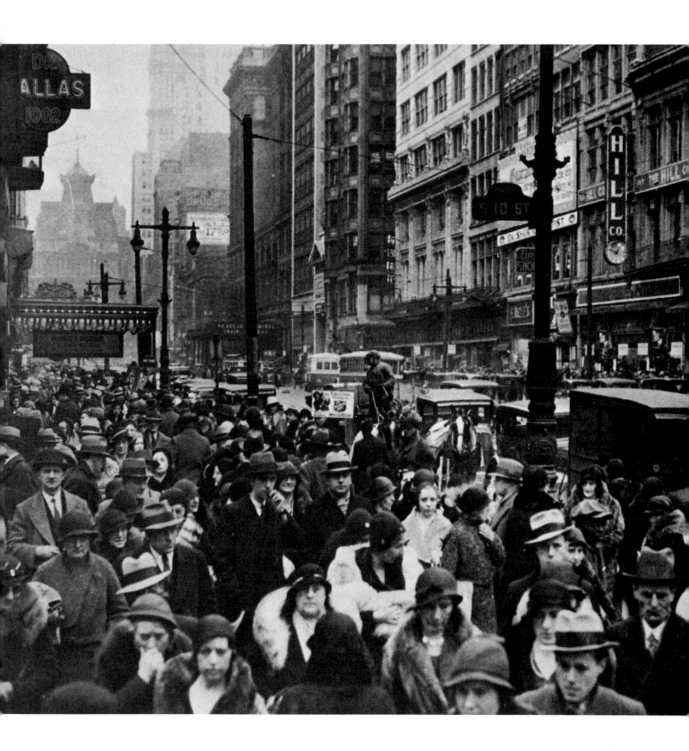

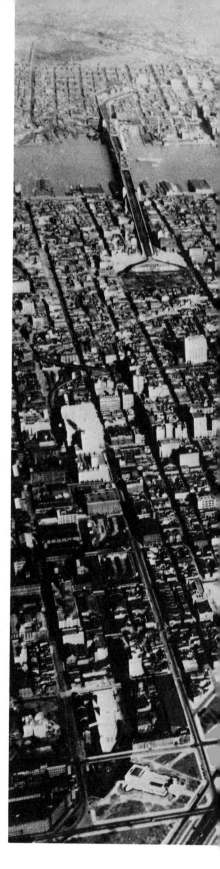

All the elements of a monumental American downtown had been assembled in Philadelphia when this aerial photograph was taken in 1930. The street layout may have been 250 years old by then, but virtually everything else that captures the eye here was the work of the last four decades. A forest of skyscrapers stretches south and west of City Hall, with smaller offshoots along North Broad Street and near Independence Hall to the east. At the northern edge of the downtown are the two new automobile routes—the Delaware River Bridge and the Benjamin Franklin Parkway. Such physical achievements were the conscious theme of photographs like this one, designed to show how a new city had arisen in the heart of old Philadelphia. But this photograph tells us more than it was meant to. For one thing, there is the contrast between the northern and southern edges of the downtown. To the north a buffer of factories, railroads, depots, and warehouses stretches from the Delaware all the way across the Parkway to the Schuylkill at the bottom of the picture. To the

south, the downtown ends abruptly but unevenly. In the absence of a buffer zone, skyscrapers quickly give way to row houses, and luxury high rises give place to immigrant back streets within a very few blocks. Except for the new cluster southwest of City Hall, Philadelphia's downtown had expanded within fairly narrow corridors: between Market and Locust Streets and along Broad Street. The result is evident here—the sea of row houses comes right up to the edge of the central business district. But by 1930 work and home had become separated. Despite this physical proximity, most people who worked in the new downtown lived outside of the scope of this scene, and the row house residents usually had little to do with what went on in the neighboring skyscrapers. Ensuing decades would reveal that this situation was neither healthy nor stable.

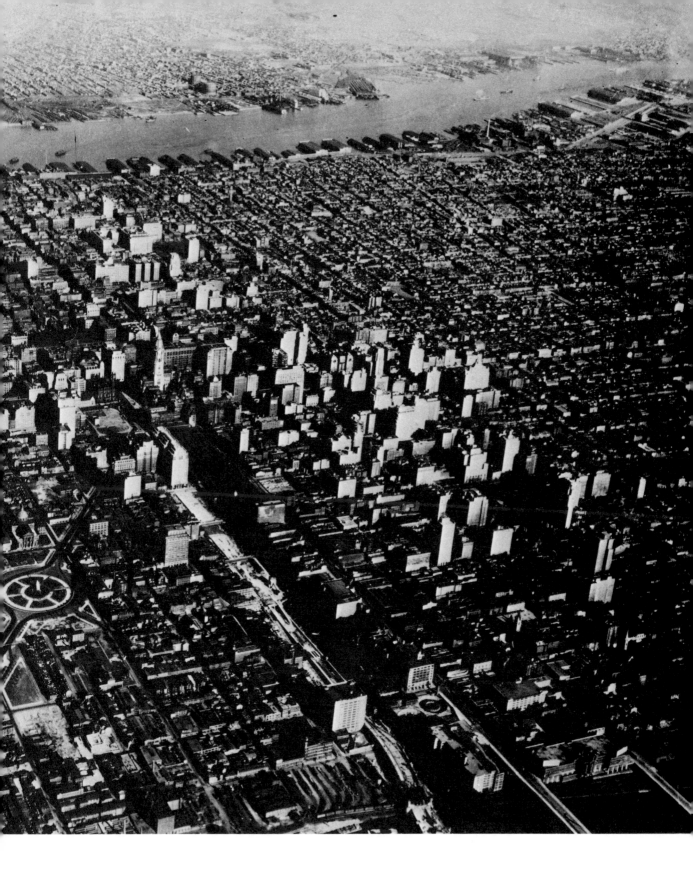

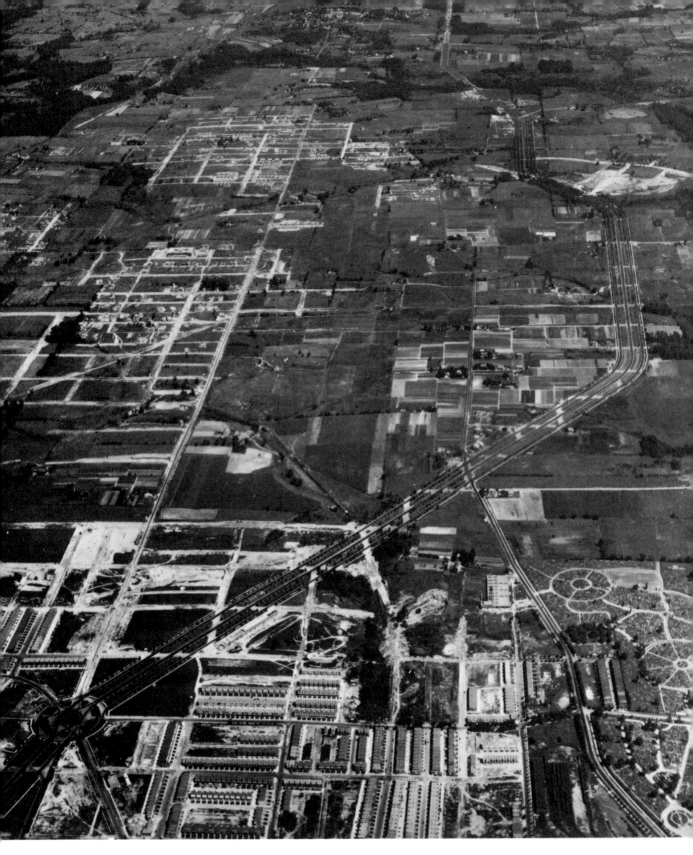

Urban growth in the twenties:
looking northeast along Roosevelt
Boulevard and Castor Avenue from
Oxford Circle, September 1927.

The New Philadelphia

Philadelphians created a new city for themselves between 1890 and the beginning of World War II. This new Philadelphia was home to a million people and spread over a much larger area than the old city that it surrounded. The continual building and expansion gave Philadelphia a sense of vitality and dynamism throughout the period. Some of the new neighborhoods continued the old pattern of mixed residence and industry, but most were exclusively residential. Some of the new neighborhoods could be defined by the class or ethnicity of the majority of their residents. But regardless of their ethnic makeup, these communities were organized around modern patterns of shopping and commuting, and dominated more by private life in the home than public life in the street.

Though the city expanded steadily throughout this period, the years just before and after World War I marked a transition to a new kind of growth. From the early 1890s to the early 1920s, Philadelphia's population grew at a rapid pace, and while the city's physical expansion kept pace with this growth, only in West Philadelphia and upper North Philadelphia west of Broad Street was there a spectacular extension of the built-up area. In contrast, from the effective end of European migration in 1924 through the start of World War II, Philadelphia gained little population, but its developed area spread out far to the north, northeast, and southwest. In this new expansion, advances in technology translated social divisions into physical separation. The first period was dominated by the trolley, the second by the much faster elevated, subway, and automobile.

In the earlier decades, up to the 1920s, home construction outpaced population growth, reducing overall density. Upwards of 8,000 houses a year were built in the quarter-century before World War I, about 90 percent of which were two- and three-story row houses. While the typical two-story house with indoor plumbing, a porch, and a small back yard was just out of reach of most industrial wage earners, enough skilled workers, small businessmen, and white-collar workers could afford them that by 1910 over a quarter of all Philadelphians owned their own homes, and many thousands more were paying off relatively short-term mortgages. As people moved into new homes, their houses in the older neighborhoods became available for rent to others who were poorer or who had arrived in the country more recently.

Every year developers purchased more farms and estates, and the urban frontier advanced a little further. The 1890s saw a fairly even advance in all directions, with industrial

areas like Kensington and Nicetown growing as quickly as more exclusively residential districts like Strawberry Mansion and Haddington. After the turn of the century, the Market Street Elevated accelerated development in West Philadelphia; between 1900 and 1920, the population of West Philadelphia more than doubled, to over 350,000. The El shifted the center of West Philadelphia south, away from Lancaster and Haverford Avenues, as new areas along Market Street opened up for commuters to the growing downtown. Other sections of steady but much less spectacular expansion in this period included the textile and manufacturing centers of Richmond, Tioga, and Nicetown, and South Philadelphia west of Broad below Wharton Street. This rapid expansion of the row house city took its toll on rural Philadelphia. In 1890 the city boasted some 800 farms totaling 33,000 acres. Thirty years later, both figures had been halved.

Most of the new building before World War I created what are sometimes called "streetcar suburbs" within the city limits. While the older industrial/residential pattern was still being recreated around specific rail or port centers, the streetcar suburbs emerging in North and West Philadelphia represented something altogether different. These were areas almost devoid of industry, in which most people made their living by providing local services or by working in downtown jobs that they commuted to by trolley. The new relationship between jobs and homes was complemented by new ways of shopping. Market houses, curbside markets, and pushcarts were rare. As early as the turn of the century, mail-order sales, grocery chains, and downtown department stores were transforming shopping habits in the new neighborhoods. Storefront dwellings were still common, and shopping strips remained the centers of community socializing. But such strips were fewer and more concentrated than in the older parts of the city, and there was much less activity outside on the street as compared to inside in the stores. Finally, the new neighborhoods also had a distinctive ethnic makeup. People of British, German, Irish, and other northern European backgrounds predominated to a much greater degree than they did in the city as a whole. Before World War I the new Philadelphia was far more a refuge from immigrants than an immigrant refuge.

That situation changed rapidly once the war and the short depression that followed were done with. Pent-up housing demand helped spark a surge of new construction that carried through to the onset of the Great Depression. But after a last spurt of immigration from Europe

and the American South, population growth gave way to population rearrangement, and that process carried on through the 1930s.

The housing boom of the 1920s added nearly 100,000 homes to the city's total. Most of the building was in North and Northeast Philadelphia, especially along the upper reaches of the Broad Street Subway and the Frankford Elevated, and in the area between them. Growth was rapid in neighborhoods like Olney, Hunting Park, Oak Lane, Lawndale, and Feltonville, and along Roosevelt Boulevard, Castor Avenue, and Frankford Avenue. The only other areas with comparable growth were Wynnefield, Overbrook, and Mount Airy. Expansion to the south and southwest, on the other hand, was slowed by poor drainage and water supply problems. Though only 20,000 homes were built in the Depression-wracked 1930s, the trends of the 1920s continued in the broad movement to the north and the expansion along the auto traffic corridors in the lower Northeast. But now the rest of the city was either shrinking or static. West Philadelphia gained only 50,000 people in the 1920s, and none in the 1930s. Between the rivers, south of Wingohocking Street and Frankford Creek, the city actually lost about 200,000 of its 1,250,000 people in those two decades. But beyond those limits to the north and northeast, the population increased in the 1920s from 250,000 to over 400,000, and rose further to nearly 500,000 people by 1940. Because of the rapid growth of this area, with its large lot sizes and dispersed development, the city's physical expansion seemed to accelerate even as its population increase slowed and then went into reverse.

Though the overwhelming majority of the homes built in the 1920s and 1930s were two-story brick row or twin houses, there was now more variation of style than there had been at the turn of the century. Houses affordable for middle-class families were often set well back from the street, their front lawns leading to an enclosed porch or an elaborate façade. Blocks in the new Philadelphia were often broken by driveways leading to garages, rather than by the hidden courts and alleys of the old city. Gas and electric appliances and hookups were available in most new homes. Of course the amenities varied with the price. After the wartime inflation was over, the average house price gradually fell from $8,500 to $6,500 through the 1920s. But because only about one-eighth of all Philadelphians made as much as $6,000 a year in the middle of that decade, the fragile boom of the twenties was sustained through credit,

Philadelphia in 1940.

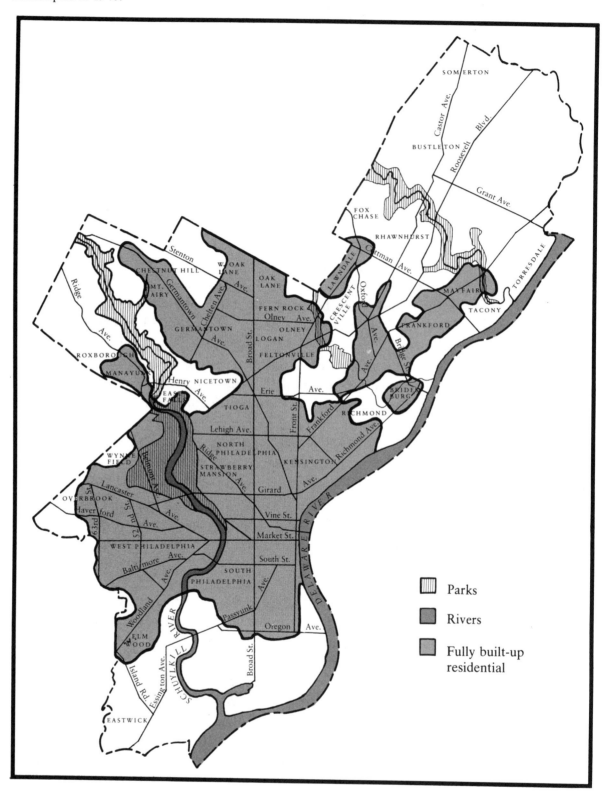

Parks

Rivers

Fully built-up
residential

second mortgages, and expansionary pressure from the savings associations. Just over half of all Philadelphians finally owned their own homes by 1930, and the city still led the nation in the number of home owners. But a striking internal contrast had emerged. In almost every neighborhood that had been developed before 1890, a majority of the people still rented. Exactly the opposite was true in the neighborhoods developed after 1890. Unhappily for many families, the Depression soon reduced that contrast, as thousands of mortgages were foreclosed and the proportion of homeowners citywide dropped well below 50 percent by the late thirties.

In the 1920s and 1930s, as the new neighborhoods emerged and the population of the old city fell, immigrant and black families were able to move out of their initial areas of settlement. In most parts of the city, residential turnover was high, with a majority of residents staying in one home an average of less than ten years. Though there was some movement of Italians to West Philadelphia and of Germans to Logan and Feltonville, the most visible migrations were undertaken by blacks and by eastern European Jews. Both lower North Philadelphia and northern West Philadelphia became one-third black by the end of the 1930s, with the latter area continuing to attract the higher-income families. As the black population increased, however, areas like northern West Philadelphia became much more homogeneous than they had been before. The Jewish migrations had a similar, though less dramatic, effect in such neighborhoods as Strawberry Mansion and Wynnefield. Eastern European Jews spread rapidly into newer parts of northern and West Philadelphia in the 1920s and 1930s. The contrast between the Italian and Jewish experiences is particularly striking. While the immense Italian population of South Philadelphia remained almost constant in the 1920s, the Jewish population dropped by over 40 percent. Thus did the two largest of the new ethnic groups find different ways of accommodating to the growing city; one by dispersing through it, the other by extending its own central area out into previously open land to the south.

Yet most of the new Philadelphia remained in the 1930s what it had been at the turn of the century—a haven for the families of white-collar or skilled industrial workers, the middle class, and the descendants of immigrants from northern and western Europe. They left the older city to the blacks, the southern and eastern European immigrants, the poor, and the unskilled. Except for the manufacturing districts, which had still been expanding to the north and northeast up to World War I, the new neighborhoods were noticeably different from their

predecessors. They were far more physically homogeneous, as the two-story brick row house reigned virtually unchallenged. In place of the old farmers' markets and pushcarts, food retailing was dominated by chains like A&P and American Stores, which together had over 1,500 outlets in the city by the mid-1920s. Within ten more years, supermarkets and shopping centers like the one at 69th and Market had begun to appear as well.

Public and parochial schools, especially the high schools, also became focuses of local activity and identity in the new neighborhoods. Between 1920 and 1937, the city built twenty-four new junior high schools and eight high schools in expanding parts of Philadelphia, from Bartram High in the southwest to Olney High in the north. Given the absence of local industry and the relative weakening of the ethnic and religious bonds of the older communities, the schools filled an obvious need for neighborhood definition. It was, after all, precisely because they lacked such identifying characteristics as factory districts or market areas that the streetcar suburbs were considered so desirable. But the very nature of the new development guaranteed little long-term stability and cohesion. Ironically, the domestic attractions of the new Philadelphia thus assured a continual state of turnover and transition in the residential neighborhoods.

Rural Philadelphia in the early twentieth century was more than just open land waiting for development. Surrounding the ever-advancing built-up area of the city were distinct communities, ranging from old market villages and traditional estates to shanty-towns and shacks. Two such communities are depicted here. This photograph was taken in 1906 at 58th Street just below Baltimore Avenue, near the isolated cotton-mill village of Angora. The fence beyond the tracks to the left guards the Callaghan estate, built by the

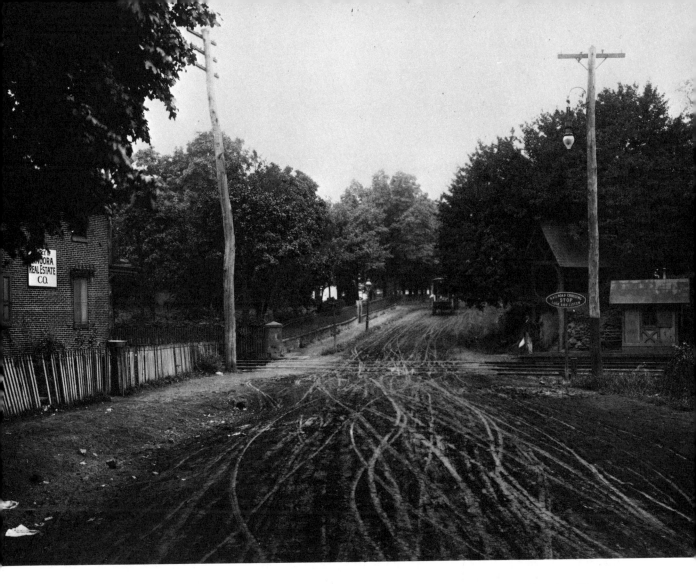

founder of the Angora mills during the Civil War. Across from the estate were the grounds of the Church Home for Children. But despite the unpaved road and encroaching forest, row house development had already advanced to 52nd Street and Baltimore Avenue, within half a mile of this intersection. As the Angora Real Estate sign suggests, the area was in transition. In less than a decade most of this land was also converted into row housing indistinguishable from the rest of West Philadelphia. A similar fate befell the very dif-

ferent neighborhood pictured on the next page. This was the "Neck," the open area of South Philadelphia below Moore Street. A place of rural poverty, wooden and tarpaper shacks, marshes, shantytowns, and squatters, it had a social life and customs all its own. Pictured here is the intersection of two of its main roads, Stone House and Stamper's Lanes, in June 1924. The site is near the present inter-

section of 3rd and Bigler. The streetlights remind us that the built-up city was already only a few blocks away to the north and west. Though the drive to rid the city of this presumed nuisance began in earnest a few years after this photograph was taken, the last residents of Stone House Lane were not forced out until the mid-1950s.

Philadelphia's growth was spearheaded by transit lines, the appearance of which in open areas usually preceded home building by several years. Development often radiated far out along such lines before the less accessible areas between them were built up. Two of Philadelphia's most important areas of early twentieth-century development are shown opposite. Oxford Circle, the major break in Roosevelt Boulevard between Broad Street and Pennypack Park, is depicted in the top photograph, taken in 1913. The Circle was located where the new Boulevard met both Oxford Avenue, an old-fashioned toll road as late as 1904, and Forty Acre or Hartshorn Lane, later called Castor Avenue. In some plans, Oxford Circle was eventually to resemble Picadilly Circus or the Étoile in Paris. But its remarkable resemblance here to the kind of suburban development usually associated with the years after World War II indicates its true future. Fifteen years after this photograph was taken, Oxford Circle was surrounded by row homes and the Boulevard was part of U.S. Route 1, the main auto and truck route on the East Coast. The Frankford Elevated played a more modest role in the growth of the Northeast. The economic relationship between transportation and residential development was rarely captured as directly on film as in the 1915 photograph at right of Frankford Avenue and Bridge Street, the line's terminus. The advertised development only took off in the 1920s, and then mainly affected properties further beyond the El than Penn and Pratt Streets. The immediate area up to Bridge Street had already been developed by 1910, and was probably affected adversely by the noise and dirt of the El. The areas further up Frankford Avenue, within easy access of the El, benefited directly in the way advertised here.

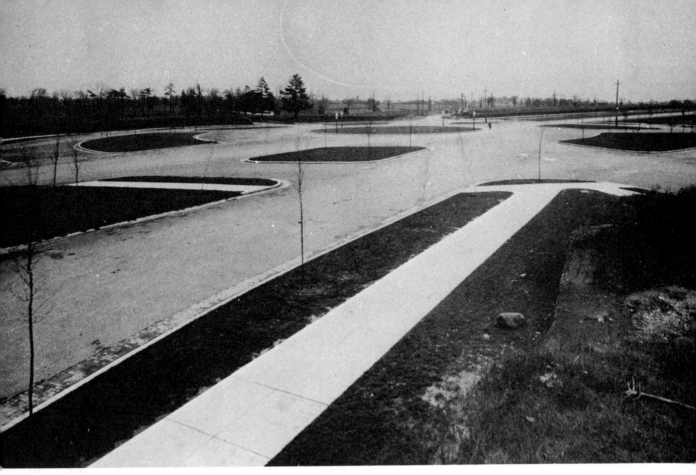

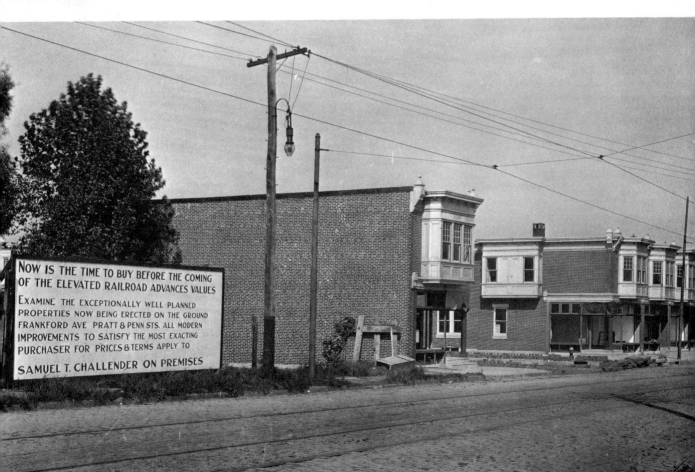

NOW IS THE TIME TO BUY BEFORE THE COMING
OF THE ELEVATED RAILROAD ADVANCES VALUES

EXAMINE THE EXCEPTIONALLY WELL PLANNED
PROPERTIES NOW BEING ERECTED ON THE GROUND
FRANKFORD AVE PRATT & PENN STS. ALL MODERN
IMPROVEMENTS TO SATISFY THE MOST EXACTING
PURCHASER FOR PRICES & TERMS APPLY TO

SAMUEL T. CHALLENDER ON PREMISES

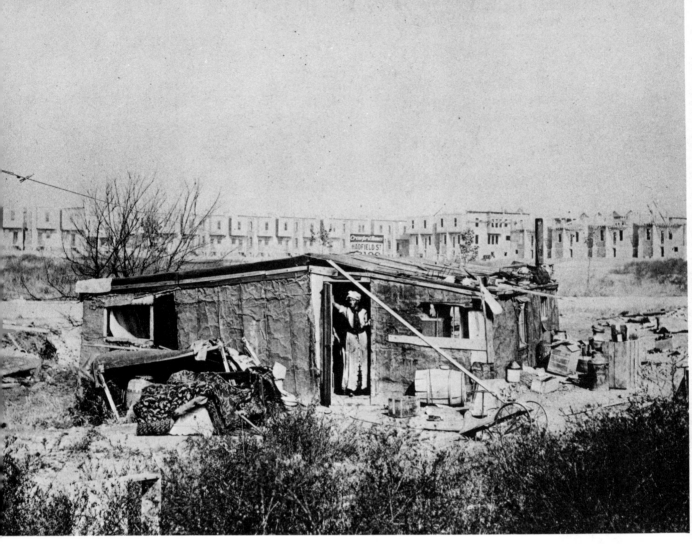

Row house construction was not done by the single house or even in sets of a dozen houses, but more typically in multiples of twenty-five, or the number that would fit on a small block. The sense of an inevitable, overwhelming advance that this produced is conveyed in the photograph above. It was taken in October 1915 in what used to be called "the dumps" near 57th and Willows in West Philadelphia. The two-story houses being built on Hadfield Street in the background were all on identical 15′ × 62′ lots. Within three years the shack in the foreground was gone, the land oc-

cupied by another block of similar homes. This part of southern West Philadelphia was a classic streetcar suburb, having almost no industry and a population primarily of British, Irish, and German extraction. The rapid development of the teens caused the population of the Forty-sixth Ward (Market to Baltimore, west of 46th Street) to double to 80,000 by 1920. But as the population became more homogeneous and middle class, the area's black population fell slightly. So the probable fate

of the woman in this photograph was symptomatic of the development of the whole area in the decade before World War I. The postwar housing boom is illustrated in the photograph on the facing page, taken by the Housing Association in the early 1920s. The caption noted proudly: "New Airlight Individual Homes—All Stages of Construction from Breaking Ground to Occupancy—Several Thousand Now Under Construction." To the Housing Association, these homes with basement garages seemed the ideal response of private enterprise to the needs of average families.

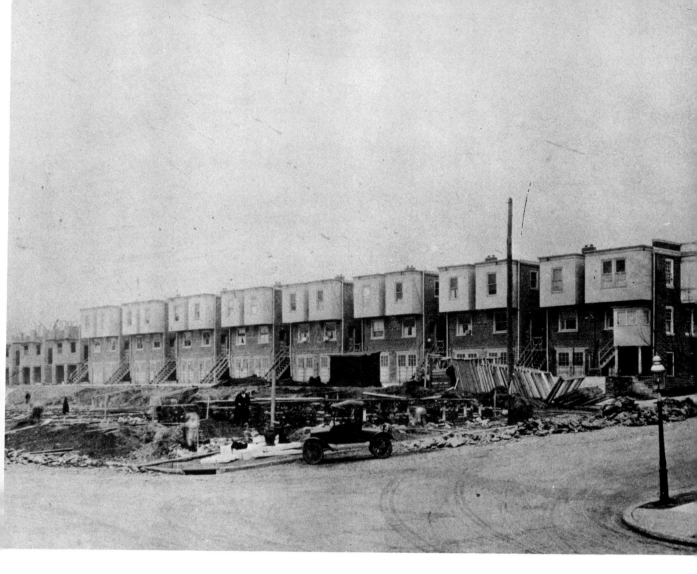

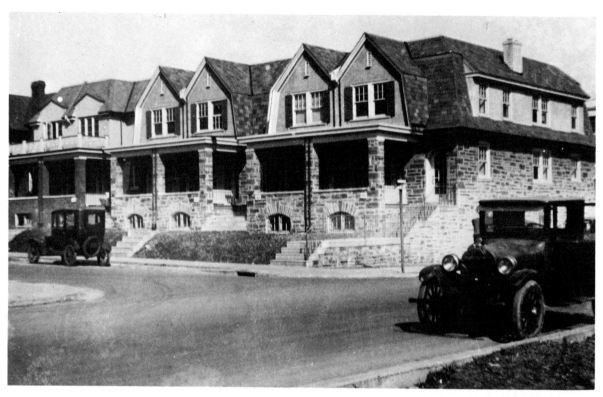

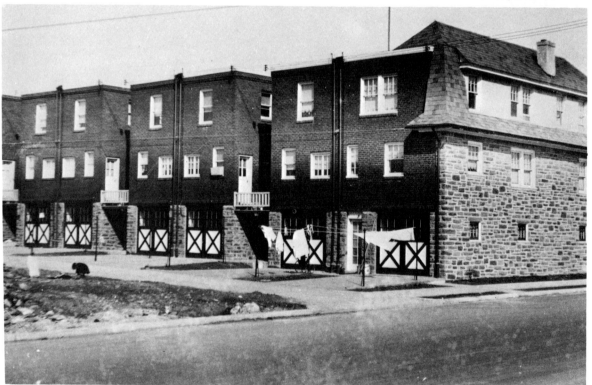

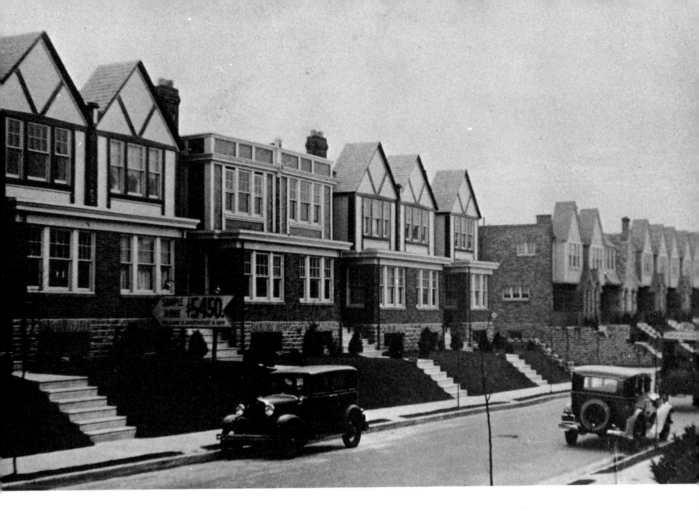

Most of the homes constructed in the twenties on the northern and northeastern fringes of the city were built for families of middle-class, white-collar commuters. The homes pictured on the facing page, located at 6100 Fairhill Street in Fern Rock, offered a hot water heater, basement garage, brick fireplace, and tiled bathroom. Financed with two mortgages, the homes could be bought new in 1927 for $8,100, or $1,400 down and about $50 a month. Seventy-five such homes were built by Wendelin Fisher & Sons across the street from the park named after their family. From the front these houses looked something like detached twins or single homes, but the rear view shows them for what they really were—row homes for the middle class, with a close resemblance to their poorer cousins downtown. Nevertheless, the semi-suburban environment and the Reading Railroad's Fern Rock station nearby made these homes attractive to many families. Further to the east, some less expensive homes offered in 1931 by William Davenport and Sons are pictured above. They were located at Elbridge and Tackawanna, not far from the corner of Levick Street and Frankford Avenue in the lower Northeast. Much of the area was still open land in the thirties, even after these houses were built. Besides listing the usual interior features, the developer's brochure noted that the number 66 trolley and the elevated put these homes only half an hour from City Hall, and emphasized that both public and parochial schools were within two blocks. In short, this was an ideal commuter suburb within the city.

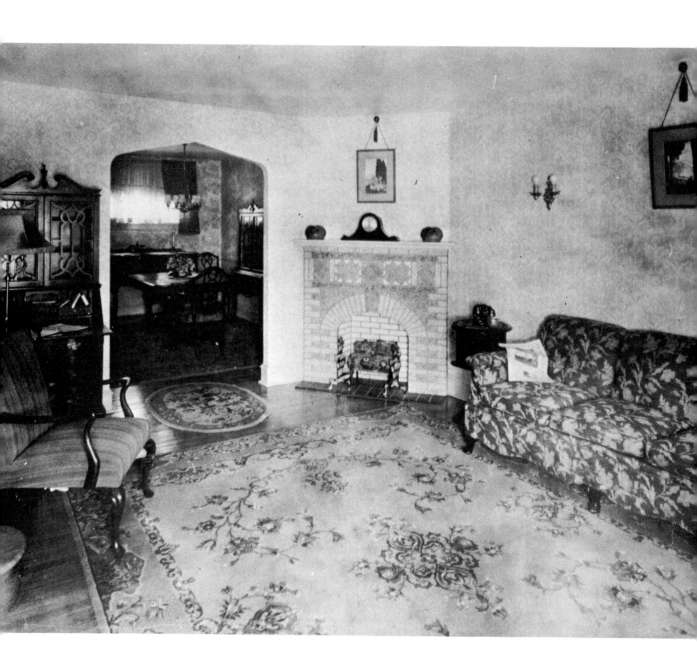

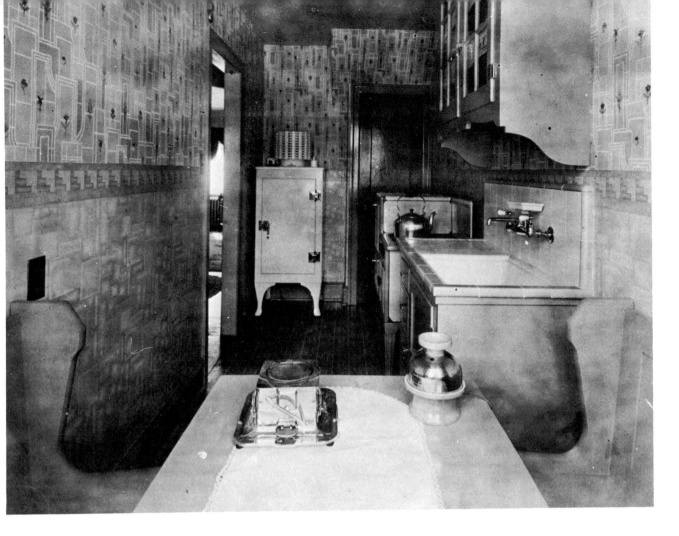

The ideal of middle-class domesticity in the new Philadelphia is displayed in these interior photographs of the "*Philadelphia Inquirer* Model Home." Offered for sale in 1931 by Davenport and Sons on the 4200 block of Barnett Street, these houses were only a block from the Elbridge and Tackawanna homes pictured on the preceding page. These three-bedroom detached twins qualified for the *Inquirer*'s annual model home competition because their $3,995 price tags fell within the means of the average family. Whether that family could also afford the rugs and furniture pictured here would be doubtful, especially in the Depression. However, these photographs do provide a guide to the popular expectations and aspirations of the period. The living room is filled with the symbols of modern technology, including telephone, radio, and electric lights in profusion (as well as a conspicuous copy of the *Inquirer* on the sofa). The obviously ornamental fireplace, complete with electric log, serves through its very uselessness to emphasize the modernity of the room. Though the combined kitchen and breakfast nook measured only about 6′ × 15′, it featured a gas range, an electric refrigerator and other electrical appliances, tile drains, and inlaid linoleum. The home had three bedrooms and a bathroom upstairs, a dining room, and a garage, all on a 16′ × 83′ lot. Unfortunately, the housing market of 1931 was dominated by foreclosures rather than sales, and for most Philadelphians the prosperity depicted here had to be postponed until after World War II.

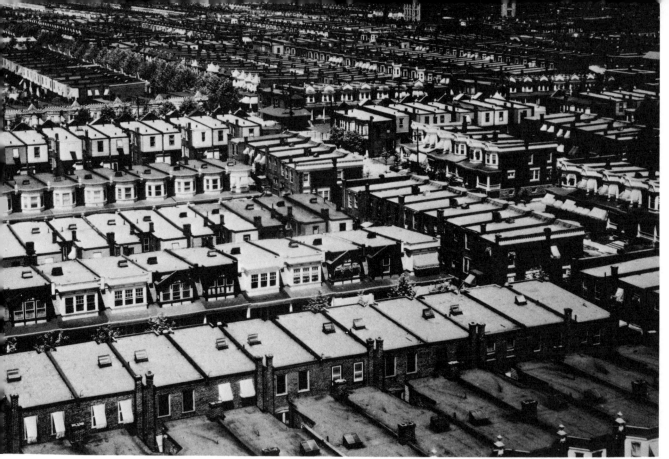

The new neighborhoods were surprisingly diverse despite the general uniformity of the row house structure. The photograph above was taken in July 1920 looking northwest from the roof of the new Misericordia Hospital at 54th and Cedar in West Philadelphia. In the immediate foreground are blocks of 54th, Yewdall, and Conestoga Streets filled with small row houses, all of which offered the small luxuries of porch and front lawn. This area had been developed about 1910 during the great building boom in southern West Philadelphia. There was no industry nearby, and the most prominent large building visible is the Hamilton Public School at 57th and Spruce, a not uncommon situation in the new neighborhoods. A much more elaborate adaptation of the row house form was found in the wealthier neighborhood of East Mount Airy. The top photograph opposite, taken in 1926, shows Montana Street, one of four similar garden streets developed in the twenties between Chew and Sprague Streets near Stenton Station. These large houses had enclosed front porches, extensive yards, and garages. Under construction in the background were the Stenton Plaza Apartments, which backed onto the Reading tracks. This was almost entirely a commuter suburb, with a negligible ethnic population and no significant industry, even along the railroad. In contrast, South Philadelphia was usually considered ethnic, industrial, and physically uniform, but the photograph at right disproves that stereotype. This street of twin homes along 18th Street near Shunk was part of a large development that filled about six blocks with similar houses in the first decade of the century. The area had been part of the Stephen Girard Estate, the legacy of which was Girard Park, three blocks to the west. The nearest industry was even further to the west, though the U.S. Army Quartermaster Depot was not far away, at Oregon and 20th. When this picture was taken in the 1920s, most residents were of the same northern European ethnic background as those in West Philadelphia, with an especially large Irish presence. There were as yet few Italians, though some movement was underway. With its tree-lined streets, its wide sidewalks, its fairly expensive homes, and its air of stability, this neighborhood on the southwest fringe of the old city was the epitome of a streetcar suburb—down to the two trolley lines intersecting at the corner.

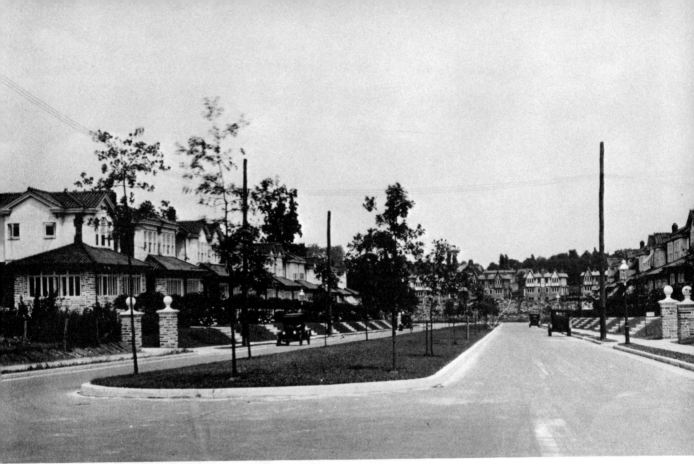

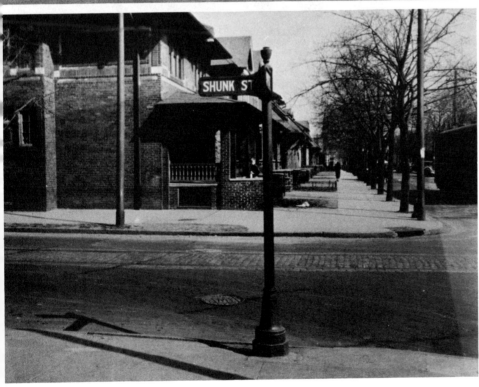

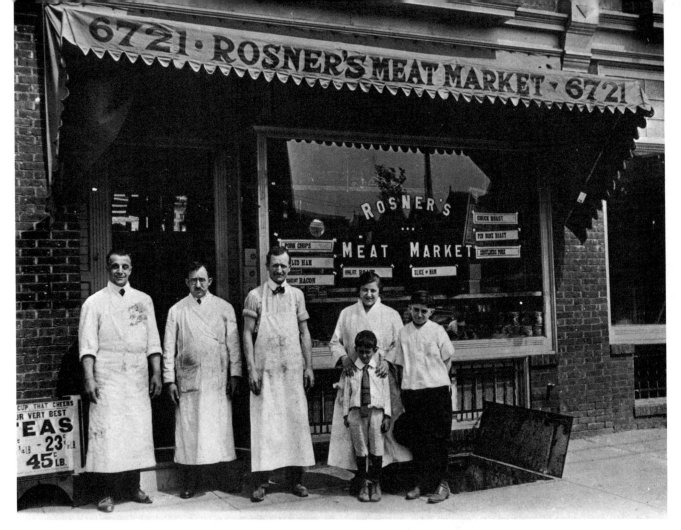

The hundreds of thousands of Philadelphians who moved to the emerging communities are badly underrepresented in the photographic record. Neither prominently rich nor colorfully poor, they eluded the attention of reform and commercial photographer alike, except for the standard posed studio portrait. Of course, people took photographs of their own families, but these rarely included their everyday surroundings. These photographs are therefore exceptional. The picture above is of Charles Rosner's Meat Market at 6721 Elmwood Avenue in Southwest Philadelphia, some time in the late 1920s. This is the same Rosner family pictured on page 159. The Rosners moved to Elmwood just after the neighborhood had been developed, and opened their business on the block betwen the brand new Tilden Junior High School to the east and the General Electric plant to the west. As Hungarian Jews, the Rosners were in a small minority in this predominantly nonimmigrant area. However, even in a community like this, it would not have been unusual for butchers and meat dealers to be Jewish immigrants. At right, Emil Reidel and family pose in front of their bakery at 58th and Vine Streets around 1905. Reidel had come to Philadelphia from southern Germany, via Switzerland, in 1890. After operating a bakery in South Philadelphia for ten years, he moved to the urban frontier in Haddington. This was one of the boom areas at the turn of the century, and Reidel was fortunate to open his shop only about three years before the completion of the Market Street Elevated gave a tremendous boost to the expansion of this part of West Philadelphia. Haddington soon became a white-collar commuter suburb. As in Southwest Philadelphia, most of the residents were either old-stock Americans or of Irish or German descent.

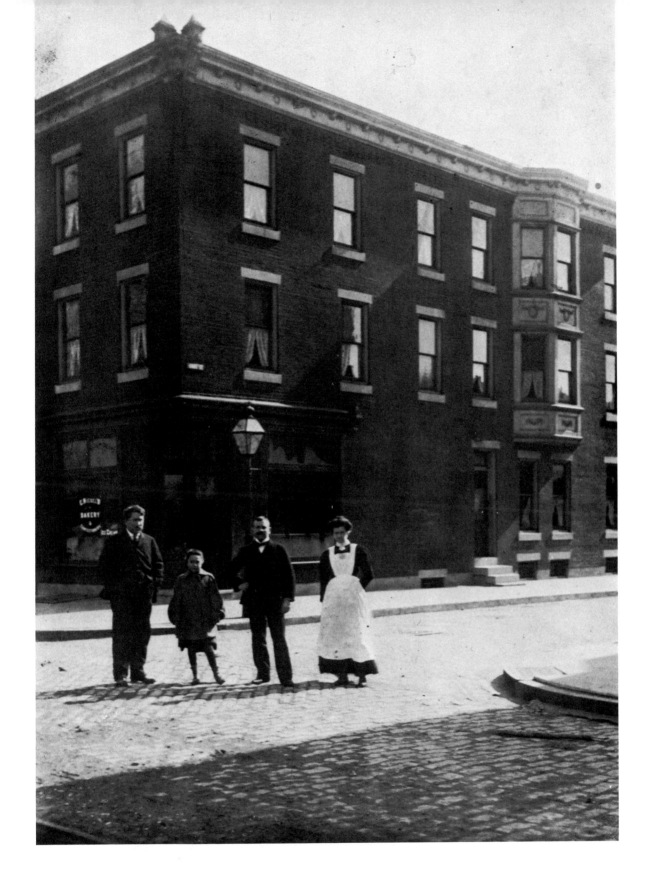

An exception to West Phila-
delphia's ethnic pattern was an
Italian enclave that developed in
Morris Park, not many blocks
northwest of Reidel's bakery. It
was here that the Ricci family,
pictured in these four photo-
graphs, settled. Antonio Ricci
came to Philadelphia in 1907,
four years after leaving the
Abruzzi, and followed his father's
craft of tailoring. The top photo-
graph at right was taken at his
family's first home in Phila-
delphia, 6433 Vine Street. It
shows Ricci's five children, as
well as a sign indicating the tai-
loring trade carried on inside.
The family had moved four times
within a very small area when
the middle photograph was
taken in 1915 at 529 North
Gross Street, near 63rd and
Girard Avenue. Family and
friends are shown in the small
back yard of the house. By this
time the growing Italian com-
munity had a formal center in
St. Donato's Church at 65th and
Callowhill. In the bottom photo-
graph, from the 1930s, two of
Antonio Ricci's now middle-aged
sons pose with fellow bocci play-
ers at the corner of 65th and
Girard. The photograph on the
facing page, taken in 1929, is a
relatively rare view of the neigh-
borhood's residents, unhappily at
the funeral of Antonio Ricci's
seventeen-year-old grandson
Tony. The funeral was a neigh-
borhood affair, for the Riccis
were by then among the senior
members of the ethnic commu-
nity. These last two pictures indi-
cate that a good deal of the
close-knit community life and
ethnic customs associated with
the older city survived behind
the bland exteriors of Morris
Park's suburban homes.

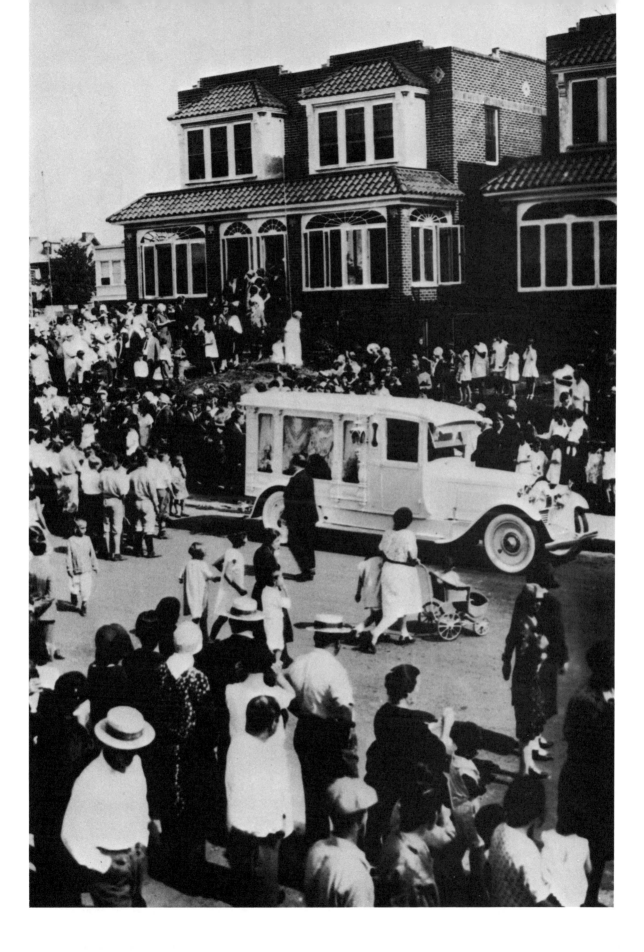

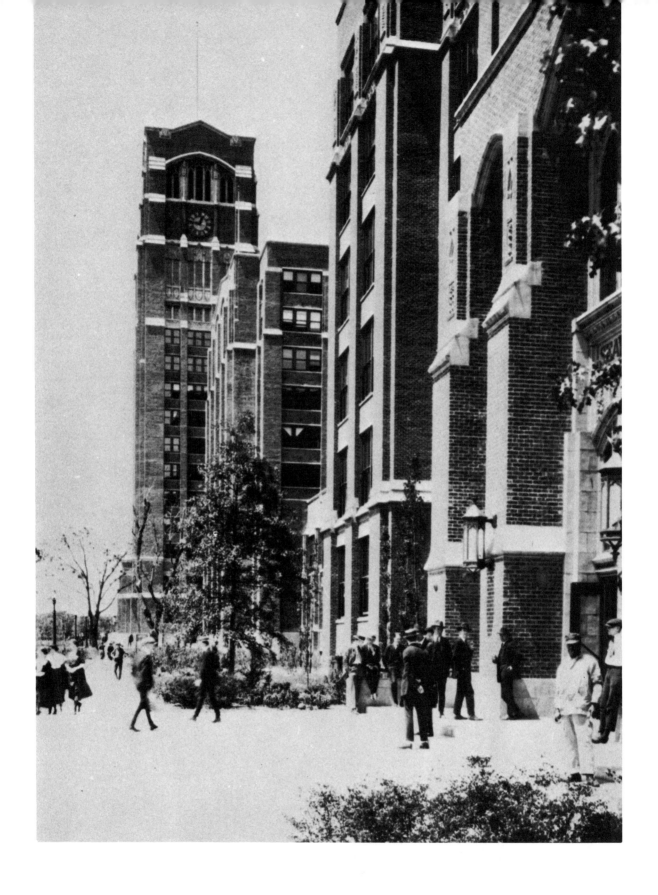

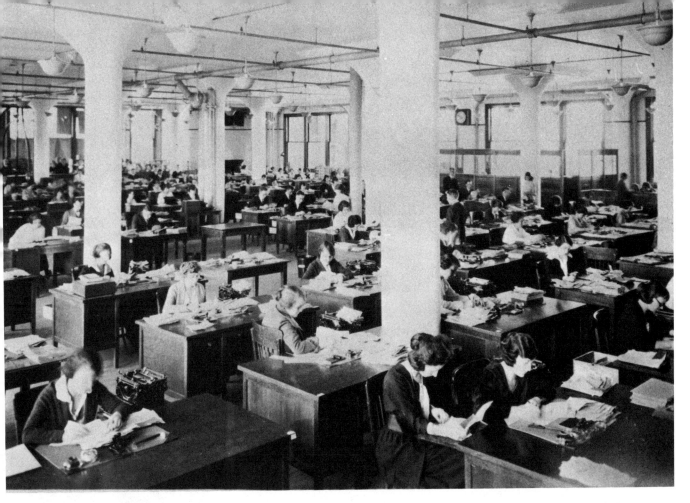

Working and shopping in the new Philadelphia were both dominated by changes in the American economy's ever-expanding service sector. A well-known local symbol of that economy, depicted in the photograph at left, was the Sears, Roebuck regional headquarters, store, and warehouse at Adams Avenue and Roosevelt Boulevard, completed in 1920. There were seven buildings in the complex, with the central tower rising fourteen stories. The buildings were constructed on the very edge of urban development, and well into the 1930s there were large undeveloped tracts nearby. The interior view above shows part of the predominantly female work force. This was white-collar work performed under in-dustrial conditions, as thousands of mail orders had to be received, filled, and sent out by highly specialized workers in a minimum of time. Nevertheless, both views reveal that Sears provided residents of the adjacent neighborhoods with a much more attractive work environment than had the old industries. The new shopping strips were also much less cramped than their older counterparts, as the 1938 photograph of Broad Street near Rockland Avenue in Logan illustrates (next page). By then this neighborhood was about thirty years old, and was a well-established middle-class community. Looking south from just below the Logan station, the neighborhood's main business area reveals some interesting combinations. While most of the small stores lining both sides of Broad Street were individual operations, there was an American Stores grocery and a Woolworth's between the florist in the foreground and the seafood store towards the back. Most of the shopping was done inside the stores, but there is still a surprising amount of merchandise out on the street. Hunt's Rockland Theater reminds us of the vitality of local movie houses in the late 1930s, while the only other large buildings visible, the telephone company and the garage, underscore Logan's modern character. With the Sears building, they represented the service economy of the mid-twentieth century, not the industrial economy of the nineteenth.

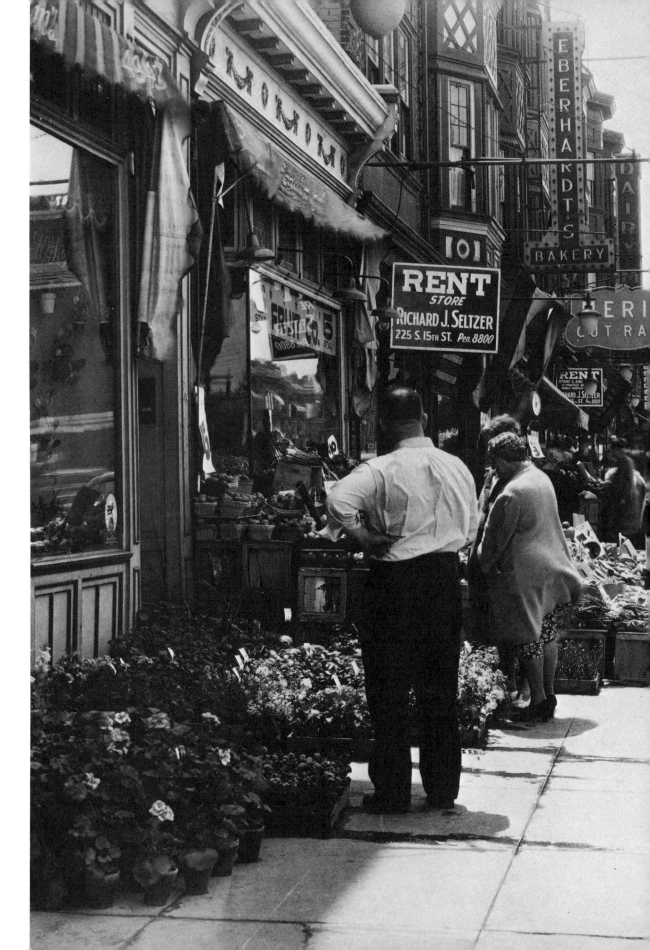

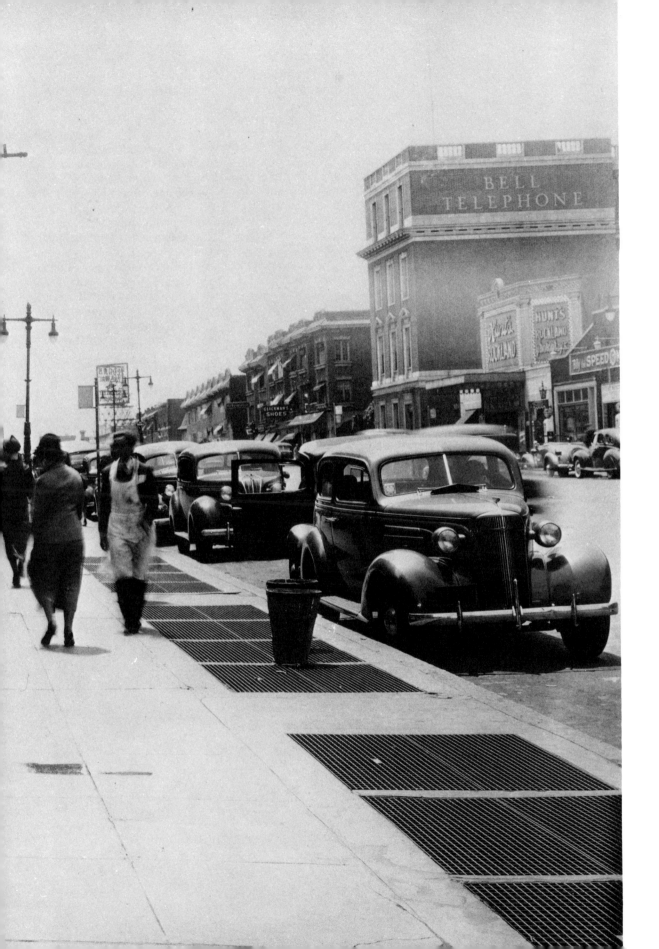

By the late 1920s, the communities developed since 1890 equaled the population and exceeded the area of the built-up city of that earlier date. Their diversity is illustrated in these aerial photographs. Below is a 1926 view along Lincoln Drive towards the southeast, with the Queen Lane Reservoir in the background. Two large apartment complexes form a striking exception to the usual skyline of residential Philadelphia. In the foreground is Mayfair House, under construction at Lincoln Drive and Johnson Street, and behind it is Alden Park Apartments, newly opened near School House Lane. More typical of the prosperous far northwest were the large stone houses in the foreground, which had been built during West Mount Airy's rapid growth in the first two decades of the century. Several miles to the east was the neighborhood pictured opposite, top. Taken in 1927, it shows part of Logan around Roosevelt Boulevard between Wyoming and Rockland on either side of the Reading tracks. It had been developed in the teens, along with the Boulevard itself, and became home to many Germans and Russian Jews, most of whom engaged in professional, entrepreneurial, and white-collar pursuits. The photograph opposite, bottom, depicts the vicinity of the L. H. Gilmer Solid Woven Belting plant in Tacony in 1929. The plant had been built in the teens, but most of the homes were slightly older. All were within easy walking distance of such major enterprises as the Disston factory. Gilmer's factory, between St. Vincent Street and Cottman Avenue along Keystone Street, had an advantageous location astride the Pennsylvania Railroad's main tracks to New York. In contrast to both Logan and Mount Airy, this new neighborhood was based on industry, and had a large Catholic immigrant population, symbolized by Our Lady of Consolation Church in the upper left of this photograph.

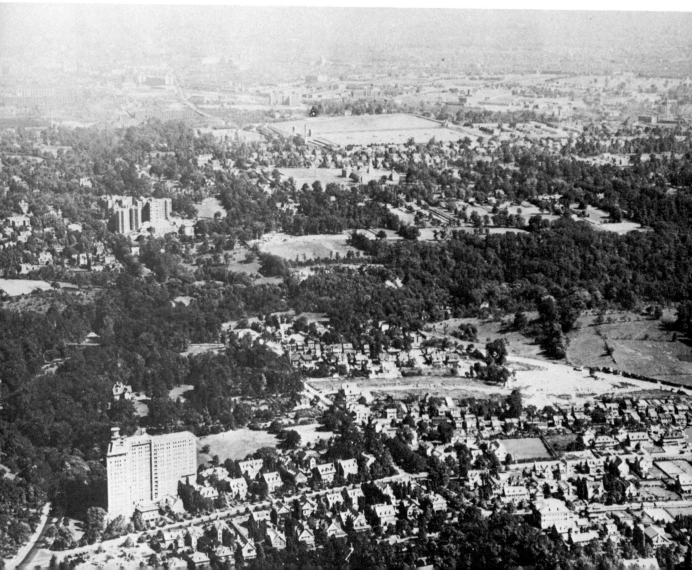

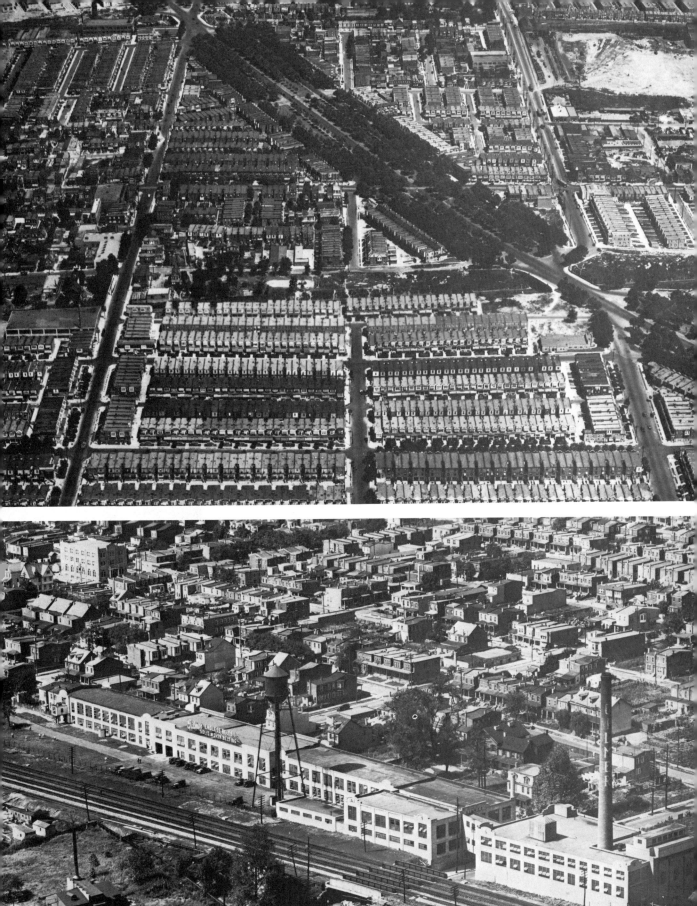

A more scientific kind of aerial photography became central to early Delaware Valley planning efforts in the twenties. The privately funded Regional Planning Federation conducted a comprehensive aerial survey of the whole metropolitan area in 1928 as part of the preparation of an overall plan for the next fifty years. Just as older reform groups had used photography to heighten public awareness of the living conditions of the poor, so the Federation wanted to use it to illustrate the evils of unregulated urban sprawl. Their survey was carried out by the Aero Service Corporation from a height of 13,000 feet, and the original photographs were at a scale of about 1,600 feet to the inch. These three photographs trace Roosevelt Boulevard from its be-

ginning at Broad Street near Hunting Park all the way out past Pennypack Park. In obvious contrast to the other aerial photographs, the aim here is to show an overall land use pattern rather than to detail individual structures. The first photograph, below, includes the area from the Midvale complex in Nicetown east to Tacony Park and from Olney south to below Erie Avenue. The northern and eastern sections had been developed only recently and there was still some open land around Hunting Park Avenue in the lower right-hand part of the picture. Development was much sparser in the lower Northeast from Oxford Circle to Cottman Avenue, shown in the middle photograph. Only near Oxford Circle and in Lawndale (upper left) had large areas been built up. Much of the rest of the lower Northeast was still farmland, with neatly plowed strips visible from the air. The subject of the last photograph, the area from Cottman Avenue past Pen-

nypack Park, was even more rural. The only significant urban growth was taking place along Castor Avenue, where twin homes had begun to appear on the newly laid out streets. But for the most part, this was to be the new Philadelphia of the 1950s, not of the 1920s.

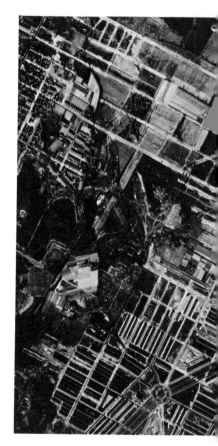

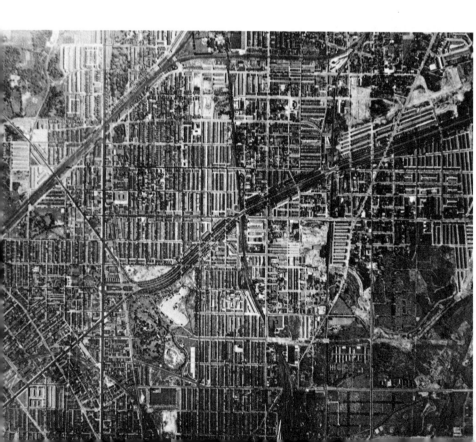

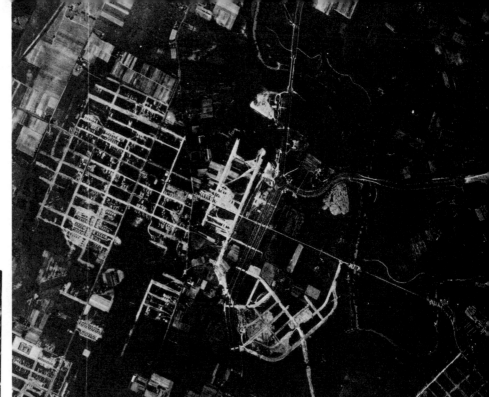

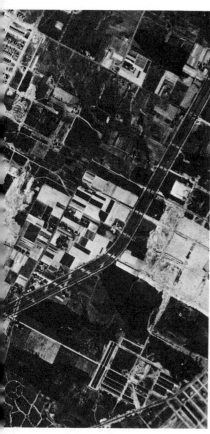

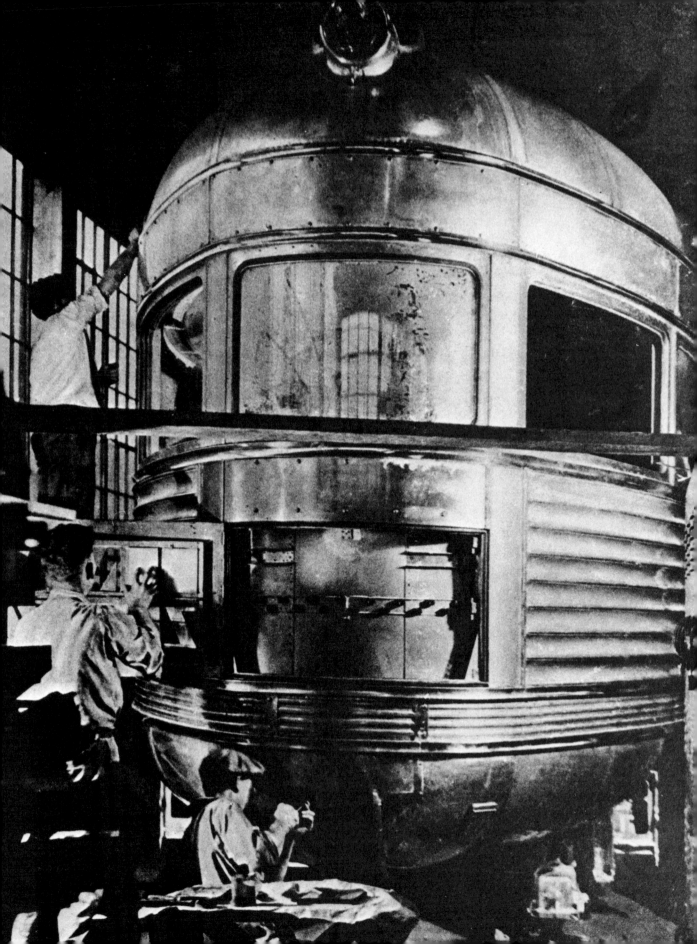

The City of the 1930s

At the end of the 1930s, Philadelphia expressed the previous half century of development far more than it suggested the shape of things to come. More than half of the city's people were still immigrants from Europe and the American South, or the children of those immigrants, and the city was dominated by such traditional industries as railroad car manufacturing (pictured opposite). It remained the second-largest manufacturing center in the United States. While its newer districts—both the monumental downtown and the residential neighborhoods—were the products of more recent technologies, they relied on an elaborate system of trolleys, subways, and elevated trains that had already passed its peak. Philadelphia was a city of contrasts balanced between old and new, between the legacies of the nineteenth century and the creations of the early twentieth.

One such contrast could be found among the people themselves. Though mass immigration had ceased fifteen years before, Philadelphia had hundreds of thousands of people, both black and white, who were obviously foreign to the ways of urban America, and different from most of their fellow citizens. Many of these people continued to live in nearly self-contained communities, from Polish Manayunk to black South Street. The foreign-language press flourished, and in large sections of the old city Yiddish and Italian were more widely spoken than English. Despite their expansion into various parts of the city, Italians, Russian Jews, and Poles were far more concentrated with people of their own kind than were Philadelphians of British, Irish, and German extraction, who were spread more evenly around the city. Residential segregation of the city's quarter million blacks had become more intense as their numbers increased. There was now a black ghetto in central North Philadelphia to add to the old one in South Philadelphia, and an emerging one in West Philadelphia. Segregation was never as rigid for the city's nearly 300,000 European immigrants, but their employment opportunities, social life, and choice of neighborhood were very often dictated by their ethnic origin and the network of personal contacts related to their ethnicity. Such networks remained important to the social life of the city's other groups, including the Irish and the Germans, but had ceased to play the crucial role in relation to jobs and homes that they did for the more recent immigrants.

By 1940 Philadelphia's developed area covered nearly ninety square miles, and the actual urban concentration spilled over into the suburbs on all sides. The major undeveloped

The Budd Co. in the late thirties.

area within the city's boundaries was in the Northeast, but even there by 1940 the section between Roosevelt Boulevard and the Delaware River was built up all the way to Pennypack Park. On the other side of the Boulevard, development had just about reached Cottman Avenue, with some open land remaining below that line. Smaller undeveloped tracts remained in South Philadelphia below Oregon Avenue to the east of Broad Street, and in the farthest corners of Southwest and Northwest Philadelphia.

The city was still overwhelmingly a community of row homes. Detached twins and single-family homes were common in such prosperous middle-class neighborhoods as Mount Airy, Wynnefield, Germantown, and Oak Lane, but even there they formed a minority of the total housing. There were few high-rise apartment houses, though smaller apartment buildings could be found downtown, in West Philadelphia, and in Germantown. But generally, from Oxford Circle in the Northeast to Eastwick in the Southwest, Philadelphia's new neighborhoods, like its old ones, were based on the uniform and inexpensive row house. Of course, everything was not stagnant and standardized. Exterior and interior arrangements varied, and the appearance of the new row house neighborhoods was rarely as monotonous as the old. Front lawns, porches, small backyards, and decorated façades gave many areas a more interesting look. Lot sizes had generally increased, and fewer homes were crammed onto each block.

These physical differences reflected the basic divisions of Philadelphia in the late 1930s. For the city of the early 1890s, erected before the era of the trolley, the subway-elevated, and the automobile, still existed and was still home to over 800,000 Philadelphians, including most of the city's blacks and southern and eastern European immigrants. This older city was an area of tightly packed, deteriorating housing, especially in North and South Philadelphia west of Broad Street, in which most residents rented their homes and tended to move every few years. Around this nineteenth-century city, the new neighborhoods had developed in an arc extending from the Delaware River at Bridesburg across to the Schuylkill, down through the length of West Philadelphia, and back to the Delaware through lower South Philadelphia. About a million people lived in this much larger area. Every ethnic group was represented, though a majority of the people here were not from immigrant families. Some of the new neighborhoods, especially those built before World War I, contained a good deal of industry, but most were almost exclusively residential.

In this city of the late 1930s, large numbers of people, including many professionals, white-collar workers, and the better-off skilled industrial workers, no longer lived near their jobs. These were the people who could afford to live in the new residential communities and commute to work. Most lower-paid workers, and of course local shopkeepers, kept to the older pattern of living near their jobs. And about half of all the industrial jobs were still within three miles of City Hall. The industrial districts remained organized around riverfronts and railroad lines, with 90 percent of the manufacturing done within half a mile of a rail line. The pattern of residential neighborhoods filling in the spaces between groups of plants, factories, and warehouses still prevailed in South Philadelphia, in North Philadelphia up the industrial corridors along Erie and Hunting Park Avenues, and in the whole Richmond-to-Tacony riverfront district. But a different pattern of uniform residential development dominated West Philadelphia, the Northeast, and the northern tier of neighborhoods from Mount Airy and Germantown over to Feltonville and Fern Rock.

Despite the growth of this nonindustrial city, Philadelphia in 1940 still retained a large and diverse manufacturing base. Textiles, metals, paper and publishing, food processing, and chemicals remained dominant, with textiles employing a quarter of the city's industrial workers—about 90,000 people. The city also had some new industries, such as electronics, automobile parts, electrical machinery, plastics, and synthetic fibers. While manufacturing was thus still varied, it was no longer done mainly in small units. The presence of large mills, factories, and refineries was visible proof that there were now many more Philadelphians working in big establishments employing over five hundred workers than in small shops of fifty or less. All in all, despite the Depression, the city was very much an industrial center in 1940. It actually led the nation in the output of nineteen products, ranging from hosiery and paper to cigars and machine engines, and it was the second producer in thirty-seven other areas. Unhappily, it was also true that many of these industries were past their prime. Philadelphia's massive Budd and Brill works, producing railroad carriages and streetcars, were symptomatic of the problem. Many of the city's manufacturers occupied outdated structures, turned out obsolescent products, and depended on rail and river transportation in what was becoming the age of the motor truck.

If the industrial district looked old in 1940, the opposite was true of the downtown. A forest of skyscrapers surrounded City Hall. The PSFS Building at 12th and

Market, the classic modern skyscraper, reached 491 feet, and a half a dozen nearby buildings exceeded 300 feet. By tradition, however, none exceeded the height of City Hall. The downtown area received about 700,000 commuters a day from within Philadelphia, and another 175,000 from outside the city limits. The area from 4th to 23rd Streets and from Lombard to Callowhill Streets had over 5,000 stores and over 2,000 industrial establishments. But the downtown was an oasis by 1940. To the northeast and southeast it was bordered by the city's worst slums and deteriorating nineteenth-century housing. These areas of small row houses and hidden courts and alleys stretched on the southeast side from 8th Street to the Delaware River and from Lombard to Christian Streets, and on the northeast side from Race all the way up to Girard Avenue and from 6th Street to the river. The downtown was bordered in the southwest by the old black neighborhood centered around South Street and on the northwest by a mixed area of warehouses, factories, and bad housing lying just below the Parkway. Both rivers were the sites of heavy industry and multiple railroad lines that hemmed in the downtown. While many of the people working in the lower-paid service jobs and small factories downtown still lived within walking distance of their jobs, the vast majority of center city workers came into work from the west, north, and northwest by mass transit.

When the Philadelphia Rapid Transit Co. became the Philadelphia Transportation Co. (PTC) on January 1, 1940, its system consisted of sixty-one trolley routes covering 673 miles, thirty bus routes of 462 miles, and three subway-elevated lines of 65 miles. All of the bus routes had been created since 1923. The PTC carried about two million passengers a day at its birth, and they averaged about half an hour per trip. The rail lines outside the PTC system carried less than 2 percent of the commuters who lived in Philadelphia, although many suburbanites used them. The city also contained about a quarter of a million automobiles by the end of the thirties, the same number as ten years before; the Depression had put a temporary stop to the automobile revolution in Philadelphia. A 1934 survey showed that only one worker in seven used a car to get to his or her job. Twice as many walked to work. Of course the numbers varied from area to area. In the old city built before 1900, over a third of the people still walked to work, as their grandparents had, while in the newest sections it was a third who used their cars on a daily basis. But even among suburban commuters, as among all groups of Philadelphians, the automobile was still second to the various forms of mass transit.

Those relationships among walking, driving, and mass transit epitomize the Philadelphia of 1940. One era of change had come to a close, but the next had not yet really begun. The great achievements of the previous decades had been the absorption of successive waves of immigrants into the life of Philadelphia and the simultaneous physical creation of the modern city. In addition to new ethnic groups, new transportation systems, new neighborhoods, and a new downtown, Philadelphia by 1940 contained 400,000 telephones and half a million radio owners and electrical customers. Two thousand miles of streets were paved with asphalt or granite blocks. The city had the world's largest water filtration system. Parks covered 8,000 acres, more than double the size of Fairmount Park alone. The land around the Tacony, Cobbs, and Pennypack Creeks had been preserved as green spaces in the city.

Naturally, there were still many reminders of former times. Alone among large cities, Philadelphia used horse-drawn trash wagons and street sprinklers. Gas lamps were almost as common as electric ones in the streets, with well over 20,000 in use. Coal was still the standard home energy source. The city had over 50,000 storefront dwellings. The overcrowded courts and alleys of the older neighborhoods between Girard and Washington Avenues contained a similar number of homes without indoor plumbing. At the other extreme, the Far Northeast remained devoted to truck farming, and Bustleton and Somertown were surrounded by farmland. Philadelphia's city limits included 10,000 acres of farmland, including twenty-five farms of over 100 acres. Throughout the city, it was not hard to find sights, sounds, and smells recalling the days of horsecars and steam power. But these were the exceptions; Philadelphia had in fact become a very different place in 1940 from the city of 1890.

It was not simply that by 1940 the city had a little under two million people, compared to a little over a million fifty years before. For the dominant themes of the period had been diversification, specialization, and dispersal, as well as construction, expansion, and growth. The near-doubling of the population had been accompanied by a tripling in the city's built-up area and a dramatic fall in population density and overcrowding. The downtown skyline had also tripled in height, as the largest office buildings reached thirty stories instead of ten. The City Hall area had become a hub of commerce and government dominating the whole of William Penn's original Philadelphia. The surrounding compact industrial city, with about a million inhabitants, had itself been encircled by a new Philadelphia. This sprawling metropolis

of varied residential neighborhoods was now home to another million people. Both the old and new neighborhoods were patchworks of different groups of people, some dominated by class, some by ethnicity, others by a combination of the two. With the average family moving more than once a decade, this pattern was in a constant state of change and flux. The Philadelphia of 1940 was indeed a complex inheritance to be passed on to the remainder of the twentieth century.

Two streams of people—an unemployment line (right) and a shopping crowd (page 260)—illustrate the different cities that existed in Philadelphia at the end of the 1930s. The unemployment line was photographed in February 1938 near Broad and Erie, in the middle of industrial North Philadelphia. With the renewed economic downturn of 1937–1938, unemployment throughout the city was estimated at over 25 percent, and many of the men on this relief line had probably been out of work for more than a few months. The *Philadelphia Inquirer*'s photographer was able to capture on their faces the range of emotions from confidence and hope to despair and resignation that nearly ten years of depression had produced. He depicted as well the wide variety of people caught up in the economic catastrophe, which was never felt as severely downtown as it was near Broad and Erie. The Depression affected retail sales and white-collar work less drastically than it did industrial production, and the shopping and entertainment found downtown attracted crowds throughout the 1930s. The photograph overleaf was taken in March 1940, when the Depression was easing but still very much alive. Looking east from 10th and Market, Easter shopping crowds fill the streets from the Wilbur-Rogers clothing store, with its contemporary art deco sign, past the Horn and Hardart automat and the Victoria Theater, to Strawbridge & Clothier and Lit Brothers in the distance. The posts are decorated with banners for the campaign of the United Charities, a forerunner of the United Way. But the poverty and unemployment that still dominated large parts of the city are hardly in evidence here.

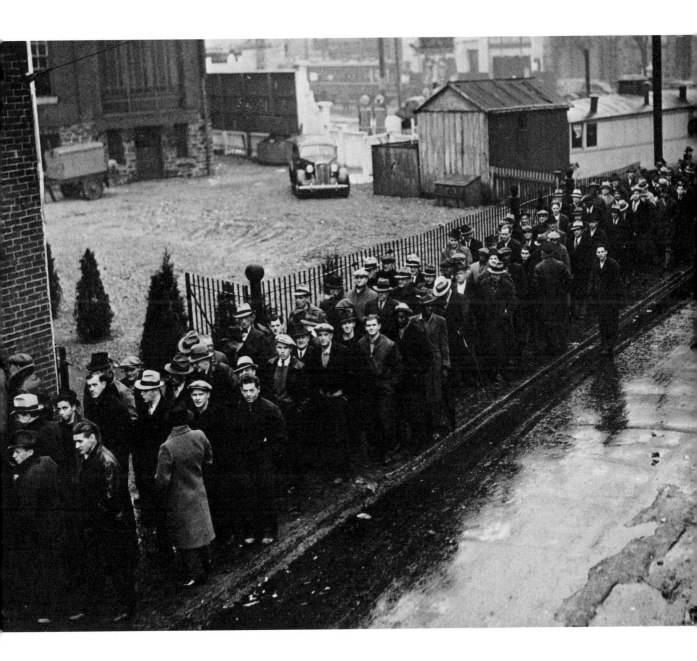

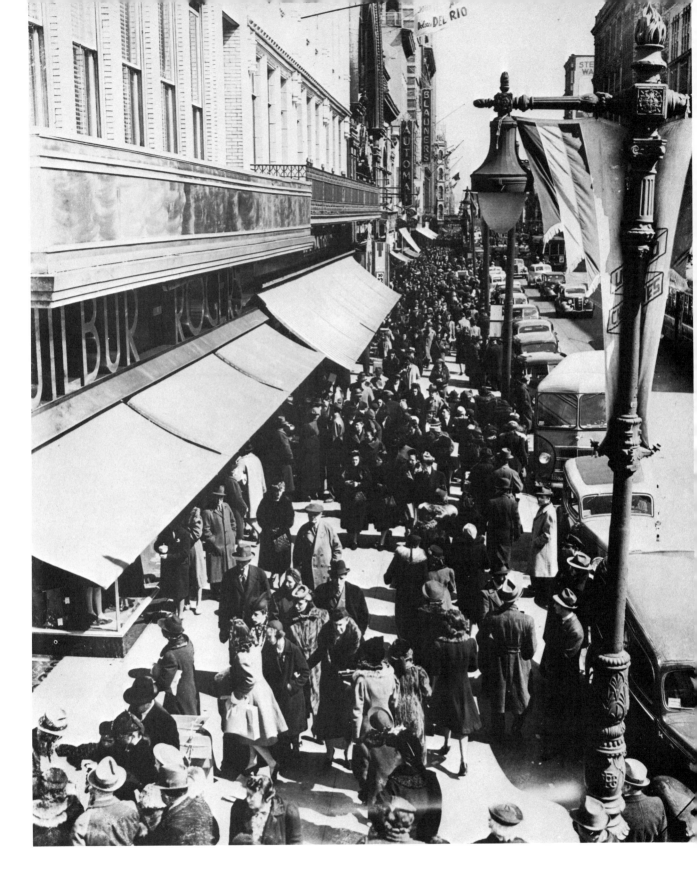

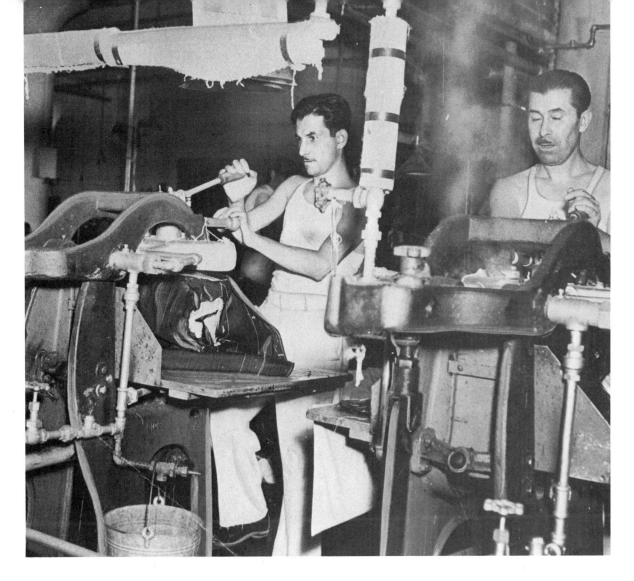

Throughout the Depression the textile industry remained the heart of Philadelphia's traditional industrial base. In 1939 there were over 1,300 textile firms producing some $300 million worth of goods. But the plants were old and the working conditions poor. The photograph above, taken by a reporter from the *Philadelphia Record* in July 1939, shows two pressers making lightweight worsted suits. The caption noted that the two men, Oreste Ghezzi and Pete Vatulli, were working in a temperature of 102 degrees and urged the paper's readers to "give a thought" to them the next time they put on a cool summer suit. The photograph on the next page shows cramped and potentially hazardous conditions at Fox-Weiss furriers, 1130 Chestnut Street, in 1940. There were many clothing manufacturers in this downtown area, usually operating in crowded lofts on the upper floors of the five- and six-story buildings common in the area. The Fox-Weiss business shared a six-story building with Loft Candy; it was next to the much larger clothing establishments of Oppenheim Collins & Co. and B. F. Dewee, and directly across the street from Lane Bryant. As both of these photographs remind us, Philadelphia's clothing industry was dominated by Jews and Italians, and its high-volume, low-margin economics translated into hard and uncomfortable labor for its workers.

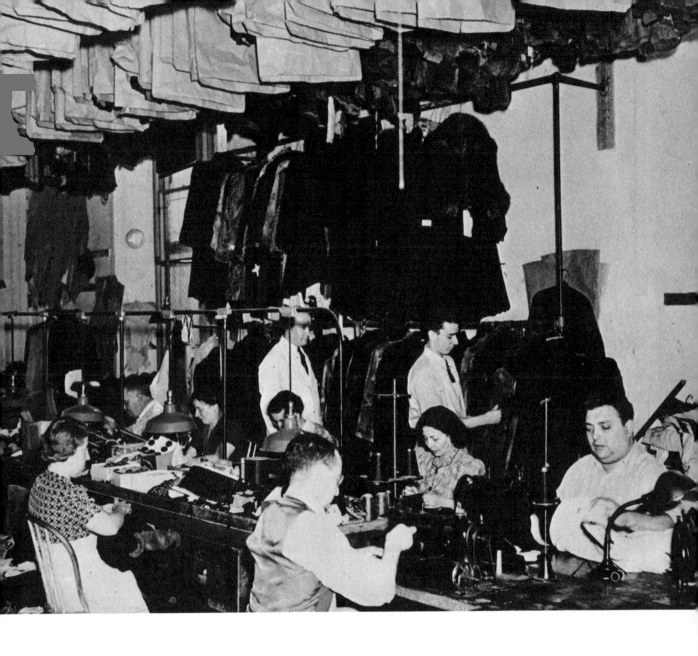

The size and diversity of Philadelphia's economy ensured that the city would have some significant new enterprises to add to its older ones. Perhaps the most prominent were in the radio industry, which was the city's eighth largest in terms of value of production by 1940. The Atwater Kent Co. was one of the earliest mass radio manufacturers in the United States; its huge plant on Wissahickon Avenue, shown in the photograph below, was built between 1923 and 1926. By the time this photograph was made in 1940, Philco had taken over the plant. Originally an electric storage battery company, Philco had begun making radios in 1928 and by the early 1930s it led the nation in production. At its older site, at Tioga and C Streets in Kensington, it pioneered in the complete production of radio sets from basic raw materials. The company was still the nation's leading producer in February 1937, when Philadelphia *Record* took the two photographs of its workers on the next page. Mass-production techniques and a sexual division of labor were clearly key components of Philco's operation. The women are doing the delicate work, while the men do the physical assembly and checking. Another nationally known Philadelphia-based enterprise was the Burpee Seed Co., whose operation at 18th and Hunting Park is illustrated in the photograph on page 265, taken by a photographer for the Office of War Information in 1943. Burpee's workers, most of whom were women even in peacetime, formed part of the fastest-growing segment of the city's work force—clerical, sales, and service workers. By 1940 these numbered nearly 250,000, compared to slightly under 300,000 craft and manufacturing workers. In fact, this photograph of men and women filling seed orders was taken in the building Burpee had acquired in 1935 from the Sauquoit Silk Manufacturing Co., a classic representative of Philadelphia's industrial past, whose workers are depicted on page 90.

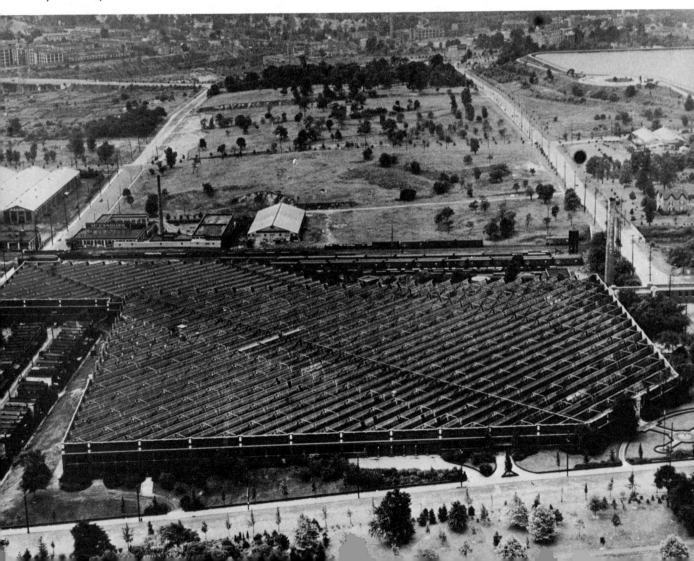

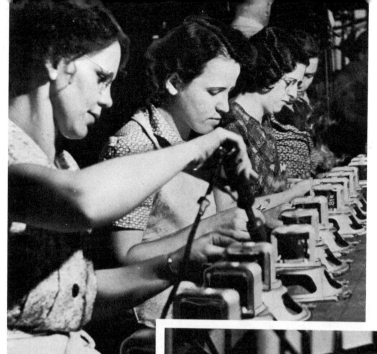

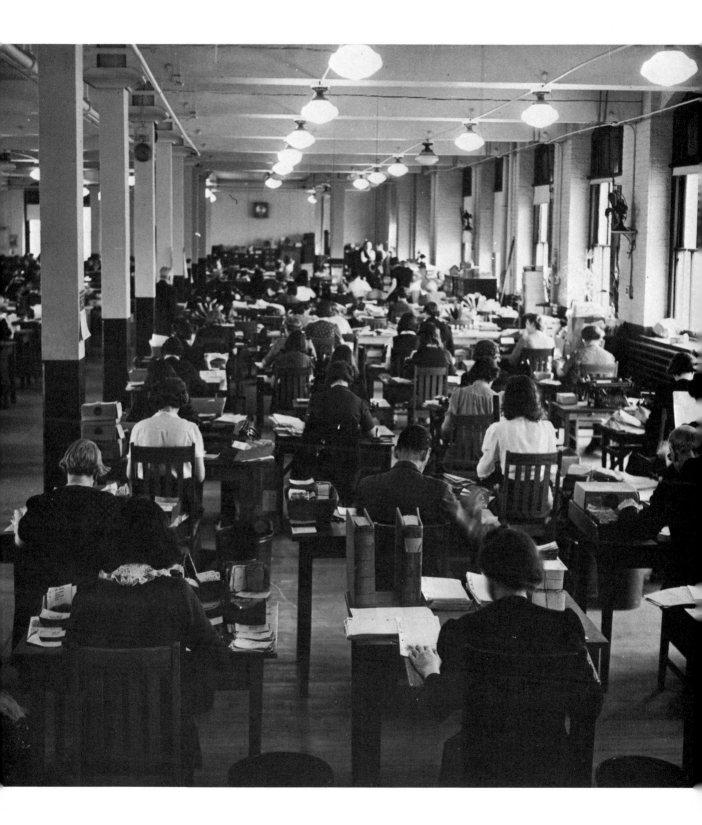

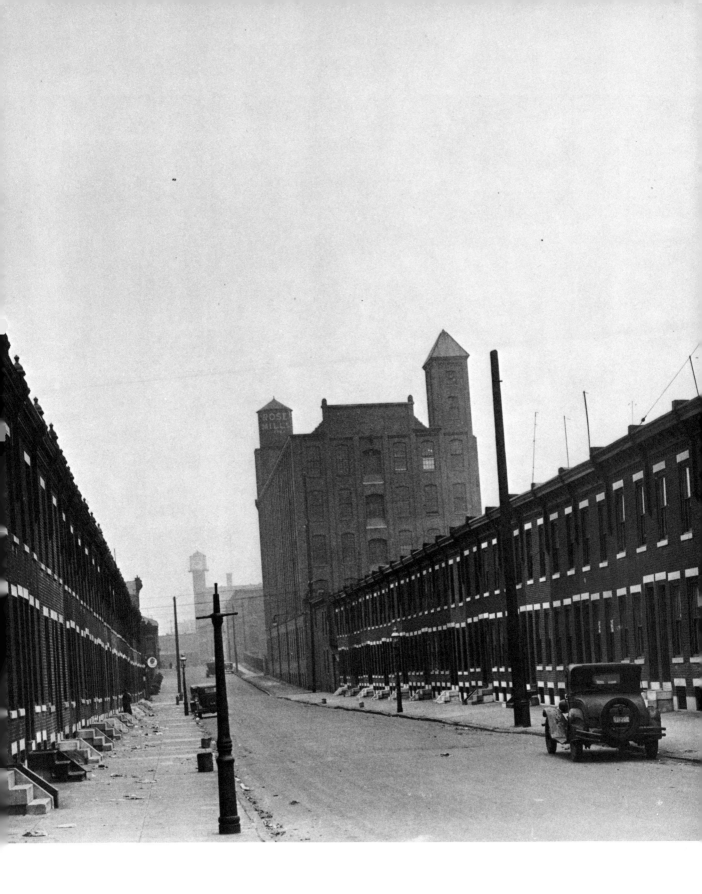

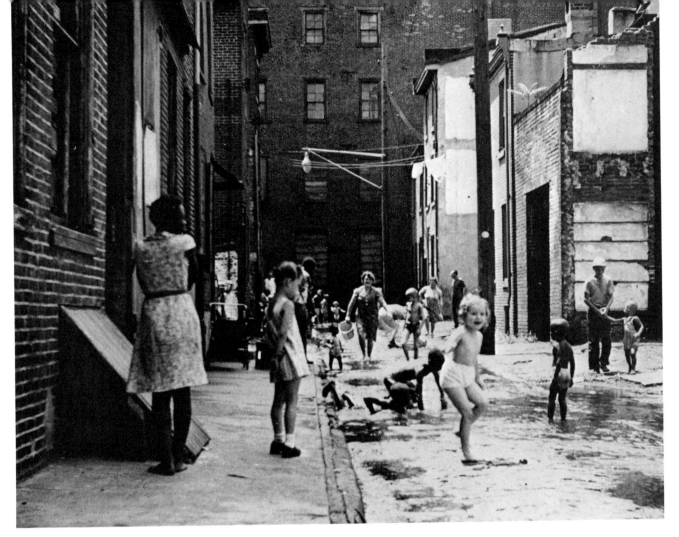

The physical aspect of the city's old industrial neighborhoods had changed little in the 1920s and 1930s, and the ways in which they were photographed had also remained fairly static. In the picture at left, Lewis Hine, then working for the WPA, captured a classic row house scene about 1937. This was Rosehill Street, leading up to the Rose Mills at C and Indiana in the main textile manufacturing center of Kensington near the Fairhill Station. The street was lined with about sixty row houses, each no more than 14′ × 25′. The homes on the left backed on to railroad tracks and a coal yard. By focusing on the mill and the emptiness of the street, Hine

captured the bleak desolation of the neighborhood, which had been hit especially hard by the Depression as a result of its dependence on textiles.

The Depression was ending when the photograph above was taken for the Housing Association in July 1941. But it reveals the same kind of unhealthy drainage and paving problems as depicted in similar photographs taken thirty years earlier. This was the 800 block of North Leithgow Street, between 4th and 5th and Brown and Parrish Streets in the old Northern Liberties section. Leithgow was a

small alley in this area, dead-ending into the furniture factory in the background. It was lined with two- and three-story row homes, many of which had already been torn down or abandoned when this photograph was taken. The neighborhood remained home to many eastern European immigrants, both gentiles and Jews, and had a growing black population. It was also still poor, with unemployment above 33 percent as late as 1940, and only a fifth of the residents owned their own homes. Neither the fading Depression nor the approaching war were able to have much effect on the deep-seated poverty of an area like this.

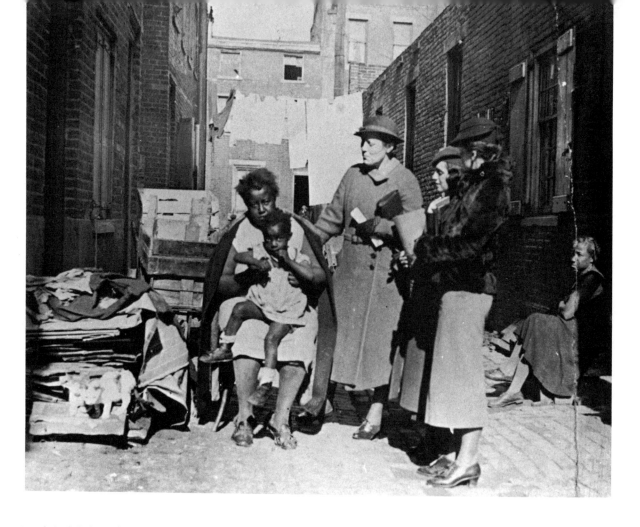

In Philadelphia, the public housing projects initiated by the New Deal coexisted with older forms of private assistance. The photograph above typifies the traditional approach. It depicts a 1934 Housing Association tour for Drexel students to the slums of South Philadelphia. Here two students and a staff member pose uncomfortably with residents of Fox Street, an alley leading off 1224 Fitzwater. This was still a neighborhood of poor blacks and Italians who rented rooms in tiny overcrowded row houses. In the absence of vigorous city action, the Housing Association continued to try to improve conditions through inspections of the kind pictured here. The more direct policy of public housing was never applied on a large scale in Philadelphia, partly because the city was dominated by a Republican party hostile to the New Deal. The only federally funded local scheme was the Hill Creek housing project at Adams and Rising Sun Avenues, shown in the two photographs opposite. Politics and financial restrictions forced the Public Works Administration to cut back on the planned 929 units and build the project outside of the city's developed area. This is illustrated in the photograph at right, which was taken looking west across Tacony Creek Park to the built-up area around Front Street and Olney Avenue. The project was next to the Crescentville Electric Storage Battery Co., some of whose buildings can be seen at the bottom of the picture. There was room for the open space, trees, and curved streets (illustrated opposite, top) that were part of the community ideal that influenced New Deal housing policy. Hill Creek, with 258 units, opened in 1938 and provided its carefully selected tenants with the best in modern conveniences, at an average rent of only $7.50 per room per month. But this project did nothing to solve the needs of the hundreds of thousands who lived in the inner city's aging neighborhoods.

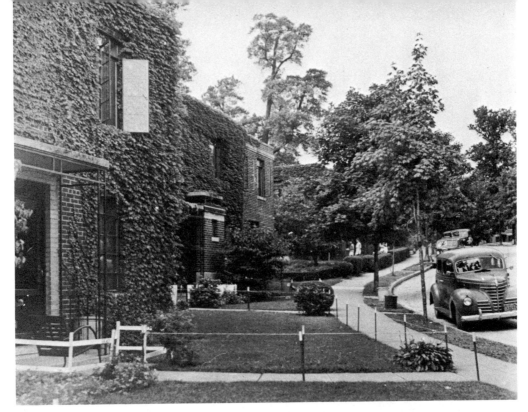

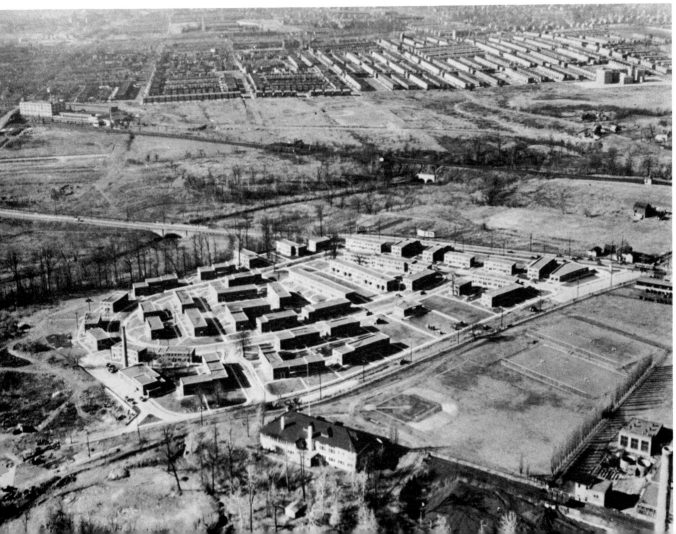

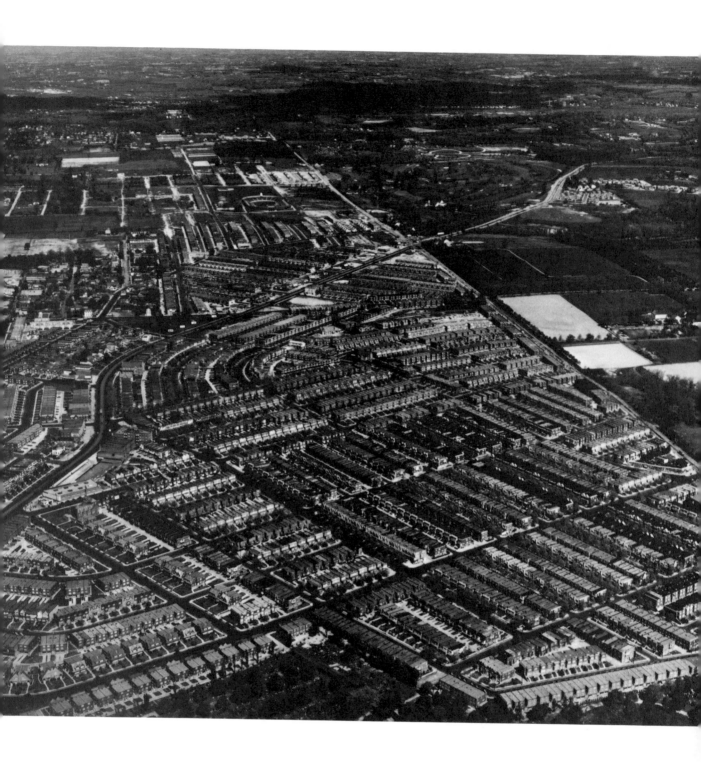

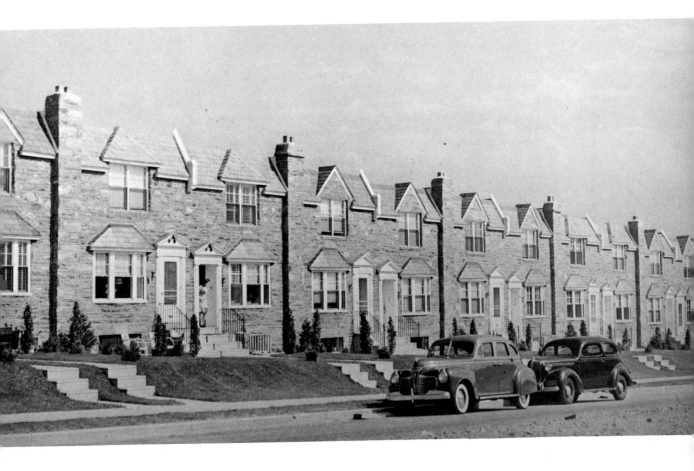

While they generally remained free of the housing problems of the old neighborhoods, parts of the new Philadelphia were certainly mature communities by 1940. The aerial view at left of West Oak Lane, taken in May of that year, shows one such neighborhood. One of the boom areas of the 1920s, West Oak Lane took shape as a pleasant, desirable, and prosperous middle-class community. This view takes in the area from Northwood Cemetery west past Ogontz Avenue and Limekiln Pike along the northern border of the city. The acres of modern, substantial two-story row houses were broken only by a few churches and theaters, and one group of large twins between Ogontz and Lime-kiln above Tulpehocken Street. But just as the old city had its photographic stereotypes of suffering children in overcrowded alleys, so too the new city was acquiring an unflattering image of its own. The photograph above, taken by John Vachon, one of the well-known photographers for the New Deal's Farm Security Administration, captures the treeless uniformity of the city's new sections in October 1941. Vachon, interested in the suburban stereotype of anti-septic sameness, didn't even record where these houses were, though it was probably the lower Northeast. To the photographer, the homes were more interesting as a symbol of the new residential environment than as part of any specific neighborhood. The FSA photographers took relatively few photographs in Philadelphia during the 1930s, preferring Pittsburgh as a place to document the despair of the Depression decade.

The pattern of old industrial and new residential neighborhoods was broken in the city's center and on its fringes. An especially dramatic portrayal of the downtown is the photograph below, taken as Nazi Germany's *Hindenberg* passed over Philadelphia on August 8, 1936. Beneath the airship is the city's cluster of skyscrapers, stretching south from Broad Street Station, just past the nose of the *Hindenberg*. To its immediate right City Hall tower and the PSFS Building form an incongruous pair. The rest of Philadelphia's central business district drops off gradually in height from Market Street south and west to Rittenhouse Square. On the right side of the picture are the immigrant neighborhoods of South Philadelphia. West Philadelphia begins in the foreground, with the Pennsylvania Railroad tracks, 30th Street Station, and the new Post Office. The Market Street Elevated aims at the heart of downtown. Clearly this part of West Philadelphia was more an annex to the downtown than a part of the great residential district that spread behind it.

Far off to the northeast, a very different kind of Philadelphia could be found in the late 1930s (right). The old farm building pictured at Oxford Avenue north of Rockwell in the city's Fox Chase section was something of an anomaly by then, but it was by no means unique. Although twin homes had been put up all along Rockwell and Hasbrook Avenues, some farms and open areas below Pennypack Park had not been subdivided. Beyond the park were even larger areas devoted to agriculture and the manorial lifestyle, some of which persisted well into the postwar era.

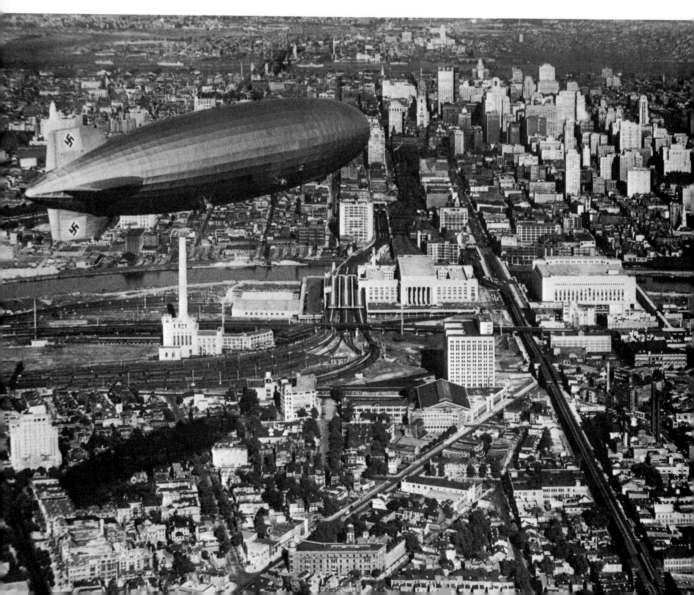

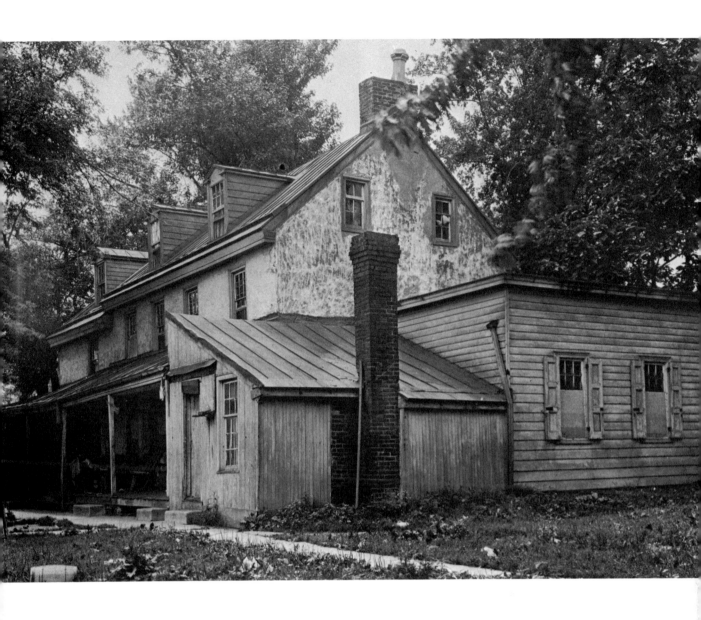

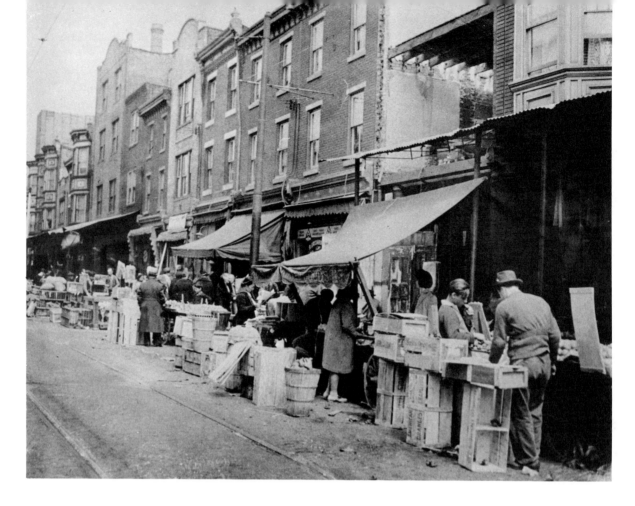

The contrast between the old and the new in Philadelphia in 1940 is illustrated in these photographs. Along South 9th Street above Federal the traditional pattern of street shopping was flourishing in April 1941 (above). The scene had changed little since the early years of the century. But this kind of marketing was already regarded as a curiosity in the rest of the city, a reminder of days gone by. Old-fashioned farmers' markets were restricted to Delaware Avenue, South Street, and here in the Italian market area. A very different kind of curiosity captured the imagination of photographer Philip Wallace—the new supermarket. Pioneered by small companies in the early 1920s, the supermarkets began to appear widely in the 1930s and chains like A&P were soon consolidating their smaller stores into the new model. Wallace depicted one of Philadelphia's early Food Fairs in the later thirties (opposite); both photographs suggest that supermarkets have evolved little since their invention. The key innovations were variety, ease of movement, self-service, and quick turnover. Shopping was facilitated by the ubiquitous shopping cart, an early model of which—no more than an old-fashioned woven shopping basket on wheels—is seen here. The whole operation was in almost every way the direct opposite of the slow, personal, individualized way of shopping illustrated in the photograph above.

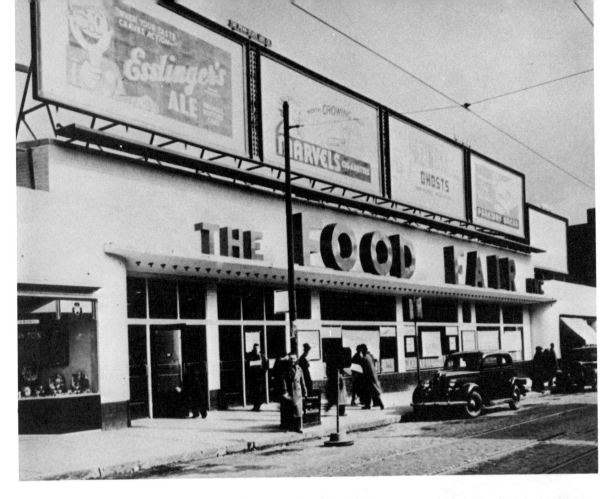

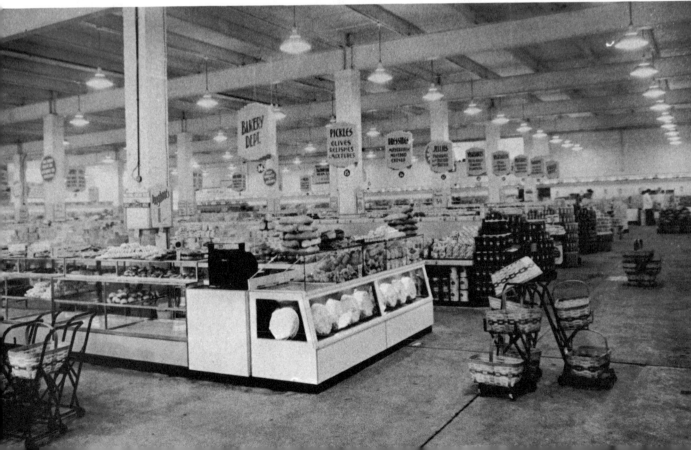

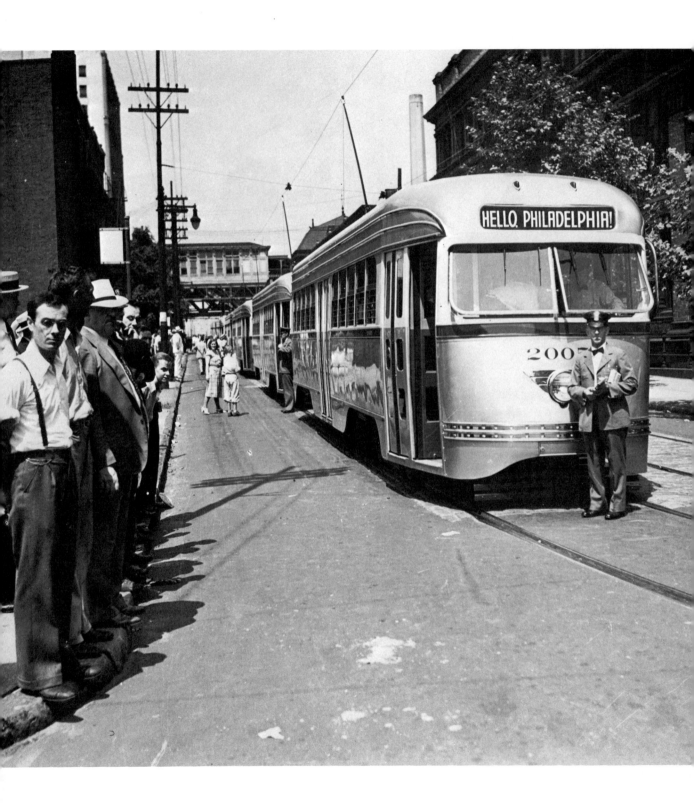

Philadelphia's trolley and subway-elevated systems were at the height of their popularity and development in the late 1930s. The PRT system carried 650 million passengers in 1939, over a million round trips per workday. Two-thirds of the trips were made by trolley, a quarter on the subway-elevated, and as yet only one in sixteen on the new bus routes. The heavy use of the trolley system led to the purchase in 1938 of new streamlined cars. Some are shown at left on their first day of operation along 32nd Street between Market and Chestnut. These new cars signaled a bright future for the trolley system that never materialized. Instead, many of these cars were destined to run for decades beyond their planned life, eventually symbolizing the system's decline rather than its renewal. In contrast to the PRT's shiny new cars, the Broad Street Subway at City Hall looked old and run down in November 1939, after only eleven years in operation (right). The problems of maintaining a clean and attractive underground station were immense and the whole system was susceptible to rapid deterioration. The Broad Street Subway had been extended throughout the 1930s, but the City Hall station at its center was cramped and dingy from the beginning. Limited to two main lines and always short on maintenance, Philadelphia's subway-elevated system remained very much a secondary transportation network, despite the millions lavished on its construction. It did, however, relieve some street-level congestion in center city.

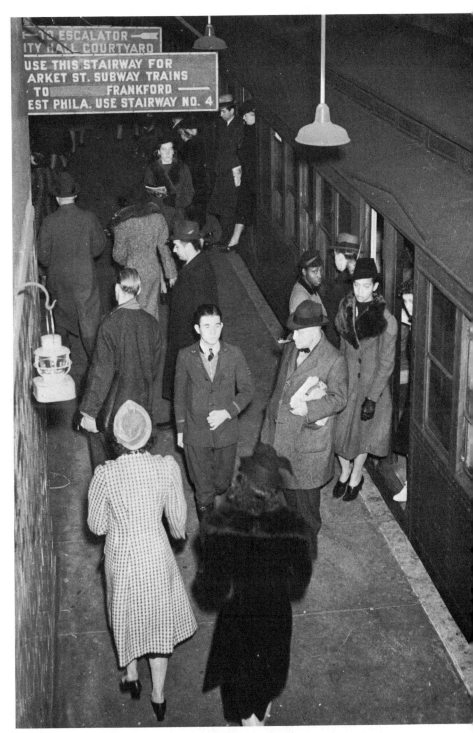

Cars and trucks had come to play a vital, if not yet central, role in moving people and goods around the city. Over 400,000 Philadelphians had driver's licenses in 1939, and there were nearly 50,000 trucks registered locally. But mass concentrations of cars in the city were still rare enough to attract the photographer's attention. Thus, H. Armstrong Roberts photographed a filled lot along the west side of the Schuylkill below South Street in 1937 (below). The lot was convenient to the University of Pennsylvania, which owned the land, and to the six-year-old Convention Hall. Unfortunately, there were few such open spaces elsewhere in the central city, and parking was not as easily managed as it was here. Traffic control was still somewhat disorganized in the northern parts of Philadelphia, even though automobiles were becoming an integral part of life. The photograph at right, taken at Broad near Chew Street in 1938, depicts the city's main artery without so much as a dividing line other than the signs prohibiting turns, and with a policeman trying to regulate automobile flow. Yet truck and auto traffic is fairly heavy in this automobile-dependent neighborhood. The photograph opposite, bottom, illustrates the impact of the new technology on an area that was never designed for it—the Dock Street Market. Far larger than their horse-drawn predecessors, these trucks have made the old market in 1940 impossibly congested. Eventually the whole food distribution operation had to be moved to the city's outskirts. The automobile required that much of the city be remodeled, but the transformation here, as elsewhere, had to wait until after World War II. The photograph was taken for the *Philadelphia Record*, which edited out the names on most of the trucks and buildings.

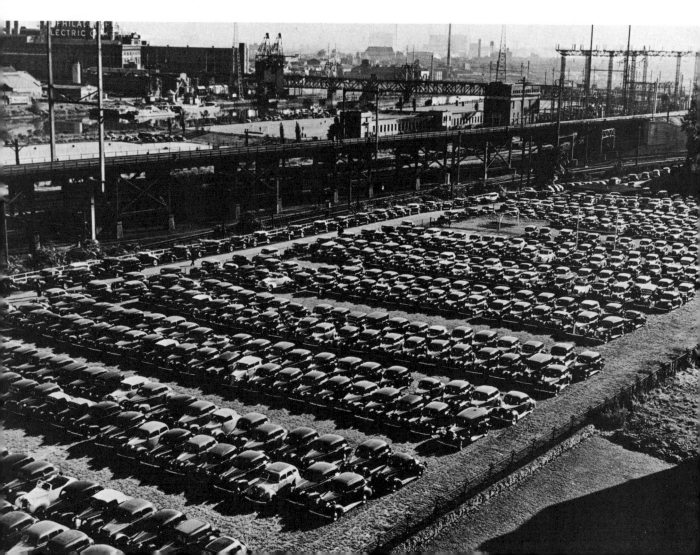

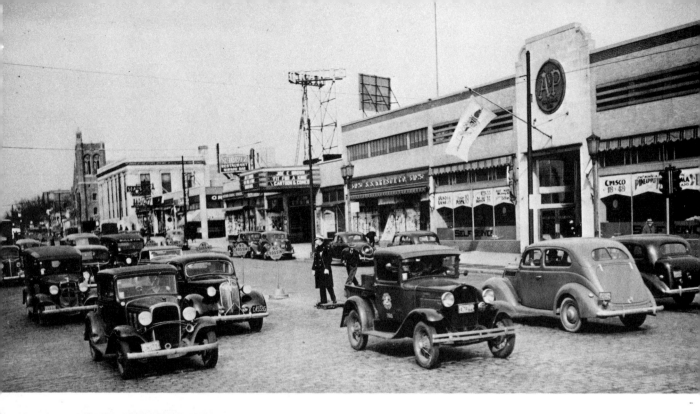

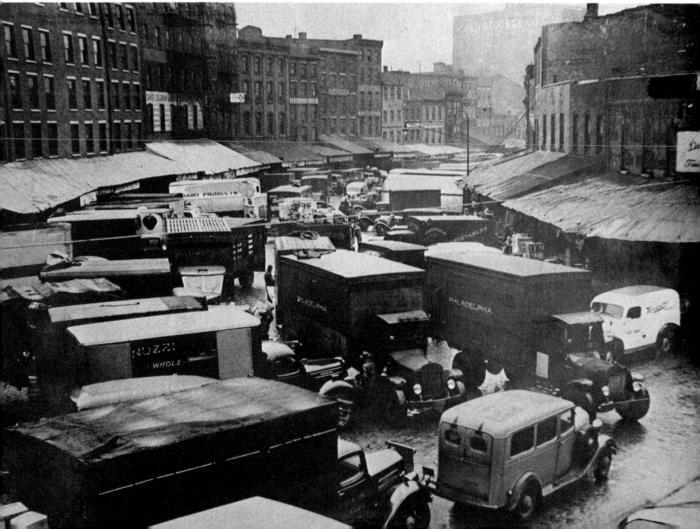

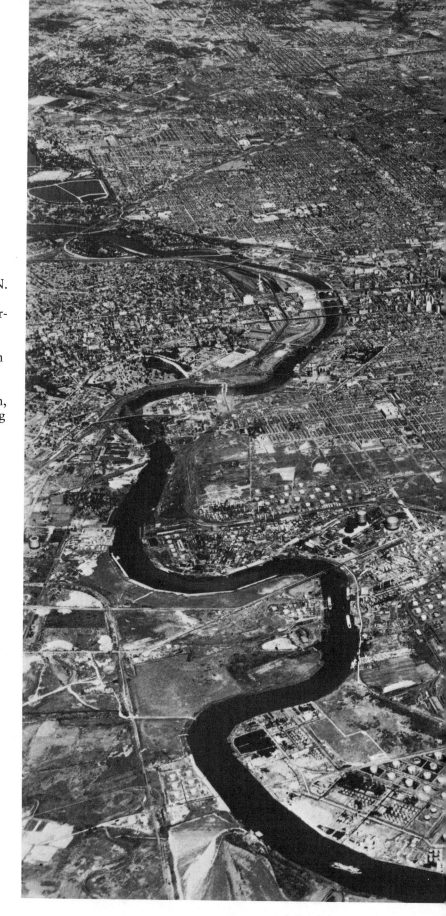

Forty-four years after William N. Jennings photographed Philadelphia from a balloon over Fairmount Park (pages 8–9), a similarly panoramic scene was captured from the window of an airplane. By 1937 Philadelphia consisted primarily of a reconstructed monumental downtown, an old industrial core, and a ring of newer residential communities, still surrounded by a substantial rural fringe. The major parts of the city are all included in this view, which looks northeast from above Girard Point. The area in the immediate foreground had been the site of oil refineries since the late nineteenth century, though they had expanded in recent decades. Behind them were the newer parts of South Philadelphia, clearly continuing the physical arrangements depicted in the 1893 photograph. In the far distance, past the central business district and North Philadelphia, open land is visible in Cheltenham Township and the lower Northeast. Only such an aerial view can reveal how the pattern of jobs, homes, neighborhoods, and transportation lines created by the city's people over two and a half centuries came together to form the larger community called Philadelphia.

280

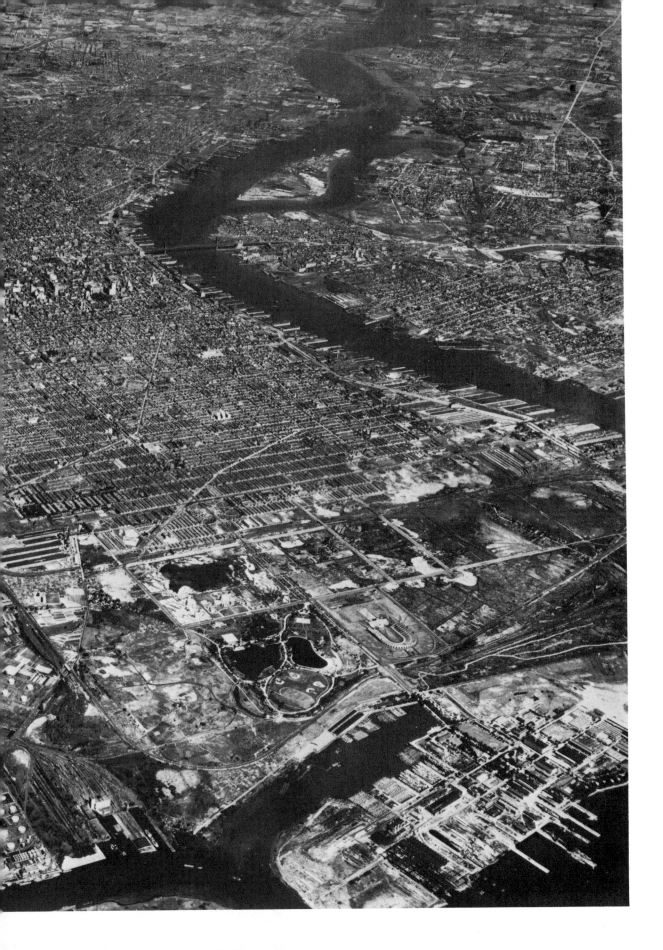

Sources

Abbreviations

Atwater	Atwater Kent Museum
Balch	Balch Institute for Ethnic Studies
City	City Archives of Philadelphia
FLP	Free Library of Philadelphia
HSP	Historical Society of Pennsylvania
Inq	*Philadelphia Inquirer* Collection, Department of Special Collections, Temple University Libraries
LC	Library of Congress
Lib. Co.	Library Company of Philadelphia
NARS	National Archives and Records Service
PHMC	Division of History, Pennsylvania Historical and Museum Commission
UA	Urban Archives, Department of Special Collections, Temple University Libraries

Page numbers appear in **bold face** type.

The City of the 1890s

2 HSP; 8 FLP; 9 FLP; 10 UA; 11 UA; 12 City; 13 City; 14 City; 15 City; 16 City; 17 City; 18 HSP; 19 HSP; 20 HSP; 21 HSP; 22 UA; 24 City (top), HSP (bottom); 25 City; 26 HSP; 27 HSP; 28 FLP; 29 City.

Immigrant Havens

30 UA; 35 UA; 36 UA; 37 UA; 38 UA; 39 UA; 40 UA; 41 UA; 42 UA; 43 UA; 44 UA; 45 UA; 46 UA; 47 UA; 48 PHMC; 49 City; 50 PHMC; 51 City; 52 City; 53 UA; 54 HSP; 55 UA; 56 PHMC; 57 City; 58 UA; 59 City; 60 City; 61 City; 62 City; 63 UA; 64 UA; 65 UA; 66 UA; 67 FLP; 68 Lib. Co.; 69 Lib. Co.; 70 UA; 71 City.

Workshop of the World

72 PHMC; 76 Lib. Co.; 77 PHMC; 78 FLP (top), PHMC (bottom); 79 PHMC; 80 HSP; 81 HSP; 82 PHMC; 83 PHMC; 84 PHMC; 85 PHMC; 86 PHMC; 87 PHMC; 88 PHMC; 89 PHMC; 90 PHMC; 91 PHMC; 92 PHMC; 94 PHMC; 95 PHMC; 96 PHMC; 97 HSP; 98 PHMC; 99 PHMC; 100 Balch; 101 UA; 102 City; 103 HSP; 104 City; 105 City; 106 UA; 107 UA; 108 Balch; 109 Balch; 110 PHMC; 111 PHMC; 112 PHMC; 113 NARS; 114 NARS; 115 NARS; 116 PHMC.

The Vision of Reform

118 UA; 124 City; 125 PHMC; 126 Atwater; 127 UA; 128 UA; 130 UA; 131 UA; 132 UA; 133 UA; 134 UA; 135 UA; 136 UA; 137 UA; 138 UA; 139 City; 140 UA; 141 NARS; 142 City; 143 PHMC; 144 City; 145 City; 146 UA; 147 UA.

A Gallery of Faces

148 UA; 151 UA; 152 City; 154 UA; 155 HSP; 156 UA; 157 UA; 158 UA; 159 Balch; 160 PHMC; 161 PHMC; 162 Lib. Co.; 163 Lib. Co.; 164 Lib. Co.; 165 Lib. Co.; 166 Lib. Co.; 167–169 Lib. Co.

Technologies of Change

170 PHMC; 177 City (top), HSP (bottom); 178 UA; 179 City; 180 FLP (top), UA (bottom); 181 City; 182 UA; 183 City; 184 PHMC; 185 City; 186 City; 187 PHMC; 188 City; 189 City; 190 Atwater; 191 UA; 192 UA (top), City (bottom); 193 UA; 194 City; 195 HSP.

The Rise of the Downtown

196 HSP; 202 City; 203 UA; 204 PHMC; 205 UA; 206 Lib. Co.; 208 UA; 209 City; 210 City; 211 UA; 212 City; 213 City; 214 UA; 216 UA; 217 UA; 218 UA; 219 FLP; 220 UA.

The New Philadelphia

222 FLP; 229 City; 230 UA; 231 UA (top), City (bottom); 232 UA; 233 UA; 234 UA; 235 UA; 236 UA; 237 UA; 238 PHMC; 239 UA (top), HSP (bottom); 240 Balch; 241 Balch; 242 Balch; 243 Balch; 244 HSP; 245 HSP; 246 City; 248 UA; 249 FLP; 250–251 UA.

The City of the 1930s

252 FLP; 259 Inq; 260 Inq; 261 HSP; 262 HSP; 263 HSP; 264 HSP; 265 LC; 266 NARS; 267 UA; 268 UA; 269 UA; 270 FLP; 271 LC; 272 FLP; 273 City; 274 FLP; 275 HSP; 276 Inq; 277 Inq; 278 LC; 279 Inq (top), FLP (bottom); 280 FLP.

Index

A & P (food stores), 228, 274
Abruzzi, 242
Adath Jeshurun Congregation, 60
Adelphia Hotel, 199
aerial photographs, 9, 35, 37, 54, 56, 220, 248, 250, 280
Aero Service Corporation, 250
Alden Park Apartments, 248
Allegheny Avenue, 3
almshouses, 119
American International Shipbuilding Co., 110
American Museum, Menagerie and Theater, 212
American Stores, 228, 245
American Street, 58
Angora, 228
Arch Street, 18, 197, 212
Art Museum, ix, 9, 215
Association of Day Nurseries, 147
Atwater Kent Co., 263
automobile, impact of, 174–176, 190, 193, 256, 278
Awbury Arboretum, 65

Bainbridge Street, 37, 147, 158
Baker Bowl, 35, 54
Baldi, C. C. A., factory of, 43
Baldwin Locomotive Co., 14, 72, 75–77, 159
Balta Brewery, 54
Baltimore and Ohio Railroad, 21, 176
Baltimore Avenue, 228
Baptiste Catering, 109
Barnett File Works, 56
Bartram High School, 228
Bellevue Stratford Hotel, 173, 199
Bell Telephone Co., 173, 187
Benjamin Franklin (Delaware River) Bridge, 172, 199, 220

Benjamin Franklin Parkway, 190, 199, 200–201, 215, 220
Bergdoll Brewery, 54
Bergner Brewery, 54
Bethesda Rescue Mission, 124
Betz Building, 197
Beulah Street, 118
Bigler Street, 229
Bijou Theater, 212
blacks, 119, 164; employment of, 73, 106, 109; migration of, to city, 31, 40, 63; population of, 5, 31; residential areas of, 10, 33, 40, 50, 53, 55, 63, 123, 160, 199, 227, 232, 253, 267, 268
Board of Education Building, 215
bocci, 242
Bourse Building, 197
Brewery Place, 47
Brewerytown, 54
Bridesburg, 32, 74, 254
Bridge Street, 181, 230
Brill (J. G.) Co., 76, 83, 255
British: ancestry, 56, 62, 224, 232; immigrants, 7, 31; population, 5, 71
Broad Street, 3, 14, 27, 35, 62, 188, 190, 193, 195, 245, 250, 258, 278
Broad Street Station, 5, 197, 215, 272
Broad Street Subway, 172, 181, 225, 277
Bromley & Sons, 56
Brown's Court, 127
Brown Street, 58, 164
Budd Co., 252, 255
building and loan societies, 4
burlesque, 212
Burpee Seed Co., 263
buses, 172, 256
Bustleton, xv, 3

Callaghan estate, 228
Callowhill Street, 14, 16, 159
Camden, 3
camera, 35 mm., xiii
carpet manufacture, 91, 95
Castor Avenue, 222, 225, 230, 250
catering, 109
Catherine Street, 173
Cedar Street, 238
Central Penn National Bank, 198
Central Soup Society, 124
Chamber of Commerce, 95
charities, 119, 124–125
Charities and the Commons, 122
Chauveau's, Anthony J., confectionary shop, 26
Cheltenham, 27, 280
Chestnut Hill, 101, 172
Chestnut Street, 26, 197, 206
Chestnut Street Opera House, 26
Chew Street, 238, 278
Chinatown, 200
Chinese, 119
cholera infantum, 138
Church Home for Children, 228
cigar shops, 21, 211
City Beautiful movement, 200–201
City Hall, ix, xvi, 5, 9, 25, 172, 197, 200, 215, 255, 272
city of homes, 3–4
City Parks Association, 147
class conflict, 7
Clearview Avenue, 65
Cobbs Creek, 147, 257
Conestoga Street, 238
Connie Mack Stadium, 35
consolidation of 1854, xv
Convention Hall, 278
Cope family, estate of, 65
Cottman Avenue, 248, 250, 254
Cramp Shipyard, 110

Crescentville Electric Storage Battery Co., 268
Cresson Avenue, 71
crime, 126
Cunningham Piano Co., 100
Curtis Publishing Co., 117

daguerreotype, xiv
Davenport (William) and Sons, 235, 237
Davis Glazed Kid Factory, 56
Davis Yarn Mills, 71
Delaware Avenue, 22, 201–202, 204, 274
Delaware River, 3, 5, 22, 25, 31, 75, 174, 201; waterfront, 199–202, 204, 255
Delaware Valley Regional Planning Federation, 250
depression, 1890s, 7, 26
Depression, 1930s, xvi, 71, 73, 75, 86, 181, 218, 225, 255, 256, 258, 261, 271
Diamond Street, 62, 63
Dinwiddie, Emily, 47, 123
Disston saw works, 85, 248
Dobson Mills, 91
Dock Street Market, 44, 204, 278
downtown, xv, 5, 25, 26, 35, 171, 197–220, 255–256, 272, 280
Drexel University, 268
Dumont's Minstrels' Theater, 212
"dumps, the," 232
Durfor Street, 53

Eagle Builders' Iron Works, 76
Earle Theater, 218
Eastern State Penitentiary, 9
East Falls, 74
East Rittenhouse Street, 65, 133
Eastwick, 254

Eddystone, 75, 77
8th Street, North, 211
Eire Avenue, 3, 250, 255, 258
Elbridge Street, 235
electricity, impact of, 171, 173, 186
electronic equipment, manufacture of, 74, 255
11th Street, South, 26
Elkins, W. L., 27, 171
Elks, Benevolent Protective Order of, 206
Elmwood Avenue, 240
Empress Theater, 71
Engel Brewery, 54
English immigrants, xvi, 18
Erlanger Theater, 198
ethnicity, 5; and employment, 74. See also specific groups

Fairhill Street, 235
Fairmount Avenue, 9, 58
Fairmount Park, 9, 200, 215, 257
Fairmount Reservoir, 9
farming, 28, 75, 224, 250, 257, 272
Farm Security Administration, 271
Federal Street, 53, 274
Feltonville, 225, 227, 255
Fern Rock, 181, 235, 255
ferries, New Jersey, 172, 185
Fidelity Bank Building, 198
5th Street: North, 166; South, 21, 25, 38, 152, 155
54th Street, South, 238
Filbert Street, 211
Fisher (Wendelin) & Sons, 235
Fitzwater Street, 135, 158
Food Fair, 274
Forrest Theater, 198
49th Street, 3
4th Street, South, 11, 48
Fox, Hannah, 120

Fox Chase, 195, 272
Fox-Weiss Furriers, 261
Frankford, 3, 31, 181
Frankford Arsenal, 113
Frankford Avenue, 225, 230, 235
Franklin Court, 127
Franklin Home for the Reformation of Inebriates, 124
Free Library, 215
Fremont Hotel, 212
Front Street, 17, 56, 58, 147, 151, 162, 268
"furnished-room district," 5

garment trades, 75
gasoline station, 175, 193, 195
German: ancestry, 56, 62, 224, 232, 240; immigrants, xvi, 7, 18, 31; residence, 32, 54, 56, 58, 60, 123, 227, 248
Germantown, xv, 3, 40, 65, 133, 254, 255
Germantown Spinning Mill, 65
Ghezzi, Oreste, 261
Gilliams and Stratton, 21
Gillinder and Sons, 98
Gilmer (L. H.) Solid Woven Belting plant, 248
Gimbel's, 5, 174, 198, 206
Girard, Stephen, 201–202
Girard Avenue, 5, 17, 27, 155, 179
Girard College, 9
Girard Estate, 238
Girard Park, 238
Gladstone Hotel, 199
glass manufacture, 98
Glenwood Avenue, 54
Goebel, E. S., 187
Goldman, Emma, 126
Gray's Ferry, 32
Greek Orthodox Church, 166

grocery store, 62, 224, 245
Gross Street, North, 242

Haddington, 31, 224, 240
Hadfield Street, 232
Hamilton Public School, 238
Hardwick and Magee Co., 91
Hasbrook Avenue, 272
Head House Square, 50
Health Department, 142
Hestonville, 3
High Line (Pennsylvania Railroad), 176
Hill, Octavia, 120
Hill Creek housing project, 268
Hindenberg, 272
Hine, Lewis, ix, 122–123, 141, 267
Hogg Alley, 102
Hog Island shipyard, 110
home, single family, 4
Home for the Homeless, 124
Horn and Hardart's, 211, 258
horse, use of, in urban transportation, 176
Horstman's Court, 135
Housing Conditions in Philadelphia, 47, 123
Houston, Henry Howard, 101
Howard Street, South, 44
How the Other Half Lives, 121
Hunting Park, 225, 250
Hunting Park Avenue, 255, 263
hygiene, 133, 139

immigrant neighborhoods, 3, 31–33, 37, 38, 48, 119–123, 129, 163, 201, 227, 253, 267, 272
immigration, European, xvi, 7, 31, 149, 223, 224, 253
Imperial Woolen Co., 66
Independence Hall, ix, 220

industrial areas, 3, 14, 31, 32, 56, 60, 63, 66, 71, 73–74, 100, 215, 227, 254, 258
industry, diversity of, 73, 255, 263
Insurance Company of North America, 215
interior views, x, xiv
Irish: ancestry, 56, 62, 224, 232, 240; immigrants, xvi, 7, 31; population, 5, 32, 123; residence, 12, 18, 44, 55, 60, 63, 71, 238
Italian: employment, 74, 86, 102, 103, 261; immigrants, xvi, 7, 10, 119; language, 253; market, 5, 274; residence, 5, 32, 33, 43, 50, 53, 65, 71, 97, 123, 135, 160, 227, 238, 242, 268

Jacquard apparatus, 91
Jaspan (Joseph) and Sons, 44
J. C. H. Galvanizing Co., 56
Jefferson Street, 63
Jenkintown, xvi
Jenks, Helen, 135, 151
Jennings, William N., 9, 280
Jewish: employment, 261; immigrants, xvi, 7, 10, 11, 31, 240; residence, 4, 5, 32, 33, 37, 38, 48, 55, 56, 58, 60, 63, 123, 152, 155, 160, 199, 227, 248
Johnson, Alba, 159
Jonathan, 4
Jones, Jacob, farm of, 28
journey to work, 4, 7, 74, 175, 181, 190, 201, 256

Kane Public School, 63
Kater Street, 38
Keebler factory, 215
Keith, John Frank, ix, 150, 167
Kemble, William, 171

Kenilworth Street, 47
Kenneth, 7
Kensington, 5, 31, 54, 56, 74, 76, 91, 110, 167, 224, 263, 267
Keystone Street, 248
Kittredge, Mabel, 129

Landsmanshaftn, 33
Land Title Building, 198
land use pattern, 12, 16, 18, 250
land values, 199
Lansdowne Avenue, 28
lantern slides, 133, 138, 158
LaSalle College, 27
laundry, Chinese, 17, 71
Lawndale, 225, 250
League Street, 151
Lehigh Avenue, 3, 56
Leithgow Street, North, 267
Levering Street, 71
Levick Street, 235
Levin's Bakery, 48
Limekiln Pike, 271
Lincoln Day Nursery, 147
Lincoln Drive, 248
Lingerman, Samuel, 166
Lit Brothers, 5, 187, 198, 206, 258
Little Italy, 43
Locust Street, 220
Locust Street subway, 172
Locust Theater, 198
Logan, 32, 181, 227, 245, 248
Logan Square (Circle), 215
Lombard Street, 10, 119, 135, 147
Lower East Side, New York's, 11
Loxley Court, 18

McKinley Court, 165
McNelis, Michael, 141
McNichol, Sunny Jim, 200
Mahood's Range and Stove Co., 176

Main Line, xvi, 4, 27, 172
Main Street, 66, 71
Manayunk, 3, 31, 32, 66, 71, 253
manufacturing, xvi, 3, 54–56, 73–100
Market-Frankford Subway-Elevated, 172, 176, 181, 185, 198, 224, 225, 230, 240, 272
markets, 3, 48, 50, 160, 274
Market Street, 21, 170, 172, 176, 206, 218, 220, 258
Marshall Street, 4, 60
Mayfair House, 248
Medico-Chirugical Hospital, 215
metal trades, 74–76, 113, 255
Midnight Mission for Rescuing Fallen Women, 124
Midvale Steel Co., 113, 250
Mifflin Square, 53
Mildred Street, 43
Millbourne Mills, 179
minstrelsy, 212
Misericordia Hospital, 238
missions, 119, 124
Mochrik, Simon, 101
Montana Street, 238
Montgomery Avenue, 86
Montrose Street, 43
Moore Street, 228
Morris Park, 242
mortgages, 235
Mt. Airy, 225, 238, 248, 254, 255
Mt. Vernon Public School, 135
Mt. Vernon Street, 193
Moyamensing, 31
Moylan Park, 63
Mummers Parade, ix
musical instruments, manufacture of, 100

National Child Labor Committee, 123, 141
National Housing Association, 123
Naudain Street, 44
Navy Yard, 35
"Neck," 4, 228
needle trades, 5
New Deal, 268, 271
New Jersey, suburbs in, xv
Newman, Bernard, 133
New York Silk and Woolen Store, 48
Nicetown, 32, 54, 74, 224, 250
9th Street: North, 212; South, 5, 274
Noble Street, 14
North American Building, 198
Northeast Philadelphia, 75, 195, 225, 230, 235, 250, 254, 255, 257, 271, 272, 280
Northern Liberties, 5, 58, 267
North Philadelphia, 9, 27, 28, 32, 35, 54, 58, 60, 62, 63, 86, 223–227, 253, 254, 258, 280
Northwood Cemetery, 271
nurseries, 147

Oak Lane, 32, 225, 254
Oak Lane Avenue, 28
Oak Lane Village, 28
Octavia Hill Association, ix, 10, 37, 47, 65, 106, 120–123, 127, 129, 133, 135, 151, 154
Ogontz Avenue, 271
Olney, 32, 33, 172, 181, 225, 250
Olney Avenue, 172, 268
Olney High School, 228
Oregon Avenue, 133
Our Lady of Consolation Church, 248
Overbrook, 185, 225

Oxford Avenue, 60, 230, 272
Oxford Circle, 222, 230, 250, 254

Packard Building, 198
padrones, 33
parks and playgrounds movement, 147
Parrish, Helen, 120
Passayunk Avenue, 155
paving, street, 174, 188
Pemberton Street, 158
Pennsylvania, suburbs in, xv
Pennsylvania Railroad, xvi, 22, 25, 35, 172, 176, 185, 202, 248; Suburban Station, 172
Pennypack Creek, 147, 257
Pennypack Park, 250, 254, 272
Percy Street, 155
Philadelphia and West Chester Traction Co., 179
Philadelphia College Settlement, 120
Philadelphia Electric Co., 173, 186
Philadelphia Housing Association (Commission), ix, 43, 58, 122, 123, 133, 135, 138, 139, 147, 268
"Philadelphia Inquirer Model Home," 237
Philadelphia International Airport, 110
Philadelphia Mint, xiv
Philadelphia Rapid Transit Co. (PRT), 171–172, 179, 256, 277
Philadelphia Society for Organizing Charity, 125
Philadelphia Traction Co. (PTC), 256
Philadelphia Warehousing and Cold Storage building, 58
philanthropy, Quaker, 120
Philco, 263
Phillies (baseball club), 54

playground, 147, 151
police mug book, 126
Polish: employment, 74; national parish churches, 33; residence, 31–33, 50, 71, 123, 253
pollution, 176
poolroom, 211
Poplar Street, 58
population, xv, 5, 31, 171, 199, 223, 225, 232, 248, 254, 257
Port Richmond, 32, 54, 74
Poth Brewery, 54
poverty, 119–123, 149, 267, 268
Protestant Episcopal Mission, 44
Providence Court, 30
Provident Mutual Life Insurance Building, 198
PSFS Building, 198, 199, 255, 272
public housing, 268
public markets, 11, 50, 53, 58
public schools, 143, 228
Public Works Administration, 267, 268
publishing, 117, 255
pushcarts, 5, 48, 60, 75, 160, 224, 227

Queen Lane Reservoir, 248

race, 5
Race Street, 212
Race Street Pier, 142
radio broadcast, 173–174, 187
radios, manufacture of, 74, 263
railroad network, 3, 172
Rau, William H., 77
Reading Railroad, 14, 35, 65, 172, 176, 235, 238; North Broad Street Station, 54
Reading Terminal, 5, 197, 206
Real Estate Trust Building, 198

reform, housing, xiii, 101, 119–123, 127, 133, 135, 268
Reidel, Emil, 240
Ricci, Antonio, 242
Richmond, 224
Ridge Avenue, 190
Ridge Avenue Subway, 172, 181
Riis, Jacob, xiv, 121–122, 135
Rittenhouse Square, 5, 21, 27, 199, 272
Ritter Furniture Factory, 55
Ritz-Carlton Hotel, 199
Roberts, H. Armstrong, 278
Rockland Avenue, 245, 248
Rockland Theater, 245
Rockwell Avenue, 272
Rodin Museum, 215
Rodman Street, 129
Roosevelt Boulevard, 172, 222, 225, 230, 245, 248, 250, 254
Rosehill Street, 267
Rose Mills, 267
Rosner, Charles and Maryann, 159, 240
row house neighborhoods, 31, 33, 232, 254

St. Donato's Church, 242
St. Hedwig's Church, 215
St. James Street, 44
St. John's Church, 66
St. John Street, 76
St. Ludwig's Church, 54
St. Mary's Street Library, 120
St. Paul's (Lutheran) Church, 58
St. Paul's (Roman Catholic) Church, 43
sanitation, 133, 142
Saturday Evening Post, 117
Sauquoit Silk Manufacturing Co., 90, 263

Saxton, Joseph, xiv
Scandinavian immigrants, xvi
Schall, Charles, 16
Schmidt's Brewery, 56
School House Lane, 248
Schubert Theater, 198
Schuylkill River, 3, 9, 21, 173, 174, 200, 220
Sears, Roebuck and Co., 75, 245
2nd Street: North, 164–165; South, 50
Sesqui-Centennial Exposition, ix
7th Street: North, 60; South, 101, 135
sewer lines, 174
shantytowns, 7, 228–229
Shibe Park, 35
shoe repair, 101
shopping center, 228
shopping strips, 4
Shunk Street, 238
69th Street, 172, 181
62nd Street, 28
skyline, 197–198, 220, 272
Slavic immigrants, xvi
slums, 7, 47, 119–123, 133, 135
Smith Playground, 147
Snellenberg's, 5
Snyder Avenue, 3, 172
South Philadelphia, 3, 5, 32, 33, 35, 53, 74, 97, 148, 163, 201, 224, 227, 228, 238, 253–255, 268, 280
South Street, 2, 4, 5, 10, 21, 44, 48, 58, 160, 172, 253, 274
Southwark, 37, 38, 58, 154
Southwest Philadelphia, 32, 240, 254
Sprague Street, 238
Spring Garden district, 5, 32
Spring Garden Street, 75

Spruce Street, 199, 238
Stamper's Lane, 229
Starr, Theodore, 120
Starr Garden, 37, 135
Stenton Plaza Apartments, 238
Stetson, John B., 86
Stetson Co., 86
Stone House Lane, 229
stone yards, 21
Strawberry Mansion, 32, 224, 227
Strawbridge and Clothier, 5, 206, 258
streetcars, 7, 83; electrification of, 7
streetcar lines, 3, 230
street cleaning, 102
suburbanization, xvi, 7, 176, 223–227
suburbs: railroad, 4; residential, 3, 7, 27; streetcar, 224, 228, 232, 238
subways, construction of, 181
sugar refining, 5, 48, 105
supermarkets, 228, 274
sweatshops, 75, 97
Syrians, 163

Tackawanna Street, 235
Tacony, 85, 248
Tacony Creek, 147, 257
Tacony Park, 250, 268
Taylor, Frank H., 95
tenderloin, 5, 200, 211–212
textile manufacture, 5, 73–75, 90, 91, 95, 97, 255, 261, 267
Third Ward, 40
3rd Street, South, 229
13th Street: North, 14, 179; South, 196, 211
33rd Street, North, 54
Thompson Street, 54
Tioga Street, 32, 74, 224

transportation, public, 5, 25, 171–172, 175–176, 179, 185, 197, 256, 277
Trinity Reformed Church, 60
Trocadero, 212
trolleys, 25, 37, 83, 171–172, 179, 185, 224, 256, 277
Tutendari family, 43
12th Street, North, 62
20th Street, 5
24th Street, South, 21
23rd Street, North, 215
typewriter, 77
typhoid fever, 174

unemployment, 7, 73, 258
Union Baptist Church, 40
United Charities, 258
United Gas Improvement Co., 173
University of Pennsylvania, 278

Vachon, John, ix, 271
Vatulli, Peter, 261
vaudeville, 212
Vendig Hotel, 199
vending, street, 21, 43
vice district, 197, 200, 212
Victoria Theater, 141, 258
Vine Street, 5, 58, 179, 200, 215, 240, 242
vocational education, 143
Vulcanite Paving Co., 188

wages, 77, 225
Wallace, Philip, ix, 147, 193, 195, 274
Walnut Street, 25, 193, 206
Walters Milling Co., 54
Wanamaker's, 5, 25, 197, 198, 218
Washington Avenue, 5, 43
Water Street, 162

water supply system, 174, 188, 257
Wayfarers Lodge and Workshop, 125
WDAR (radio station), 187
weaving, hand loom, 95
West Oak Lane, 271
West Philadelphia, 3, 27, 28, 32, 176, 223–227, 228, 232, 238, 240, 242, 253–255, 272
Wharton, Susan, 120
Wharton Street, 3, 224
Widener, P. A. B., 27, 171
Wilbur-Rogers clothing store, 258
William Penn High School, 143
William Penn statue, 5
Willows Street, 232
Wilson, G. Mark, ix, 66, 162–166
Wilton Hotel, 199
WIP (radio station), 174
Wissahickon Avenue, 263
Wood Street, 215
Woodward, Dr. George, 101
Woolworth's, 245
working women, 73, 77, 86, 113, 187, 245, 263
Works Progress Administration, 123
World War I, 113, 139, 200, 204
Wright (E. A.) printing and engraving plant, 55
Wynnefield, 185, 225, 227, 254

Yewdall and Jones woolen mills, 97
Yewdall Street, 238
Yiddish, 38, 152, 253
YMCA Building, 198
Young Women's Union, 38
YWCA Building, 197

Zane Soap and Chemical factory, 66
zoning, 123, 193